THE JOHN HARVARD LIBRARY

Howard Mumford Jones
Editor-in-Chief

THE

ART-IDEA

By

JAMES JACKSON JARVES

Edited by Benjamin Rowland, Jr.

JHL

THE BELKNAP PRESS OF
HARVARD UNIVERSITY PRESS
Cambridge, Massachusetts

1960

Library of Congress Catalog Card Number 60–11559

Printed in the United States of America

CONTENTS

v

CONTENTS

CONTENTS

CONTENTS

CONTENTS

INTRODUCTION

Today the name of James Jackson Jarves is mainly associated with the famous collection of Italian paintings that came into the possession of Yale University in 1871. In actuality, however, his career, or rather the varying careers he followed overshadow this landmark in the development of an understanding in America of the beauties of medieval and renaissance art. We are here concerned with his activities as a writer.

It will be useful to give a précis of a life lived in many different worlds during a period when most Americans were restricted by cultural and geographical insularity. James Jackson Jarves was born in 1818, the second son of Deming Jarves, who shortly after James's birth was to make a great fortune by manufacturing Sandwich glass, one of the most famous early American industrial enterprises. In 1837, for reasons of health, young Jarves was sent to the Sandwich Islands. He arrived at an unhappy period, for King Kamehameha III had just abolished the old pagan cults and given his kingdom over to the piety of the missionaries. Jarves resided in Hawaii on and off until 1851. During these troubled years he began his literary career by writing a history of the Hawaiian Islands. This was published in 1843. Another production of this period was his *Scenes and Scenery in the Sandwich Islands, and a Trip Through Central America*, also published in 1843. During his time in the islands he had been editor of a periodical, the *Polynesian*, and had been embroiled in the various attempts of the French to secure the sovereignty of the islands for themselves.

After a brief period as Special Commissioner for Hawaiian Affairs in the United States, Jarves sailed for Europe in the autumn of 1851, apparently for commercial purposes. During his residence in Paris from 1851 to 1852 he seems first to have become aware

of works of art as a result of his visits to the Louvre. He developed a conventional preference for Murillo's Immaculate Conception and for an obscure Dutch picture which he admired for its "perfect finish and lifelike tone." There is no indication that he was then aware of the collection of Italian primitives that had been formed by Napoleon's art director, Baron Vivan-Denon. Sometime in 1852 Jarves and his family (he had married in 1838) left Paris for Florence. In the Tuscan capital Jarves became a member of the literary and artistic circle that included the Brownings, Mrs. Frances Trollope, and Mrs. Jameson,[1] the authority on Christian iconography.

In Florence he seems first to have cultivated a taste for the obscure early Italian painters. In this he was guided largely by his reading of the critical works of Alexis Rio[2] and Lord Lindsay,[3] both of whom had earlier influenced Ruskin in his discovery of the Italian Primitives. Under the influence of these critics and of the pictures he saw in museums, Jarves became a collector of the neglected paintings of Italy from the thirteenth to the sixteenth centuries. In the late eighteen fifties he conceived the idea of establishing a gallery for his pictures in Boston, since the collection furnished a lesson in the development of the Italian schools. He approached Charles Eliot Norton in 1859 in the hope of selling his pictures either to the Boston Athenaeum or to some group interested in establishing a public gallery of art. Despite Norton's interest, the

[1] Mrs. Anna Brownell Jameson was the writer of a series of volumes under the general title of *Sacred and Legendary Art* that began to appear late in the eighteen forties. In these she treated the iconography of the Madonna, the Saints, and the monastic orders. Her descriptions and the illustrations in her books form a kind of history of Church art from early Christian times to the seventeenth century. Although Ruskin claimed that she was totally devoid of any critical faculty in art, Hawthorne noted that Mrs. Jameson could read a picture like a book.

[2] Alexis François Rio was the author of *The Poetry of Christian Art*, published in 1836. This work was notable not only for its sympathetic account of early medieval painting, but also for its historical treatment of Italian art. In its insistence on the import of mysticism and the spiritual life the work is in some ways more a history of religion than a true history of art.

[3] Alexander William Crawford, Baron Lindsay, wrote a three-volume work entitled *Sketches of the History of Christian Art*, published in 1847. This was a survey of the early artists dedicated to the Church. Its orderly historical method no doubt inspired Jarves to form a collection illustrating by actual examples the progress of art.

effort came to naught, and then began the long and shoddy story of Jarves' attempts to dispose of his collection. When his pictures were exhibited in New York and Boston, they aroused only curiosity. Not until 1871 were 119 of his early Italian canvasses finally sold for $22,000 to the Treasurer of Yale College.[4]

To the first edition of *The Art-Idea* Jarves prefixed an essay about his pictures, which were deposited in the sixties with the New York Historical Society. In forming his collection Jarves seems to have been actuated by a compulsion to acquire objects as if it were an act of creation to do so — the kind of compulsion that drives collectors into a passionate pursuit of their quarry regardless of all obligations. He seems to have had in mind an historical sequence of paintings that would, as it were, illustrate the theories of Rio and Lord Lindsay; and whatever part purely aesthetic pleasure may have played in his purchasing, the driving force behind his accumulation was the idea of assembling pictures illustrating the progress of art from the naïve efforts of the Dugento to what was for Jarves the more accomplished naturalism of the Seicento. Yet *The Art-Idea* contains no critique of the paintings he acquired in Florence, although there are traces of his sympathy for the Italian primitives in the body of the book.

The rest of Jarves' life was mainly passed in Europe. He loved Florence, where he acted as a buyer of European works of art for wealthy Americans and for General Cesnola, the embattled director of the Metropolitan Museum of Art. Until he died in 1888 Jarves was obsessed with the notion of transporting European works of art to America in order to improve the taste of his countrymen. He married a second time in 1862, but he outlived both his first and second wife and four of his six children, dying in Switzerland though his body lies in the Protestant Cemetery at Rome.

If Jarves' role in building up collections of art in the United

[4] The trials and tribulations of Jarves in his efforts to dispose of his collection have been related by Francis Steegmuller in *The Two Lives of James Jackson Jarves* (New Haven, 1951), and by Theodore Sizer in "A Forgotten New Englander," *New England Quarterly*, June 1933. Steegmuller's book is the only full length biography of Jarves, and contains a complete biography of Jarves' own writings (pp. 309–313). Sizer contributed an entry on Jarves to the *Dictionary of American Biography*.

States was thus important, his pioneering work in that field was but a part of his activity in developing an American taste for art. To this end he wrote a small library of books on art, not to speak of travel books, biographies, and catalogues. His books on art, however, have special importance for understanding American cultural development, and among these *Art-Hints, Architecture, Sculpture and Painting*, published in 1855, is a leading document. This is a sort of primer of art history written for Americans having no knowledge of the Old Masters. The book makes an eloquent plea for the importation of the treasures of Old World art into the New World, and is interlarded with long quotations from Jarves' masters in criticism, Rio, Lord Lindsay, Ruskin,[5] and Mrs. Jameson. Nevertheless his next important venture in criticism, *The Art-Idea*, first published in 1864, reprinted in 1865 and several times thereafter, is the more important work. *Art Thoughts, the Experiences and Observations of an American Amateur in Europe*, first published in 1870, is in many ways the most mature statement of the ideas Jarves adumbrated in his earlier books, but *The Art-Idea* is probably the most influential of Jarves' volumes and has therefore been chosen for reprinting here.[6]

The Art-Idea first appeared as Part II of Jarves' strangely titled *Why and What am I? The Confessions of an Inquirer. In three parts* (Part III was never published). Part I of the proposed trilogy is called *Heart-Experience, or the Education of the Emotions*, and is a pseudo-autobiographical "novel" ending with an exposition of Jarves' ideas on divorce, a product of his own marital unhappiness. This book is one of the curiosities of romantic writing in America, for it belongs to a genre but little practiced in Jarves' own time, the literature of confession. There is, however, no obvious connection between *Heart-Experience* and *The Art-Idea*; and in the second edition (1865) Jarves dropped the pretense that the volume was the second part of his trilogy, and revised the subtitle

[5] John Ruskin's ideas and influence hardly need a detailed exposition here. It was his enthusiasm and artistic sensibility, as well as his insistence on morality, that affected Jarves' approach to art.

[6] On Jarves' taste in art, see George Boas, "The Critical Practice of James Jackson Jarves," *Gazette des Beaux-Arts*, May 1943.

to *Sculpture, Paintings, and Architecture in America*. Obviously, then, *The Art-Idea* exists in its own right as a statement of aesthetic theory and of the history of art; and as such it influenced the development of American taste.

What is the general context of Jarves' statement? Dominant in his thinking is the notion of the continual progress and increasing perfection of art in the direction of an ideal naturalism. One of the reasons for his exasperation with Manet's Olympia, which he saw in 1863, was that its affected flatness and stiffness seemed to him a deliberate and unforgivable step backward on the road to perfection. True it is that Jarves sometimes finds it difficult to reconcile this mode of thinking (what has been called the "biological fallacy") with his Ruskinian admiration for the medieval. On the one hand he deplores Giotto's lack of scientific definition of reality; on the other, he praises his attempts at naturalism, a naturalism which Jarves does not, however, relate to the influence of Franciscanism. Giotto failed to satisfy Jarves completely because his naturalism was not nineteenth-century realism. He gives Giotto credit for "nobility of thought, dramatic energy, fertile invention, and truth of conception," he admires in Giotto a "harmonious variety of minor motifs singularly touching and effective, giving a lofty opinion of poetical power," but for Jarves the ultimate test is always realistic representation. Like his contemporaries Jarves was unable to see that Giotto was not interested in realistic representation in the sense of the scientific observation and lyric nature-worship that made up the nineteenth-century ideal of naturalism. This theory and this difficulty are central to Jarves' "art-idea."

People brought up within the framework of representational art today find it virtually impossible to bring themselves to look at or to judge the work of the Abstract Expressionists. In Jarves' time it was equally difficult to regard works of art from any point of view except that of content and morality. Jarves belonged to an age in which taste was governed almost exclusively by the edifying and pious sentiments expressed in a picture and, as a corollary, by the realistic means necessary to enhance this message and content. He is never, even in a remote sense, interested in style

per se. He finds it difficult to understand the "unnaturalness" that arises out of deliberate discrepancies of scale, as in Michelangelo's Pietà in St. Peter's. It was impossible for him to grasp the fact that an artist's distortion of nature might be a purposeful means of stressing a spiritual aim or idea. He was in this sense a child of his time.

The Art-Idea is Jarves' personal explanation or definition of what art means to him. In his "Preliminary Talk" he declares, "It is *my* Art-Idea, being a candid confession of the impressions which the study of art has made on my individual mind." He divides the uses of art into three main functions: Decoration, which he defines as ornament, or everything having both utility and a scope for beauty; Illustration, which he describes as teaching under an aesthetic form; and Revelation, which he explains as imagination, or everything that stems from the likeness of things not in this world. Elsewhere he remarks: "Whatever reveals the unseen in aesthetic guise, that is ART!"

For Jarves, as for many of his contemporaries, art was, then, part education and part edification. Even of Greek art he says that "the Grecian passion for the beautiful was the most cogent refiner of nations." This almost places Greek art on a par with Christian art, in Jarves' view, as a source of moral discipline. It was generally agreed in Jarves' time that art was something to control the mind, to keep men from slipping into a dreadful slough of immorality and vulgarity.

Jarves liked to dwell on the pious idea that art is something inspired by faith. This doctrine he is even able to apply to classical art by noting that the Greek artist was "inspired by faith which, like that of Fra Angelico by prayer and devotion, opened up to him celestial visions and specific manifestations of the favor of *his* gods and their delight in his work."

Nevertheless one of Jarves' special bogeys was the baleful domination of art by church and priesthood. Even of classical times he asserts that "as fast as the Greek intellect outgrew the priestly domination, it advanced in taste and knowledge." For him there was something sinister in the Roman Church, which he thought

of as a force trying to engulf the whole world politically as well as religiously. He argues that the art of his own time springs from a response to "the vital power of free Christianity as a progressive force to regenerate mankind." Modern art is to replace the evil art of the Renaissance. Apparently Jarves envisaged a kind of Renaissance of Protestant art, in which artists were to paint pictures from actual life out of an elevated purpose — something, in other words, not unlike the moralizing realism of Hogarth. Our author notes that "the best art is that which at once most enlightens our intellect, soothes and elevates our feelings, and awakens refined pleasure."

It seems obvious from his writing on Italian religious painting in *Art-Hints* and in *The Art-Idea* that Jarves was torn by the same conflict of Protestantism and Romanism that disturbed Ruskin in the formulation of his aesthetic. Under Ruskin's influence and from Ruskin's resolution of this dichotomy Jarves makes his plea for a Protestant or non-sectarian religious art without the stigma of Roman dogma as a basis for a democratic art acceptable and appropriate for the future development of art in America. The conflict was of course partly resolved by considering the Italian Primitives as simple craftsmen working in a period before the Church assumed the universal political power that Ruskin and Jarves saw as the ruin of art. Such ideas were of course not unfamiliar to an American public that had followed Ruskin since the publication of the first volume of *Modern Painters* in 1843.

Jarves' discussion of ancient art is typical both of him and of the taste of his period.[7] The works of classical art he selects for discussion belong to the same category of sentimental genre that he admires in the work of contemporary painters; and he chooses only those pieces of Greek and Roman art that somehow conform to the Victorian feeling for the sentimental and the coy. Hedged about by the fear and guilt alleged to be part of Puritan Christianity, he was unable to see beauty in anything sensuous, the result being

[7] It is difficult to determine whether or not Jarves had actually read any of the popular authorities on classical art, like Winckelmann. Apparently he was familiar with Lessing's ideas about the Laocoön.

that he automatically condemns nude and erotic subjects which to him can represent only depravity. Skillfully avoiding the mention of works in any way erotic or depraved in his account of ancient sculpture, he covers with righteous opprobrium such statues as the Old Peasant Woman and the Drunken Old Woman of the Capitoline, for these he considered unedifying and unpleasantly realistic. The examples of classical art he discusses were all tourist favorites; his interest in them, based on content rather than style, is a reflection of the same taste that conditions his feeling for later art.

It has been noted that one of the great influences on Jarves' life and taste was that of John Ruskin. When Jarves interprets Gothic architecture as something "taken from the growth and variety of the natural world," and as the embodiment of the spiritual and imaginative faculties of man, the ideas echo those of Ruskin. On one occasion, to be sure, Jarves complains of Ruskin's suggestion of the desirability of returning to the forms of medieval architecture for domestic building, the reason being that for him medieval architecture reflected a debased social condition far below the higher stands of morality and of function he descried in the architecture of the nineteenth century. Yet Jarves follows Ruskin in gauging art by the virtue of its makers; this is consonant with his theory that the decline of art in the post-Renaissance period coincides with the material rise of the papacy, which Jarves regarded as a repudiation of liberty and reform. Jarves naturally subscribed, however, to the myth of the honesty of medieval craftsmanship, and from this assumption, like many of his contemporaries, he inferred ideas of functionalism. Functionalism appealed to the moralism of Jarves and his fellow Victorians who argued that art, like life, should be sincere and true.[8] Following Ruskin, Jarves is continually seeing styles of architecture as reflections of the societies that produced them. Thus he condemns Chinese and Indian art and architecture as reflections of barbaric and backward civilizations. In this judg-

[8] It is not unlikely that ideas of architectural functionalism were affected by the new concept of biological evolution and adaptation that were part of the intellectual climate of the sixties.

ment he may have been also partly affected by the writings of James Fergusson, the architectural historian who wrote that "China possesses scarcely anything worthy of the name of architecture." If so, he must at the same time have skipped over this writer's sympathetic treatment of the ancient art of India.

But perhaps the most important part of *The Art-Idea* — certainly one of its major components — is Jarves' account of American artists. Concerning them he seems to have been able to express himself without the religious prejudices and without the clichés that mark his accounts of European art. His survey of painting in America begins with Copley. His completely negative treatment of that painter is valuable, if only because it reveals how little "Colonial" art was esteemed in the mid-nineteenth century. Just as Jarves followed Fergusson in condemning all pre-Revolutionary architecture, so he discusses our one great pre-Revolutionary painter with the statement that "Copley painted some hard, realistic portraits here, cold in color and aristocratic in type." In speaking of Copley's facile English style he dryly observes, "There is nothing in his art to make him a loss to America." But Jarves has a word of appreciation for Gilbert Stuart's "diaphanous" style and dexterity, although, he says, "his qualities are not such as now most command the popular applause."

Jarves must be one of the first to harp upon the theme of Washington Allston's isolation and artistic starvation in New England, a tragedy later embroidered by Henry James in his biography of William Wetmore Story. Actually, it seems, Allston's tragedy was neurotic frustration stemming from his inability to complete the canvas of Belshazzar's Feast, an inability that long haunted him. It would also appear that lack of competition as well as lack of competent criticism really blighted Allston's life in America, not the hostility of the New England environment. It is rather odd that Jarves should remark that "Allston had less sympathy with landscapes than with the human figure," since today we regard Allston's landscapes as the most sympathetic aspect of his production. Jarves was, however, discerning in his criticism of Allston's surviving figure pieces. He is able to recognize the empty senti-

mentality of Allston's Beatrice and the labored quality of Jeremiah and the Scribe.

Jarves' analysis of the essentials of Thomas Cole's landscapes is equally interesting. He points out that Cole's importance as a founder of a really native landscape school, admirable in the Catskill and Adirondack pictures, was rather unhappily offset by the painter's use of landscape as a grandiose instrument of moral instruction. "Cole," says Jarves, "is greater in idea than action . . . like most artists who live in the ideal, he was unequal in his work." Jarves remarks that Cole left no followers, but this is not entirely accurate because Frederick Church worked with Cole during his last years. Jarves was quick to discern the essential superficiality and bombast in those gigantic panoramas of Church's, adaptations of compositional and coloristic elements in Cole's imaginary scenes, which by and by conditioned the painting of sensational subjects from actuality. Jarves was equally shrewd in recognizing Doughty and Alvan Fisher as pioneers of American landscape painting. One wishes he had devoted more space to these artists whose names, he lamented, were already fading from memory at the time he wrote.

Jarves' pages are full of names of painters now entirely forgotten. Who has ever heard of Sontag, Babcock, Cephas Thompson, or John Tilton? To Jarves, however, these personalities seemed as filled with bright promise as were Hunt and La Farge. Most of the minor masters Jarves praises reflect the work of the Barbizon school, which Jarves admires for both its sentiment and its luminosity. One such artist was J. Foxcroft Cole, whose pastoral subjects, by virtue of their luminous atmosphere and heavy impasto, suggest the work of his master, Jacque, and whose little French landscapes are not unlike Corot in technique and feeling. Another artist deserving reinstatement is Babcock. His rich color and idyllic, if classical, subject matter are suggestive of the Venetian tradition earlier exemplified in American art by Allston and Morse. Jarves does not mention Morse, but his dissection of Page,[9] another "American Titian," seems nowadays completely justified. If he

[9] William Page, sometimes referred to as the "American Titian," was a particular friend of Browning and his circle. On Page and his work, see Joshua Taylor, *William Page* (Chicago, 1957).

writes of Page that "a great artist is hidden somewhere but he eludes actual discovery," he is going out of his way to be kind, since in his analysis of Page's novelties and plagiarisms, Jarves hints that Page never really progressed beyond the ambitious second-rate.

Like other Victorians Jarves was afraid of sensuality and spontaneity, fears that made it impossible for him to appreciate the luxurious concept of painting typical of much nineteenth-century French art. The end of art for Jarves is forever moral — it is to "intimate an existence above the level of the worldly and the vulgar," and to eliminate "from man's nature the coarse, sensuous, and superficial, substituting the beautiful, good, and permanent." These high aims constitute what Jarves considers the purpose of democratic art — to elevate an entire people. As inspiration for democratic art Jarves selected only certain virtues in the French painters — not the sensuous depravities of David and Delacroix, but the kind of landscape and genre purveyed by such mid-century French artists as Troyon, Rosa Bonheur, Millet, and lesser exponents of a highly moral, a democratic domesticity. The emulation of such models — he refers to them by the loathsome term of "home painting," by which he apparently means genre painting — would, he thought, appeal to and elevate Anglo-Saxon taste. He intimates that Eastman Johnson might embody this ideal, and by 1870, when he published *Art Thoughts*, he had become aware of the virtues of Winslow Homer in this regard. Jarves' enthusiasm for minor, if moral, French genre painters, however antipathetic to us because of his sentimentality, is typical of his period, but it is also possible to detect in his argument a restatement of Hegel's idea that genre reveals the poetry of human nature and that it should not be content with the gross and banal recording of "real" men and "real" things. For Jarves, moreover, genre painting represented the best expression of Protestant democratic feeling. He saw Protestantism as a vivifying force for individual liberty, and one supposes that analogous ideas would have been expressed in his ideal of Protestant painting, something he conceived of as replacing the decay of art which for him had followed upon the

growing power of the Roman church in and after the Renaissance.

If we wish to estimate Jarves as a writer of the mid-nineteenth century, we of course cannot try to reconcile his ideas with the tastes of today. We cannot, for example, say he is a first-rate critic whenever he happens to anticipate a twentieth-century point of view, and then call him silly when he is blind to faults apparent to us. Inevitably Jarves was affected by the moral and sentimental climate of his time. It is, however, also apparent that many of his judgments on art and artists can stand in the universal sense.

The most "dated" passage in Jarves' book is his appraisal of Elihu Vedder. Jarves was completely taken in by the empty and pretentious "symbolism" of Vedder's allegorical themes. The Secret of the Sphinx, for example, is typical of Victorian academic literary painting, obvious in content and lacking profundity, but our author admires it. He seems not to have known Vedder's charming Tuscan landscapes, so solid and filled with light that to the twentieth-century eye, they are evocative of early Corot and are far more moving than Vedder's bogus mysteries.

Jarves applies the idea of evolution to the arts. Occasional sentences seem to indicate some acquaintance with Darwin's *Origin of Species*. "Art in our day," he writes, "has the accumulated knowledge of ancient and modern civilizations to teach it wisdom." His discussion of Italian Primitive art and his collections were dedicated to demonstrating progress towards perfection, and without doubt, in judging the painting of his own time, he thought in terms of development towards an ideal.

Jarves' ideas of art as an illustration of the processes of dynamic evolution and progress were really nothing new. Here was only a reflection of the scientific climate of the late eighteenth and early nineteenth centuries, in which nature was regarded as in a constant state of growth and change. This rationalist point of view reached its climax with Darwin's *Origin of Species* in 1859. As Jarves expresses this theory, "All nature is a struggle, under a given organic impetus to evolve out of the lower a higher plane of being." In other sections of the book Jarves' ideas parallel the related organic esthetic of Emerson. "Each work of art sprang irresistibly

from necessity that art grows out of the wants and ideas of the people." Another statement of Jarves' on "the underlying spirit of the Gothic" is again in the spirit of the times. When Jarves writes that the Gothic reveals "the right of free growth as of nature herself, borrowing from her the models or forms into which it incarnates its fundamental ideas," we have a statement that is related to the ideas and practice of men like Thomas Paine, who is remembered for his borrowing of structural systems from natural forms.

As one of Horatio Greenough's recent critics observed, "The pioneers of this inchoate, organic esthetic found the principles of a new art form in the biological processes of nature and the artifacts that were unconsciously conceived along the functional lines of natural forms." Greenough and Emerson subscribed to these same ideas and Jarves, apparently without knowing the writing of either man, expresses similar advanced thoughts.

Greenough's remarks on the functional beauty of the clipper ship are well known, and so, too, is his suggestion that the architect could learn much from the shipbuilder: "Could we carry into our civil architecture the responsibilities that weigh upon our ship-building, we should 'ere long have edifices as superior to the Parthenon, for the purposes that we require, as the *Constitution* and the *Pennsylvania* to the galley of the Argonauts." There is one sentence of Jarves' that completely parallels Greenough's famous remarks and serves to indicate to what extent Jarves moved in the ambient of functionalism that prevailed in mid-century New England: "But the vital principle, *love of work*, that gave to the sailing vessel new grace and beauty, combining them with the highest qualities of utility and strength into a happy unity of form. As soon as an equal love is turned toward architecture, we may expect as rapid a development of beauty of material form on land as on the ocean."

Although Jarves substitutes "love of work" for what Horatio Greenough called "function," [10] his remarks on the building of

[10] Greenough's ideas on function may be found in *Form and Function*, ed. Harold A. Small (Berkeley and Los Angeles, Calif., 1947).

locomotives and steamboats parallel Greenough's account of the functional beauty of the clipper ship and the trotting-wagon. He concludes like Greenough that if an equal love were turned towards the architecture of buildings, a similarly creditable design could be ours on land. Jarves seems to follow Greenough in his admiration for the humble beauty of the New England farmhouse, as suited to the land "as the caterpillar to the leaf that feeds him." Jarves speaks of the truth and naturalness of an architecture built for protection and displaying an adaptation "suited to climate, materials at hand, and social exigencies."

We must remember that in these middle decades of the nineteenth century the ideas of functionalism proclaimed by Greenough, Emerson, *et al.* were in the realm of theory rather than practice. There was still a gulf fixed between "architecture" as a fine art and "building," a division that was the subject of often acrimonious debate in architectural circles and led even such distinguished supporters of functional construction as Henry Van Brunt and, later, William Morris Hunt to choose the easier road of eclecticism or the revival of earlier styles in their own practice.

Jarves goes out of his way to condemn the Renaissance style in architecture as represented by Gabriel's palaces on the Place de la Concorde. This style he hoped would never be introduced into his native land. Jarves' (and Ruskin's) wholehearted endorsement of medieval styles of architecture may have had some influence upon the popularity of Victorian versions of Romanesque and Gothic which began to appear in America at mid-century. But what is, from the modern point of view, more deplorable is the disrepute attached by Jarves to American Colonial — that is, to specifically Georgian and Classic Revival architecture, styles which are without question, we believe, the finest the country has produced. Yet Jarves was able to recognize something felicitous in the severe Doric beauty of the Tremont House of his time and of the Philadelphia Exchange. On the whole, however, he has little to say for Greek revival architecture. His moral concern with function makes him blind to the intrinsic beauty of the only type of architecture that came near to providing the United States with

a national style, in fact that, for a period however brief, brought order and harmony into American city planning.

Jarves is never more perspicacious than in his discussion of the American sculptors whom he knew in Rome and Florence.[11] He was among the few to point out the sentimental prettiness and the lack of technical distinction in Thomas Crawford, Hiram Powers, and the whole group of expatriate neo-classicists. He can, apparently, forgive much if his sculptors show signs of idealism or of that favored Victorian attribute, "genius," in contradistinction to the mere mechanical ingenuity of men like Powers.[12] For example, he tries to find some distinction in Greenough, who, he says, was unequal to his conceptions. Possibly this is the conventional Ruskinian fallacy of transferring the virtue of the man to his art. Sometimes, of course, it is difficult to follow Jarves' enthusiasm; to us, for instance, Erastus Palmer appears to be only a homegrown product of the school that produced Powers and Harriet Hosmer. And in writing about William Wetmore Story, Jarves seems to have been affected by the same "literary" ideas that often conditioned his criticism of painting. One accustomed to judge art by literary standards and to measure its effectiveness in terms of dramatic illustration found it easy to point out differences between the occasional merits of Story and Crawford, differences that to us are outweighed by the banality of the conception and the lack of quality in the technique of both men. In this connection it is worth remarking that for Jarves the Rogers groups betokened the emergence of an edifying school of native genre of the same quality he hailed in painting. Aware as he was of the moving pathos in some of these confections, Jarves was unable to discern the sculptural weaknesses of John Rogers' pictorial tableaux. Nevertheless he deserves credit for recognizing this sculptor's capacity to "give even to the commonplace almost the dignity of

[11] For an account of this whole group of American sculptors in Italy, see Albert Ten Eyck Gardner, *Yankee Stonecutters* (New York, 1946).

[12] Jarves was in the minority in disparaging Powers' superficial tricks of technique. Many of his contemporaries, like G. S. Hillard, author of *Six Months in Italy*, were completely taken in by him, and even Hawthorne found his work exquisite and affecting.

the heroic," just as he is ahead of his time in praising the originality of Rimmer and the moving power and spiritual expressiveness of Ward's Freedman.

In his plea for state support of art for public education and enjoyment, Jarves in all likelihood drew his ideas of the duty of the commonwealth towards the arts from Ruskin. He extolled Central Park as an example of art in its civic function. He makes a strange comparison between Central Park and Harvard College, pointing out that improving the park as a setting for happiness and physical well-being is not to be mentioned in the same breath with Harvard College, which he found "so restricted in purpose and so hopelessly ugly in external features." In condemning Harvard for "holding the knowledge of Greek accents or roots to be of more account than the thought the Greek tongue contains," he was expressing the same rebellion against the lifeless teaching of the classics that Byron and others had expressed.[13]

Jarves was one of the first to make a plea for the cultivation of beauty in the architecture of shopfronts and in the arrangement of window dressing. Even the aesthetic possibilities of horsecars came under his critical eye. The essence of his philosophy of art as an instrument for public benefit is contained in his statement: "We cannot make the world more beautiful without making it better, morally and socially. The Art-Idea is the Beautifier." Jarves' dream of the ultimate benefits to be conferred by Central Park are, to be sure, somewhat beclouded by his curious vision of a vast nonsectarian cathedral to be built there as a monument to "that perfect toleration which democratic liberty means."

One may smile today at Jarves' serious pride in Boston as a city where "pictures having ideas are quicker appreciated than in New York," the latter being a city wherein art exhibitions were visited chiefly by the idle and the fashionable, or at his statement that Boston "is one vast reading and lecture-going society." Judgments like these spring out of his crusade to have art enter American daily life. He aims at the same target when he pleads for professorships of art and for museums rivalling those of Europe. He

[13] Gilbert Highet, *The Classical Tradition* (New York, 1957), pp. 491f.

gives a brief summary of the history of public galleries in Europe, paying special attention to the Louvre and the National Gallery. He discusses the functional requirements of museum buildings and insists on historical sequence in the arrangement of objects in them. He pleads for the introduction of art into manufacture and industry, and like Greenough he praises the beauties of the clipper ship and the farmhouse because these productions are the outgrowth of use and of the materials at hand. In the same vein he predicts that architecture may become the first great American art, shaping itself in conformity to the needs of the people and the land.

By his energy and pioneering courage Jarves belonged to that hopeful generation which saw the promise of greatness emerging in all aspects of American life even during the darkest days of the Civil War. Jarves hoped for a cultural awakening, one in which art could at last become for all men the ornament of life and the companion of work. Both the energy and the directness of his life and of his writing differed greatly from the older, courtly life (and taste) vanishing in the dawn of a newer, more material American world, as radically different from Jarves' generation as his generation of artists were different from Allston and Stuart. Although one may find his crusading ardor naïve and his tolerance limited, Jarves is to be remembered for his important role in forming American taste. There had been other writers on American art. In 1834 William Dunlop published his *History of the Rise and Development of the Arts of Design in the United States*, a sort of biographical dictionary full of errors and of prejudice, but valuable as a record of personalities among early American artists. Henry Tuckerman published his *American Artist Life* in 1867, an account of American art, sometimes scholarly, filled with the usual Victorian sentiment, and with the usual nineteenth-century sweetness and light. Like some modern critics Tuckerman praised all the good artists and loved all the rest of them rather because they were Americans than for their quality as painters or sculptors. But neither work has the honesty and perception of Jarves' chapters on the art of his own country in *The Art-Idea* and, later, in *Art Thoughts*.

Jarves is memorable not merely for his awareness of the beauty

of early Italian painters but also for his vision of art as nourishment sustaining all the world. The judgment that a man is ahead of his time generally carries with it the corollary that his name is therefore soon forgotten. After his death in 1888 Jarves slipped rapidly into oblivion, and many years were to pass before even his collection at Yale received the attention it deserved. Jarves never held an academic post and could not, therefore, reach the wide public or achieve the kind of pedagogical immortality one associates with Ruskin or with Charles Eliot Norton. Lacking a college degree and untrained by our modern standards, he had nevertheless an intuitive feeling for beautiful things. His missionary zeal in passing on his story of hard-won joy and knowledge to his fellow countrymen is one of the most engaging aspects of his personality. Amid the variety and scope of his personality there is visible a glowing figure, as Francis Steegmuller says, far more filled with life and with a sense of the largeness of life than many better known Americans of his time.[14] Today we are beginning to see that Jarves is a key figure in the development of American culture.

BENJAMIN ROWLAND, JR.
Harvard University

[14] Steegmuller, p. 290.

A NOTE ON THE TEXT

For the John Harvard Library reprinting of the text of *The Art-Idea* the first edition of 1864 has been used. When the 1864 edition was published it bore the subtitle, "Part Second of Confessions of an Inquirer" (*see* p. xiv of the Introduction to the present volume).

The first edition included Jarves' long preface entitled "Some Preliminary Talk With the Reader." This essay has a particular interest for the modern reader because of its account of Jarves' attempts to dispose of his famous collection of Italian paintings.

The second edition of 1865 did not include "Some Preliminary Talk," and the title of the book was changed to read, "The Art-Idea: Sculpture, Painting, and Architecture in America."

The third and fourth editions of 1866 and 1877 repeated the format of the second.

Jarves' text has been reprinted here exactly as it appeared in the first edition. Nineteenth-century spelling and punctuation have been scrupulously reproduced; inconsistencies in usage within the text are faithful to the original. Certain small errors that Jarves made in the spelling of proper names are noted by the editor, and these have been silently corrected in the modernized version of the original analytic table of contents that appears on pp. v–ix above.

THE

ART-IDEA

BY

JAMES JACKSON JARVES

SOME PRELIMINARY TALK

With the reader, of the nature of a personal confession, which, if he disapprove, being forewarned, he will skip, of course.[1]

IN 1857, Messrs. Phillips, Sampson & Co. published a book of mine, the first of a series, called, "Confessions of an Inquirer." It referred to the Education of the Heart, and was to have been followed by two others, one relating to Æsthetic Culture, the other to the Religious Idea. My wish was to trace the growth of a mind through a diversified life to that period when there should be developed in it wise submission to the divine laws of BEING, and devout thankfulness for the gift of *being*. Notwithstanding the time that has elapsed since "Confessions" was printed, and its absorption into the reservoir of effete books commonly known as "out of print," I still cherish the idea of completing the original intention. The present volume is Part Second. A portion of it was written in 1857. Strictly speaking, it is *my* Art-Idea, being a candid confession of the impressions which the study of art has made on my individual mind.

Before dwelling particularly on the art-topic, I wish to explain myself in regard to Part First. The book made some stir at the time, but in general was misunderstood. It was a mistake to publish it in its precise form, using lay-figures to personify ideas, opinions, and experiences; for America looks with matter-of-fact eyes at literature, as well as other things. My lay-figures were held to be live persons, the book an autobiography, and myself very erring. I had lived so long in Europe in circles which permitted entire intellectual freedom that it never occurred to me, especially after the MS. has received the approval of eminent literary authority, that its real spirit and intent would be so miscomprehended and misapplied. I did not understand my audience, and suffered accord-

3

ingly, if you will, deservedly. Some persons may be entertained by the pith of a few of the opinions on "Confessions of an Inquirer." As a curiosity of see-sawing criticism, I put them in parallel columns.

"A deadly foe to cant and humbug, very peculiar, fascinating, and well written." — *Boston Post.*

"An outpouring of sarcasm, ridicule, bile, and spleen against Christianity." — *Puritan Recorder.*

"A great deal of true practical philosophy, pervaded with a moral, manly spirit, and clear, simple, and yet forcible language." — *N. Y. Courier and Enquirer.*

"Ill-concealed dislike of Evangelical Christianity, without any very marked ability." — *Christian Witness.*

"A book likely to make men think, as it is full of thought. An earnest, loving spirit, independent, hardy, sometimes defiant thinker, though ever expressing himself after the manner of gentlemen and Christianity." — *Boston Traveller.*

"Leavened with no reverence for things human or divine. A confirmed trifler, like Voltaire. — *Christian Watchman.*

"Chronicling in a wild but beautiful form a great amount of spiritual and personal experience." — *Philadelphia Bulletin.*

"It betrays idiosyncrasies of character not of a healthful type, tinctured with Theodore-Parkerism. Objectionable and offensive." — *N. Y. Evangelist.*

"It contains some noble tributes to Christianity, especially where the author speaks of his mother, whose piety seems almost to persuade him to be a Christian." — *Christian Advocate, Nashville.*

"The writing of a man who, from disease or breeding, or other sad fortune, does not know the sex of the mother that bore him." — *Monthly Religious Magazine.*

"A collection of scenes through all of which there runs a golden thread, holding in continuity many a philosophic truth and gem of thought. It must be read to be appreciated." — *Worcester Palladium.*

"As worthless a book as it has been our duty often to pronounce upon." — *Philadelphia Presbyterian.*

"It cleaves to the core the silly themes and absurdities of a certain class of bigots." — *Northwest Home Journal.*

"After we had begun the book, we could not well put it down till it was finished, such new, rich veins of thought constantly opened up before us." — *Providence Journal.*

"The 'Confessions' have a more central and artistic unity than if they were an exact literal record of external events. Full of suggestive statements, and may be truly said to be alive." — *Christian Examiner, Boston.*

"It is unique; but it thinks the reader's thoughts and makes the reader's confessions. Full of common truths and healthy aphorisms, which make one merry as well as vigorous. Its moral reflections have a profundity at which we pause to think; and anon their elasticity buoys us into the regions of airy speculation." — *Life Illustrated, New York.*

"A strange medley of queer fancies, doubtful and abominable theology, and transcendental vagaries." — *Boston Congregationalist.*

"To publish such a book is unpardonable in an author. Of his infamy we are ashamed." — *Honolulu Friend.*

"A very eccentric book, full of odd ideas and expressions." — *Lutheran Observer.*

"Mr. Jarves has made a mistake in this book, which he will himself regret that he has published. His peculiar talent lends a charm to all that he writes, and the volume abounds in those delicate and effective touches which characterize all his productions. But it is a grand error nevertheless." — *Harper's Weekly.*

Taking readers behind the scenes serves to show them how critics, like doctors, will disagree. "Harper's Weekly" has the truth. It was an error in form, but not in idea, which might have been treated so as to avoid the shocks it occasioned to sensitive consciences and tastes, had they been foreseen. But I do not regret it. It has brought me warmer sympathies and more cordial approval than anything else I ever did. Tokens of esteem, often from strangers, on account of good done them, more than compensate for the frowns of those incapable of looking at the book from a

correct point of view. It has the disadvantage of being incomplete. Moreover, some of the alleged defects are part of the artistic plan of the final unity. I could not depict a soul as perfect on entrance into earth-life, or endow it with consummate wisdom, refinement, and piety. Man is sent here to attain these by *growth*, experience on experience, until he reaches the farther limits of the finite. This clue to "Confessions" may put some of its blemishes in another light, after the reader disabuses himself of other personality than he can apply to himself or any one in general, in the mixed lights and shadows of existence. They are put strongly individualistic, because it was necessary to give them a Rembrandtish *chiaroscuro*. But there were those who took in the purport from the first. A German reviewer says: "The ideas on the mission of evil, on its self-destructive tendencies, and on the way we should accept, bear, and utilize it, are more than true, — they are sublime. We cannot read them without recognizing in them the utterings of a mind familiar with this useful foe; that has been elevated and purified and strengthened through him; and that bears in its features, words, and actions, the hidden, yet unmistakable 'Shibboleth' by which the members of the largest lodge, the Lodge of Sufferers, recognize each other." Truly and eloquently put, O critic!

A literary lady writes: — "The 'Confessions' remind me of those of Rousseau in their honesty, charming language, and exquisite pathos; but emanating from a purer soul, they appeal, unlike Rousseau, only to the pure in heart. If I were the Inquirer, and could know I had *one* reader whose mind had followed my confessions with an interest as profound as mine has his, I should be glad I had written the book." Thanks, gentle one!

A few copies only got to Europe. The "Revue Britannique" of July, 1858, rightly calls it, "Une espèce de roman psychologique. Cet American rappelle tour à tour Montaigne, Rabelais, Sterne, et son compatriote Melville," etc.

Reader, if ever you wrote a book that predisposed half your world to look upon you as a moral pariah, because of their stubborn prejudices or unwillingness to interpret it rightly, you can

appreciate what it is to have strangers comprehend at once your speech.

I will now give the most precious tribute of all, dear words of discernment from a quarter whose culture, virtue, and genius have become the property of mankind: —

"It is very pleasant, dear Mr. Jarves, to be able to tell you how much struck and interested I have been by your book. Let me say it at once. For my part, with some drawbacks, (there *are* certain things in the book I could wish away,) my sympathies have gone with you, and glowed as they went. The spirit of progress is in the book, and yes, with a large Christian heartiness, making it everywhere beautiful. Also, it is a suggestive book. I like it much. My drawbacks refer to certain coarsenesses here and there, and some things in the earlier pages, but chiefly to a somewhat flippant way of representing doctrines of the churches, (the Trinity, for instance,) which seems to me to represent ill the real spirit of reverence which is in you. Also, I object to seeing Christ's name on the category with Shakspeare's, or even Sweden-borg's; it jars me. Yet I sympathize with you deeply, almost every-where. I breathe free in the book, and feel in my face the freshness and promise of the future as I read it.

"I enclose you a little slip which Mrs. Jameson sent in to me with the book when *she* had read it, because I am sure you will like to know the impression on such a mind, so spontaneously expressed.

"Wishing you the full enjoyment of the highest things to which you look, let me remain,

<div align="center">

"Your affectionate friend,

"Elizabeth Barrett Browning."

</div>

Mrs. Jameson's slip reads, — "There is so much in this strange book which pleases me, and in which I sympathize, that I must thank you *particularly* for lending it to me."

Subsequently, Mrs. Browning wrote to a common friend: — "Mr. Jarves's book I like very much. There are some really noble and touching things, and the whole is suggestive. He stands higher with me, both intellectually and morally, than he did before. Mrs. Jameson is much pleased by the book, and she is not easily pleased, you know, and is very susceptible of offence in respect to matters of taste."

With the approval of these minds and hearts, I can with serenity

abide the time when those who have misconceived mine shall come to a better understanding of them.

A critic charges me, in "Art-Hints," with judging "harshly of our own artists," of a lack of "consideration due to the patient struggles of American genius," and of "directing the finger of scorn and contempt upon the best works of our best men." How far this is sustained each reader will judge for himself. I am unconscious of such a spirit either in "Art-Hints," in which I made no attempt to criticise the artists of America, or in this volume, in which I have spoken freely of their works. The organic sensitiveness of the artistic mind is so acute that it sometimes mistakes candor and honesty for invidious remark or personal bias. But fealty to art is the chief duty of any one who writes upon it. An author's opinions are of value only as they are just and true. He owes it to the public to speak the truth exactly as he feels it, where it is allowable, even if it contradicts something he has said before, or differs from the conclusions of others. True progress fears not to be called inconsistent or unkind. Indeed, better a thousand contradictions daily than adherence to one error. "Art-Hints" was written in the fervor of a fresh intellectual enjoyment. On account of its earnestness, it met with a kind welcome, both in England and America. The feeling that pervades "Art-Idea" is identical with that of the former work. Divergencies of conclusions are owing to deeper investigation and riper judgment. Inconsistencies of intellectual decisions inevitably occur at every step of mental growth, for each one lifts the mind on to a higher and broader platform. The only case of attack on "Art-Hints" by distorted interpretation and invective ridicule was on the part of the late "Crayon," edited by the artists Stillman and Durand, whose unfairness elicited from Mr. Ruskin a letter to me, in which he says: "Your book seems to me very good and useful in many ways." "I was sorry — very heartily — for the general tone of the review in the 'Crayon,' but heartily delighted by the answer to you about Turner. I think you not so much *wrong* as short-sighted in early all you say about Turner." "I think you have the true feeling for art, and will be very useful in the good cause."

8

I refer to this letter in justice to Mr. Ruskin, because he was right. I was *"short-sighted."* The estimate of Turner now given is the result of a more diligent study of his paintings.

The "New Path," a Pre-Raphaelite journal of New York, independent and useful in its way, referring to "Art-Studies," says, — "Mr. Jarves's mind is so *soaked* in conventional doctrines that his perception of the nobler works of God is secondary to them." What this sentence means it is difficult to discover. It implies "conventional doctrines" to be noble "works of God," with which my mind is "soaked," in preference to "nobler works." Only let my mind be "soaked" with any works of God and I am content, despite the critic's exclamation, "Who cannot see that this state of mind is opposed to all true growth?" *

Personally, I rejoice to receive criticism, even of a stringent character. The sound points of an author, as of an artist, can take care of themselves. He wishes to know the weak ones; to be taught by those who know more, and who, looking on his work with keen, impartial sight, can see it from other points of view than his own. But no uniform standard of criticism of art, applicable to all temperaments and stages of mental growth, can be fixed upon. The love of art cannot be forced or coerced, any more than faith or friendship. It may take a wrong or low direction; but so long as it is genuine, the true seed of progress is in it. Every individual is amenable to the divine monitor God has established in him. If he hearken to that, sooner or later he will fall into a true, if not a "new path," in art and life generally.

One word as to the enjoyment of art. Fatigue of mind or body mars the zest and capacity for it. We must approach art somewhat differently from nature. Air and exercise are the best tonics for delight in landscape. The greater the physical difficulty over-

* The Eccentricities of Criticism would make as entertaining a book as the *Curiosities of Literature*. In the London *Fine Arts Quarterly* for October, 1863, there appeared an article of mine on the "Artists of America," which was noticed by the New York *Round Table* in not a flattering spirit. Shortly after, the article in the *Quarterly* was translated into German, and published in the *Dioskuren* of Berlin, which translation was *translated back* into English for the *Round Table*, as a *German criticism* on "art and artists in America," containing "some very interesting remarks on our leading men," etc.

come, the more satisfaction in securing the coveted object; and the wider the field, the more its variety stimulates the corporeal faculties to adventure within it. An explorer of the landscape is invigorated by the same agencies that produce weariness, for nature is essentially recuperative. Art is the reverse. Exhaustion and indifference arise from its too prolonged pursuit. Blood and muscles are not refreshed by painted atmospheres and pictorial views. On the contrary, nothing drains the general vitality faster than art-objects viewed as sights. The body rebels at undue efforts put on it for pleasures of the spirit. This physiological fact should be remembered by those who are tempted to overwork, lest, owing to repeated lassitude of mind and failure of strength, they grow faint-hearted, and relinquish that study which, if but judiciously followed, will ultimately refresh both mind and body.

My theme, more than most others, demands a sympathetic understanding between readers and the writer. He should clear away as much as possible prejudices and misconceptions, so as to give his topic in its full strength. The first point is to present himself truthfully. I am not, "at all events, an artist," as is often stated. This I regret, as it is the profession which would have given me the highest satisfaction. Critics also assert that I evidently have as much leisure and means as taste for studies in art. In this they likewise err. He who digs for ideas finds not gold. For a speculative, theoretical mind to wander in quest of worldly wealth into the marts of mammon, would be as sensible as for a mouse to voluntarily put itself within reach of the playful claws of a hungry cat. But I entertain the notion that every one should try to leave earth the better for his having lived on it; also, in instructing himself to impart to others. The complying with a request often made, to relate what led to certain experiences in regard to matters which have grown to be of a public nature, must be my apology for being personal.

At fourteen years of age, broken in health and debarred from books, I was compelled to exchange the climate of New England for the tropics, residing chiefly in the Hawaiian Islands until 1848, while all my subsequent life has been a struggle for enough physi-

cal strength to prevent it from being wholly sterile and joyless. Opportunities for instruction were uncertain and variable, limited, in fact, to *browsing* by the way-sides of knowledge. The reader can judge whether a discursive life, fettered by ill-health and the necessities of maintenance, compensates systematically trained scholarship. The stall-fed student, even if his intellectual food is prepared for him in set amounts, at fixed intervals, without choice of his own, has advantages which are not offset by the wild flavor of what, in comparison, might be called game-fed literature. At all events, the untutored learner is at signal disadvantage aside the well-broken-in scholar. He must find, prepare, and serve his own mental diet. But should he be tabooed from printing, as some intensely learned critics seem to decide, because he is not their equal in fine writing and classical acumen? Are they too wise to know, that, as pure gold deposits itself in the rude rock, so salutary thoughts are sometimes found embedded in unlettered speech? On the other hand, it is pleasant to be esteemed "a finished scholar" by flattering reviewers; but, to my loss, this assertion is not true. No more opportunity has been given me for that than to be an artist. An inquirer after knowledge I indeed claim to be, a vagrant from necessity, ready to confess mistakes, and to share experiences with persons not smitten with vulture-eyed pedantry and mutual-admiration exclusiveism, but who esteem an independent and honest effort to get truth and declare it as entitled to as fair a hearing and as courteous treatment as is given to writers more fortunate in prestige of fashion, fortune, or scholastic clique. But to the story.

In 1851, being in Europe, engaged to write for the press, periodical articles swelled into books, chiefly relating to art. The preparation of an abstract of the history of Italian painting, published in 1861 under the title of "Art-Studies," gave rise to the project of an historical series of old masters to illustrate the book, hoping that it might eventually be made the nucleus of a public gallery in Boston. Knowledge in this department is of slower growth than most others, for it requires the sixth sense, or a sort of intuition, which in man is sluggish in developing. I was sometimes deceived,

but often deceived myself. Finally, ten years' devotion to getting together characteristic specimens of Italian artists was not without fruit. I did not expect to obtain masterpieces. They have been long since absorbed into public galleries, or remain fixtures in the places for which they were painted. Nevertheless, the series obtained gives a fair view of the schools and periods it represents. Some of the paintings would be valuable additions to any gallery. The London "Athenæum," speaking of the collection as a whole, admits that "it contains specimens of many artists yet unrepresented in Trafalgar Square, such as Sano di Pietro, Sodoma, Gentile da Fabriano, and many minor but interesting names." It stood for years the brunt of European criticism in Florence, where it was but a step from an authenticated masterpiece to an example of the same painter in my collection. In Europe there are enough trained amateurs to establish public opinion without resort to documentary evidence. But in America it is essential both to establish the genuineness of these paintings and their importance to art-education. I have been under no illusion as to popular sympathy. No one more practically knows the obstacles to be removed before the goal is reached. That goal is the founding of a museum of fine arts, in which my pictures may find a permanent location free to the public. Short-sighted persons see in this attempt only a mercenary speculation, or a disposition to injure our artists. The latter notion is losing currency, because our best men not only are friendly to their eminent predecessors, but acknowledge indebtedness to them.

It remains to dispel the former imputation. While the pictures were in Europe, a member of the art-committee of the Athenæum, having learned, through his own sources of information, of their value and genuineness, wrote to Florence, desiring to know the object and destination of the collection, and whether it could be secured for Boston. I replied that nothing would gratify me more than to have it established in my native city, and in aid of it I would give one third of the cost, if the friends of art would contribute the remainder. At a meeting of the trustees of the Boston Athenæum, October 10th, 1859,

"the following resolution was unanimously adopted: Resolved, — That the Trustees of the Boston Athenæum, desirous to second the generous design of Mr. Jarves, and to secure for the Athenæum and the citizens of Boston a collection of works of peculiar value, hereby guarantee a subscription of $5000 toward the purchase of the Jarves Gallery, provided that the remaining sum needed for its purchase be raised by private subscription, or otherwise, within a month from this date. The undersigned confidently appeal to all lovers of art in the community to assist them to obtain a gallery of paintings which will be of permanent value, and which in its kind will be unrivalled in America.

EDWARD C. CABOT, FRANCIS E. PARKER,
ROBERT W. HOOPER, MARTIN BRIMMER,
 CHARLES E. NORTON."

The money was not all subscribed within the month, and so the project was suspended. What means were subsequently used to defeat my special ambition in regard to Boston, and to hinder the citizens from seeing the collection as a whole, so as to judge of its value for themselves, will further appear. If I am compelled to mention names, it is because there have been underhand efforts to incite prejudice against my project. It is for the Boston public finally to decide whether their interest and credit will be best promoted by continuing trusts of an æsthetic character with those who have labored to frustrate locating the collection in their city.

In 1860, I was invited to bring the pictures to New York, on exhibition, a certain sum being guaranteed. They were favorably received, and had not the civil war begun, my plan for a free gallery would have been sustained. But enterprises of this nature had then to be postponed. April 10th, 1861, the following letter from Boston was received: —

"DEAR SIR, — The undersigned have felt much interest in the object to which, for some years past, you have been giving your time and thoughts, namely, the acquisition of a gallery of the works of early Italian masters, as illustrative of an interesting epoch in the history of art, and of the spiritual and intellectual life of the age which gave them birth. They have heard with great pleasure of the remarkable success which has crowned your exertions, and of the many original, curious, and excellent works which have come into your hands. They have also

learned, with much satisfaction, that your collection has been duly appreciated by the taste and knowledge of the citizens of New York, and that its value is recognized by those whose opinions in art are entitled to the highest respect. They are very desirous that the citizens of Boston, your place of birth, should share in the pleasure and advantage to be derived from a collection like yours, unique in this country at least. They therefore request of you that you will cause your pictures, or a portion of them, to be exhibited in Boston.

R. C. WINTHROP,	C. E. NORTON,
G. S. HILLARD,	LOUIS THIES,
T. SARGEANT,	B. S. ROTCH,
E. C. CABOT,	G. H. SHAW, and others."

Forty paintings were brought to Boston and exhibited with success, causing numerous requests to see the entire collection. This was impracticable then, for want of suitable accommodation. But it has been owing to' no indifference to their wishes that the public were not gratified. The art-committee of the Sanitary Fair, last December, advertised for pictures to exhibit in behalf of the noble charity they represented. Wishing to contribute to their funds, and to give my fellow-citizens a view of the whole gallery, I offered mine for that purpose. But the committee made me no reply.

An explanation in regard to one active member, Mr. G. W. Wales, may throw light on the disinclination to notice the offer. This gentleman, to me a stranger, visiting Florence while the gallery was there, in company with an individual who acted as a sort of *commissionaire*, when I was absent came into my house, going into private rooms to look at the pictures, and occasioning a reprimand to the servant who had let them pass contrary to his orders. Strangers were accustomed to visit the collection, but by previous notice and request, as had been done by another member of the art-committee, Mr. E. L. Perkins, who courteously wrote, thanking "Mr. Jarves for the pleasure he had in visiting his pictures, in company with a distinguished English artist and some ladies, who were highly gratified with their visit."

Directly after the uncourteous and unsought visit of Mr. Wales, invidious attacks were made upon the collection, and statements circulated to my detriment. These were brought to my notice,

but often too late to correct the false impressions given to persons who otherwise would have favored the enterprise. This gratuitous hostility has been continued ever since. Critical inquiry or honest skepticism, to the intent to develop truth, no matter how searching the knowledge brought to bear, would have been heartily welcomed as an aid towards establishing the genuineness of the objects in question and making known my intentions. I deprecate only covert unfairness, untruth, and malice prepense. "*Maledicus e malefico non differt, nisi occasione.*" The motives which prompted the desire to bring my private property and personal acts into disrepute are as unknown to me as extraordinary, under the circumstances. One may judge of the quality of the discernment evinced by the denunciation of objects as worthless which have the weightiest European testimony of their value and authenticity. Mr. Thies, an authority Bostonians recognize, writes of the Leonardo, — "If Bostonians can secure this one picture, we need not envy the Louvre or Lord Suffolk theirs." Hon. W. B. Kinney, late Minister near the Court of Turin, says "from personal knowledge, that the collection has been cordially approved at various times by artists and connoisseurs of the very highest repute, — critics whose concurring opinions would be received in all European circles as final and conclusive." Yet, so strenuously has it been asserted by inimical parties that I did not possess the documents claimed, giving official testimony in regard to the Old Masters, that I have been applied to for the originals to show to people of influence who had been made to disbelieve the fact. Indeed, beside the expense and toil incurred in getting valuable old paintings, the owner in America is virtually called upon to show that he is not a rascal in having them, while not a few individuals are inclined to treat him as if he were trying to bring a pest into the country; individuals, too, of common intelligence and ordinary humanity in most matters. Hon. Charles Sumner, however, who *studied* the pictures carefully in Europe, writes, — "I cannot conceal my astonishment that you have been able to bring together a collection of such surpassing historic and artistic interest. To a student, in our country, of the great Italian school of painting it must be invaluable; and as the

beginning of a gallery of art, I hope, from the bottom of my heart, that it may be secured for Boston. It contains pictures of which, I think, any gallery might be proud, and also specimens of certain masters, which, if now allowed to slip away, may not come again within our reach." Mrs. H. B. Stowe expresses her opinion to a third party, "shared by M. Rio and the most competent persons with whom I conversed," that as "an historical series it is incredibly good; only very *peculiar* advantages could have put it into Mr. Jarves's hands." "The collection is a very fine one, even for Italy, — fine in the neighborhood of the Belle Arti. What, then, would it be for Boston!"

The editor of the New York "Crayon," without knowing me or having seen the pictures, writes of both, — "It is said that the collection of 'Old Masters' got together in Italy by one Jarves is for sale. A pamphlet has been circulated, setting forth the immense labor without regard to cost, the hair-breadth 'scapes from dirt, knavery, and superstition, the self-sacrifice and intense enthusiasm of said Jarves in his search of these said canvases, with the moving accidents by flood and field," and more of this sort to ridicule and defeat my purpose. Mr. Sumner, however, expresses the kindly wish, "that yet another pleasure will be yours, in the gratitude of an enlightened community, freely rendered towards one who has so quietly, faithfully, and bountifully contributed to improve its taste and enlarge its knowledge." Approval or disapproval is weighty according to its source. The abuse of the "Crayon" was the natural action of its editorial idiosyncrasies. Who blames the gnat for stinging, or cares to mar its joy in its luscious drop of stolen blood? Still, no such pamphlet as the "Crayon" described was circulated by me. Probably it refers to a private circular prepared by the committee of the Boston Athenæum, and distributed among their friends while I was in Europe.

During the past three years the collection has found a congenial home in the galleries of the New York Historical Society. Keeping it together longer being beyond my pecuniary ability, I am forced to offer for sale some of the pictures, intending, however, to keep the Italian historical series as complete as possible, in the hope that

eventually those sold may rejoin their associates in a public gallery, and become once again part of the Jarves "Old Masters;" the reward coveted being to have my name honorably associated with what is endeared to me by a long labor of love. Those only who have devoted themselves to the acquisition of objects which, like art, are the product of the human soul, can appreciate the full force of the affection for them which gradually entwines itself around the heart of the collector. Each one suggests a separate history; some special sacrifice, toil, disappointment, or success; a patient waiting on hope deferred and conflicting emotions. Every picture has its own speech of encouragement and reward, its individual fulness of æsthetic joy and spiritual sustenance. The old painter becomes my friend and neighbor, with whom I hold vital communion, and for whom I provide hospitable entertainment. It is no light matter to sever these delicate ties, or even to part one painting from another, after they have grown into a unity of feeling and purpose. If I had had no other satisfaction than that which has come from the acknowledgment of spiritual comfort, aside from æsthetic enjoyment, which some persons have found in them, it would be ample compensation for the loss of the worldly benefit which so much "dead capital," as it is termed, incurs. The appreciating sympathy of noble minds has exceeded the brightness of my most enthusiastic dreams. Railway-bonds are good things, but the bonds of spiritual strength imparted are a better investment for the long future. Whether success crown my particular efforts is of no account, for the cause advocated is sure to take root in the American heart and grow. Art must live, though the individual shall die from out of the land.

The general reception of the pictures and opinions formed of them both in New York and Boston, though in neither place have they been all seen, have more than met my expectations. Old pictures are not a fashion, and never should be. The educated estimate of their value for the specific purposes of art-galleries has gained ground faster than was anticipated, while opposition yearly grows less. To those who wish to inform themselves of the experiences acquired in collecting them, the introductory portion of "Art-

Studies," under the head of "Authenticity," will be not without interest. The "Descriptive Catalogue," published as an "Appendix" to the work, is the result of several years' inquiry, assisted by the best European criticism. It is not immaculate, nor indeed is any, for trustworthy historical testimony is comparatively rare, and most pictures must be decided on from internal evidence. This class in most part was old before America was discovered. Some of mine are perfectly pure, others have been conscientiously repaired in parts, (not repainted,) so as to preserve the original thought and style, while the collection, as a whole, is as free from reproach in this respect as are galleries of Europe. We cannot expect old masters to exhibit the freshness and soundness of modern, though there are many that date four centuries back in better condition now than paintings only a few score years of age, owing to greater fidelity of technical treatment and earnestness of artistic purpose. Before long, it will seem strange that so much skepticism and opposition should have existed in this country in regard to a gallery for the public benefit. To Mr. Thomas J. Bryan, of New York, the credit is due of originating the attempt ten years ago, by offering to his native city, Philadelphia, his invaluable series of the French, Flemish, Spanish, and German schools, which include specimens that any country might be proud to possess. His offer was declined. These rare old pictures were looked upon by the city fathers as unworthy of houseroom. Thanks to the perseverance of Mr. Bryan in keeping his gallery open to the public, the sentiment in regard to old masters has changed for the better. His liberality and enterprise have established the fact of their value as a means of æsthetic instruction. At first, such property could be exposed with impunity. There was no one to do it the poor honor of thieving, still less of depreciation. Since the discovery that it has a marketable value, some of Mr. Bryan's pictures have been stolen. One of mine has also disappeared, and another was cut into after they were made free to the public. Both Mr. Bryan and myself regard these larcenies as symptoms of progress. But if any one reflects upon the indifference of Americans as a race to old art, the cold reception given Mr. Bryan's generous efforts is not surprising. There are many who esteem art,

and yet are unable to reason on the feeling within them. The country at large suffers from the pretensions of those who, on the capital of courier-led sight-seeing abroad, and the purchase of a few dubious objects of art, generally through the agency of interested parties, profess to be guides, and are sometimes accepted as such in their respective cliques by dint of oracular sayings, not unseldom backed by misrepresentations, sometimes original, and sometimes palmed off on them for selfish purposes. A lie let loose has always the advantage at first of truth, for a stern-chase is apt to be a long one. The reptile is not always discovered before it has deposited its venom. In this connection, I cannot refrain quoting from a letter to me by a distinguished English author and fellow-laborer, who, having suffered, could sympathize. He says, — "That petition in the Litany, 'Forgive our enemies, persecutors, and slanderers, and turn their hearts,' is immensely more difficult to pray than most people think. It is very easy for people to forgive their enemies when they haven't got any; but if they have, — truly there are verses in the Psalms which one cannot help wishing sometimes to appropriate more than said verse of the Litany. As for me, I truly and humbly confess that I could wish to have some interest with the Devil, that he might prepare a warm point of flame or two for the tongues of people who tell wicked lies for no purpose but that of wickedness. If they have an *interest* in lying, well and good. I can pardon them with all my heart. Forgers who forge for money's sake, politicians who lie for place' sake, cowards who lie for fear's sake, and so on, — all manners of rogues who get anything by lying, I can pardon and pity. But your wanton-malice rogue I can't, at least until he repents."

Few persons appreciate the density of ignorance and prejudice in this direction, unless brought in contact with it. Those who look on art in a little and selfish way oppose all projects that are great and comprehensive, that include the future as well as the present. But the climax of opaqueness of ideas is in those who are smitten with little taste and less knowledge, united to an insatiable wish to dictate. There is scope enough for every one to work in harmony, for every taste to be gratified and all zeal made useful, if petty

notions and senseless prejudices are put underfoot. This cannot be, however, while men who are not qualified to tell an original from a copy, scarcely one school from another, and certainly do not know a counterfeit from a genuine picture, nor a restored one from one perfectly pure, impose themselves as judges of art on any community. Miner K. Kellogg, one of the few American artists qualified by study and experience to speak intelligently of old masters, says, — "The only certain and satisfactory proofs of the originality of an ancient picture having no positive history are those inscribed upon its surface by the hand of the master himself. These will be found in the qualities and characteristics of the composition, drawing, color, and execution, together with that sentiment peculiar to the undoubted works of the painter. To decide justly from these criteria upon the claims of a painting to originality is the province of those only whose judgment has been matured by a long and careful examination of the varied productions of the artist to whom it is attributed, and also of the works of his contemporary scholars and imitators. It is besides desirable that he should have acquired some practical knowledge of art. If after the scrutiny of persons so critically competent a work be pronounced original, it is then, and then only, that written testimonies become interesting and of historic value." *

Twelve years' experience in the studios of artists and restorers, and in public and private galleries, surely is a better basis of knowledge than no such experience, though by no means establishing infallible judgment. Of the many amateurs my opportunities have brought me in contact with in America, outside of professional restorers, I have met but one who at a glance could pronounce infallibly upon the genuineness of a painting, detect its exact restorations, or if a counterfeit, expose it. On the other hand, I have heard excellent judges in most respects, and even eminent artists, pronounce emphatically in favor of the authenticity of a picture whose origin was the most doubtful of an entire gallery. The eye,

* Researches into the History of a Painting by Raphael Urbino, entitled, "La Belle Jardinière," ("Première Idée du Peintre,") by Miner K. Kellogg, London, 1860; a pamphlet well worthy the attention of amateurs of art for its force and clearness of statement.

like the ear in music, must be specially trained in these matters. No one goes to the Archbishop of Canterbury for an opinion on iron-clads. But as foolish a thing is daily done in art. If one had a sewing-machine or a steamboat to present to the public, every street and wharf could furnish an *impromptu* committee qualified to judge of them. But a gallery of old masters is quite another affair. The primal committee of appraisal must be European. Opinions and testimonials from time to time have come from unexpected quarters, the more welcome because of their official authority. After leaving Italy, a diploma was sent me as an honorary member of the Academy of Fine Arts, (*Socio Onorario delle Belle Arti di Firenze,*) the Academy "*volendo darle un attestarto di stima per gl' insegni suoi meriti negli studj artistici.*" It is due to the friends who have seconded me to tell an incident as grateful as it was unlooked for. Surely, this honor would not have been conferred by one of the oldest and most distinguished institutions of art in Europe on an absent stranger, had it entertained the same opinions of his labors which have been circulated in his native city to defeat them.

But although opposition and misjudgment have come from townsmen, Europeans have freely bestowed their encouragement. The opinion entertained in Italy of the "Old Masters" may be gathered from an article in "Il Mondo Illustrato," August, 1861, Turin, bearing the initials of Professor P. E. Guidici, a distinguished writer, and Secretary of the Belle Arti.

"Mr. Jarves, a citizen of Boston, (*uomo di non comune ingegno,*) for many years a resident of Florence, after having made a profound study of art, as shown in several works, (*pregevolissimi libri,*) desired to form a collection of ancient pictures. When we consider that for half a century Italy, especially Tuscany, and notably Florence, has been ransacked for works of art to be taken out of the country, there did not seem much hope that Jarves, by his researches and labors, could obtain by the force of perseverance the marvellous (*maravigliosi*) result he finally has. Enjoying the aid and advice of eminent artists, he succeeded in obtaining nearly one hundred and fifty old masters, the greater part of the Florentine school. It must be added that he originated the idea of a chronological series, representing the progress of art dur-

ing five centuries, from the triptychs of the mediæval epoch down to Raphael and Andrea del Sarto. Beside this, the collection has fourteen Byzantine, Græco-Italian, and Italian pictures before Cimabue, including one of this great Florentine master, from whom critics date the resurrection of our art. Also of Giotto, Giottino, Cavallini, Duccio da Siena, Taddeo and Angelo Gaddi, Andrea Orgagna, Spinello Aretino, Simone Memmi, Beato Angelico, Sano di Pietro, Giovanni di Paolo, Dello, Paolo Ucello, Benozzo Gozzoli, Masolino da Panicale, Masaccio, Filippo and Filippino Lippi, Cosimo Rosselli, Sandro Botticelli, Pollajuolo, Verrocchio, Pinturicchio, Mantegna, Lorenzo di Credi, Albertinelli, Francia, Perugino, Franciabigio, Sodoma, Becafumi, Giovanni Bellini, Giorgione, Paris Bordone, Sebastiano del Piombo, Cesare da Sesto, Bronzino, and various others.

"These embrace the most famous names in the annals of Italian painting. They are not given at hazard, nor has Mr. Jarves any desire of pecuniary gain, nor anything in common with those fanatical amateurs who even in good faith love to magnify their possessions, decorating them with the pompous names of museums. Not wishing to make them pass for more than they really are, he does not pretend to give all of them as *absolutely* perfect works, but as fair specimens (*monumenti efficaci*) of the pictures of various epochs in their genuine condition as far as can be, the whole showing the commencement, progress, and beginning of the decline of the several schools. Nevertheless, some are extremely rare, (*rarissimi*,) and others of wonderful beauty, (*maravigliosa bellezza*,) such as two paintings by Giotto, one of the Peruginesque manner of Raphael, one of Luca Signorelli, — a noble composition of twenty-three figures, representing the adoration of the Magi, a picture in perfect condition, never having been injured (*assassinato*) by restorers, — one of Francia, a splendid (*stupenda*) Leonardo da Vinci, and above all a Gentile da Fabriano, signed, whose pictures are extremely rare, representing a Madonna and Bambino in a Gothic niche. This work is greatly superior to others attributed to the same Gentile."

There follows a particular description of the *casone*, or paintings taken from the bridal chests, celebrated in the annals of Florence for their beauty and richness, particularly the superb specimen representing *Il Trionfo d'Amore*, a subject borrowed from Petrarch, but made as original as charming by the mediæval artist.

The Professor says, in conclusion, "Italy will lament the loss of

so many treasures of art, designed for the nucleus of a gallery in Boston, the Athens, or, more properly speaking, the Florence of America;" adding that Italy out of her abundance can spare some of her art-wealth, and bidding them God speed. "If," he says, "these pictures had ears to hear me, I should say, from the depths of my heart, 'Go to the New World, become missionaries of culture to a great people, who have riches and power in abundance, but who greatly need the softening and refining influences which spring from educating mind and heart in the worship and divine knowledge of art.' P. E. G."

Sir Charles Eastlake, President of the Royal Academy, London, and Director of the National Gallery, writes:—

7 Fitzroy Square, London, Nov. 16, 1858.

"DEAR SIR, — I rejoice to hear that you propose to send your collection of specimens of early Italian masters, in its entire state, to America. Few would have taken the trouble you have gone through in discovering and obtaining these works. Your continued residence in Tuscany has enabled you to avail yourself of many excellent opportunities. Good fortune has also sometimes rewarded you; but to your discrimination and knowledge your success is chiefly to be ascribed.

"I consider that the series in question would form an excellent foundation for a gallery of Italian art; and I trust, that, in your native country, it will be appreciated and kept together," etc.

Professor Migliarini, Director of the Uffizi Gallery, Florence, and Signor Burci, Inspector, attest emphatically the value of the collection. M. Rio, of Paris, whose works on art have given him a European reputation, does the same, saying of the Leonardo, "I have not the least hesitation in declaring that I fully believe it to be the work of that great master. The genuine pictures of Leonardo are so rare that the want of one has left to this day a sore gap in the gallery of many a sovereign." Baron Garriod, of Turin, confirms its genuineness at length.

Evidence of the value and appreciation of the pictures in Europe by competent judges could be indefinitely multiplied. In one sense it is humiliating to be compelled to do even this much in a cause

which carries with it no satisfaction other than may be eventually derived from succeeding in doing something for art in America. Meantime, it subjects one to calumnies and mischief, a common penalty, doubtless, of those who labor for public objects, but which no one fully appreciates until circumstances compel to so sorrowful an acquaintance with the latent meanness of human nature. On one side, it is asserted that I am engaged in an attempt to palm off on my countrymen a worthless lot of old canvases and panel-paintings; and on the other, by a class who admit their value, that they were got by fraud. These statements disturb me no farther than as they operate to prejudice minds incompetent to decide for themselves, but inclined to candor, against the cause I plead. To such I would repeat that my ambition from the first was to present the entire gallery to my native city, and that only because of absolute inability to give the whole did I, after written inquiry, propose that a portion of my expense should be repaid. This is not said by way of extenuation; for if I had seen fit to make money by dispersing the gallery, it would have been a proper transaction: certainly, one which would have vindicated my practical sense in the eyes of most of my countrymen. Instead, I have kept it together in obedience to the original idea, and in the last extremity offer to part with a few pictures, to enable me to give the remainder, unencumbered, to the learned Society of New York that from the first gave them hospitable welcome. The funds for getting them were in part my own earnings, and partly loans from a relative, who, in consenting to render substantial aid, warned me I was half a century too soon in the matter. The question now is, shall the collection be kept entire for public purposes, or be dispersed into private hands? There is more feeling in regard to this than indifferent persons conceive; but unfortunately it is among those whose means are not commensurate to their public spirit. One wrote from Europe, after offering to do all in his power (including a loan) to prevent the dispersion of the gallery, the idea "makes my dreams uncomfortable. I keep thinking I see the Singing Angels begging down Broadway with their open music-books, followed by Fra Angelico's saints and bishops with their angelical blue-book, and

they might as well be in Hades as there." Yes, once dispersed, many will be the regrets of those who know their worth! Not so much for their technical qualities, noble as these are, as for the spiritual delight they proffer. An anonymous writer in one of the Boston journals, after seeing them, pathetically exclaims, — "The Old Masters have gone. The faces that have become to us the faces of friends have disappeared. The pleasant inner room where we have loved to find a brief repose from every-day weariness of life is closed. What has it left us of cheer or help or strength? The result, like that of any genuine experience, is difficult to state in words. Life's highest quantities and rarest felicities do not admit of precise measurement or statistical arrangement. Yet the gain may be none the less real for not being tangible or apparent to sense." "Yes, we wanted those old pictures. They have done among us a work which could not have been achieved by masterpieces of consummate finish, if devoid of the informing soul which gives to *them* their charm, their power, and their immortality."

I close my plea by another extract, taken from an unknown writer in the New York "Sunday Times" after they were exhibited in that city. To have given even one person the satisfaction he depicts is no small offset to the jibes and sneers of those whose eyes are still unopened. If the pictures are destined to dispersion, they will still be missionaries of good in private homes; if kept together as one speech, they will utter their truths to many minds like his who says:

"I have been again and again to the Jarves Gallery, morning and evening, by daylight and by gas-light, alone and in company, with my catalogue and without it, after examining the 'Art-Studies' very carefully and before I had looked at the book which talks so much and so well about the artists and the works thus introduced to America; and I never once have failed to be profoundly interested in the paintings. I am not learned enough to decide whether they are originals. I have heard people ridicule the idea that a Rubens or a Murillo could be in this gallery. I have heard them tell the immense value of the collection, if each work were what it is claimed to be in the catalogue. I know all about the improbability of the pictures being authentic. I know how ridiculous Americans have made themselves by accepting as original

whatever was palmed off by designing foreigners. Still, I fancy Mr. Jarves is as likely as any one to know; his opportunities for judging and his advantages for choosing have been greater than those of many; he is well indorsed by competent authority. And he does not claim great things. He does not pretend to offer us masterpieces, and so at once disposes of the objection that it would be impossible to obtain masterpieces; he also obviates the outcry of those who ask, 'Is this all?' He says, distinctly, 'This is not all. Raphael did infinitely better things than this, yet this is a bit of his producing. Giorgione colored with immensely more success than on this canvas, yet Giorgione put these colors where you see them. And as one likes to look at the autograph of a genius, here you have it; here is the sign-manual of the kings of art.'

"But I don't trouble myself with the question of originality. I have not even been most interested in the works that bear the greatest names. The oldest pictures have had for me a more remarkable fascination. I have sometimes gone to the gallery early, before any one else had arrived, and given myself up completely to the spell they exercised: at least there was no doubt about their age; if they were not by Giotto and Cimabue, and Guido and Gaddi, they were by the pupils of those masters; they had been seen and probably retouched by the great artists. They were evidently from churches and palaces; some still bear the arms of noble Italian families painted on their frames; others are altarpieces or triptychs; they have added to the pride of Guelphs or Ghibellines, of Medici or Barberini. They have incited the devotions of knights and ladies, weary of the world, its contentions, and its fascinations; they have soothed some broken-spirited monk; they have comforted some sorrowing, solitary nun. They have looked down on gay artists or holy priests, on brilliant scenes or secluded shrines. They have hung in lordly galleries or on cloistered walls. They were painted before America was discovered, and when their creators had little thought that they should ever be brought thousands of miles beyond the sea.

"All this brood of contemplations is sure to flutter round me as I gaze on the dingy frame and cracking canvas; and it gives me a pleasure, melancholy indeed, but perhaps as genuine as any that the artistic qualities of the pictures can excite. But this is not all. I like to trace the earnest religious fervor everywhere visible in these works. To me they are full of character. I can see in them all the devotional ardor of the Roman Catholic religion; all the fondness for symbolism of the ancient church; all the tenderness of that faith which worships the mother of Christ; all the profound spirituality of the mysteries and the sacra-

ments; all the simplicity of belief which Protestants call credulity, but which is, to me, a confidence as desirable as it is unattainable. To me these quaint old pictures are full of meaning. If I were a good Catholic, my devotions could well be warmed before some of those representations of the Virgin 'full of grace;' if I prayed at all to the saints, I could pray more fervently when gazing at pictures of saints so saintly as these. It seems apparent enough to me that the men who did these works believed in the religion they illustrated; that their work was a religion; that they meant to do God service in their work; and if God is served by aught that is done by man, I believe that these works, executed in a spirit so evidently religious and sincere, have contributed indeed to his glory. How different from the religious pictures painted to-day! They are full of an expression profounder than any religious painters of our time can embody, because the men had a profounder religious sentiment than men of our time often attain to. Their religion was a matter of feeling as well as of the intellect; and it is the feelings, not the intellect, that rule mankind. Passion governs us all; and when religion is a passion, that passion, like every other, is expressed in all the man does, or thinks, or says. Then we have Fra Angelicos and Domenichinos, St. Pauls ascending to heaven and Virgins that are quite divine.

"To see this earnestness struggling for expression through imperfect utterances and unwonted means, and by dint of its reality accomplishing expression, is interesting to me. To see religious fervor beautifying these uncouth faces and almost transfiguring these awkward forms; to see a saintly glow illumine features full of artistic faults, and to find a meaning in these strange old pictures that suggests the sweetness of John or the terror of the Apocalypse, the sorrow of the Ecce Homo or the divine majesty of the risen Redeemer; to see this portrayed by those who handled the brush with so little knowledge of the appliances or the secrets of art, is to me more than interesting. I like always to watch earnestness and genius struggling with difficulty, because I know that in the end earnestness and genius combined are sure to conquer. And I gaze at picture after picture, with this thought ever uppermost. So if sometimes the awkwardness is ridiculous and the anachronism absurd; if there is no perspective in a picture; if the sky touches the house-tops, and the halos of the saints are too conspicuously gilded; yet when I everywhere detect this childlike simplicity and profound earnestness, when I pass along in chronological succession and find how art was gradually developed and the powers of the artists approached maturity, I am careless of the cavils and the censures of the hypercritical or the indifferent. Whether the Da Vinci

is an original or no, I cannot tell; whether the Raphael was ever touched by the greatest of painters, I do not pretend to decide; but I am sure I have gained from this gallery a more correct appreciation of the peculiarities of the early masters, a more thorough knowledge of their style, a more absolute sympathy with their spirit. I have learned from it a higher estimate of catholicity of taste; a willingness to find beauties in art even though disguised by uncouth swaddlings; a readiness to receive the teachings of those who feel and think, even though their utterances be sometimes couched in harsh tones or awkward syllables. I have learned that the body is more than raiment; and although it is well to have the spirit clothed in the raiment of a beautiful body, that the spirit sometimes informs the most unlovely frame, and breathes out through and despite the unloveliness, displaying its own divinity."

I have written the preceding pages for two reasons: first, that the time is close at hand when the public will be interested to know what led to the beginning of galleries of old art here; and secondly, because, having been driven to battle for the Old Masters, it becomes a duty to uphold them heartily. But this volume will show that my views, so far from being partial and narrow, extend to all art of all times, as a great agent of civilization; and that my zeal is no more for ancient than modern work, but for genuine work of every epoch. True, I make no disguise of individualistic delight in some art more than others, though striving to deal justly with all. If what is done promote art-culture, it will be ample return for labor incurred. Since these sheets were given to the printer, two events rejoice me greatly. One is the munificent gift of Mr. T. J. Bryan of his gallery to the New York Historical Society, in aid of their noble enterprise of an historical museum and art-gallery in Central Park, now about being accomplished; and the other, that, "all plans having failed," according to one of our journals, from "opposition, skepticism, prejudice, and misappreciation, and Boston being deprived of the nucleus of a gallery of great interest and beauty," New York has come forward to secure the "Old Masters" permanently for her great national institution, as the following circular declares:—

"At a meeting of the Historical Society, held on the first instant, a

committee was appointed to confer with Mr. Thomas J. Bryan in reference to his valuable collection of pictures becoming the property of the Society.

"The committee takes pleasure in informing you and the members of the Historical Society that Mr. Bryan has presented to the Society his entire collection of pictures, numbering about two hundred and fifty, and valued at over one hundred thousand dollars, on certain conditions, which, it is presumed, will be readily complied with.

"The committee would also inform you that Mr. Jarves has expressed a desire that his valuable collection of early pictures should become the property of some public institution in the city of New York, and has very generously offered his collection to the Historical Society, on condition that the pictures be relieved from a mortgage of twenty-five thousand dollars. These pictures (as the committee is informed) have cost Mr. Jarves over sixty-six thousand dollars. Some time since a proposition was brought before the Society, at one of its regular meetings, to offer Mr. Jarves the sum of fifty thousand dollars for his collection; but as the Society had not the funds to appropriate in that way, the subject was dropped.

"The committee has ascertained that it is now the intention of Mr. Jarves to sell his pictures, separately, to individuals; which, if done, would scatter one of the most valuable collections connected with the early history of art that exists in this or any other country, — an event to be regretted by all who take an interest in art, and particularly by a society whose object is to cherish and foster everything that appertains to the history of this and other countries, and the arts connected therewith.

"If the Jarves collection is now broken up, the opportunity will forever be lost of getting together another so valuable.

"Should the Historical Society be so fortunate as to possess the Jarves pictures, they would, with those of Mr. Bryan, form a gallery of rare historic interest, as illustrative of the progress of art from the earliest to the present time."

"When the subscription has amounted to the sum of twenty-five thousand dollars, the money will be handed over to the treasurer of the Historical Society, to be applied as set forth in the foregoing statement.

<div style="text-align:center">

EDWARD SATTERLEE, 62 East 23d Street,
C. G. THOMPSON, 20 Lexington Avenue,
WM. J. HOPPIN, 61 Pine Street,
GEO. H. MOORE, 36 West 18th Street,
A. M. COZZENS, 42 Bond Street.

</div>

"*New York*, March 24, 1864."

If this be done, will you not then be joyful with me, kind reader, that at last these Old Masters, despite ridicule and ill-will, shall have found a place of rest in the New World, in which, in the eloquent words of Professor Guidici, to fulfil their destiny of "missionaries of culture to a great people?"

"Vivit post funera virtus."

THE ART-IDEA

I

Life a Self-enlarging Sphere. — The Mental Relationship of Men.

LIFE may be likened to a sphere which includes an inexhaustible series of circles of knowledge. In the beginning we are but a simple point. But mind having the power of self-increase, each successive experience enlarges its circumference. Ultimately it may include within its grasp all love and wisdom short of Divinity.

The mental processes by which we thus enlarge our circles are worthy of attentive observation, partly from the satisfaction of analyzing and appreciating the mind's growth, but chiefly as indicative of the illimitable future of knowledge which they gradually open to our view, in the degree that we humbly, earnestly, and continuedly demand to know the secrets of Immortality.

If it were not for this ever-expanding Future to tempt us on, we should speedily despair of the Present, and pronounce it only vanity and vexation. But the farther we advance, the more power we comprehend within ourselves; so that the pleasure of learning rests not so much on that which we have attained to, as with what remains for us to know. Each fact, thought, and acquirement is but so much oil added to our lamp, whereby to diffuse greater light to our intellectual vision. Knowledge becomes teachable and humble in proportion to its advancement, because it measures all things in an increasing light; while ignorance, believing its farthing candle to be the sun, ever shows itself vain, contradictory, and headstrong.

Wherever there is a sincere disposition to know, wisdom responds; but the dirty work, the wick-trimming and lamp-cleaning, is wisely left to ourselves. We must with our own fingers keep our cans open and our torches burning. In doing this we receive, as of our own right, a never-failing supply of the divine fuel, whose heat expands our souls, filling the universe with their presence and desire.

The several phases of knowledge are as clearly distinguishable in the advancement of the mind, with their relative effects thereon, as are the varied experiences of the affections in the growth of the heart. But our progress is necessarily a mixed one. Body and mind by turns coerce one another. Now soul is uppermost; then undermost. This busy, idle, capricious, restless, doubting, believing, struggling, despairing, hoping, praying ME, with its entanglement of sense and spirit, in shadow and sunshine, ever strives to present to the world a self-balanced, imposing I; but the superficial glance only can be deceived by it. The clairvoyant eye of experience sees within the alternate victory or defeat. Indeed, so cognate are our natures, that the real life, or outer sham, of a fellow-being may prove to be the counterpart of one's self. Without the universal tie of humanity, the artist's or author's appeal would be as responseless as a stringless harp. In some form or other, happiness is life's common object. Whatever bewilderments beset its pursuit, all men instinctively seek it; the wise in the garb of divine truth, the foolish in the delusions of a selfish and sensual life. If, reader, you are of the former class, bear, we pray, with the abstract character of our remarks for a while, until we have shown the connection between the art-idea and divine truth, in the great design of civilizing and making glad the earth. But if the other path charm you most, pause here, for we do not wish to invite an unappreciating mind into the sanctuary of Art.

"What ho! What tidings have you for us?" Such is our constant cry to brother and sister more advanced in the search. Cheerfully, lovingly, comfortingly, have many responded, holding out their hands to aid us to reach their point of view. When there, though not always seeing as they did, still we have seen farther and clearer than before. Thanks! many, many thanks! What we have received

CHAPTER I

it is a duty as freely to give. If, therefore, we can aid toiling spirits, even as ours has often been helped, like harvest-seed cast upon the Egyptian waters, this labor, in due time, will be returned to us in the true bread of life.

II

Art-Queries. — Origin and Nature of Art. — What has it done for us? — What are its Possibilities? — What Relation does it bear to Science? — Vagueness of Words. — Definition of Art.

WHAT is the origin and nature of the art-idea? What has it done for us? What are its possibilities? What relation does it bear to science? Such are some of the points we wish to suggest thought upon, rather than hope to entirely elucidate.

But a serious difficulty arises, in the outset, from the uncertainty of words. Goethe aptly observes, "To speak is to begin to err." Unless we can first make clear the exact meaning we attach to the terms applied to art, any attempt to discuss its nature would be futile, because we should have no fixed ideas to reason from.

Words, unfortunately, are vague in the ratio of their generalization. Thus art, science, religion, philosophy, God, and all other comprehensive nouns, convey to different minds conceptions as various as their several moral and intellectual attainments. Truth must indeed remain the same, for it is eternal and immutable; but it is always relative in degree to the individual, being proportioned to his intelligence and capacity. Language is the more perplexing because every grade of knowledge and even temperament, has its own formula of expression. As minds grow, words also change their significance to them. It is impossible, therefore, to fix upon a definition of general terms so exact as to convey precisely the same import to all individuals. The most any one can do is to explain as clearly as possible what is meant by himself in the use of an ambiguous or controvertible word.

Without undertaking here to define art precisely, we may generalize it as the love of the soul in the sense that science can be considered its law. Each is requisite to the proper action of the other, as its counter-weight or balance. Art adorns science. Science is the helpmeet of art. Their action and interaction are close and intimate. Apart, the one is erratic, mystic, and unequal in its expression, the other cold, severe, and formal; because Beauty is the main principle of the former, as Utility is of the latter; while Truth, of mind or matter, and consequent enjoyment or benefit therefrom, is their common aim.

A more popular definition would be simply to call Art the ornamental side of life, as Science is its useful. That is, whatever is produced by man in which beauty is the predominant feature, may be considered as having its origin in the art-idea; while things primarily necessary or useful, although in a common sense classified as of the arts, may be viewed as the distinctive expression of the scientific faculty. We build, manufacture, classify, investigate, and theorize, under the first-named power. It clothes, warms, feeds, protects, and instructs man, and is the prime agent of his comfort, material progress, and general knowledge. But our pleasure is more intimately related to art as the producer of what delights the eye and ear and administers to sensuous enjoyment.

This is, however, merely an external or superficial view of art and science, and has reference simply to mundane objects. The final definition is based upon their connection with the unseen, — that subtile and diviner sense, which, as it makes Science the material expression or image of Wisdom, so it renders Art the spiritual representative of Love. By its inspiration, art aims to convey or suggest ideas and feelings, which, by appealing more directly to the imagination, lift us above the ordinary laws of matter, into the world of spirit, and, as it were, lets its light shine through upon our physical senses, so veiled by material beauty that we can endure its effulgence; or, we may say, like pictorial language to children, it brings down the incomprehensible, by a species of incarnation, to the range of finite faculties.

Art-forms are, first, the expression of man's attempt at a por-

traiture of nature, in its manifold variety, according to his individual understanding thereof; and, secondly, a reaching-forth after the possibilities of his faith and imagination. In this latter sense it is the instrument of the spiritual and intellectual creative faculty, and its mission is to foreshadow in matter the thoughts of man in his search of the beautiful or infinite. This is its Idealistic bias, as the former is its Naturalistic. The one is based upon the perceptive and imitative faculties, the other upon the inventive and creative. For the first, God has written a plain copy in the material creation; and for the second, he has let into the soul, as a window, imagination, through which reason catches glimpses of a nature more perfect than that seen only by the external eye.

Although we consider Art-expression as dualistic, from the fact that nature itself is divisible in relation to art into two great divisions, namely, that which is the fruit of the external senses alone, and that which is more particularly the product of idea, yet, generically, art-motives are threefold: —

First: Decoration, or that which has for its object ornament and pleasure, and is addressed chiefly to the sensuous faculties. This is the most common, and enters largely into food, clothing, building, manufacture, and polite manners, in short, everything which, over and above absolute necessity, gratifies the æsthetic sense.

Secondly: Illustration, or that which has mainly reference to the intellect; teaching, preservation, and reminiscence being its chief aims. This includes historical, descriptive, and portraying art, and is based directly on facts and natural truths.

Thirdly: Revelation, or the imaginative side of art, expressing the inner life and its subtile element, as inspired by the religious or poetical faculties, or, under the control of a debased will and the inferior passions, revealing the possibilities of the spirit for the base and sensual.

Art, consequently, has varied aspects, according as it is inspired by the perceptive, rationalistic, or imaginative faculties. Although we find in different ages and artists an intermingling of these three characteristics, yet in general there exists a predominance of one inspiration above the others sufficient to particularize an epoch,

and permit us to speak of it as the ruling motive. In any of its phases art is simply a medium by which the thought or feeling of the time and artist is spread open like a book, to be read and judged of all men. Of itself it is neither good nor evil, but speaks equally or mixedly the language of sense, intellect, or spirit, as the will dictates. From its passivity it is a delicate test of the moral and intellectual culture and inmost life of all who employ it; because, being the result, in material expression, of man's aspirations, feelings, and faith, it discloses, with the exactness of the daguerreotype, the precise condition of the individual mind, and the general characteristics of the era in which it has its being.

Poetry, music, and the drama, as well as painting and sculpture, must be included in the generic term Art, because, in each, truths of beauty and harmony of form, color, sound, action, or thought, are sought to be expressed under combinations the most pleasing and incentive alike to our sensuous, emotional, and mental faculties; and we are in consequence more or less let out of ourselves into general nature or particular humanity, or made to penetrate deeper into the mysteries of our own being, rather through the force of sympathetic feeling than of logical analysis.

Therefore whatever has the power to thus affect men, and is neither directly derived from innate or pure reason and science, nor is the manifest language of nature itself, but suggests the spirit, power, or presence, alike of the seen and unseen, and yet is only their artificial expression, — that is ART.

III

The Importance of Art as a Teacher. — *Liability of over-estimating it.* — *Liability of under-estimating it.* — *How it affects the Unculti-vated Mind.* — *To be cultivated.* — *Its Importance as a Vehicle of Knowledge.* — *Its Utility in Elementary Education.* — *Relative Nature and Functions of Science and Art.* — *The Dangers of Art.* — *The Chief Obstacles to Science.* — *Character of Inspiration.* — *Knowledge essen-tial to Art-Understanding.* — *In what Manner Art becomes Efficacious.*

SINCE art bears so close a relationship to our faculties, it follows that it must be of vital importance to our civilization. In the enthusiasm of a favorite pursuit or sudden mental illumination we are liable to overrate its instrument, as, later, when having entered upon new and more exalted reaches of knowledge, a tendency to underrate the previous agencies of our progress is apt to occur. Art is peculiarly liable to misconception in either of these particulars, on account of the difficulty of defining its limits, and from its alliance with feeling, by whose impulses judgment is so often over-borne and justice obscured.

The simple rule by which art affects the uninstructed mind is that of natural affinity. To whatever we are most inclined inward-ly, we turn with most satisfaction in its external expression. Thus the simple, tender, and true appreciate most keenly the works of art in which those sentiments are best manifested. Some turn directly to the merely intellectual, in which art is made secondary to scientific or historical truth; they see, with undisguised delight, that the natural and positive fact is skilfully represented, and the

external object or scene familiarized to their eye; this is their greatness of art. A few only are primarily and spontaneously touched by evidences of the highest motives: the struggling as of captive spirit to escape into a celestial atmosphere, where emotion forgets rule and becomes sublime in its very ignorance of mechanical execution by its suggestiveness of noble effort. There are minds, however, that see in such work only matter for ridicule or antipathy; they turn with zest to vulgar imitation, by which the things or passions which please them most in the possession or exercise are made obvious to their sight and desire.

A correct appreciation of art is of gradual mental growth and study. Shakspeare's plays would be a sealed book to a savage, and Beethoven's music an unmeaning noise. But the feeling for art is innate in men, although widely differing in extent and purity. With all, early contact with art is like the primary experiences of infancy with the persons about it. A disposition to manifest the natural bias of the character is the result. This tendency, as we have previously remarked, necessarily implies a disclosure of the inmost likings of heart and mind. It is therefore interesting to accompany intelligent and impressible individuals on their first introductions to the art-world. Their proclivities often are as ingenuously and naïvely developed as are those of unsophisticated savages on seeing for the first time the gewgaws of the white man.

The importance of art as a vehicle of knowledge is but imperfectly appreciated, because its results are so common. But, were all the pictorial, engraved, or sculptured representations of scenery, costumes, natural objects, deeds, and men, in short, all that, being of the past, we necessarily could not see, and which, of the present, is out of the range of our immediate vision, taken from us, the greater part of history and of the surface of the globe would cease to have to us a tangible, vitalized existence. In the mind's childhood, words are but an imperfect means, as compared with form and color, of conveying accurate impressions of actions and objects. Art, therefore, in its primary stage, is the elementary education of individuals and nations. By pictures and toys we give to children their first ideas of things not under their own immediate observa-

tion. Infancy, in education, reverses the rule of the mature mind. It seeks to know the outside of objects, asks first what a thing looks like, and but slowly learns that the external, with all its infinite variety, is but the changeable and transitory image of a few simple principles of mind and matter, into which God has breathed the breath of life.

In reference to education, art, therefore, is initial. The earliest alphabets were but rude pictures, or symbols of objects and ideas. Before man acquires the faculty of mental sight, by which the artificial signs we call letters convey to him impressions adequate to the things they represent or to the thoughts they embody, he must have first learned his lesson of the outer world, both from nature and art, or otherwise words would be to him meaningless. Even in its higher, not highest degree, art performs but an inferior function, compared with abstract science. It is to that what the body is to the spirit; for it exists only as an appeal to our soul, through thought or beauty embodied in matter, and therefore, in this aspect, cannot go beyond suggestion.

Science, apart from its material mission, by which it seconds art and descends to be a servant of man, has still a nobler purpose, and talks face to face with spirit, disclosing its knowledge direct to mind itself. By unfolding the laws of being it carries thought into the infinite, and creates an inward art, so perfect and expanded in its conceptions that material objects fashioned by the artist's hand become eloquent only as the feeling which dictated them is found to be impregnated with, and expressive of, the truths of science. The mind indignantly rejects as false all that the imagination would impose upon it not consistent with the great principles by which God manifests himself in harmony with creation. As nature is His art, so science is the progressive disclosure of His soul, or that divine philosophy which, in comprehending all knowledge, must include art as one of its forms. Hence, in order that art be effectual as a teacher, it must be consistent with that which teaches it. Otherwise it falls into isolated or inferior truths, and, by being detached from those great principles which alone give it moral value, it perverts knowledge and corrupts the heart.

40

CHAPTER III

While art, therefore, is valuable as an elementary teacher by reason of its alliance with science, it particularly exposes man to seductive influences, through the medium of his senses, from its greater affinity for feeling. In the degree that the soul's vision is obscured by carnal instincts, sensation and reason develop themselves in the direction of external life, seizing upon that as their chief object of pleasure and investigation, and thus, by ignoring the divine origin and purpose of matter, come to view it as the ultimate good of existence. This sensuous proclivity of art is its chief snare, but its force depends upon the tendency of human will. The chief obstacle to science is its inexorable demand upon pure reason, which implies the labor of thought; for the exercise of the mind is as necessary for its growth as is that of the hands for the cultivation of the field. If art or science recognize the spirit's integuments as the sole objective reality of life, corruption and falsehood are certain to ensue. We cannot know or possess unless we work, not in pride or despair, but in faith that as we plant so shall we reap. On the other hand, in viewing forms simply as the incrustation of spirit, and in subjecting the outer to the inner life, we more nearly approach the sources of beauty and truth.

In one sense, all truth comes of suggestion; so, in the same sense, does all falsehood. In the one instance we call it inspiration; in the other, temptation. But whence and how thoughts and ideas come and go, no man can tell. There is an impenetrable barrier to finite faculties. Yet those laws of being which to earthly senses are obscure and indefinable, will, in the greater light of future life, become as clear and intelligible as gravitation or numbers are now. It is in vain, therefore, to seek to define how we think, or become conscious. We can hope to discover the principles and laws of all things connected with our present being, except the cause of being itself, which all mankind spontaneously resolve into the indefinable proposition, GOD. On this all must rest. But, while the essence of life is so mysterious that even Jesus compared it to the wind, — whence it cometh, and whither it goeth, no man being able to tell, — yet it is palpable to the humblest understanding that the quality and direction of its thoughts depend upon the will. God does not

force himself upon reluctant minds, or overcharge their faculties with ideas disproportioned to their powers; but, as they labor for good or evil, so come thoughts and feelings corresponding to their desires; as one flower attracts from the atmosphere the sweetest of odors, while another collects the foulest. Thus it is that we are inspired. Our minds receive from the unseen a spiritual nutriment, which strengthens them in the direction they would grow. With some individuals, cultivation regulates its pace; thought comes orderly, and is systematically progressive. These are our sages and men of science. With others, it springs up in strange exuberance, flashing tropical colors from way-side seeds, burning, scintillating, and startling by its sudden and unequal fires; great truths amid rank weeds; a wilderness of chaotic beauty and noble forms. Out of such inspiration speaks the artist, poet, and seer.

While art should partake of the character of inspiration, free, earnest, and high-toned, embodying the feeling which gives it birth, its forms should exhibit a scientific correctness in every particular, and, as a unity, be expressive of the general principle at its centre of being. In this manner feeling and reason are reconciled, and a complete and harmonious whole is obtained. In the degree that this union obtains in art its works become efficacious, because embodying, under the garb of beauty, the most of truth.

I V

ART being so important an element in education, it must necessarily exercise a corresponding influence over a mind in contact with it. The natural world presents one form of divine teaching, and art another. Both, we repeat, are the incarnation of spirit in form. The first is the direct sculpture, painting, music, and poetry of God himself; the second is the material given to man, with the power of communicating, through the agency of his hands, suggestions of his own nature, the universe, and their joint Creator. By the exercise of this indirect creative faculty the artist partakes of a divine function, insomuch as Divinity delegates to him the infinite talent by which he represents the creative principle, and, by its stimulus, is trained for a loftier being.

But few men possess the ability to communicate manually the evidence of a divine embassy. All, however, have more or less discerning power, and hence are correspondingly able to receive, and sit in judgment upon, its credentials. Great artists are, of consequence, rare, while competent critics are not infrequent. As art-feeling is innate in all men, though widely differing in degree, art must have a message for every one brought within its reach.

What has been that message to you? to us?

43

The first picture that we can recall was a "Coronation of Napoleon I.," which we saw when eight years of age.[1] Our first impression was of wonder how a flat surface could be made to present such an appearance of projected figures, and the impulse was to approach the canvas to detect the mechanical means by which it was produced. When satisfied that it was veritable painting, the story absorbed our attention, and we took our first vivid lesson in history.

In America the art-feeling necessarily remains in a great degree dormant, from lack of its objects. Hence, when Americans are first introduced into the world of art of Europe, their feeling being suddenly aroused without the counterpoise of a ripened judgment, they are blinded by excess of light, and manifest their tastes and predilections much after the capricious manner in which children express their wonder and desire upon their earliest entrance into a toy-shop. But their indiscriminate rapture or aversion gradually subsides into an intelligent perception of art-motives, and an earnest inquisition into its principles; for no people are more eager in the exploration of the unknown, as its horizon bursts upon their vision.

Our first great experience was the Louvre gallery. Wandering through its interminable ranges of pictures, or lost in its vast halls of statuary, we became oppressed, confused, uncertain, and feverish; filled with unaccountable likes and dislikes; passing, in a convulsive effort to maintain mental equilibrium, sweeping censures upon whole schools, and eulogizing others as foolishly; hurrying from one object to another with delirious rapidity, as if the whole were a bubble, ready to burst at any moment; until, with a weary, addled brain, but unmoved heart, we gladly escaped into the outer air for breath. Our puny self was crushed by the weight and variety of the intellect incarnated within those walls. With nature on every scale we had long been at home in various quarters of the globe. Her scenes had always brought delight and repose. If new and overwhelming, they indeed crowd emotion into a thrill of joy, or a gush of tearful passion; but it is an excitement that soothes, and leaves the beholder wiser, happier, and better, if there be in him

any affinity with the great soul of the universe. Mrs. Browning once told us, that, upon reaching the summit of Mount Saint Gothard, she was constrained, by the force of the mountain gloom and glory, instantly to weep. All persons whose hearts are not made callous by ignorance, vice, or familiarity, are keenly susceptible to the eloquence of nature.

The first interview with true art produces a movement of the soul scarcely less spontaneous and deep, when we abandon ourselves with equal confidence to its influence. But if, in mental pride, we refuse to test its power over our hearts before we have canvassed its claims in the light of an uneducated understanding, confusion and folly are sure to follow. In beginning with art let us walk humbly. Like nature, it primarily addresses itself to the emotions. Set aside criticism, therefore, until we have learned something of ourselves through the language that moves us. To be a critic before we are a scholar is both rash and silly. And, indeed, in learning to judge of art, it is better to seek for beauties and recognize merits before aiming to discover defects and shortcomings. The foundation of art-appreciation must be developed from within. After that comes the time to inquire, analyze, and theorize. We rushed too self-confidently into an unknown sphere, and got well brain-pummelled for our conceit.

A series of mistakes gradually led us towards the right road. We have begun to get more correct views of art. They are not its highest or deepest; but they are our highest and deepest of to-day, and, in comparison with earlier ones, wise. We offer them, because there are some minds treading the paths that we have trod, to whom our experience may shorten the way; while to those in advance beseechingly do we cry, Give, give! even as we seek to give! Stoop your flight to ours, even as by these confessions we try to measure for others the first weary steps of progress with sometimes sad, often disappointing, and yet never wholly joyless, mile-stones. So shall wisdom, from its unselfish use, be largely meted out to you again by the great Giver!

V

Primary Relation of Art to Religion. — Priestcraft appropriates Art. — Origin of Sculpture. — Painting at first Subordinate. — Primary Significance of Color. — The Rainbow as a Symbol. — Object of Art in Egypt, — India, — China. — Definition of Spirit and Spiritual. — Want of Art among the Hebrews. — Its Development in Greece. — Gradual Divorce from Sacerdotalism. — Final Freedom of the Artist. — Result.

RIGHTLY to understand art, we must ascertain its governing notions, in its several phases of national or individual development. So intimately associated is it with religion, in all incipient civilization, that it becomes difficult to speak of it otherwise than under that head. Both sentiments are innate in the human mind, and each, in its beginning, develops itself chiefly through feeling. But the latter, being the more powerful and comprehensive, makes at first of the former a mere instrument to express its ideas, in the form either of symbols, or images of the celestial powers that the untutored imagination conceives as presiding over the destinies of men. Hence early art is always found subordinate to the religious sentiment, which it seeks to typify with but little regard to the æsthetic principle of its own being. Only as it escapes from vassalage to priestcraft does it assert its proper dignity and beauty.

By priestcraft we refer to those crude notions of divinity which obtain among all men in their first essays to comprehend God, and which become more obscure or material through the mistaken and selfish policy of priests, in invariably clothing their superior knowledge in the guise of sacred mysteries. To perpetuate their influ-

46

ence, they deem it necessary to present to the people some visible embodiment of their doctrines. Among the first symbols of Deity were the most common natural objects, such as trees and stones. A desire to personify in material form the unseen life or intelligence which governs the world, combined with the feeling for the beautiful, undoubtedly gave rise to sculpture. Painting was at first a mere accessory to it. Indeed, color had for ages a greater typical than ornamental significance; and even now, in many minds, it finds noblest appreciation from a lovely chord of symbolism of the glories and virtues of the celestial world, and its letting down for finite enjoyment a portion of the infinite, subdued to the standard of our feeling and comprehension, which, as in the rainbow, remains to earth in all time a living hope and joy.

In those earliest seats of civilization, Egypt and India, the sacerdotal influence was long the governing one. Consequently, the artistic feeling was overborne by the theological, and their art was soon petrified into a rigid and fixed expression of metaphysical ideas, giving to their idols forms as unchangeable and enigmatical as their enigmatical conceptions of nature. India still retains her elaborate, symbolical art, — a personification of her religious philosophy to the initiated, but to the masses presenting a worship scarcely one degree removed from gross fetichism. In China the spiritual life is still more absorbed in the material. In these countries, embracing nearly one half the human race, art, having been made a slave, has avenged its degradation by presenting falsehood for truth, perpetuating error, and barring progress. The art of a nation is at once its creed and catechism. We need no other literature to reveal its mental condition than the objects of its religious belief or sensuous delight. With this key to the soul in hand, the comparative intelligence and progress of races are easily unlocked. Without the aid of a false and immovable art, as the easily understood substitute of printing, it is scarcely conceivable that the popular mind should have remained as immovable as it has in the East. Wherever art is thus circumscribed we find a similar result. The object itself takes precedence of the idea, and becomes an idol. Worship is replaced by superstition, so that art is presented either

47

as a mummified dogma, or in grotesque, mystical, and unnatural shapes, and barbarous displays of color, corresponding to the false and sensual theology which inspires it.

The Hebrew legislators fell into the opposite extreme to the Hindoos, and, from their reluctance to attempt to embody their notions of divine things, quenched the artistic spirit of their people so completely that even for the decorations and symbols of the temple Solomon was obliged to apply to the Tyrians, — who were themselves by no means an artistic people, — as did, later, Herod to the Greeks, when he adorned it to its utmost magnificence. Yet the Jews allowed a certain scope for art in their religious architecture, and the objects used in their ritual, which was in later times wholly repudiated by the fanatical excess to which the Puritans and Quakers carried the proscription of idolatry by Moses, making it to apply to all art. By them life itself was deprived of half its legitimate happiness, while among the idolatrous Orientals art became a perverter of the soul on account of its divorce from intellectual freedom.

It is to Greece that we must look for the first development of true art. That country was, indeed, not without its symbolical creations which resembled nothing on the earth, whatever the theological imagination might conceive as existing in the heavens, or as necessary to represent metaphysical mysteries. Many of its figures were as strange and graceless as the extraordinary emblematic art of India. Diana of Ephesus was a female monster. Grecian chimeras, and three-eyed, double-headed, and hundred-armed statues, were analogous to Oriental image-mysticism. But in its fauns, satyrs, nereids, and kindred imaginative beings, originating out of the pantheistic element of its faith, we find the growing ascendency of the natural and beautiful holding the symbolical in subjection, until, in the best examples of the Grecian chisel which have descended to our day, we perceive art not only to be wholly emancipated from priestly servitude, but, through its inherent intellectual force, or, more strictly speaking, genius, to have won for itself the position of teacher. Art and religion were indeed, in one sense, identical; but the mind was unshackled, and left to its

normal action. Thus the poets and artists of Greece, instead of being made the mouth-pieces and artisans of a formal faith, became the creators of a more beautiful, refined, and natural mythology, by which the sculptured gods, while emblematic to the philosophic mind of the highest possibilities of nature and humanity, were brought home to the sympathies and thoughts of the people. The *word* was indeed made flesh, though in a sensuous, æsthetic sense, inferior by far to the Christ-love which descended later upon men, to elevate them to a still higher phase of life, but superior to the religious notions which had heretofore governed the world.[1] Grecian art became, therefore, a joint revelation of the emancipated intellect and imagination, inspired by the beautiful to deify the natural man by making him the pivot upon which God and nature turned. An exaggerated standard of the intellectual and physical powers and passions, aiming at the god like in expression by the elimination of material weakness and all signs of imperfection, or a personification of natural phenomena and of the thought and feeling suggested by their action, taking the guise of poetry and embodied by art, — not, as in India, in a grotesque accumulation of the unnatural and purely symbolical, but in shapes drawn from the visible creation, idealized into the highest beauty of form and meaning the imagination could conceive, and approved by science, because analogous to and founded upon the visible examples of nature; — such were the mythology and art of Greece.

VI

Origin of Mythology. — Effect on Grecian Art. — Its Emancipation from Egyptian Art. — Examples. — The Egyptian Apollo. — The great Law of Change as applied to Art. — Antagonistic Qualities of Greek and Egyptian Art. — How we are to judge of Past Art. — Analysis of the Causes of the Perfection of Grecian Art. — Reaction of Philosophy vs. Polytheism. — Grecian Faith and Art perish together. — Rise of Monotheism. — Effect upon Art. — Christianity repeats the Practice of Paganism. — Better Seed. — New Unfoldings of Faith, followed by Relapse to Primitive Ignorance in Art. — Laws and Examples of Grecian Art.

THE foundation of the earliest religions was either in external nature, the effect suggesting a cause, or in the mind of man himself, repeating, as it were, his own sensuousness or intellectual force in superhuman shapes. Both these causes tended to the development of a prolific mythology. So fixed in a mental childhood is the disposition to personify the objects of belief, that even the Jews themselves were very far from reposing in absolute monotheism. They were the Puritans of antiquity; as the Egyptians may be said to have shown, in their priestly assumption, flexibility of action, and unchangeableness of dogma, the likeness of Romanism; while the Greeks more resembled those modern nations which have thrown off priestcraft. Inspired by love of philosophy, they opened up their minds to the widest ranges of thought and poetry, and, borrowing from the learning and experience of all nations, culminated their wisdom in Aristotle and Plato, and their art in Phidias and Apelles.

Although beauty was the inspiration of Greek art, it was not left to the dubious direction of mere feeling, but subjected so skilfully to the acutest rules of science, that their best sculpture makes us forget art by its seeming naturalness. Whether their painting was equally advanced with their statuary still remains a mooted question; but we may be assured, that, so far as it went, it was subjected to similar rules.

That the beauty and freedom of Greek art were emphatically due to the genius of the nation itself is amply proved by the earliest specimens of their sculpture. One of the most remarkable of these is the bas-relief of Leucotea, Bacchus and Ninfé, of the Villa Albani, at Rome.[1] In it we see the dawning emancipation of Greek from Egyptian art, showing, by the greater freedom of treatment, an attempt to adapt the still rigid attitudes, bound limbs, massive and imposing formalism of the latter, — which can be properly expressed only by the kindred qualities of granite, porphyry, and other adamantine rocks, and owes its character as much to their color as to form, — to the more perfect uses of marble, and the natural suggestiveness of that more flexible material for greater liberty, a nicer sense of beauty, and a more refined expression. In striking contrast with this beginning of Greek art upon the rules and practice of the Egyptian, thus declaring its derivative origin, is the example of the later reflex influence of the former upon the latter in the Egyptian Apollo of the Vatican, which combines, in the most harmonious degree, while retaining the main characteristics of each, the motives and excellence of either school.[2] The god now walks, — or, rather, can, if he sees fit, — for his legs are at liberty, and yet retains the severe majesty, grandeur, and simplicity of his Egyptian temperament, exhibiting a superhuman strength and firmness of body and character, united to the Grecian purity and refinement of form, material, and expression.

By the force of his artistic liberty and more correct appreciation of man as his highest type, the Greek artist had thoroughly freed himself from the dogmatic formalism and rigidity of Egyptian art. In taking away its prominent characteristics of painful endurance, passivity of inert strength, preponderance of matter in size and

weight, stereotyped posture and expression, he not only emanci-
pated art from prescribed forms and the dictation of priests, but
also endowed it with individual liberty of thought and workman-
ship. Egyptian artists were accounted as artisans or image-cutters
of the lowest castes, and their craft by law descended from father
to son. Yet, as a whole, the art of Egypt atoned in large degree
for its want of freedom of progress by the mysterious sublimity
of character arising from the nature of the material and its broad
and majestic treatment. Doubtless the Egyptian idol was shorn, in
the popular national mind, of the strength of its divinity by the
innovations of Grecian origin; but, to the more cultivated race,
Apollo had emerged from the bondage of the land of Egypt, and
walked forth truly a god.

The spirit of Egyptian art was from theological necessity formal
and unvaried; of the Greek, free and changeable. Consequently,
while the one allowed no motion to its artistic creations, but rested
hope and faith on the passive and petrified sublimity of its sacred
images, the other delighted in joyous, sensuous life, and brooked
no restraint upon the will or actions of its divinities, for what was
happiness and possibility to them was likewise joy and possibility
for humanity, only in an inferior degree. It is therefore instructive
to compare, in their respective sculpture, the antagonistic qualities
of their religions, and to trace the mutual influence of parent and
child, — for much of the civilization of Greece may be said, in its
incipiency, to bear that relation to Egypt, — and then to contrast
both with early Etruscan sculpture, and note how distinct and
independent in its origin and feeling the last seems from the other
two, aiming at the natural and vigorous, but lacking the more
beautiful inspiration of the Greek mind, although finally overborne
by it.

Every phase of existence contains within itself its seeds of de-
struction, or, more strictly speaking, change, by which a higher
condition of life is ultimately evolved out of the lower. Ideas and
manners go through as natural a process of growth, decay, and
renewal in new forms, as does the vegetable creation. Nature,
having done with one class of thoughts or things, never recalls

their existence. Their uses perish with their non-necessity. We could as successfully revive a race of behemoths or ichthyosauri as a defunct faith, or arrest the course of a star as easily as summon back an obsolete feeling.[3]

This inexorable law should be kept in view in judging of past art. It is impossible for the moderns to look upon it with the same tone of mind as its contemporaries. To them it was both belief and beauty. The former we can appreciate only as we disinter fossils, to inform our intellect of past facts as the predecessors of present; but of the degree of the latter, its rules being unchangeable, all time is qualified to judge, if it but ascertain them. Hence it is that ancient, and indeed all art not based on our own play feeling and faith, necessarily loses its primary significance reaches us only at second-hand. Our understanding, either the persuasion of conventional taste or sound cultivation first approve before we praise it; while all art that *lives to* influences us through our sympathies or desires.

Greek art is in so great a degree an æsthetic idealizatic higher faculties of man as the climax of nature and seed of every man having latent within him the capacity of a even its fragments continue to be viewed as the noblest specimens of true art yet produced. By this we mean art as divested of other motive than its own laws of being. The religion out of which it sprung is forever dead. Consequently, ours is not a front, but a back view. We prize it not so much in relation to the embodie idea, which only scholars can correctly appreciate, as from broader relation to common humanity and the universal la nature. Tried by this standard, we find it complete and co so far as it goes. And, further, as we come to understand religious motive, it appears so harmonious and beautiful witchery well-nigh carries us mentally back to the era whe peopled the earth with its sacred images. If we cannot believe with those subtle imaginations which divided nature into numberless divinities, or raise our own to that poetical height which, through ingenious and often sublime fables and myths, recognized in its phenomena, or brought home to their hearts, great moral as well as

physical laws, still we can sympathize with the feeling that led them to see divinity in nature, and devote their wealth of mind and substance to making the Unseen appreciable and effectual to all men.

The Greek artist wrought in accordance with pantheism, stimulated by religious fervor and intellectual activity of æsthetic desire. In the progress of mind there sprung up a reaction of philosophy, which, by reversing the popular sight, saw in symbols and dogmas only the particular livery of transitory ideas, and sought by the path of infidelity to gradually find its way to higher truths. But the philosophic mind in no age represents the common actual; it simply announces its possibilities and future proclivities. Therefore, in generalizing epochs, we must take the common mind as the great fact, however often exceptional minds shine forth like lighthouses over the benighted ocean of popular opinion. The religious and civil life of Greece was the ultimate of progress which it was possible to evolve from merely sensuous and pantheistic principles. But the development of its free thought has contributed largely to the new phase of civilization, which, springing out of the comparatively insignificant and barbarous Jewish protestantism, basing itself on monotheism, under the name of Christianity, has virtually supplanted polytheism as the dominant power over the entire globe.

One God, instead of legion, is therefore the great religious notion of the present cycle, in contradistinction to the preceding. Judea has succeeded Greece as the religious teacher of civilized peoples. In the struggle between the opposing thoughts, Greek art perished with the civilization on which it was founded. As its faith died out, so its forms partook of a corresponding moral decay. The inherent vice of polytheism, or the deification of the natural, after it had passed its climax of progress, hastened its final dissolution by the corruption bred out of the exaltation of the sensual over the intellectual; base ornament becoming the primary motive, instead of true beauty, while the pure taste that was born of æsthetic law was lost in low desire and gross ignorance.

The victory of monotheism over polytheism not only overthrew temple and statue, but mind itself relapsed into its primitive bar-

barism as regards art. It had to begin a new career from a fresh starting-point; and as, in the departed civilization, paganism at first had made art a mere instrument to symbolize its faith, so Christianity did the same. Everywhere it was subordinated to the new motive-power of progress. Apart it had no real existence. Byzantine thought became entirely theological. Wars and politics hinged upon articles of faith. Even when art was used as ornament, it was made to partake of a mystical and sacred character, illustrative of the dominant ideas. Indeed, the new creed was so little understood in the spirit of its founder, that it tended rather to provoke subtle speculation and controversial passions than to regenerate the heart.

Nothing narrows the understanding faster than the polemics of controversial theology, when made the basis of sectarian strife for political power, or of ecclesiastical tyranny. In the civil wars that accompanied the gradual dissolution of the Roman empire, all art worthy of its Grecian parentage rapidly declined. Its decay, however, was hastened by its own innate tendency towards sensuality. Apart from the noble specimens which have survived as a legacy of knowledge and example to modern art, there are, it must be confessed, chiefly disinterred from the buried cities of Campania, but characteristic of classical civilization everywhere, numberless examples of a prurient taste for the low and base, which modern propriety will not even permit to be seen as relics, but on discovery consigns at once to a new darkness as complete as the old in which the lava had buried them. We must not consider, however, that these objects were simply the results of a licentious art. To the early ancient mind, generation had a sacred significance. The worship of Venus was by no means intended, in its primitive point of view, as a scandalous exhibition of sensual passions; on the contrary, acts and objects which Christianity rightly puts out of sight were then held in public esteem, as emblematical of divine mysteries. These emblems have, in many instances, survived their original meaning, and yet within themselves silently perpetuate its spirit. Thus, the obelisk is rich in symbolism. It was the sacred *phallus*, the sun's prolific ray, a pole and spindle of the sky.[4] Even

the Christian cross is but the union of the most ancient signs of the male and female organs of generation, formerly signifying human life, and now risen to the still loftier significance of the regeneration of the soul.

These examples, which might be indefinitely multiplied, should teach us, before condemning them, to inquire into their origin and meaning, and then to judge them from the mental point of view from which they arise. The obsolete of to-day is the vital truth of yesterday. The *phallus* of antiquity was seen and also worn by refined women without any of those sensations which would now attend its exposure, even in the lowest of the sex. Catholicism replaced it by that cross which the Puritan cannot regard without a holy shudder, as an emblem of idolatry, although the Papist esteems it as his priceless symbol of salvation.

While, however, investigation into the past teaches us that everything, whatever its present appearance, has its origin in some legitimate sentiment or necessity, yet it equally discloses the fact, that, by long use and continued familiarity, the most sacred rites and images may in time lose their spiritual efficacy, and become instrumental in sensual degradation. That this was the natural revolution of mythology, history amply confirms; but its very corruption prepared the way for reformation, by the tendency of the undisciplined mind to counterbalance one extreme by another. Hence, the purity of Christianity, and its doctrines of immortal life, took deep root and spread rapidly at that era of the world's history when the so-called heathenism was most rife, and all reformation seemed most hopeless. In reality, the world had never been in a better condition for its reception. Polytheism, as a faith, had everywhere died out or been shaken in the philosophic mind, which was honestly infidel, and inquiring what to believe. The masses saw in their condition all that the popular religion had to offer them, — sensualized and brutalized lives on earth, and vague shadows or nothingness in the future. To them, therefore, Christianity, with its spiritual hopes and promises, was a priceless offering. They grasped it at random, as a lifebuoy floated to them on the sea of time.

Two thousand years have nearly elapsed, and the unfolding of Christianity to its ultimate has scarcely been comprehended, much less practised. As yet we are in its very incipiency in our own moral condition; consequently, we should look leniently on the errors of our predecessors in faith. Christianity was the antithesis of paganism; therefore it should not surprise us, that, in the primary reaction, when mind went back to the impulses and ignorance of childhood, because put into a new phase of development, the misunderstandings and untutored emotions consequent upon juvenescence should have been manifested.

Whatever was of the old religion was looked on with suspicion. Art, in common with other knowledge, shared this disgrace. As it was necessary, however, to address the public mind through a pictorial literature, the new priestcraft, after it became confirmed in power, did as its heathen predecessor had done: seized upon art as its bondsman, and put it to work to rudely illustrate the dogmas with which it strove to rule mankind. For nearly one thousand years the clergy controlled art, and kept it in a state of barbarous rigidity or underdeveloped expression, analogous to its present condition among the stationary Orientals. In architecture there were repeated and partially successful attempts to escape this bondage; but the chief features of art were immobility and ignorance; its object, to delineate the legends and doctrines of the new church, in designs of childish and almost savage rudeness and simplicity; and its tendency in a certain degree mythological, because it multiplied objects of worship, and perpetuated, in a sense the most intelligible and convincing to the common mind, old superstitions, disguised under new names and forms. The dark ages are indeed a lamentable epoch in human history, if we view them only through their falsity, selfishness, and intolerance; but when, amid all these tares, we see the seed, as planted by Christ in humanity, constantly growing upwards and struggling successfully towards greater light, we feel assured that the human mind, as in the slow changes in the geological world, was preparing the way for the higher spiritual growth whose dawn is now perceptible on our moral horizon.

It was thus, that, while purer and nobler motives of life were gradually unfolded to humanity through Christianity, art, by being violently severed from the intellectual freedom which had made it so estimable in Greece, was thrown back to its infancy, in point of science. The human mind was swayed by it less as art than as idolatry or symbolism. No doubt, in either of these functions its influence is far greater than in its own right, because it becomes, through them, the exponent of the most powerful motives that can affect humanity. But this influence is consequent upon the absolute degradation, or the imperfect enlightenment, both of art itself and the being to whom it is addressed. In its grosser and most prevalent form, it partakes of fetichism; in its milder and more intellectual, it perpetuates superstition, substituting external rites and forms for inward godliness; and in both, it successfully appeals only to the lowest sentiments and intelligence. Worse than all, in the degree of its actual repulsiveness and positive coarseness is its power to control the mind that reverences it. As we see among savages stones and rude idols possessing divine authority, so, among the more cultivated races, on the same principle that falsity and superstition, being in themselves morally hideous, seek an external manifestation in corresponding appearances, minds, however intelligent they may be in some respects, if in religion they are governed by fear or bigotry, devote themselves, either in language or art, to such expressions of mere ugliness or gross materiality as most fittingly embody their motives and feelings.

By keeping closely in view this art-law we shall be better able to appreciate the difference between Greek art and that which took its place. In Greece the artist was restricted, by a refined natural taste, founded upon his intellectual code and sensuous creed, to the expression of the highest degree of beauty conceivable. Nay, more. Not only must his execution be beautiful, but his choice of subject must be such as would æsthetically please. In form, posture, costume, or color; in the employment of passion, and even pain; in short, in whatever he undertook, he was required, not only by the popular will, but, as in the instance of Thebes, by statute law, to avoid the ugly and depraved, and constantly to aim at the en-

noblement of humanity by the suggestion of its most graceful and exalted moods. To such an extent was the devotion to the beautiful carried, that prizes were given to the handsome men or women who won the suffrages of the judges at public competition. Beauty actually conferred historic fame, because, at least in theory, it was associated with corresponding mental and physical gifts. They also believed in the influence of beautiful objects about them to foster and elevate the national standard of beauty, and to impart its magnetism to unborn children, through the impressible faculties of their mothers. Their games, also, were of a joyous, sensuous character, incentive to manly strength, womanly grace, and general elegance; while those of the Romans served to inculcate brutality and thirst of blood. The Greeks, in consequence, grew refined and humane, the Romans rude and fierce in deportment. Next to the moral discipline of Christianity we can cite the Grecian passion for the beautiful as the most cogent refiner of nations. Winckelmann tells us that the Arcadians were obliged to learn music, to counteract their morose and fierce manners, and, from being the worst, became the most honest and best-mannered people of Greece. It is true there were exceptions to these exalted notions of the beautiful, forming a subordinate school, corresponding in character, but with lower motives, to the ordinary *genre* artists of modern times. Those who delighted in base, common, or morbid subjects were nicknamed "artists of filth." In the case of Pyrecius, cited by Lessing, parents were advised by Aristotle not to exhibit his pictures to their children, lest their imaginations should be soiled by ugly images. Above all faults, Greek taste condemned exaggeration and caricature, or any artifice which could not plead law for its use, as necessary for the æsthetic object in view. By artifice we here mean simply imitation in the degree of deception legitimate to art, but foreign to any appearance or employment of trickery, by which the senses are vulgarly deceived. Indeed, Grecian good taste was the ripe product of a slow and steady growth of æsthetic knowledge. Their early statues were rudely built up of different materials, wood and marble for instance, the extremities being made of the more precious article.

Sometimes they were painted to imitate dress, and even actually clothed, — puerilities of art, which are paralleled by the practice of the Catholic priesthood of today. As fast as the Grecian intellect outgrew priestly domination, it advanced in taste and knowledge.

Antiquity is, however, by no means without plentiful examples of false art. It had its freaks of effect, in the employment of color in statuary, as we perceive in the remains of tints from which Gibson [5] borrows his reprehensible practice and theory, endeavoring to amalgamate hues and forms under conditions not recognized by nature herself, and therefore not to be sanctioned by sound taste, — and in the combination of differently colored materials in the same statue, as in the fine Apollo at Naples,[6] whose head, hands, and lyre are of white marble, while the voluminous drapery with which the body is clothed is of black porphyry; thus destroying the unity so requisite in sculpture between the pure and simple character of the material and the singleness and purity of expression demanded solely through form, any attempt to heighten which, by the addition of colored eyes of glass or ivory, or by paint, as we find in some antique bronze and marble busts, naturally shocks, because they are not only ghastly, like rouge on the cheeks of a corpse, but they lie to our senses. Vulgar attempts at deception arouse only disgust and indignation. It is evident they met with no permanent favor in Greece. The Apollo, in the same hall, entirely of dark green basalt,[7] disappoints in statuesque effect as contrasted with the pure white marble; but it is not objectionable on the score of low artifice or lack of unity. We find fault simply with the choice of material to the use of which, in such a character, no treatment, however successful, can wholly reconcile the spectator.

The ability with which the Greek artist, by the rigor of his education and the exactions of his judges, was able to dignify even the commonest act, is prominently shown in the noble statue of Lysippus, or the Athlete of the Vatican.[8] The action is simply scraping the sweat from his arm, than which in idea no subject can well be more vulgar; but the attitude and expression, independent of its pure anatomical detail and superior execution, are such as to sug-

gest, in the classical sense, the "godlike." In the statue of Modesty, in the same hall, notice how much its value depends upon its simplicity, repose, and the chaste management of drapery, — the seemingly easiest and secondary efforts of the artist being made to give the highest character to his work! So, in the figure of Silence,[9] of the Capitol, we see how successfully it speaks, simply through the nice discrimination of its author in its attitude, every line proclaiming the art-motive and affecting the spectator with a like feeling.

In the multitude of ancient statues we find but few examples of intentional variation from the æsthetic law of Greek art. Of these perhaps the most conspicuous is an Old Hag, (Hecuba?) of the Capitol, admirably done, if one delights in the exhibition of a decrepit female form, and a countenance of care, misery, and possible crime.[10] It is disgustingly correct realism. Once it may have had value as a portrait, like the well-known bust of Æsop,* in the Villa Albani,[11] but now can conduce to no other end than to justify the refinement of the antique taste in inexorably condemning such a choice and treatment of sculpture. The Drunken Woman, in the same museum, is of a similar character.[12] It repels the feelings from the sex by its opposition to that we hold loveliest and best in it. There are, however, among the bas-reliefs in the Borbonico Museum of Naples, instances of this treatment which, from their spirit and feeling, reconcile one to its occasional use. They are the Blind Man, who touches our emotions rightly, and the Bacchus, who with his gay revellers is so jollily tipsy that it is impossible not to sympathize in their merriment, despite the sage axioms of temperance.[13]

In the representation of animal life the Greek artist was almost equally successful as with the human. In fine, beauty, as evolved from unity, harmony, and the highest truths of form, color, and expression, to the intent to produce intellectual and sensuous satisfaction, was inexorably required of him.

* See Appendix, Note A.

VII

BEFORE proceeding to a more particular analysis of Christian art as a whole, we must enlarge upon the radical difference between it and that of antiquity, arising from their antagonistic primary principles of sensuous pleasure and self-sacrifice; the one aiming at heightening every enjoyment, whether of body or intellect, on the plane of present happiness, and the other of subduing the natural desires, as in themselves sinful, and seeking to win a future good, and to escape a future retribution, by the purifying processes of self-denial and expiation. In both cases, through the excessive culture of these opposite principles, the body became

the sufferer, and by the inevitable workings of sensualism or asceticism avenged outraged morality. But it was as natural for one extreme to be succeeded by the other, as for the tide of the ocean to rise and fall. The generous culture of the Greek produced more pleasing effects, because his scope was normal humanity and his aim natural beauty. The Christian attempted a more difficult task, and with a loftier purpose. He sought to portray the triumphs of the spirit over the body. Instead of seeking sensuous beauty, he sought rather to manifest his contempt of it. No longer was the body a cherished friend of life, but its direct foe. Studiously depreciating it, he destroyed the harmony which should exist between holy feeling and beautiful form. His motive was indeed noble; but ignorance and fanaticism too often turned his art into burlesque or horror. Even the person of Christ, his God, was subjected to this coarse treatment, on the ground that his earthly life was a prolonged humiliation, and his death an expiation of the sins of the world. To him he was a literal man of sorrows and the chief of martyrs. For a time, that sacred figure, to portray which under the most lovely human type art now considers its highest triumph, was designedly represented as ignoble and vulgar. It was only when the Christian artist began to appreciate the rules of Greek taste, that he emerged from his error, and succeeded, though imperfectly, in connecting his spiritual aspirations with a more congenial outward expression. Unfortunately, before he had perfected his style, he was seduced from his purer motive into a love of the external, and learned to prefer workmanship or mere scientific skill and force to idea; so that, without surpassing, according to the inspiration of his faith, the best works of the plastic art of Greece as inspired by its religion, he has simply hinted the superior excellence of his motive. The Greek perfected his work, and rested awhile upon the high standard he had created. His Christian brother, on the contrary, has never fully reached his aim. Within one generation — that of Raphael — he passed rapidly from those art-motives, which, if conscientiously persevered in, by the aid of science might have long ago carried Christian art to a corresponding degree of perfection with the Grecian, into a stage that marked

the decline, rather than the advance, of his new-found teacher. Mankind was not yet ripe for the perfect development of art. It preferred for a while longer dead bones to new soul-forms. It is evident to every student of human progress that Christian art, thus far, has been but a series of attempts, as fluctuating and as disappointing as the expression of Christianity itself. Hence, we have still to look for its complete advent. This will not be until the heart of man, more fully warmed by Christ's love, prepares his understanding to receive a larger measure of divine wisdom than has yet been given to it.

No just comparison, therefore, at this period, can be instituted between the completed classical and immatured Christian art. The one attained its full growth and passed away; while the other, founded upon deeper and more enduring revelation, is but in its childhood. Indeed, it is but reawakening from the lethargy to which the looking back of the past three centuries to the forms and ideas of its predecessor, rather than to its spirit and knowledge, doomed it, after it attained its first genuine expression in the Pre-Raphaelite efforts that succeeded its primary dogmatic formalism.

Christian art has had thus far three phases of being. First, the theological, when the church dictated its laws. This lasted from the time of Constantine to the thirteenth century.

Secondly, the religious, which began in the awakening of the European mind at the termination of the preceding epoch, and continued until the sixteenth century.

The first period was the reign of superstition; the second, of devotion. Interwoven with the latter, and fostered by mediæval enterprise, was that intellectual freedom which, however imperfect in action, helped to vindicate the rights of mind, and leavened the new schools with the principles of growth. Two grand streams flowed from this union: the one, true and earnest, looking to nature as a guide, while continuing to find in the religious faculty its chief aliment, welcoming such aid as the then partial knowledge and sparse examples of pure classicalism afforded it; the other disinterring ancient art as a model, accepting its forms without its spirit, and devoting it to pride and pleasure. Out of this last grew

that anomalous, mongrel, semi-sensual phase, which, taking the precedence of the first, formed the third, and is known as the Renaissance. It was a fusion of pagan philosophy with modern unbelief, at a time when the heads of the Roman church, setting an example of skepticism and licentiousness, saw only in art an instrument of self-glory or sensual gratification. From such a soil what other harvest could be garnered than decline and corruption? *

There are grave objections to generalization. In condensing the mental characteristics of individuals or epochs a degree of misapprehension or injustice can scarcely be avoided. Yet, in looking back over the stream of time, certain lights and shadows are so conspicuous as to give a general tone to the view. Doubtless a nearer sight would disclose the brighter or darker spots, now lost in the far distance. It is sufficient, however, for common distinctions to faithfully report the view as a whole.

There is perhaps as much art-superstition in the world now as in the ages succeeding Constantine. Scores of millions of Roman and Greek Catholics still worship the rudest and tawdriest pictures and images. Their ideas of religion are derived from them. Protestants in art and faith spoke in former days as now, but their voices were drowned in the great tide of ignorance and credulity. The mediæval revival of learning scattered somewhat the mental darkness that brooded over Europe. Mind began, in all directions, to light up the horizon. Art felt the impulse, and most gloriously did it shine forth for a while; less, perhaps, under the inspiration of a more enlightened piety, than of a higher spiritual consciousness. But its illumination was too partial. Being exclusively devotional, it failed to satisfy the varied desires of a freed and growing understanding. The naturalistic schools gave it another impetus. Then came the fatal imitation of departed classical art, prostituted to the lusts of power and sense, in its uses pregnant with evil, but, in the spirit of investigation it awakened, filled with eventual promise of wisdom from out of the experience of the past. Thus the evil and

* We have, in a previous work, devoted to the Italian schools, examined in detail and given the history of mediæval painting. See *Art-Studies*, Chap. III. *et seq.*

good of all these eras are contemporaneous. Each contained the elements of the other, gradually unfolding their respective properties, as one extreme excited another; the truth, meanwhile, through all its checkered expressions, growing apace, and preparing the world for a fourth phase of Christian art, now arising, and which, from its broad scope and recognition of all nature and humanity as its inspiration and science as its co-worker, may be called the Catholic or Universal.

To better illustrate the essential differences in the character and execution of classical and Christian art, a few of the best-known examples of each may be put in contrast. The comparison is unequal in respect that, while the former can now only be represented by detached and more or less mutilated sculpture, the latter has the advantage of painting still existing in the localities for which it was designed, and, to a certain extent, the continued existence of the feeling in which it was conceived. Its disadvantage consists, as we have before remarked, in its being but an imperfect expression of the religious thought out of which it has sprung, while Greek art is the ripe fruit both of pagan faith and knowledge. A philosophic mind may, however, sufficiently elevate itself to view each by the light of æsthetic judgment.

In which, as a whole, are the spirit and purpose of art best manifested?

Rightly to answer this, we must first ascertain the relative superiority and inferiority of the underlying idea. Next, we have to get at the degree of identification between the object and the idea. As this is complete and exact, and the inspiration pure and lofty, so is the art in degree perfect. Infants are called artless, because body and mind correspond so naturally and harmoniously. Art is artless in the same sense when its outward form as well expresses its governing idea.

The Greeks rarely sought to represent physical suffering. They deprecated any departure from the strictly beautiful and pleasurable. Whenever, as in the Laokoon, the exhibition of bodily pain became necessary, it was made subordinate to æsthetic taste.[1] In this group, undergoing a death of the utmost anguish and horror,

there is, in the father's silent appeal to heaven for his sons' escape from an inexorable fate, and the pitiful look of the children directed to him whose sins are thus visited upon them, a moral beauty which overpowers the sense of physical agony. We perceive the awful fate impending, and are spared the absolute rack of flesh and blood. This the artist would not give. He does not permit Laokoon to cry aloud, though one can anticipate his convulsive sighs. Hence our feelings are moved to pity and admiration by his endurance, without being disturbed by vehement action, or the sense of the beautiful and grand being marred by the writings of bodily anguish. As a whole, the conception is simple and lofty. There are errors of detail in execution, particularly in the unchildlike faces of the sons, and a misconception of the instincts of the anaconda species of serpent in biting, that prevent this group from ranking among the highest specimens of ancient art. Still, we feel that a great soul is expiring in awful torment, and teaching the world a great lesson, particularly if we view the group in its symbolical sense of "sin," or the *throttler*, which Max Müller says is the original meaning or root of its name. Spirit predominates. Idea and object are identical, and true art is attained.

Much of the character of this group depends upon that subtile principle of repose which distinguishes the best antique art from most of modern work. Although violent and convulsive action is suggested by the nature of the scene, the artist has so skilfully chosen the moment of execution, that we feel, above all else, its deep quiet. We are placed upon the very brink of the final catastrophe, when the breath is suspended, every muscle is prepared to exert itself to its utmost opposition, and each nerve is vital with agonizing anticipation; the victims see their doom, and instinctively prepare to resist it, even though the utter inutility of resistance is manifest; but the artist leaves us, in their joint struggle, a moral suggestion of *hope*, the angel-sister of sin, to lighten the otherwise too painful impression upon the spectator; and the consciousness of all this is given by the skilful seizing of the exact instant in which the stillness of instinctive preparation procedes the last fearful effort of tortured nature to escape its doom.

The Dying Gladiator is another specimen of ever-living art.[2] It is an incarnation of the spirit of the universal brotherhood of men in their common heritage of suffering and death. A man dying by blood-drops from a stab! A simple and common subject; yet how beautiful and suggestive the treatment! Upon nothing of ancient pathetic art have we lingered with more gratification. Criticism is absorbed in sympathy, and the fear or pain of death in the spirit's retrospection of life and inquiring gaze into futurity. Behold a fellow-being prematurely sent by a violent death to the mysterious confines of eternity, and about to solve the common problem of life, whose evils have been to him so prolific a heritage. God aid him!

Is any St. Sebastian, St. Lawrence, or other martyr of Christian art, more truthfully and pathetically represented than this dying Pagan? Suppose the artist had left the sword stuck into his side, and his limbs violently disturbed by the muscular distortion of gaping wounds. What then would have been the effect? Yet the common fashion of Christian art is to appeal to the coarser sympathies, by exaggeration of physical sufferings, emaciation, or the tokens of poverty and asceticism. The idea is no less identified with the object than in Grecian art; but, while the latter sought to dignify humanity, Christianity, on the contrary, sought a development of spiritual growth by means of fleshly penance and suffering. Its art indeed essayed to illustrate its thoughts; but, having mistaken the intention of Christ, who came "eating and drinking" to the intent to reconcile the twofold nature of man and direct its harmonized energies towards heaven, it need not surprise us that it fell into a gross materialism, whose effects on spiritual education were scarcely less lamentable than were those of pagan sensualism. Out of it grew that terrible imagery of fiery torment which it harrows the mind even to think of for one moment, — the Christian hell, whose pangs were likened to a serpent's ever-gnawing envenomed tooth, — a perpetual lake of flaming brimstone, dense with lewd and blood-lusting demons, of indescribable and monstrous shapes and insatiable appetites, gloating in the foulest wickedness and quivering with unmentionable horrors, whose sole

occupation was to torture, throughout eternity, the unabsolved of the church, finding in their agonized flesh and mangled bodies the most savory morsels of their quenchless appetites, — in short, a future more prolific of material horror than the maddest Pagan imagination had ever conceived, under the authority of a supreme devil, in whom, as Satan, was incarnated all evil, and who, through fear, was made the rival and antagonist of the Christian's God. Such was the fearful conception by which the new art sought to reform mankind.

But, while so base a conception was made a primary agent of conversion, the artistic allurements of heaven, outside of its architectural magnificence and supersensuous materialistic imagery, were singularly ambiguous and uninviting. With all the accumulated wealth of its precious stones, brilliant colors, and walls of alabaster, it was but a sort of purified Olympus, swept clean of its sensuous enjoyments, and given over to stiff rows of the redeemed, in quaint, uncomfortable costumes, with musical instruments monotonously chanting and singing evermore around thrones filled with a triumphant hierarchy of the church. This was the commonly received imagery, both in art and literature, of future bliss. We speak of it irrespective of its language of symbolism, or the genius of those artists who so spiritualized their art as to lift it above all material significance, and invested it with a truly celestial beauty and meaning.* With such crude ideas of the life to come, joined to rank errors in the uses and purposes of present existence, arising from viewing its means and pleasures as so many fatal snares for the soul, it is no wonder that Christian art, so long as it continued exclusively under this bondage, became the opposite, in æsthetic character and meaning, of Greek art.

The Greek artist avoided sensualism as long as he preserved his strict intellectuality. His Christian successor inadvertently plunged into the meanest and most cowardly materialism, in his unwise abhorrence of sense. The motives to gain that spiritual life which he so illy comprehended were based upon the lowest principles of human nature. Men were to be frightened into good morals, or

* See *Art-Studies*, Chap. VIII.: Fra Angelico, Sano di Pietro, and their school.

coaxed into acquiescence to pet dogmas, and heaven itself bribed by atoning privations, a renunciation of social duties, or perversion of humanity's gifts. In short, the Creator was to be made pitiful and humane by the self-degradation of the being he had created in his own image.

In India and Egypt, art, being purely symbolical, was originally interpreted in the sense of the mysteries, often sublime and pure in conception, it was intended to illustrate. As art, however, its significance, or, more properly speaking, its influence, was but secondary. Still, it had its rules; and the subtlest scale of human proportions, making of the little the colossal, and giving all statuary to which it was applied beauty and grandeur of form, is said to be traced back to Egypt. Science, however, never there attained sufficient ascendency over priestly dictation to unfetter their statues and bid them walk. Even the early Greeks chained theirs, lest they should escape. Oriental nations chained thought, and kept their art in hopeless slavery. But, however monstrous, puerile, and false their conceptions of nature and divinity might be, they conveyed them to the popular mind in an emblematic art, so unlike natural objects that the sacred truths thus published through obscure, fanciful, and extraordinary mediums were without that direct shock to blood and nerves consequent upon the pictorial damnations of Christianity. Yet the doctrine of a material retribution had its origin in the East, from Chaldea and Persia finding its way into Judea, and thence into Christendom, in its present form.

Dante's "Inferno" embodies the common notion of hell of Christian sects. By his far-seeing mind, and those of kindred perceptions in any age, it would be received only in a typical sense. But to the mass it was and is a material truth, — a place of torment, where even divine love is powerless to give a drop of water to cool the burning tongue. In this respect Dante is the great prototype of mediæval plastic art, just as Milton's poetical legends of heaven's wars, derived though they be from Roman Catholic art and traditions, have become the unquestioned traditionary lore of Protestant Christianity, and as Homer's "Iliad" was the bible

of classical art. In either case, art simply embodied the popular notions of the times, and, by the force of its genius, conveyed them to coming generations with the authority of law. Orgagna,[3] Michel Angelo, and their compeers are the culminations, in painting and sculpture, of Dante's poem. They translated its horrors into form and color, in so earnest and terrible a manner that even an enlightened understanding cannot view their works without sickening dismay. The latter borrowed of antiquity its peculiar notions of doomed souls to heighten the malignity of his day of judgment. But how feeble is the Greek hades compared with the Christian hell!

A grosser plagiarism and less inventive great art-composition does not exist, than the famed Sistine Judgment. It is Dante's idea, with the principal figures borrowed in composition from the earlier masters, made anomalous by the introduction of pagan thought, foreign in feeling to the main subject. In posture and anatomy Michel Angelo here burlesques himself, although there is not a stroke of his brush which does not show the power of a great master. Still, as a whole, the weightiest judgment it conveys to the critical mind is upon the artist who could thus fetter his lofty genius to so ignoble an end. We see by this fresco how much Michel Angelo fails in comparison with Phidias, on account of the restraint put upon æsthetic taste by the severity of his creed, and its development, by him, of a morbid humor in matters of religion, which one, however, respects for its earnestness and as a rebuke to the licentiousness of infidelity around him. Even when he asserted his independence in the nude figure, ecclesiastical authority subsequently added draperies, on the ground of scandalous improprieties; so that we do not now see his work as he would have had it seen; and this should be remembered to his favor.*

The range of Greek art, in comparison with its successor, was indeed limited; but, so far as it went, it was loyal to its own laws. Hence the choice of its subjects and their treatment were in the

* For a more complete view of Michel Angelo, see *Art-Studies*, Chap. XIV.

main rigidly confined to an exposition of its purest principles. The sculptures of the Parthenon are the purest specimens of Greek taste now known. One cannot gaze upon their broken fragments without a swelling sensation of life. Theseus is sublime in his simple, godlike truth, — a man on his way to divinity. So, in an inferior degree, are the Apollo [4] of the Vatican and the so-called Flora at Naples.[5] The latter would be improved by knocking off its modern head, and leaving the imagination, inspired by its delicate and graceful flow of drapery, suggesting, rather than showing, its exquisite though colossal proportions, and its chaste, majestic attitude, to invest it with its original perfection. Notwithstanding its great size, we feel the fascination of the charming woman; and though a goddess, the delicacy and tenderness of the sexual nature compel our love. Examples of female loveliness, of manly strength, of heroic action, and of the faculties of head and heart, and beauty of form, that most worthily represent man or woman under the guise of a Juno, Minerva, or Venus, a Hercules, Juniper, Mars, or Bacchus, and other personages of a populous Olympus, are too familiar to readers to require to be more particularly pointed out. In their virtues and vices these gods are alike human, and, in consequence, upon our own level of motive and action, or within the range of our own capacities.

Added to this strong ground of a common interest growing out of sensuous sympathy and a certain affinity of mutual possibilities of life, are the naturalness and refined taste exacted by the classical conception of beauty. Not only our feelings are moved, but our judgment is won. Even if, as in the Torso de Belvedere, we see only a mutilated trunk, it is instinctive with life.[6] Like the Elgin marbles, it reveals to us an art that comprised an harmonious union of majesty, grandeur, and breadth of composition, united to exactness of detail so truthful in the minutest particulars, and so full of ease, grace, and vitality, as to seem more like the divine inspirations of the creative power itself than the result, as it was, of a laborious and conscientious application of the laws of matter to the representation of spirit. In art of this character we realize that the artist has penetrated the great mystery of nature, namely, that

organic form, being the concrete of spirit, is spontaneously evolved and exfoliated, as it were, in sympathy with the action and necessities of the inward principle or soul. His aim has therefore been to give a beautiful exhibition of their unity, from his artistic standard of the exaltation of sensuous humanity, and the personification of his poetical pantheism. The success of his art depended upon its being alike comprehensible by reason and feeling, and approved by taste.

Christian art, as we have shown, was on a less correct scientific foundation. It abandoned itself more to feeling based upon faith, without at first comprehending that true wisdom in all things consists in discovering law, and obeying it. As, however, the Greek artist had passed through this phase of progress, it was equally necessary for the Christian to do the same in the pursuit of his ideal. Two distinct stages of growth mark his course: first, the one in which he sought, as his primary object, to symbolize his faith; secondly, when, the religious impulse having exhausted itself, the reverential feeling lost its connection with prescribed forms, and reason began to inquire if there were no further development for art. Out of this inquiry has sprung, it is true, a host of evils, — classical imitation, materialism, mannerism, skepticism, and the usual reactions attendant upon individual mind suddenly freed to follow its own bias. But every success or failure may be regarded as so much useful experience for future generations. Art, in our day, has the accumulated knowledge of ancient and modern civilization to teach it wisdom.

The best art is that which at once most enlightens our intellect, soothes and elevates our feelings, and awakens refined pleasure. In proportion as there is a want of harmony in these relations, it fails in its mission. Bad art, like that of the ascetic school of Romanism, prompts the mind to a love of ugliness and horror for their own sake, and is a stimulus to superstition. In Greece and Rome it took the direction of sensuality and infidelity, and finally ended in corruption and debasement. All bad art acts after the instinct of a poisonous reptile. It seeks to fascinate its victims before injecting its venom. Our own day is saved from the evil of the Renais-

sant school by the vital power of free Christianity as a progressive force to regenerate mankind.

We have now arrived at that period in which reason is more imperative than faith. It is the transition-age between feeling and wisdom. Inquiry is its motto. As we investigate, we detect an affinity between the two, suggestive of their perfect union, when our mental vision shall be sufficiently enlightened to comprehend the entire motive of being, and our senses harmonized to its loftiest aims.

In the present stage of art-growth we cannot look upon its earlier productions with other than a critical judgment, though still retaining a sympathy with their motives. The ideal in art is a comparative term of excellence. One man's insight or knowledge is the farthermost horizon of his brother; just as, in the imaginative or thought faculty, the remote possibility of an inferior individuality, even in its super-creative sense, is simply the actual or natural of a superior. By keeping this psychological fact in view, we get hold of a perfect clue to critical inquiry, and are the better enabled to enjoy all things after their degree and kind. Although cultivation sinks the ideal of one person to the level of the natural of another, the imagination continues to hold up before the mind's eye the mirror of a still superior nature, to tempt men onward in the never-ending pursuit of beauty. Unrealization is the true motive-power of progress. The innate curiosity of mind impels it to constant inquiry after truth, led on by persistent hope of final repose in perfect work, — a perfection which always seems to be, but never is, within its grasp. In the search for the divine no two minds are precisely parallel. Still, although the focus of vision differs in all, there are general principles applicable to every subject.

Any work which suggests the loftiest capabilities of its motive, or demands an active imagination or sympathy to interpret it, possesses the germs of excellence; but that which forces the feelings to apologize to reason for violations of probabilities and possibilities, and of other rules of a refined taste, is in itself false art, and should have no influence outside of the motives which originated it.

Of such productions we have a notable instance in the Pietà of Michel Angelo, at St. Peter's, Rome, a common art-motive of the Roman Church.[7] This group is simply a mutilated, naked corpse of a man in an impossible position, in the lap of a woman already overburdened with drapery. Nature does not recognize such scenes. No mother sits holding the dead body of her son, disfigured with ghastly wounds, in her arms, for the plain reason that she could not if she would, and what she cannot do nature does not impulsively suggest. As art, therefore, this group fails. If, however, the religious faculty can find in it any aid to its piety by its symbolism, it is not without its use; nor need the subject-matter blind us in this or in kindred topics by great masters to the merits of details or general treatment.

Domenichino's St. Jerome, of the Vatican, is a similar violation of artistic rule, instigated by the ascetic side of religion. A naked, attenuated, disgusting exhibition of worn-out humanity, suggesting a long and painful life amid dirt and privation; the very dregs of a man, so emaciated that even the grave-worms must feel cheated of their lawful banquet, with posture and expression corresponding to such an ending of life, its forlorn misery heightened by the contrast of plump youth, and the rich attire of an attending priest; by his side, a subdued, spiritless lion, emasculated of his forest nature; overhead, a group of frolicsome, vulgar boy-angels; the entire painting sensuous in color and feeling, and rich in natural and architectural beauty: such is the extraordinary composition of an artist who has by it won the applause of Christendom. In reality, his choice of subject is as faulty in regard to the canons of high art as his treatment of it is irreconcilable to æsthetic taste and a proper understanding of Christianity.

Raphael's celebrated Transfiguration, in the same room, violates, though in a less conspicuous degree, the rules of art. In composition it forms two distinct paintings, with no connection beyond a forced meaning. Although designed in the principles of naturalistic truth, as a picture, its perspective is as impossible as is its entire grouping of personages, monk with Jew, false to the real scene. The grace and vigor of Raphael are indeed there; but the color

is harsh and brown; his early simplicity and correct feeling are gone; and this is due to the interference of ecclesiastical power and patronage with his taste and knowledge, causing him, as it caused all other artists similarly positioned, to subject the laws of art to the dogmas of a creed, by which bondage art has always suffered and true religion has never gained.

The highest effort of Christian art must necessarily be to represent the person of Christ, and the thrones and powers of his celestial kingdom. Therefore, the respective idealisms of the Classical and Christian artist — the one as shown in mythological creations, and the other in the attempt to prefigure the divine in the shape of the Father, Son, Virgin, or angelic host — are fair subjects of comparison. In our present analysis we refer not to *motive*, but simply to *execution*.

Which has been most successful in the treatment of their subjects?

Sculpture has never, to our knowledge, aspired, as has not unfrequently, to portray the first person of the Trinity, except in a minor way, as we see in Luca della Robbia, and works of his school. Why the impossibility of the one should have been considered as the possibility of the other, especially in an inferior medium, considered in relation to the majesty, power, and awe of the divine presence, — for the expression of which, pure marble, or, as in Egyptian art, granites, porphyries, jaspers, and other adamantine rocks are far more fitting than the glass of the mosaicist or the frail material of the painter, — we are at a loss to know. But so it is! Consequently, we are obliged, in this comparison, to ignore the coarse representations of the Almighty of the early Byzantine mosaics, and the later and more painful failures, because sinning in the light of more knowledge, of the great masters in fresco and oil, who, from the time of Cimabue to Camuccini, of our day, have attempted to define, in form and color, the undefinable and illimitable, and pass on to those incarnations in sculpture of divine attributes, which are within the legitimate scope of art.

Michel Angelo's Christ, of the church of Santa Maria sopra Minerva, at Rome, is less sucessful than his awe-inspiring Moses.[8] Instead of the man of sorrows, submitting to earthly authority, yet

of surpassing strength and beauty by virtue of his divine spirituality, chastely clothed in a seamless garment, misled by his passion for anatomical expression, the sculptor has made a nude, bound athlete, whose muscular proportions and strained attitude neutralize a somewhat lovely and appropriate countenance.

Of our own times, Tenerani, who ranks at the head of Italian sculptors, in his colossal Christ, for St. Peter's, has succeeded no better.[9] The drapery is well managed, but he has represented the Saviour in the act of blessing, which uplifted hands, and tumbling forward from his seat, apparently to the imminent risk of the spectators being crushed; while the sensual lines of the mouth and the vulgar treatment of the hair destroy what divinity of character the statue might otherwise possess, and make it appear very much like many of the prosaic figures of the popes, in whose company it is destined to sit while papacy endures.

Tenerani has, however, in the Torlonia chapel of the Lateran church, more successfully treated the Descent from the Cross. The Virgin's face is particularly fine, and the feeling and composition of the group are excellent. His Angel, in the church of the Minerva, is a successful suggestion, in sculpture, of a spiritualized presence.

Were we to descend to the lesser orders of heaven's hierarchy, we should find, as with Niccola Pisano, Ghiberti, Mino da Fiesole, Donatello, Leonardo da Vinci, Thorwaldsen, and others, instances in which prophets, apostles, and saints have been worthily rendered, and may be favorably compared, as far as such objects admit of comparison, with the productions of classical art of corresponding dignity of position or elevation of sentiment, in the light of their respective faiths. But even their dignity and holiness are subjected to trammels of tradition or of symbol, by which the artist is never left wholly free to work out the entire power or purity of his imagination. In this respect he is not on an equal footing with his Greek brother, who looked not so much to history or creed for his inspiration, as to his own conception of what a god or incarnation of any particular attribute of nature or divinity should be; and thus in his Genii, Parcæ, Furies, Gorgons, Muses,

Nymphs, Graces, Heroes, Fames, and kindred creations of his fancy, — the angelic host of heathendom, — or his higher celestial beings and men deified, knowing no other rule than the promptings of his own genius, subjected to the established laws of æsthetic taste, he wrought in greater freedom, and attained to a higher and more varied ideality.

Sufficient evidence of this fact is to be found in the average productions which either epoch has bequeathed to us. In the vast amount of classical sculpture now extant there is, indeed, a large mass of the poor and commonplace, — the product, not merely of its decline, but of the feeble efforts of feeble men in its best era. Let us continue, however, the comparison of the general character and spirit of all, not with the imitative results of revived classicalism, which must, of necessity, be inferior to its teacher, but with that which, being genuine Christian sculpture, in motive and direction, can be fairly brought into comparison with Pagan work, and submitted, equally with it, to the test of criticism.

The Christian statues, as we have before remarked, have the advantage of being whole, and in their proper places. Examine them, therefore, whatever to be seen, — whether topping the Lateran, surmounting the portico and colonnade of St. Peter's, densely peopling the Cathedral at Milan, guarding the bridge of St. Angelo, looking down from Giotto's Campanile and the Gothic niches of Orsanmichele upon the gay crowd of Florence, or as they appeal to us from the ecclesiastical edifices of papal Christendom of every age and nation, — and then go into the museums of classical sculpture, and compare, not the originating thought, but the freedom, grace, and spirit of execution, the beauty, *pose*, and action, the arrangement of draperies, and the feeling and expression of each object in relation to its particular inspiration, of the Pagan with those of the Christian era, and see which as art, irrespective of idea, excels.

In the comparison we purposely exclude all strictly portrait-sculpture, whether of tomb-work or not, and confine it to those objects which are either the direct inspiration of the respective faiths, or are simply the idealizations of personages who, having

died without leaving any likenesses of themselves, have, as it were, intrusted posterity with their recreation in art-forms, in accordance with their posthumous reputations. In this respect, the prophets and apostles of Judea and saints of Christendom may be fairly placed side by side with the demigods and other Pagan conceptions of Greece and Rome. We can, on this basis, justly compare a Minerva or Jupiter of Phidias with a Madonna or Christ of Michel Angelo; a Venus of Scopas, that of Milo, or a Juno of Polycletus with any of the numerous St. Catherines; St. George of Donatello with the Apollo de Belvedere; a Hercules with a St. Christopher; a Faun of Praxiteles with a St. Babiana of Bernini; the Ludovisian Mars or Juno with a Christ or Virgin of Sansovino, or a Santa Susanna of Quesnoy;[10] the Modesty of the Vatican [11] with the Charity of Bartolini; and, finally, the entire figure-sculpture of classical Paganism with that of Christendom. While awarding to the best Christian art lofty idea and great naturalistic vigor of treatment, and, as with Donatello, soul-lit expression and a burning zeal that seems to consume flesh as with the fire of a tenfold heated furnace, it is a relief to turn from the school as a whole to the antique Isis, Minerva, Flora, and contemporaneous statues at Naples, fashioned in the principles of beauty. We shall be the less astonished at the marvellous success of the Grecian artist if we recall the fact, that, beside his intense love of the beautiful, he was often inspired by a faith, which, like that of Fra Angelico, by prayer and devotion, opened up to him celestial visions and special manifestations of the favor of *his* gods and their delight in his work. Hercules vouchsafed a vision of himself to Parrhasius, who painted him from his divine aspect, as in our own day Blake claims to have done of men who left earth centuries ago. Ecstatic inspiration has not been confined to the Roman Catholic artist. His Pagan and Protestant brethren have been likewise favored. The pious ancients had also their severe rules of propriety in regard to religious art, — rules as pure and spiritual, and, perhaps, in the best time of their art, as scrupulously adhered to, as were those of the mediaeval artists in all that related to theirs. They blamed those of their artists who used courtesans for models for

their images of goddesses, as severely even as did the church Christian artists for like practice, and with as much effect, if we may judge from both their works. Their only entirely nude goddess was Venus, — nude, not in the outset from sensual ideas, but as an idealization of female beauty. If the Christian faith pledged its artist to surround the pious in death with visions of just men and women made perfect, so the Pagan artist sought to cheer his dying brother with consoling images of the inevitable change, like those of "virgins ever young," significant of immortal youth. Even the Fates and Furies were thus represented, and not as devils to torment. So that if the Pagan failed to equal the mediæval Christian in his hope of a heaven, neither was he tortured by equal fears of a future retribution. These contrasts of faith are plainly perceptible in their respective arts. Not a little of the symbolism of paganism was so complete and perfect of its kind that Christian fancy has lovingly perpetuated it. Cupid is immortal, so is Psyche; the two, embracing, denote the union of body and soul. Indeed, with all our spiritual knowledge or feeling, we have not surpassed the significant beauty of Greek thought in its incarnated suggestions of immortal life.

The entire sentiment of Greek art was averse to asceticism. The bas-relief of Diogenes in his tub at Naples comes as near being an exception as anything we know of.[12] But how unlike the Christian feeling! Diogenes chooses the city for the practical demonstration of his cynical maxims. He wishes to reform his countrymen by an egotistical parade of his philosophical contempt of luxury. But all he asks even of a king is that he shall not stand between him and the sun. He lives like a dog to excite curiosity and to be a perpetual reproach to the effeminacy of his fellow-citizens, whom he despises. Whether the tale be strictly true or not, this is the classical art-motive, as indicated by the artist.

Compare this with the St. Jerome of Agostino Carracci, at Naples,[13] and measure the distance between Pagan and Christian asceticism. The saint is by himself in a desolate wilderness. No human eye witnesses his self-inflicted penance and the stern subjection of his body to the spiritual purification demanded, not of his

reason, which condemns it, but by his faith. He has fled from man to be alone with his God. It is the salvation of his own soul, and not the reformation or reproach of his neighbors, that prompts him to kneel naked on the hard rock, and to beat his breast with a sharp stone, in his anguish of convicted sin. There is no sunshine for him while his soul is in peril; no material comfort, however lowly and common, appeals to his sensibility; it is alive only to the eternal joys and horrors of the future life, as seen by his theological vision. Were an imperial Alexander to address him, he would not let go by the opportunity to reason with him of the life and judgment to come; and his eloquence would the more prick the heart from the deep sincerity and earnestness of his baptism of isolation, contempt of the joys of this world, and anxiety to escape the flames of the hell he so solemnly announces to his fellow-mortals.

This painting, as a composition, is one of the best efforts of this school. It shows not only a genuine feeling of the subject, but an appreciation of classical rule in art not common in the treatment of kindred topics by Christian artists. The saint's head is remarkably fine; his expression and attitude, as his gaze clings fixedly to the crucifix before him, powerfully suggest the character of the emotions of his stricken soul. Our sensibilities are not wounded, nor is our taste outraged by vulgar violence and coarse suffering; but, in the action hinted at rather than directly expressed, we have the full force of the anchorite's dread penance; while in his countenance may be traced a gleam of the ecstatic hope and promise in his Saviour's blood which underlies his self-abnegation. The landscape is in keeping with his feeling, — solemn, wild, solitary, and mystic, — a fit haunt for an anguished though not wholly despairing spirit; while in color the picture is singularly harmonious with its ascetic motive.

Heathen and Christian grotesque are no less strikingly opposite in character. In the former, the sensual, fanciful, and ludicrous prevail; while, with the latter, we have more of religious mysticism or stern and gloomy significance. To one there is a moral; in the other, entertainment. Nowhere in Christian art is there a more striking example of the solemn spirit of its grotesque than in the

subterranean chapel of the Certosa convent near Florence, in a fresco of the Temptation and Fall, by an unknown artist.[14] Eve is handing the apple to Adam. As she lifts her hand, swiftly flying towards the two from the high heavens, inclining rather toward the woman than the man, is a death's-head, with the lower portion of the jaw gone, and wings attached, like those given to seraphs and cherubs, only hideously stunted, the whole frightfully suggestive of impending, quick-coming, omnivorous evil. If the Christian imagination has ever suggested more of the consequences of Eve's sin in a single image, so appropriate in every respect to the moral to be conveyed, and yet so natural in its idealism of horror and warning, we have still to find it.

Examples might be indefinitely multiplied, from the great masters of both eras, to illustrate still further the relative consideration, in the Classical and Christian branches of art, which the artists of each attached to the beautiful in itself, as well as the essential differences of their motives; but those who are familiar with their works can readily continue the comparison, if desirable. They will find that even the greatest Christian artists have been successful only in the degree that they have freed themselves from the restrictions imposed upon art by its subjection, in choice and treatment, to the dogmatic ideas of the age. In that grand monument of Michel Angelo's genius, Il Penseroso, in the Medici Chapel at Florence, and its kindred groups, we find his native greatness unshackled, except by the natural limitations of material. Faultless, as viewed by the standard of a Phidias, these masterpieces are not; but the grand creative sentiment of heroic Greek art, without its complete harmony and refinement, is legibly stamped upon them. They give the spectator new conceptions of the power of art, and the imagination is stimulated to penetrate the fulness of meaning of a genius that suggests a breadth and depth kindred to Infinity.

VIII

IT must be conceded that to the Greek artist is to be awarded the palm of superiority in the more perfect identification of idea and object, in accordance with the strict demands of high art, based upon his supersensuous idealism. Christian art failed, as we have shown, in one phase by its contempt for and abasement of the natural body, under the mistaken notion that future happiness was to be proportioned to present misery and sacrifice. The world, instead of being a place of enjoyment and happiness, had become one of denial and martyrdom. Eternal justice was made intelligible to the common mind chiefly by appealing to physical sensations. As illustrations from ordinary nature to depict the joy of heaven or the torment of hell failed to be sufficiently emphatic to arouse seared consciences, the imaginations of poets, artists, and preachers were stimulated to the utmost to vividly portray supernatural degrees of each. Hence the future state of the Christian became the strongest incentive to the new and strange in art, embodying not only a greater scope for the horrible, but also its reverse.

As FEAR had given rise to a demoniacal imagery, so at last did LOVE, by means of art, hint at a spiritual happiness, such as no

religion had ever proffered to man. No sooner did the love side of
the new faith begin to have weight, than there arose artists to make
it familiar by song, sculpture, and painting. If Dante sang of a
material hell, he equally opened new and more spiritual heavens
to those that hungered and thirsted after righteousness. Contempo-
rary with and rapidly suceeding him were artists whose imagina-
tions were purified and invigorated by this ever-renewing and ex-
haustless element of Christianity. Their topics were the triumphs
of a pure faith, love, hope, and charity, — the exchange of earthly
treasures for the golden crowns and dulcet harps of paradise,
whether by martyrdom, noble use of life, or lingering suffering,
it mattered not, so that the good gifts of immortality were won.
In season and out of season, through perils of body and tempta-
tions to soul, a select and godly few kept alive the spirit of true
Christianity. Their lives became the new inspirations of art. Spirit-
ual in their aspirations and elevated in their understandings, their
influence lifted it into a new field, more pure, lofty, and compre-
hensive than had ever dawned upon Grecian intellect. Instead
of symbolized powers of nature, or an idealized, sensuous human-
ity, seeking to raise itself to a level with Olympus by the force of
the human will, creating a beautiful and intellectual art, there
grew up a class of men, who, in the singleness of faith in a perfect
godhead, sought by prayer and purity to draw down from it
into their works rays of its eternal and limitless joys. By them art
was purified of its sensual dross, and suddenly arose clad in gar-
ments of promise and righteousness. The stone of the sepulchre
was forever rolled away; and men for the first time were made
to feel by the medium of art that there was in store for them im-
mortal hope, and a peace that passeth understanding.

In this bringing down of heaven to earth, the artistic success
was indeed more commensurate to feeling than knowledge. But
no ingenuous heart can view the works of Cavallini, Giotto, Laur-
ati,[1] Simone Martini, Orgagna, Sano di Pietro, Fra Angelico, Fran-
cia, Bellini,* and other mediæval artists, by whom the purest
religious aspects of the human heart have been most touchingly

* For an account of their lives and works, see *Art-Studies*.

and fittingly rendered, without an inward confession of the superiority of their spiritual vision, in its revelation of the moral possibilities and divine hopes of man, to the mythological glories and expositions of Olympian life as revealed in the intellectuality of the more subtile-minded Greek.

Grecian art being finite in scope and aim, it of necessity came to an end with the exhaustion of its mundane power. Not so with that of the artist-prophets of Christianity. Their range was in the Infinite; their prayers were to the Omnipotent. By them beauty was viewed in its more spiritual sense, as the means of expressing divine perfection and the perfect development of love, — not, as with the Classical artist, for the pleasure of the creature, but for the glory of the Creator; and thus it was elevated to the highest purposes, and made the handmaid of holiness.

Witness the purity and simplicity of their primitive conceptions of landscape, and ignoring of all facts of the natural world which by their ugliness or horror might suggest falsehood or sin. Landscape to them had a symbolical meaning and spiritual significance. They surrounded their holy personages with all that was most lovely and enjoyable in nature, and gave them an atmosphere as bright and serene as their own countenances, which reflected, as art never had before, inward peace and joy. By their devout, untutored feeling they rent the veil which bars the sight of the natural eye, and suggested the progress that art may make when it shall unite to the faith that gave birth to their spiritual revelations as profound a wisdom, founded upon a knowledge of the principles and laws that connect the seen with the unseen. Inasmuch, therefore, as the underlying idea of Christian art, in its scope, moral purity, and spiritual significance, is so immeasurably beyond that of Classical art, it also contains within itself the germ of a corresponding progress. As yet, however, its specific superiority lies chiefly in its promise, while that of the latter rests upon its performance.

But it is not in motive alone that Christian art excels the antique. Its spirit is as comprehensive as its inspiration is holy. Greek art neglected the prolific field of landscape. Natural scenery appears

8 5

never to have been studied by the ancients as a specific object of art, but was used simply as an accessory to the personified creations of their pantheistic and polytheistic thought; just as in the earliest Christian art it is employed only as a simple background, or for scenic effect to sacred figures, without any attempt at representing it entirely and lovingly for its own sake. But the piety which disposed the latter to seek to express the tenderest and purest emotions of the human heart, illuminated by Christian love, in time brought the Christian artist into a more direct contemplation of the natural world, as an object worthy, in itself, of his undivided skill.

Those who more immediately recognized the landscape and its objects as direct motives of art were at first termed naturalists, although the term was no more applicable to them than to the artists of the human figure who sought their models in natural forms. But the artistic love which animates modern landscape is based upon the feeling that it is not, as the ancients in general fancied, the materialistic expression or disguise of many gods, but the creation of the one God, — his sensuous image and revelation, through the investigation of which by science or its representation by art men's hearts are lifted towards him. From this feeling springs that sincere, affectionate, and devotional spirit, so faithful to the minutest fact of bird or blossom, and that grand, solemn, and pure representation of earth, sky, and water, in their elemental distinctions, which characterize more particularly Carlo Crivelli, Benozzo Gozzoli, Gentile da Fabriano, Lorenzo di Credi, Perugino, the early Raphael, and Titian, and not only them, but a host of others worthy to be kept in remembrance. They were the originators of that branch of art now so highly prized, and which, in the natural course of learning, one would expect to see precede all others, instead of being the latest to be developed, as it was both in Greece and Italy. The walls of rooms in Rome were decorated with historical paintings and religious subjects long before landscape was employed for that purpose. Indeed, it was not used by the ancients until art was in its decadence.

In art, as in feeling, we must become little children, if we would

enter the kingdom of heaven. As we go back to the simple, tender, and true in nature, seeing God in his lesser as well as greater works, so we keep in closer communion with truth. By recognizing this principle, following out all the gradations of nature, rising gradually from the inferior to superior developments, the eyes of the artist are opened by the great law of analogy, so that his inner vision may, if he will, penetrate even the secrets of spiritual life. As he advances he will perceive a divine order and correspondence progressively flowing from divine wisdom, and thus, through forms, be led to purer conceptions of Him whom all forms suggest, but are powerless to embody.

The feeling which seduces man into fruitless endeavors to personify the Incommunicable, whether in art or creed, is nearly allied to weakness of understanding as well as corruption of heart. It originates in the desire of the underdeveloped mind to reduce Divinity to its own standard of intelligence. Hence God must be manifested to it in some tangible image, or cramped into feeble phraseology, instead of being left, by the action of his spirit in his works, to make himself felt by the inward man.

God draws the willing heart upward towards himself. Stubborn man as constantly seeks to drag Him down to his own level, by creating gods after his own likeness, — beings sensuous, fallacious, variable, partial, weak, and passionate, like unto himself, though still his superior in good and evil. Of such a character, in greater or less degree, were all the common conceptions of heathen divinities, previous to Christ's revelation of a universal Father. Even the unimaged Jehovah of Israel partook, in the minds of the Jews, notwithstanding the sublime and spiritualized language of their prophets, of their own mental rudeness and bigotry. Deities swathed and cradled in the human heart are possible subjects of art. Consequently, it has repeatedly lent itself to idolatry, by providing Baals and Astartes, golden calves and sacred bulls, in fine, any and every object of worship which was acceptable to the popular understanding, or helpful to corrupt priestcraft. The Israelites, despite the laws of Sinai, bowed down, again and again, before graven images. Like Moses, the Roman lawgiver Numa

forbade the manufacturing of representations of deities, either in the form of men or beasts, and with as little success. So did Persian iconoclasts, in their lofty conceptions of deity. A tendency to polytheism, the result of ignorance and gross materialism obtains, to a lamentable extent, among the masses of Greek and Roman Catholics of the present day. They require a visible representation of their gods. The doctrine of the Trinity, as commonly understood, supplies art with its means of conforming itself to this unenlightened desire of the human heart. It is true that the Mahometan, by his fanatical devotion to a simple notion, avoids this phase of religious error; but his life is sensual and his heaven sensuous, because his imagination is dogmatically closed to spiritual insight.

The lower the understanding, the more it clamors for an external worship, and delights in a materialized existence. Greek philosophy was indeed able to recognize the "Great Good" as the source of all life, but it was powerless to lift the people to the level of its own purer conceptions. Christianity, from the greater simplicity of its revelations and the unity it maintains between feeling and intellect, as it gradually comes to be understood, tends in a corresponding degree to eradicate idolatry from the earth. But until the common mind is developed up to a plane of being sufficiently elevated to find repose in perfected spirituality of thought, art, notwithstanding its proneness to foster idolatry, will continue to be largely employed as the initiatory teacher of religion.

To adequately represent the Christian idea of "Our Father," art thus far has showed itself to be comparatively powerless. Painting attempts it, but never as an object of worship. Wisely does it respect this sentiment; for every endeavor has but vulgarized the conception, and caused its work to be repudiated, both as art and religion. Nowhere are pictures of the Almighty popular, even among Romanists. By the Protestants they are instinctively rejected as something worse than daring folly. Not even Michel Angelo or Raphael could exalt the idea above the image of an all-powerful *old* man, majestic, it is true, but not redeemed from the marks of *time*. The Grecian Jupiter is a superior thought,

aesthetically considered, inasmuch as he is represented as the climax of man; humanity made perfect, and therefore incapable of change; wise, serene, passionless, and yet containing all passion. Jehovah in art is too much an avenging deity, too little the "Father" in Christ's sense. But if modern art has been unequal to this conception, it has not been so with regard to Jesus, the "Son." His humanity is intelligible, and therefore representable, and was soon shaped into a suffering god. But even his sympathetic nature has been found insufficient to meet the cravings of the natural man for a divinity still nearer allied to himself. Accordingly the Roman Church has deified the woman Mary, embodying in this modern goddess the beauty, maternity, and chastity of the pagan Venus, Horus, and Diana, coupled with the purer standard of female character developed by Christianity.

The Immaculate Virgin is now the most popular object of worship of Romanism, whose tendency is to still farther retrograde from a spiritual faith by the multiplication of other intermediates between God and man, in the shape of saints, relics, and the numerous objects consecrated by the Roman hierarchy to the devotion of its unenlightened disciples. In this renewed theological movement, with its consequent atheism on the one hand and increasing polytheistic feeling on the other, may be detected the dawning decrepitude of papacy, as an effete system, unsuited to the riper requirements of the human race. It presages a mental revolution, out of which religion and art shall emerge with renewed vigor for a fresh cycle of progress. Mind demands an inward, living faith. Externals in religion are everywhere losing their original significance and authority. The necessity of image-worship denotes barrenness of heart. Nowhere are madonnas and crucifixes more abundant than in the haunts of licentiousness and amid the homes of banditti. In proportion as the inner life is sinful and ignorant does it put faith in idols and talismans. After the same manner, the general immorality or insecurity of a country may be estimated by the abundance of its police, prisons, glass-incrusted walls, iron bars, and thief-traps; also by the extreme caution with which private property is guarded from the public eye. When the

human mind rises above the level of image-worship, art improves by being restricted to its legitimate sphere. Animated by loftier views of God, it perceives more clearly its duties and capacities, and aspires, not to represent the Unrepresentable, but to suggest his attributes.

IX

Architecture, the Culmination of Art, is to Man what Nature is to God. — Nature not Perfect, but Progressive. — Definition of Perfection.

THE culmination of plastic art is architecture. Comprehending all other art, it is at once its beginning and end, its primary purpose and its full knowledge. Singly, painting and sculpture address themselves to man socially. They are individual thoughts, speaking to individual souls, and men find in them companionship as they accord with their particular affinities. We look at them specifically as revelations of one human being to another, in friendly speech. True, we may misapprehend, by not putting ourselves at the same point of vision as the speaker, and therefore do him injustice and ourself a wrong, because it is only by receiving truth in the sense that it is uttered that we can appreciate the intended instruction. To some a lamb has only the savor of mint-sauce; with others it is incarnated innocence; while a few, like Swedenborg, see in its snowy fleece and dainty limbs a correspondence with some divine dogma or celestial joy. So a pigeon to one person symbolizes a god, and to another suggests a pie. Bread and wine are Christ's flesh and blood, to be approached only with awe and reverential worship, when held aloft by a priest; but if shown by an inn-keeper to the same individual, they simply excite carnal appetites. The essential difference of things lies, therefore, within ourselves. Every distinction is true in itself, but all distinctions cannot be true at the same moment to ourselves. We

accept each according to the predominating affinity of thought, passion, or sentiment. Art approaches us in a like way, presenting a scale ranging from the tangible and organic to the deep mysteries of the Godhead. As the animal, intellectual, or spiritual nature predominates in our faculties, so do we receive in kind; and the same object may be stone to one, meat to another, science to a third person, and spiritual sustenance to a fourth.

Architecture is comprehensive in the same sense as nature. Indeed, it is to man the material expression of his mind, as nature is that of the mind of God. It speaks to us, unless we study it by detached parts, as one great whole, as we view a landscape. Mere building is the anatomy or geological structure, founded on strict science; while sculpture and painting unite to cover it, as vegetation clothes the earth, with forms and colors, that suggest alike the sensuous harmonies of material things, and the loftiest aspirations of the human soul. We view architecture, therefore, in its noblest efforts, as the universal art, not only because it includes all others, but, like the structure of the earth itself, while exhibiting infinite variety, it refers all production to a common cause. By architecture the Almighty has provided for man scope for his noblest development of beauty in matter. As he uses the means given, so does he make his strength and freedom felt to the entire race. Hence it is that his greatest works have the effect of the corresponding efforts of nature. Like vast expanses of glorious landscape, mountain grandeur, and the solemn ocean, they thrill, lift, or subdue our spirits to their own moods. In the presence of noble architecture we are conscious of a greater degree of spiritual life, for men recognize in architectural greatness the spirit of something akin to their own souls. In the degree that our intelligence is cultivated, are we awed or elated at its suggestiveness of power, beauty, and wisdom.

Nature bears towards God another similitude with architecture to man. Both are the material evolvement of a common principle of construction. Man's handicraft grows out of God's creation, through analogy, and for like purposes; namely, first, to manifest himself spiritually; and, secondly, for uses in connection with

physical being. God wills, and nature appears. It is his speech for man to interpret, and thereby learn. Without it, man could have no existence, for it is the germ of his being. God changes not; but his work, or material nature, does change its aspect towards man, by man's influence upon it, and by the interaction of its own laws, in accordance with its revolving necessities. Nature, as we see it, is, therefore, no more the final perfection of God's work than is our architecture the climax of man's ultimate capacities. Both are in a condition of development, the former adapting itself gradually to the increasing and more elevated wants of man, through internal revolution and the stimulus of his science, and the latter varying with the several unfoldings of his hopes and knowledge. Nature does its duty inexorably, because directly under the guidance of a divine will. Man's will being self-poised, his course fluctuates, though its general direction is onward. Yet, as all nature is a struggle, under a given organic impetus, to evolve out of the lower a higher plane of being, it follows that, alike with man's external organization, all the inferior conditions of matter are subjected to hostile influences, which mar their beauty, infringe their liberty, and prey upon their existence. Lion's cubs die from teething, the same as infants. The perfect specimen of any kind of life has yet to be consummated. By perfect, we mean free from liability of change or death, as being the ultimate, in beauty and functions, of its class.

Everything that correctly responds to the motive of its being may be said to be perfect in the sense of fulfilling its law. Nature is prolific of wondrous beauty, order, and health, and contains within herself all that we need, or are qualified to receive and rightly use with our present limited faculties. In calling nature imperfect, we mean, simply, that such is her condition by the divine law of progress in reference to higher purposes, for which her present are but initiatory. It is heresy to talk of nature as perfect in respect to its author. What, God's work finished! God exhausted! He is the *Creator*. Creation as much goes on to-day as it did eternities ago, and will go on for eternities to come. Arrest creation, and *God is not*.

The common cant which would exalt material nature so above man in finish and uses, has no other foundation than a mawkish sentiment or false ideas of the natural world. Man himself is nature, promoted to free-will. His two loves, Utility and Beauty, are, in reality, correlative terms, and each comparative. That is to say, nature, through every gradation, unites the highest degree of the one with the highest degree of the other compatible with the object in view. Nay, more! Her forms are so significant of an interior, vital essence, that precious stones, flowers, and all that she presents of loveliness or repugnance, have, by universal consent, a language in harmony with their qualities, which speaks to us most eloquently, through types, symbols, and far-reaching significance. It is the conscience of things speaking to our conscience; like spiritwise magnetically attracted to like, as deep calleth to deep. By nothing does man more thoroughly manifest the affinity between shape and spirit than by architecture.

X

Analogy between Nature and Architecture, as the respective Creations of God and Man. — Life-Motives of Nations to be read in their Architecture. — Relation of Art-Monuments to the Religious or Governing Thoughts in Central America, Mexico, Peru, China, Hindostan, Egypt, Assyria. — The Peculiar Inspiration of the Earliest Architecture. — Pelasgic. — Etruscan. — Grecian. — Roman. — Romanesque, Lombard, Byzantine. — Gothic. — Meaning and Aim. — Defects and Causes. — Influence of the Roman Church over it. — Renaissant and Palatial Styles.

THE analogy between nature and architecture, as the respective creations of God and man, embodying in sensuous forms and hues the characteristic thought of each as inspired by a definite purpose, should be attentively considered in order to arrive at a just solution of the degree of free-will permitted to the latter by the common Creator of nature and man. We perceive in all matter, however rude, evidence of fixed design. The materials with which God has strewn the world are all instinctive with a life proportioned to a twofold end. First, that which, having nature itself only in view, illustrates the divine science of creation, growth, and revolution, independent of man, as being wholly beyond his control, although in structural organization so greatly his inferior. With or without his will or observation, the plant grows, the beaver builds, the rock becomes soil; mountains prepare their reservoirs of mud-water to fertilize the earth, and fulfil their duty as atmospherical scavengers; volcanoes continue their fiery func-

95

tions of safety-valves to the globe; storm and calm, darkness and sunshine, in fixed order, succeed to each other; doves coo, wolves snarl, serpents gather their stores of poison as instinctively as the bees honey; deserts and jungles form and disappear; planets and stars move sublimely and regularly in their appointed orbits through infinite space, missing no second of their given time; in short, all that man sees is beyond his power to create, and is both the object and subject of an unconscious science, so lofty and far-reaching that during his long sojourn upon earth he has but detected the simplest of its laws.

The relation man has to this side of nature is limited to discovery. He can neither add to, subtract from, nor vary in the smallest degree, that which God directly cares for. Unequal in organic spirit to man, matter by itself is not susceptible of choice, and consequently must obey the impulsive force of its being.

Secondly, as subservient to the higher purposes unfolded in the creation of man, matter is made subject to the impressions of his mind. Its kingdom is given to him for the expansion of his creative faculties, and to receive the stamp of his ideas. In endowing man with superior mental attributes, God was virtually bound to leave him liberty of choice, and a medium of expression for his self-development. By the secondary law and plastic character of nature, man, the soul, is constituted the master. Being akin to matter, he is himself subjected to her general laws; yet she is compelled, by the superiority on his side of the divine agencies that regulate their common existence, to become the instrument by which he manifests his own progress. At his bidding, light and heat burst forth from the cold, opaque rock, melody issues from the dumb ore, rich color from the brown earth, and each dumb or living thing obeys his creative will.

To get at the prevailing life-motive of any epoch, we must read its architecture, as well as its literature. The former is the monumental expression of the latter. In either case, we have to do with its superior minds. A nation soon recognizes in the creative intellect of its most gifted sons the quality and extent of its own feelings and aspirations, and finds in individual genius the possible

standard and direction of the race. As the great mind sings, talks, paints, or builds, so the common mind follows in its wake, finally adopting as its own the truths that are first stamped with its master's effigy.

Several races have left no other literature than their architecture; showing that, in the usual course of development, the artistic expression of mind precedes the written or abstract. Men carve, paint, and build before they invent letters, and, as we perceive in Greece and mediæval Europe, attain a lofty standard in art previous to discovering, as by printing, how to easily and cheaply preserve and disseminate thought.

Amid the forests of Central America we find the architectural *débris* of Indian races that had made a considerable advance towards civilization, without other inspiration than their own inborn energies, for they were without the advantage of intercourse with other progressive peoples. Of their religion we know scarcely anything; but, judging from their uncouth sculpture, crude paintings, and barbarous ornamentation, intermingled with an architecture that survives only in rude forms or abortive attempts at beauty, strange and defying curiosity as to practical uses, without evidence of refined taste or cultivated intellect, we must conclude that, mentally and morally, they were but upon a par with their semi-barbarous monuments.

Mexico and Peru, whose civilizations were so lauded by the unlettered soldiers of Cortez and Pizarro, have left scarcely higher indications of themselves. Judging from the European standard of intellectual growth, the aborigines of these countries were, at the best, but superior races of savages, with no intellectual cohesion or advanced notions of religion. The consequence was that their institutions vanished like wax in a furnace, before the vigorous assault of a few civilized white adventurers. The native superiority of one race over another has never been more emphatically shown than in these conquests. Of the art of the subdued Americans nothing has survived, except a few grotesque specimens of a pictorial language of almost infantile simplicity of design and complexity of arrangement, a few roads, some stone buildings or walls,

without other pretensions than rude strength, and coarse, ugly carvings and sculptures, or pottery, the hideous character of which in the one nation, and the abortive attempts at the representation of natural objects in the other, aptly illustrate in both their respectively sanguinary or despotic faiths and governments, and the nature of the abstract ideas upon which they were based.

The material objects of our love or veneration have, by a law of affinity from which we cannot escape if we would, a definite correspondence to our ideals of beauty and truth. It requires, therefore, but a glance at the images and sculpture these peoples loved and adored, to perceive how erroneous were their conceptions of art and divinity. A few rays of light had indeed penetrated their minds, as may be gathered from their moral maxims, and as may be seen in their imperfectly developed feeling for beauty in some of their designs for architectural ornamentation and domestic purposes; but these were exceptional, and served only to make the prevailing darkness more gloomy. The world has lost nothing in religious knowledge by the disappearance of their faiths; nor has art anything to regret in the ruin of their architecture and the melting into coin of their sacred vessels. Had there been in either any value beyond the material, the age in which they were made known to Europeans, being quickened by art, would have recognized their claims and sacredly preserved them. We need no fact more demonstrative of the absence of artistic value in the immense quantities of wrought gold and silver sent to Europe from these countries after their conquest, than that all went directly to the crucible, while the contemporary art of Cellini and his scholars is still sacredly guarded as the heirloom of nations. The indigenous art and civilization of America, having taken a wrong direction, succumbed as soon as they came in contact with more powerful truths and greater creative energies.

China presents a more elevated artistic development, and consequently a riper civilization; but its standard is so inferior to the Christian, that nothing but its remoteness preserves it from the fate of the native American races. Its condition is as unvarying as its fantastic grotesque art, which so graphically represents its in-

tellectual and religious ideas, — an arbitrary compound of sensualism and empty maxims, based, like its pagoda architecture, broadly and firmly upon the earth, and, like it, ever narrowing and growing lighter and curling downward, as if reluctant to mount heavenward.

The indigenous Hindoo architecture is a grotesque and capricious interblending of massive strength, feminine delicacy, and demoniacal ugliness, — a rude jumble of truth and error, in every conceivable form of grandeur, inspiration, elaborate and symbolical ornamentation, that Oriental imaginations, steeped in mysticism and revolving within sacredly prescribed circles of thought, could create. It addresses itself to the sensuous religious idea, and is allied to the Egyptian in its metaphysical characteristics. The latter is, however, more grandly spiritual. Like its rigid, limb-bound statuary, it hints at great hidden truths, struggling towards more perfect utterance. The symbolism of Egyptian architecture is deep and grand, its tendency lofty and soul-elevating; but its speech, like its creative faith, is enigmatical, and its spirit, as its intellect, kept studiously veiled, as if more inclined to doubt than to believe, yet striving to impose itself as absolute truth upon the people. Like the older Hindoo, it is mysterious and sepulchral, delighting in caves and dark passages, gloomily torch or sun lighted, reflecting from bright colors and quaint, stiff, gigantesque sculptures, gleams of art-visions which must have puzzled and awed the common mind, without inspiring it with intellectual light or divine hope.

The oldest art-monuments are those of Egypt, dating back we know not how many centuries before Abraham. Egyptian art, like that of Oriental nations in general, is chiefly characterized by immutability. Its character remains essentially the same through its long life of more than thirty centuries. Details vary in different epochs, but never sufficiently to impart to it the progressive spirit of Greek art. Freedom and poetical imagination never lent it soul-light. It never aspired to be the exponent or personification of a heroic mythology, nor did it ever ally itself to sensuous beauty, but ever maintained its dry, dogmatical, practical, domestic aspect, dealing in metaphysical abstractions, grand stereotyped per-

sonifications, or the homely details of common life and ordinary portraiture. Both painting and sculpture were strictly subordinated to architecture. Neither enjoyed a distinct, independent existence, nor were they permitted to express active passions or emotions, but confined, in painting, to a system of crude, strong, positive coloring, not inharmonious in its prismatic contrasts, telling stories after the manner of a child's book of tales, and in sculpture to rigid symmetry and an unvarying repetition of stiff postures and a mystical aspect of features. Of statuesque groups there are but two known, each of them of a domestic character: one, a husband and wife, sitting affectionately together on the same seat; in the other, the father alone sits, while his family stand around him. In fine, Egyptian art is barren of individual freedom of thought or variety of expression. It had innate capacity for better things; but inasmuch as the Egyptian mind ignored freedom and beauty, and isolated itself, so far as it could, from all foreign and progressive influences, it became, like an embalmed corpse, of value only as a record of the dead past.

Assyrian architecture was in spirit the Renaissant or Palatial of Oriental antiquity, sensual, lordly, glorifying the ruler, and surrounding him with the pomp and luxury of state. Its chief characteristic was man-worship, with its concomitant principle of arbitrary power. It had more freedom and grace than that of Egypt, although confining painting and sculpture exclusively to architectural purposes. In its grotesque we notice purer design and more legitimate use than are apparent in its modern successor.

Those nations which, from a rigid principle of faith, refused to embody their conceptions of divinity in art, in general may be said to have had no distinguishing architecture, if we except the Saracens, whose active intellects for a while overcame the prevailing sensual stupor of their creed, and gave play to their imaginations in the creation of styles which, while they protested against image-worship, contained within themselves a luxuriance of beauty that had made them a delight and wonder even to the Christian world. But the fanatic protestants against graven images of all epochs, the Jews of old, the Turks of the Middle Ages, and the Puritans and

Quakers of our day, have invariably either contemned art out-right, or, when driven to it by the necessity of localizing worship, have restrained themselves to architectural plagiarisms, or the rudest and most unsightly of edifices. Painting and sculpture were forbidden the Jews, because they might lead to idolatry. The Turks invent nothing, but take to themselves the remains of Christian and Saracenic art; while most Protestant sects, in their ignorance or disregard of the æsthetic sentiment, have been content to worship in whitewashed "meeting-houses," from which all sensuous symbols of divine beauty are rigorously banished, lest they should debase the purely spiritual conception of God; or else they plagiarize incongruous bits of architecture from their Roman Catholic or Pagan ancestors, uniting them into buildings which exhibit a medley of shop, bank, *café*, storehouse, and lecture-room, or whatever proclaims the predominance of trade, with only now and then a gleam of spiritual significance in some isolated form or feature, sufficient to show that the germ of worship is not wholly dead in the builders.

Undoubtedly, independent of religious faith, there is an innate artistic inequilibrium of race, which greatly modifies both the quality and quantity of art-development among different peoples. The old Arab or Shemitic tribes, the Jews, Syrians, and Phœnicians, added nothing to the world's art, nor have they left original monuments of any kind. Such art as they needed they borrowed from surrounding nations. Their artistic feeling vented itself in sensuous, spiritualized poetry, in abstract ideas and lofty conceptions of divinity, based upon monotheism. Notwithstanding their frequent relapses into idolatry, — during which they worshipped idols, through the principle of fear, of the ugliest description and the most demoniacal character, — a belief in one Supreme Being, not to be represented by human agency, was their ruling thought, and the one that has survived all apostasies, gradually extending its domain over neighboring races. Governed chiefly by feeling, of narrow intellects, and possessing firm and positive religious intuitions, which in general connected art with idolatry, fanatical from isolation and faith, it is no matter of surprise that the Arab tribes,

having no aptitude of race for plastic art, should have remained stationary in their civilization and indifferent to the example of European peoples. Through individuals of this spiritually impressible race mankind has, however, received its divinest truths; so that from them, as selected instruments of the Great Will, constantly proceeds an ever-increasing influence for moral good over the destinies of all men; and thus they have been made to bear the most important part thus far unfolded in the history of humanity.

Architecture first manifests itself in pure strength or force. Its earliest forms are rude and ponderous, as if the builders sought to eternize themselves in matter. Of this character are the Pyramids and the oldest temples of Egypt and India, the equally ambitious but less intelligible sacred structures of the aboriginal races of the warm regions of the Americas, and the Cyclopean and Pelasgic remains of Europe. So successful have been the authors of these works, that, although they precede all other architectural types of civilization, the lapse of ages leaves upon them a freshness and structural perfection which the later and lighter efforts of subsequent peoples have failed to retain. The principle of durability has been fully secured, and these monuments exist as literally the sepulchres of their erectors; for the little we know of them is due to the disinterment and explorations to which they have been subjected.

It seems to have been a common propensity among all early races to undertake enormously laborious and massive works, more from a barbarous ambition or senseless pride than from any necessity of protection which even the iron age of brute force and incipient civilization might have required. Such structures as the citadels of Alatri and Arpino, in Central Italy, indicate, by their solidity and size, something beyond mere defence. The sentiment of defiance is legible all over them. Doubtless they were erected in that daring spirit which led the first men, in their material conceptions of life and instinctive aspirations, to try for something more durable and better than the promise of their earth-habitation, and, as is expressed in the myths of the building of the Tower of Babel and the war of the Titans, to seek to scale heaven, aiming

to grasp through physical force what their intellects were too undeveloped to comprehend.

The earliest temples everywhere partake more or less of the character of fortifications, and these were in turn invested with a religious aspect. This age is also the era of obelisks. Man, rejoicing greatly in his sensuous existence, delighted in worshipping the cause of his being. He found in the exercise of his new-born faculties a pleasant satisfaction proportioned to their freshness and vigor. That which gave him most happiness he blindly adored, mistaking the gift for the cause. Thus, he deified sensual objects, and, with semi-savage freedom, worshipped whatever his undisciplined will or dominant passions most inclined him to love, covet, or fear. Hence the architectural expression of this epoch of the world is bold, grand, and vague. We perceive huge masses, erected with but little regard for any apparent necessity or utility, barren of other beauty than their grandeur, but full of faith in matter, yet indicating an earnestness and sincerity of purpose in groping or feeling, as it were, after God, and, although mistaking his nature and blind to their own spiritual possibilities, still seeking to honor him and exalt themselves by lavish, fruitless toil, and vast uprearings of stone over stone.

It is evident, therefore, that the religious idea invariably assumes to itself a definite form in architecture, which depends for the degree and direction of its development upon the comparative influence of intellect or feeling, being perfect of its kind as they are found to harmonize, and mystic or barren in the degree that the mental and moral faculties are subjected to a selfish or ignorant will.

The purest example in the ancient world of its unrestrained self-development is to be found in Greece. Here it took in architecture, as in other art, strictly the form of intellectual beauty. The feeling which inspired it was critically subjected to the rules of science before it was allowed freedom of expression. Hence its unity and harmony, so peculiarly representative of the artistic ideality of the race that originated it. Grecian architecture not only elates the mind from the consciousness of its intellectual great-

ness, but gives it repose from the purity of its material, the perfect correspondence of its spirit and form, and the harmony between its principles and uses. The last having disappeared with their contemporary faith, moderns, in their love for its beauty, have perverted it to purposes for which it was not intended, and thus, by divorcing spirit from form, have in a like degree impaired its character. We do not go to Parisian bourses and nineteenth-century churches, to London shop-colonnades, nor to American banks, colleges, or custom-houses, to know its beauty and worth; but our lessons are learned, and admiration won, from broken columns and dismantled temples, still lingering on their natal soil, so lovely in outline and so correct in proportions that out of their scattered fragments more perfect wholes arise to our mind's eye than from all the incongruous imitations of the present age, upon which so much time and money have been wasted.

The early Doric, in its massiveness and strength, partakes of the Egyptian type; but the simple beauty of its proportions, as in the Temple of Neptune at Pæstum, its out-door liberty, yet perfect repose, show its entire emancipation from the sepulchral spirit of the former into a thing of life delighting in open space and sunshine, lovely in color as the sky about it, severely grand in character, but free, noble, and instinctive with loftier aspiration. The Greeks, indeed, elevated architecture from a tomb into a fitting abode for their gods. Their temples were, in fact, embryo palaces; but the spirit both of their mythology and their religious rites was averse to confinement within walls. The beauty of their architecture was on the outside; their games, ritual, and plays were for the open air; their deities lived in the waters, forests, or mountains; so that the interior of their buildings was, unlike the Gothic, less attractive than the exterior. Still, it must be acknowledged that too frequent repetition of the columnal style, confined to a single order in the same locality, must have had the effect of monotony. Much of its peculiar attraction depends upon its isolation; as will be noticed at Pæstum, by looking at the ruins either as a group, or, singly, at the Temple of Neptune, which stands out so grandly and firmly against the lovely sky of Campania, purplish with its atmos-

pherical painting of twenty-five hundred years, a megalonyx of
architecture, reminding the present generation that there were
"giants on the earth in those days.'

The gradations by which this style passed through the intermedi-
ate stages into the perfected Corinthian were easy and natural,
showing the progress in intellectual spirituality of the Greek taste,
and how it finally succeeded in uniting the essence of all that gave
value to the preceding types of architecture with higher ideas of
beauty.

Grecian architecture is, however, like the mythology of the land,
strictly human in feeling. It is an intellectual aspiration, based firmly
upon the earth, rising columnward towards heaven in beautiful
symmetry and proportions, and then suddenly checking itself by
entablature and cornice, as having attained its full flight. We best
look at it externally, upon a level with ourselves. Its interior is
cold, dark, and unsatisfying. The inmost soul is not reached; the
eye comprehends at once its entire scope. It tells us of sensuous
and scientific harmonies, stimulates thought, develops in its art
the most beautiful of natural objects, but keeps us moderns strictly
to earth, and admitted the ancients only into an earth-heaven.
Its Olympus was around and over it, scarcely soaring to a greater
height than its walls; while its gods were simply heroic men, or
nature's phenomena put into human shapes. It perished because its
spirit was too finite.

The early Romans cherished no real love for art. With them a
sculptor was but indifferently well regarded. Useful and practical
works, such as sewers, citadels, bridges, roads, and whatever tended
to increase and consolidate their power, were the primary objects
of interest to the Roman people. This resulted from the large Etrus-
can element of their population. Unlike the Greeks, temples and
their ornamentation were of secondary consideration to whatever
promoted the material power and wealth of the nation. Gradually,
however, art, owing to the increase of luxury, became fashionable.
Rome then borrowed from Greece its art, its philosophy, and its
religion, adding to each. Her lust was of universal power, but
there was no bigotry in her faith. Jew, Egyptian, Greek, and

Scythian could worship freely beneath the swoop of her eagle's wings, so long as they bowed to her civil sway. She added to Grecian architecture a miniature world, — that glorious symbol of strength and dominion, the arch. Everywhere Rome is seen in the arch, — in amphitheatre, aqueduct, temple, palace, basilica, and sewer, — arch over arch, the Greek column being but its footstool. Now, the inclination is to view architecture internally. We are impressed by physical force and firmness and greatness of will-power. The eye is lifted up through vast and graceful sweeps, until it ranges along whole firmaments of noble masonry; but the sight is limited to marble ceilings and adamantine vaults.* There is no escape for thought through their massive impenetrability. A sense of power and magnificence overshadows men and things with imperial might. Rome exhausted the vitality of the Greek principle. The sensuous intellectual was wedded to material grandeur, but without any new spiritual revealment. The practical significance of the Roman architecture proper was compass and dominion. Gradually it died out, beneath the combined influences of the active hostility of more vigorous animal natures and the purer aspirations of Christianity.

Out of this combination there immediately sprang up another style of architecture, swayed by the enthusiasm of a new-born faith, and uniting the classical fragments of the past to the rude productions of unskilled hands. Semi-savage but devout hearts brought the treasures of their imaginations and their fortunes to the service of their new Lord. Whatever was dear to them must be equally dear to him. Without science, moved by deep feeling, they wrought into forms the fancies of their minds, scarcely half-weaned from heathenism, or redeemed from barbarism, and in earnest faith devoted them to the uses and adornment of the new sanctuaries. This was the Lombard era, so prolific in rough actions and rude art; when nondescript wolves, lions, and ferocious ani-

* If architectural forms are, as some suppose, in the main derived from the vegetable kingdom, it is possible that the Romans borrowed their idea of the dome — especially the flat one, like that of the Pantheon — from the Italian pine. The tops of some pines are loftily rounded, like the dome even of St. Peter's.

mals of all kinds were carved to support the columns and porticos of temples of peace and love, and capital, door, roof, and wall were alike eloquent with strange fancies, legends, and symbols, — living evidences of the enlarged scope Christianity offered to art. Those children in mental acquirements, the unlettered architects and artists of that day, repudiating or having lost all knowledge of the rules of Greek art, gave themselves wholly up to the impulse of their age, and wrote out their thoughts in stone and color, according to their needs, without other rule than their feeling, giving freely their best to express their faith and win heaven. Fish, bird, or brute, leaflet, vine, or flower, demon or angel, saint or ruffian, the grotesque or grave, whatever pleased them, or had in their eyes a symbolic significance, was added to their architecture, inside or outside, wherever space could be found to record their inspiration. A wider contrast than between the beauty and severe rule of pure classical architecture, and the wild freedom, random adornment, and savage earnestness of the early Lombard, cannot be conceived.

Passing modestly and almost imperceptibly, at first, from the Pagan basilica, which required to be but slightly modified to meet the primary democratic exigencies of the new worship, Christian architecture in the more civilized regions of Europe and Asia grew into the Romanesque and Byzantine styles, retaining many traces in ornamentation of classic art, but noted chiefly for its mosaics and frescos, by the help of which, in place of heathen statuary, it sought to reveal to the common mind the facts and doctrines of the new religion. At this epoch, extending from the reign of Constantine to the eleventh and twelfth centuries, we find in the houses of worship, as in the religious heart of the time, a strange medley of truth and error; undeveloped knowledge and crude thoughts, childish materialism and infantile sincerity, fierce bigotry and noble devotion, the lust of asceticism and the glow of true piety, barbarian fancy and gleams of refinement, noble devotion and vile superstition, Pagan relic and Christ's cross, side by side; unity and consistency in nothing, but struggle, fear, and furious selfishness everywhere; yet a gradually increasing horizon

of life and hope, — progress amid chaos: such was the state of mind and architecture during this long period.

In nothing is it more aptly represented than in the religious character and artistic value of its mosaics and paintings. When these were rightly employed as decorative art, they were found highly efficacious in investing the interiors of churches with vital warmth and beauty; but as teachers of spiritual doctrines, except when viewed as simple sacred histories, by the grossness of their materialism, the rudeness of their designs, and their ambitious materialistic attempts at representing the Almighty and heavenly host, with equally graphic illustrations of his rival, Satan, and the horrors of his sulphurous kingdom, — in short, by aspiring to the impossible in art, — they signally failed. Indeed, it may reasonably be doubted whether it is possible for such gross art to exercise a wholesome influence over mind, however ignorant; since, from familiarity with images of terror or physical evil, it speedily learns to regard them as either the natural and inevitable, or as the false machinery of religious despotism, and, therefore, as not depending in any degree upon its own state of affections. Pure materialism is a hydra-headed monster, and delights in begetting sin. The utter neglect or ridicule, in a religious point of view, to which all illustrative art founded in base fear is finally consigned, justifies us in regarding it as worse than useless.

But out of Lombard freedom and its inadequate exposition of Christianity, silently and almost untraceably, so gradual was the change, grew purer rule and more scientific execution, though still inspired by an equal depth of feeling. The Gothic, in its various branches, began to appear, leavened in Italy and Spain with the Oriental and Saracenic types, and borrowing from Rome and Greece the arch and other forms of ancient art, which kept it from perfect freedom, and finally led to its passing out of the mixed or adulterated Gothic into the equally mixed and adulterated classical or composite style introduced by Brunelleschi and his compeers, on the revival of pagan learning and philosophy. In Northern Europe it developed into a more spiritual expression of the devotion of the times. The root of its spiritual symbolism lies in the freedom

of its lines upward. They are the *infinite perpendicular*, without horizontal restraint of entablature or confinement by those elemental features of Grecian architecture which cut short aspiration heavenward, and bound it firm and solid to the ground. Height as opposed to breadth, the column to the spire, architrave to the pointed arch, — such are some of their essential contrasts of constructive spirit. Repetition of a few forms and a limited scope of adornment, noble and beautiful, it is true, and full of æsthetic repose, characterized the one almost to a monotony, especially in the skyline, and long ranges of columns, and general sameness of outline of masses, until the Romans, in adapting it to their needs, diversified it, sometimes nobly more often with questionable taste, by domes, arches, and orders, piled one above another. Inexhaustible movement or life, freedom of ornamentation, ranging from rude license to refined fancy and elevated symbolism, were the birthright of the architecture born under the Northern sky, as imaginative, wild, and daring as the temper of its sons. Fettered by no narrow system of æsthetic science, seeking mainly to give expression to their newly aroused notions of beauty, they lifted up their graceful shafts and flying-buttresses until their forms were almost lost in the welcoming heaven above them, and broke up their vaults and roofs into stone-spray as lightsome and joyous as ocean-waves, or as varied and beautiful as the witchery of the frost-work of their winters. Everywhere the true Gothic is characterized by ethereal delicacy and the uplifting of the soul to God. Internally and externally, by pointed arch and sky-aspiring dome, — not St. Peter's of Rome, but that of Santa Maria del Fiore of Florence, — by spire and shaft, by flying-buttress and lofty window, whose lights gave out celestial colors, and suggestions of "good men made perfect;" by lavish painting and sculpture, as well in the particular as in the general, it led the eye and thought upward. As the tower proclaims watch and ward, so do the spire and shaft, which so emphatically belong to this style, suggest spiritual hope. And this is its grand religious distinction over all other architecture, just as its principles of building illustrate or are taken from the growth and variety of the natural world, and in

consequence admit of infinite adaptability of use and flexibility of beauty. In its religious form, and to a certain extent in its domestic, it is the embodiment of the spiritual and imaginative faculties. Mind exhausts itself in penetrating its lofty significance, as does the eye in deciphering its infinity of artistic adornment. There is nothing sensual or coldly intellectual in true Gothic. It images the mysteries of the whole soul in its heavenward gaze and earth-progress: now obscure, now clear; bright with rays of colored light, like angel's hints, then serious; hoping and doubting; certain and uncertain; heart and intellect harmoniously moved by its silent music, or awed by its inscrutable designs; the human self annihilated, and the spirit-self awakened to a growing consciousness of its future. If the Greek satisfied the intellect, the Gothic equally responds to the spiritual faculty. Up, up, still up the vision is ever drawn, finding no limit, but, like the martyred Stephen, seeing in the negation of body a heaven open to view; and so, self-annihilated, the individual is gradually absorbed into the sanctuary. The architecture that can effect this — and there are still many cathedrals scattered over Europe that can — is truly sublime.

Too much attention is paid by moderns to the mere form of the Gothic, to the neglect of its chief characteristic feature, that which gives it a value, for spiritual purposes, beyond any other system of architecture. We refer to its stained-glass windows, and general management of color, light, and shade. Its later and best styles of windows were those which were carried out in the cathedrals of France and England to their ripest expression; the one marked by richness and lightness, and the other by richness and solidity; each beautiful, though neither of them was fully perfected before senseless innovations led the Gothic astray from its original intentions. The fulness of the religious character perhaps depended even more upon the aërial harmonies of stained windows than upon beauteous tracery or profuse sculpture. Unfortunately, but few specimens of either art exist in their original excellence. Enough, however, remains to prove that the builders of the Gothic cathedrals gave their whole souls to their work, for the double purpose of honoring God and, by means of plastic art, of creating

an encyclopædia of instruction for man, speaking to his entire understanding, either by direct knowledge, moral significance, or spiritual beauty. Accordingly, we find, as in St. Mark's of Venice, of the Byzantine school, and the Rheims, Chartres, St. Denis, and many other mediæval cathedrals, and imitated in our day in the little church of Notre Dame de Bon Secours, outside of Rouen, Bible histories and sacred traditions written in letters of stone all over their walls; and not religion only but the biographies of royal families, noble ancestral deeds, flaming in purple and gold and stamped in adamant, not dumb in their storied sepulchres, but looking down from generation to generation, a perpetual legacy of glory, faith, and example to all men; amid them, standing forth for warning, encouragement, or intellectual stimulus, science, philosophy, and the virtues and vices of humanity, in burning and eloquent allegory or stern symbol; and, above all, the artist's imagination, soaring still higher, daringly brought down from heaven, to complete his thought, its hosts and hierarchy, that they might sit in everlasting judgment alike over crowned or beggared worshipper, uttering to the heart of each, law, hope, or mercy, according to its need. But we have not yet completed our review of the architect's work. To all this, over and above the solemn shadows of column and vault, so full of religious repose, the light spring of pointed arch, heaven-climbing shaft, and sky-tipped spire, the enduring lessons of carved stone and brilliant fresco, — to all these spiritual delights he added rays of heaven-tinted light, streaming through rainbow-hued windows alive with saintly and angelic forms, and filling the whole interior of the sanctuary with a soft effulgence that soothed the soul, and by its magnetic harmony lifted thought and feeling through all their earthly gradations up to their God.

Such were the full object and meaning of this architecture, internally and externally. It had its highest manifestation, as if anticipating its coming doom with a melody like the fabled notes of the dying swan, just preceding the invention of printing. Then book-thought, that abstract expression of the spiritual and intellectual faculties, so superseded the necessity of sensuous language,

that the palsy of neglect came over it before its possibilities were exhausted, or its spirit wholly comprehended. To us, therefore, it rarely appears other than with the fatal beauty of the consumptive patient, — lovely and inviting even in its decay, shadowing forth not alone the vigor and charm of its uncompleted earthly existence, but suggesting the spiritual glories that are destined, as we would fain believe, yet to be unfolded out of its now dormant power.

Unfortunately for true art and religion, this picture has its reverse. Cathedral architecture scarcely anywhere has been left free to speak the full lesson of its creators. Born of Christianity, if completed consistently with its motive, and kept in strict accordance with its art-principles, it is the purest and most eloquent sensuous exponent of the doctrine of immortality that has yet been developed. We do not assert that its builders were better men than those of our day; but they knew far better what they were about than do our architects. Their buildings were not the plagiarized designs of one man, but the fruition of the minds and hands of many, giving their talents with harmonious concert to works embodying the greatest ideas and deepest feelings that exist in man, concentrated on the most patriotic and sacred purposes. They lived, too, at a time when the feeling for form and color was, even in an æsthetic sense, as active as ever it was among the Greeks, though under the inspiration of a wholly different sentiment. This is how the artists and architects of the Middle Ages came to give free rein to their love of the beautiful, alike in ecclesiastical and domestic architecture, costume, armor, and furniture. In fine, in everything they undertook, whether for the altar, field, or the hearth-stone, they wrought out their free and complete sense of beauty, from a passionate love of it for its own sake, and with but a secondary regard for convenience or utility.

This was the heroic and picturesque period of modern art. In its relation to sensuous effects, under the guidance of a vital and self-sacrificing, æsthetic principle, founded in Christian faith, instructive, impulsive, and joyous, it stands forth in bold relief as contrasted with the more prosaic and scientific aspect of this century, which, in its general indifference to beauty as a primary ele-

ment of life, and its devotion in preference to that which promotes not so much the enjoyment of man as his wealth and power, may be likened to the early Roman ages.

In our social amusements, when we try to revive in fancy ball or *fête* a momentary satisfaction in graceful and beautiful costume, we are at once obliged to go back to the Middle Ages for our fashions. But will any future generation ever repeat ours, except as examples of ugliness? So, the ornamental portions of our dwellings, domestic utensils, and whatever we have that is tolerable in religious architecture, are drawn either from classical antiquity or the prolific mediæval genius; showing that thus far we are imitators only, and not creators, of art.

However, it must not be lost sight of that we judge the Middle Ages not so much from the understanding and condition of the masses, as from the feeling and knowledge of their ablest minds. It was the feudal age, and aristocracy of rank or talent swayed the popular will, and stamped its effigy upon it. Hence it comes down to us with greater refinement and artistic beauty than if, as in our own, the superior cultivation of the few had been hidden or absorbed by the more material exigencies of the many, and the prosaic standard of knowledge and comfort so raised as to reduce the poetical heights and picturesque varieties of the former well-nigh to the monotonous level of the latter. But, notwithstanding our superiority in the mere power of civilization, we have much to learn and enjoy from the mediævalists, whose excess of life was of so opposite a character to ours.

Every age has its chronic weakness, or special strength. The revealers of new truths of all ages, whether poets, artists, philosophers, or saints, have a standard of feeling and a degree of spiritual insight far above those of the multitude. Being the pioneers of progress in science, art, and religion, their works, however differently shaped by time and circumstance, are nevertheless inspired by the common desire to elevate humanity in the measure and direction of their own enlarged faculties. Although we discover in all great works progressive revealments of truth, they are partial and comparative, because no mind in human form can wholly

escape the influences of our common imperfection. But there is also a downward tendency of mind, arising from the earthward gravitation of ignorance and selfishness. No class of men have more persecuted the prophets than the priests; because the one foretells change and progress, while the other clings with the intensity of selfishness to established power. The Church of Rome owes her existence to the spirit of liberty and reform she now repudiates. Having established her authority, her constant endeavor is to perpetuate it by the plea of heaven-derived infallibility. Individual freedom must succumb to her hierarchal rule. There is no truth except such as is sanctioned by the church, and nothing is true that questions her policy or power. She is a self-instituted shepherdess, and her flock are silly sheep by themselves incompetent to find their pastures.

This is the principle of all absolute power, whether in church or state. To a certain extent, direction and instruction are needed by all. The absolute in government is necessary to repress the tendency of evil and uninformed minds towards anarchy, and also to fuse and discipline diversified races and interests into orderly social life. This done, then it is due to human liberty to remove the pressure of absolutism, and permit the individual to develop himself according to his inclination, provided there is nothing in it that infringes the security and freedom of his neighbor.

Not only the Roman Church, but all other governments founded upon a selfish perversion of authority, ignore Christ's love of neighbor, from fear of inquiry and progress. In the outset this was not so much the case; for the church had her sheep to collect, and went into the wilderness to look after them, moving with and taking the lead of the general impulse that led all to hunger and thirst after better things. It is the unanimity of feeling or interest between the rulers and ruled, that, in the commencement of authority, makes it so powerful. Christianity united in one movement all who were desirous of reforms, and animated with a hopeful faith in eternal life. The artists, borne along on this spiritual tide, topped the mighty wave with the lofty sweep of their own inspirations, glorious and sparkling in the new sunlight, and filled with music

for the soul, until priestcraft, the self-constituted agent that arro-
gated to itself authority over them and the people, said, "Thus far
shalt thou go, but no farther; henceforth your art is to us, and not
to God." Then superstition and blind faith, like a blight, passed
over the people. They were to be kept children forever, instructed
only by nursery tales, and edified by toys. Religion was trans-
formed into a splendid show. Its practical teachings of love, char-
ity, hope, faith, freedom, God the Father, God the Word, and
God the Spirit, became mysteries too great for the common mind.
They were only to be symbolized in vestments, images, and cere-
monies, eloquent to attract and mystify, but dumb to the soul,
except as the banners of unqualified obedience. Heaven itself was
parodied by papacy, which assumed to itself the position of al-
mighty Judge. All spiritual truth grew to be grossly materialized.
Emblazoned altar, shrine, and relic; worship in a dead tongue;
the mass and confessional; penance, gifts, and multiplied sacra-
ments; pompous rites and gorgeous apparel; rank upon rank of
priests and parasites; churches vulgarized by tawdry dolls, gew-
gaws, and upholstery, crammed with the trophies of ignorance
and the bequests of superstitious fear, and filled with dead men's
bones become as gods; the altar degraded into a manufactory of
miracles and a golgotha of decayed mortality; the ministers of the
High and Mighty One clad in scarlet, lace, and gold; throughout,
the false, glittering, and coarse, obscuring true art and faith; men's
bodies held in pawn for their souls: such became the guise of the
religion the church proffered to the people, — a lie for truth; in-
stead of the bread they clamored for, a STONE.

This is indeed the extreme of its degradation. Amid all lives the
Christ-love, silently working the cure. But he who would now seek
out the pearls of Christian architecture must not only go to the
Roman Catholic church for them, but prepare his mind for con-
trasts as great as those we have described between its architectural
spirituality and its spontaneous adoption of tinsel and falsehood
wherewith to cheat mankind. This principle of its sway is aptly
illustrated in the Santo Spirito church, at Florence, where the
visitor will see, in a mediæval painting of the Nativity, the figure

of the Virgin covered with a brocade robe, and a tin crown upon her head. Near by is a copy of Michel Angelo's Pietà, wearing a sham necklace and crown. Candlesticks, mock jewelry, and millinery are preferred to painting and sculpture. Architecture is obscured by the low cunning of vanity or avarice, and gifts to the church are more sought for than the salvation of souls. Knowledge, even, is sepulchred, as may be seen in the miscalled Library of the Vatican, in which neither books nor manuscripts are for the public, but, in their stead, the gaudy decorations and marble floors of a *café* only are shown. St. Peter's itself is a mingled pain and pleasure. We admire its vastness, and sympathize with the spirit that would honor God with man's all of art and wealth. But its pretensions outdo its reality; and it is with indignant mortification that its sham and deceit, bastard architecture, absurd proportions of statuary, idol-worship, vain pomp, and lying relics are disclosed to us, after the first surprise at its immensity and richness has worn off. It is the embodiment of the pride, ambition, error, worldly policy, and religious arrogance of the papacy itself: not without its striking merits and large admixture of truth; but, like papacy itself, ever sacrificing the spirituality and independence of art to selfishness and superstition, under the pretext of caring for men's souls, while it lusts only for dominion over them.

It must not be forgotten, however, that Christian architecture never was more pure and spiritual than when the Roman Church was most absolute over civil power. This was owing to her being herself in a condition of progress. She was contending for universal supremacy, on the grounds of her moral and religious superiority. The age of the crusades, cathedrals, and monastic institutions was that of her primal vigor and greatest virtue. It was emphatically the triumph of her faith and feeling. But the people, seeing light, demanded more. This could not be given without imperilling her principle of absolute authority over conscience. Hence the subtle and enslaving mode of her resistance, which has gradually begotten the corruption alluded to.

Although victorious in the main over the people, she shortly found more formidable antagonists in kings, who were rapidly

rising in the political scale, as the representatives of secular, in opposition to ecclesiastical, governments. Neither could be successful without the support of those they governed. Coalitions for the common purpose of tyranny and spoil ended in rivalries and contests, in which kings generally grew stronger because they could bring more positive interests to bear upon the hopes and fears of their subjects. Their cause, too, embodied material progress, and, to a certain extent, a latitude of knowledge and enterprise which papacy repudiated. It was the germ of large civil growth, and the universal supremacy of statute law. But in its beginnings it was simply the selfish struggle of ambitious men for sovereignty. Rapidly the strictly papal feeling gave way before the newer current of the age. The pope sank the priest in the prince. Hildebrands and Gregories were succeeded by Sextuses, Borgias, and Medici; crafty, warlike, pompous, unbelieving, sensualized sovereigns, whose ambition was to play a deep game in base state-craft.

With this we have nothing further to do except to point out its effect upon architecture. While the ecclesiastical sentiment predominated, the Gothic was the prevalent mode. In the North of Europe, in its domestic type, it assumed the quaint, picturesque, and fanciful; in the South there was engrafted upon it a less odd luxuriance of form, but more of color. Everywhere it presented the same fascinating, varying aspect, a combination of devotion, rudeness, external beauty and grandeur, internal discomfort and feudal pride. Castle, palace, and cottage, each represented a perilous social condition, in which the passions and ideas of men were in the transition state between family lawlessness and civil order. Whatever is significant of wild struggle for happiness, or untamed aspiration towards the beautiful, and is sincere and earnest of spirit, however rude its expression, that has the power to charm. When to this we add the originality of their architecture in comparison with modern, its exuberance of symbol, sculpture, and painting, expressive of an age in which the mind of a people runs more into art than letters, the captivating chivalry of peoples, semi-savage in their loyalty to pomp and display, — when we consider these qualities of mediæval life, we need not be surprised that its

art so seizes upon our senses. Writers like Ruskin, with more subtlety of analysis and glow of word-painting than breadth of judgment, would persuade us to return to this style for domestic purposes; but, with all their zeal for its revival, we believe few would be willing to exchange the refinements and conveniences of a modern British home, with its capacity for beauty, if the taste be rightly cultivated, for the damp, ill-ventilated, dark, and tortuous interiors of the fourteenth-century domestic architecture, which as aptly represents the social condition of its originators as does ours the moral results of the several subsequent centuries of progressive Christianity.*

Priest having succumbed to prince, with the increasing knowledge and intercourse of the times wealth and civilization spread among the aristocracy of either class, and with them a new style of domestic architecture, combining greater comfort and luxury, but wholly divested of the religious feeling of its predecessor. Its early inspiration was pride of state, and its tendency was directly the reverse of the Gothic. With the revival of classical learning there came a reaction in the Christian sentiment of art. In the exaggerated spirit of a new love, artists for a while went blindly over to classicalism, as well for subjects as law. But as it was impossible to revive the feeling of antiquity, the result was that its forms alone became fashionable. They were used more as fragments than as wholes, and with but little regard to their original meaning or purpose, in the formation of what is generally known as the Renaissant style. However diversified is this architecture in various countries by its odd blending of antique ornament and rule with modern national characteristics, tastes, and necessities, everywhere proclaiming a bastard or transition art, yet it still maintains one universal tone of secular, in opposition to religious, feeling, and might with more propriety be termed the Palatial style. Its prevailing essence is far from being the intellection of Greek art, from which it sought its learning. Created as it was to meet the wants and refinements of the aristocratic classes, at a time when

* This opinion does not refer to the question of the feasibility of uniting to Gothic architecture the domestic requirements of the modern home, but only to the average condition of houses of the Middle Ages.

the deep, vigorous, and devotional Gothic sentiment had been suc-
ceeded by skepticism or inquiry, both in church and state, and the
latter, having overborne the former as the governing power, was
elate with pride and sensual desire, it necessarily embodied in full
the predominating character of the new phase of civil life. Unhap-
pily, it was ambitious, arrogant, haughty, corrupt, and deceitful.
Equally with churchcraft it sought to keep mankind in a perpetual
condition of caste for its own aggrandizement. Wherever we find
notable examples of its architecture we perceive this sentiment, as
much in oligarchal Venice as in despotic Spain or absolute France.
Under its influence God's houses of prayer became temples to
the pride and glory of man. Their long vistas of slender shafts and
colored windows were set aside for a pedantic style of ornamenta-
tion made up of pilfered classical pilasters and columns; for barren
walls, broken by graceless windows and stiff, proud doors; for
pagan devices and ornaments, divested of their natural significance
and appropriateness, or changed into nothingness of expression
by a debased taste or ignorant thought, and added, in empty mean-
ing, to Christian churches; for a cold magnificence of polished
marbles and precious stones; for curtains of bronze and draperies of
marble, monstrosities of art, valued solely on account of manual
difficulties overcome; for vast areas, surmounted by huge domes,
the emblems of man's earthly dominion, but suggesting no outlet
to heaven; for a palace counterfeiting the sanctuary, the lie to
God as plain upon his walls as lust and pride in the human heart;
for sepulchres of rulers and mausoleums to warriors; for St. Peter's
of Rome, St. Paul's of London, the Pantheon and Invalides of
Paris, and the Kazan of St. Petersburg; — for these and their like
were discarded the York and Salisbury Minsters, the Strasbourg,
Rheims, and Amiens Cathedrals, the St. Stephen's of Venice, Notre
Dame and St. Denis of France, the Duomos of Florence, Siena,
Pisa, and many others, which, thank God, still exist, though shorn
of their perfect glory, to rebuke the sensuality and arrogance of
mere state religion.

We do not wish to be understood as utterly condemning Palatial
architecture, except as applied to religion. For state or domestic

purposes, when chastened in the true spirit of art, it is peculiarly applicable. But the supremacy it so rapidly attained in the outset of its career was almost fatal to religious architecture, which it completely harlotized, and turned into a magazine of stolen goods. Its inherent spirit is hostile to devout thought, for it savors of luxury, magnificence, elegance, and those qualities which more directly spring from the pride of civil wealth, power, and rank. It has easier scope and adaptability to modern utilitarian and æsthetic ideas than the Gothic. It is a composite of pilferings of antiquity and modern barrenness of inventive idea, the chief merit of the architect being in *composing*, not in *creating*, a building. Forced into the service of domestic life, few architects have been successful in concealing or dignifying the common material necessities of the new uses it is put to. And yet the Palatial has its good as well as its evil side, according to our application of its capacities. As it promises to be modified and expanded by the present century, and as adopted by the people, subjected throughout to the ordeal of good taste and perfected knowledge, it proclaims a superiority in morals and domestic habits over those shown in mediæval home architecture and urban life. In this respect, we must admit its value as evidence of social progress. It betokens, also, intellectual growth. We now require that external conditions should be mated to loftier and purer internal perceptions. Refinement, cleanliness, the intercourse of the sexes, and domestic convenience, are differently understood in the nineteenth century from the fourteenth, or even the seventeenth. Consequently, the primary demands are now not, as formerly, for colors and forms to gratify the lust of the eye, but for raiment, habitations, and amusements suitable to a superior standard of living. The science of life is being more closely investigated and better understood; higher purposes are unfolding themselves. Meanwhile, though architecture loses in the wild picturesque, and life is divested of much that is seductive and beautiful, and art is robbed of its spirituality, we may be certain that the loss is only for a season. Life and art are preparing for higher flights, out of which will be evolved a union of those qualities of heart and mind most conducive to the progress and happiness of mankind.

XI

Classical and Christian Domestic Art compared. — Influence of Cli-
mate upon Art, — of Race. — Why Christianity prefers Painting to
Sculpture. — Respective Merits of the Two. — Classical Taste delights
in Human Figure, — Modern Taste, in Landscape. — The Reformation
and Northern Schools. — Protestantism and Romanism as Art-Motives.

IT will aid our estimate of the effect of Christianity upon art to
note one fact of the domestic life of antiquity, as compared with
the modern. Fortunately for this purpose, we have Pompeii and
Herculaneum to furnish an authentic illustration of the former.
In both towns Greek and Roman art were intimately blended, and
neither was overwhelmed until classical civilization was in its prime.
With the beauty, ingenuity, and religious significance of much of
their household art we are as familiar as with our own. Indeed, their
designs enter largely into modern work, solely on account of their
value as ornament. The faith from which they borrowed their
feeling having become a fable, the only interest it has to the Chris-
tian mind is that of philosophical inquiry as to its effects upon our
race.

We have before alluded to the different moral estimation, based
upon religious ideas, in which sexual intercourse and the mystery
of generation were held by the ancients and moderns. The license
which the sensual views of the former admitted in social habits and
fashions was such as Christianity, in no age, would tolerate; and
yet, almost the first and weightiest charge brought against the in-

fant Christian communities by pagan authorities was that of promiscuous debauchery.

That Paganism countenanced and even enforced licentiousness, the erotic rites of temple-worship at Babylon and Corinth, and the popular opinion held of the goddess Venus, sufficiently prove. It can, therefore, be no matter of surprise that the standard of chastity was far lower under the influence of heathen mythology than it is under the soul-cleansing precepts of Jesus. Purity of manner and speech, as now understood, proceeding from a spiritual cleanness of heart, was, in the general, unknown. Consequently, language, emblems, and pictorial and sculptured representations, which are now deservedly considered as obscene, and in their spirit corrupting, were then complacently or indifferently viewed by all classes, and even entered largely into domestic life. While a portion of these art-objects were, doubtless, free from intentional immorality, being simply upon the level of feeling of the age, and therefore provocative of no excess in it, there were numberless others too evidently the base and disgusting craft of impure imaginations, and hearts steeped in the lowest dregs of profligacy. No one who has not seen specimens of these vile creations, the more poisonous because attractive from their artistic beauty and spirit, can conceive the depth of degradation of the heathen mind in this respect. The simple fact, that, in disinterring pagan art, it becomes necessary to remove from public sight a certain proportion of its works, exemplifies the essential difference between it and Christianity, in the publicly recognized degrees of purity of mind and chastity of conduct.

However immoral in thought and action may be the moderns, there is nothing in their public or private household art, of any age, which would require, on the score of morality, a similar oblivion. Such of their art as is exceptional is chiefly based upon classical example and taste. In general, especially when its unenlightened feeling was most active, during the early and middle ages, we find, alike in church, house, and tomb, an art-motive suggestive of purity and self-discipline. Faith, hope, charity, redemption, and sacrifice, the ascetic extinguishment of carnal desires, the certain future

misery of the wicked and the eternal joy of the devout, martyrs' sufferings and triumphs, the holy "Virgin's" immaculate purity, God incarnated in man, a crucified Redeemer, the solemn scenes of the final atonement, and similar imagery, were depicted everywhere, on wall, furniture, or jewel. Opposed to the sensuous pleasures and sensual gratifications of the mythological sentiment, was, conspicuous, above all, the body-subduing and reverential awe of the newer faith, far in advance of the actual practice of its confessors, it is true, but always kept artistically in view as their possible standard.

A certain tendency to sensuous and sensual extremes, the exaltation of the physical over the spiritual, and of the grotesque and vulgar above the pure, natural, and refined, does, however, obtain in that branch of Christian art which, imitating antiquity, under the guidance of the corrupt taste and pride of power of its princely patrons, partook in feeling of the base and low. But the Christian idea has now become so firmly rooted in the public mind that these are looked upon as the warnings of a perverted knowledge and will, and exercise no influence except as examples of pernicious art.

Although religion everywhere has been the chief inspiration of art, climate has also had an influence too important to be overlooked. It has contributed greatly to the quantity of art-development among certain races, in comparison with the mechanical, or that more particularly belonging to the needs of the body. In those latitudes where nature, by her luxuriance and beauty, suggests primarily sensuous enjoyment as the object of life, where her bounties are prolific and her stimulus to pleasure active, art becomes a predominating expression of civilization. To feel, see, taste, and breathe the beautiful; to indulge largely in ornament; to polish, carve, mould, paint, and build, wholly for its sake; to spontaneously express the ruling sentiment, passion, and thought in song, music, sculpture, painting, and architecture, exalting in all things beauty of form and color above absolute convenience and utility, feeling above reason, — this is the prevailing tendency of those climates which possess the warm and genial skies of the South, without the extremes of heat and luxuriant vegetation of the tropics. Southern

Asia, Egypt, Italy, Greece, Spain, Central America, Polynesia, in short, all countries whose inhabitants live under favorable out-door conditions of climate, develop their civilization mainly in the art-direction.

Northward, the English and kindred races of America and Europe, stimulated by rigors of climate, turn their attention first towards absolute use. Nature tends to in-door life. Protection of body becomes a primary care. While in Southern Europe the love of beauty supersedes utility, producing in abundance artists skilled in ornamentation, it provides but a poor class of household mechanics. The populace are indifferent to ill-contrived windows, doors, latches, and locks, — accessible easily to thief or wind, — uneven floors, and furniture and domestic and agricultural utensils of awkward shape and coarse workmanship, though even in these latter there is large attempt at mere adornment, as we often see in the ox-carts and carriages of the Italian peasantry, which although heavy and clumsy in the extreme, are profusely covered with artistic designs in paint, while the trappings of their animals are brilliant with gilt and feathers. Frescos, statuary, carving, moulding, and painting rejoice the eye in all quarters, and seemingly compensate for the numerous defects in manufacture and building. Their chiefest enjoyment lies outside their thresholds.

Far otherwise is it at the North. Doors and windows must be nicely adjusted, or disease enters. Amusement centres at the fireside. Hence all that can render that comfortable, as a compensation for an unsmiling atmosphere outside, is of primary consequence. Art is mainly of exotic growth in such countries. To succeed at all it must first be nursed under its new-found skies. A taste for the beautiful, for its own sake, requires to be cultivated by the importation of its objects and the study of its principles. It does not spring up spontaneously, and equally with the indigenous mechanical talent, which looks to comfort, luxury, and facility in all that relates to matter, either as the servant or tyrant of mind. As out-door life leads to action and expression, so in-door life tends to repose and reflection. Freedom, which from analogy one would suppose to lean more to the former, on the contrary finds its home

chiefly with the latter, and with it those agents of science that most contribute to national growth, namely, steam, electricity, manufacture, coal, iron, education, inquiry, free trade, and liberty of speech, faith, and press; in short, scope for humanity to indefinitely expand through individual development. These agents of rationalistic and material progress have a tendency to move southward to meet the wants of the Southern races, just as their æsthetic development constantly gravitates northward, to counterbalance our too prosaic civilization.

In some countries, like France and portions of Germany, the sensuous absolutism of the one form of civilization in its present phase, church and state mutually conspiring to keep their subjects mentally stationary through seduction or force, meets the wave of popular thought and freedom from the North, and by it is tempered into some respect for the rights of the people to inquire into the origin and nature of the art, law, science, and religion, developed among or imposed upon them. Thus, it would seem, there are now two counterbalancing streams of mind, having their fountain-heads in widely apart latitudes, but from the attraction of mutual wants flowing towards each other, although diverse in their present political associations, — the one more directly the offspring of feeling, and the other of reason; both in equalized proportions and perfect freedom being necessary to a complete civilization.

While, therefore, the art-impulse is common to mankind, it is evident that climate stimulates the æsthetic development more in some nations than in others. To feel, is the primary tendency of the Southern temperament; of the Northern, to inquire; the one developing greater grace of manner, and the other superior knowledge; but both, through the common infirmity of human nature, having a leaning towards the sensual and material, and confounding the inspiration which stirs them, with the pleasures of mere sense. Of the old races, the Greeks best united sensuous and philosophical culture, resulting in the highest degree of mythological civilization, and which failed from no sufficient standard of ethics.

The world is indebted to Jesus for the highest revelation of future life and the purest standard of morality. From his example

and precepts has been evolved the present doctrine of divine spirituality seeking ever to incarnate itself in flesh. Christianity offers to humanity an untold progress, even on earth. All shortcomings of human nature are directly traceable to an insufficiency of its spirit in the heart of man. Empire and individual go down as they neglect its inspiration. Yet so vital is it with divinity, and so fitted to the necessities of our race as teacher and comforter, that, through every experiment and failure, men cling to it with renewed hope and energy, and with a clearer understanding of its requirements.

We have seen that its immediate effect was to purify art of its pagan-sensual element. Subsequently, it enlarged its scope so as not only to embrace all nature, as the image of the one God, and therefore worthy of the notice of man, but also gradually led it to condescend to every object, however humble, which was dear to his renewed heart. Rightly viewed, Christian taste exacts a much higher standard of excellence in the choice of subjects, because it requires everything it touches to be spiritually pure; and at the same time it is so meek and discerning that it calls nothing unclean that God has made. As yet we have seen simply suggestions, rather than proofs, of its art-capacity. Consequently, in treating of its art as it is and has been, we speak of it only as in an imperfect or partially developed condition, arising from the counteraction of earthly forces, and the inadequacy of present knowledge of material to control and adequately represent its idea.

Christianity introduced another change into art. It secured the predominance of painting over sculpture, particularly in those countries which, embracing Greek Catholicism, regard graven images as idolatrous. Having loftier emotions and grander thoughts to express than paganism, it required a more facile medium for its art than stone. Sculpture appeals for recognition more directly to spirit, because under no conditions, however clever, can it be mistaken for the thing itself. It resembles its subject only in form and feeling, and suggests life rather than represents it. From the qualities of its material, it is necessarily limited in motive and treatment by subtle and rigorous rules.

Painting, on the contrary, aspires to produce relief, perspective,

and space on a flat surface, and to depict soul under all conditions of passion, sentiment, or thought. It has a wider range of ideas or motives, and a larger scope of expression and execution. Hence its modern universality in art. If some critics are disposed to exalt sculpture above painting, as an art-vehicle, it is because the former has attained, through the inspiration of mythology, a degree of perfection which the latter has not yet arrived at. But the degrees and qualities of enjoyment arising from the two forms of art are so distinct that we may enjoy each after its kind without a hint of rivalry, as we do music and poetry.

The partiality of the ancients for sculpture was founded, no doubt, in part upon their peculiar views of the natural world. Failing to develop the modern theory, that all nature is the result of certain general laws under the guidance of one divine will, to their perceptions each of its phenomena or aspects suggested a special agency or ruling spirit, having more or less the appearance of man, or arbitrarily compounded of lower forms, familiar to their sight. As this system was the child of poetry, and not of science, while it recognized in a deeper degree than the modern the vital or spiritual essence of natural things, it was in practice vague, fanciful, and often conflicting. Although its personifications were not always in harmony with each other, still they were deities possessing a tangible existence to heathen imaginations. All nature was animated with them. They saw not, as we see, sky, earth, vegetation, and water, in their simple elementary distinctions; but, in their impatience to get at the living secret of these glorious objects, and to identify their uses and beauty more directly and familiarly with themselves, they either overlooked the great truth of truths, divine unity, or, obeying the dim intuitions of a few philosophers, erected ambiguous altars to the "Unknown God," thus filling their world with countless divinities of every kind. Consequently, their art, having to deal mainly with idealized forms, took more particularly the direction of sculpture. So strong was their bias for it, that they frequently sought to give to it the scope and power of painting. A number of antique bas-reliefs still exist, possessing much of the feeling of the sister-art. In bronze sculpture, there are fine

examples embodying so much of the peculiar force of painting that we feel its sensuousness and hardly miss the color. Of this character are the Mercury, Leaping and Dancing Fauns, and drunken Bacchus, of the Museo Borbonico.[1] In fact, classical painting, as we know it, seems to be a branch of sculpture. This appears by the predominance of figure-drawing, to which is given the vigor, grace, and purity of outline and expression of statuary. If we examine the numerous frescos rescued from Pompeii, Herculaneum, and Stabiæ, we find a genuine love for color and a manifest delight in its charms; but it is wholly subordinate to the display of human and deified form and action. Compared with modern art, the knowledge of the ancients of its capacities seems crude and impulsive. We have not, however, their best specimens of painting to judge from, and in consequence may undeservedly depreciate their skill.

Between ancient and modern times, the two phases of love and knowledge respectively of landscape and figure-drawing are reversed. Modern artists have much to learn of the human figure from classical sculpture and painting. In return, our time could teach a valuable lesson to the antique world of the meaning and value of natural scenery. The love of the comic, grotesque, and fanciful, is common to both. But the appreciation of the ancients is chiefly bestowed on ornamentation and the ridiculous. The Boy with the Mask in the Villa Albani at Rome is a notable instance in sculpture.[2] In general, the moderns display more wit and humor, though the antique Cupid entangled in the Folds of a Dolphin, in the Museo Borbonico at Naples, conveys a quiet sense of intellectual drollery inimitable in its way.[3]

The current of Christian art lay, very generally, in the direction of the popular religious feeling, until the Reformation, when it separated into two distinct streams, flowing from opposite fountainheads, and which may, with propriety, be termed Papal and Protestant, from the character of mind animating each, or Aristocratic and Democratic, as respects the comparative consideration given to individual freedom under the political auspices of one or the other. The art of the former corresponded to its architecture.

It was palatial, princely, hierarchical, academic, conventional; a thing of out-door grandeur and ambition; a contribution to galleries, churches, state pride, and ecclesiastical pomp. Like antique art, it has no genuine delight in rural scenes. It prefers the architecture of man to the architecture of God. The love of the country and common life is foreign to its taste. Its most finished landscape is represented by Domenichino, Claude, Salvator, and the Poussins, — beautiful in certain qualities, elevated in idea, refined or forcible in execution, but cold, pretentious, artificial, chiefly classical in motive, and in no sense of the people. Indeed, this type of art finds no charm in simple nature. Neither has it a domestic sentiment, but is exhibited to the people as something too exalted to be intrusted to their keeping, and jealously preserved, in motive, from other inspiration than that of established religion, classical learning, or princely rank. Emphatically, it subsisted upon the patronage of rulers, eking out a precarious existence, and in Italy, France, and Spain gradually declining with their decline from the intellectual superiority which first won them power, until it scarcely existed in name; and, like its [past] friends, it now survives in public esteem only through the influence of its olden prestige.

The Northern stream, drifting with the Reformation, which restored to the individual a portion of his natural liberty, went home to the people, and became an in-door art, something in topic and treatment to enliven their firesides, appealing to their common sentiments and feelings, and failings, too, for it was essentially human, and loved the earthly natural, and spoke out, in earnest sincerity, what the people believed and liked, good or bad, just as their hearts dictated. There was but little high art in this; but it was a right beginning, leaving the popular mind to choose its own loves, and, through its own experience, to advance gradually from lower thoughts and feelings to higher. Compared with Southern art-choice, the expression of the Northern is low. In the outset it represents humanity too exclusively in boorish, sensual, and little aspects. It loves beer and tobacco; boar-hunts and rough games; bar-rooms, pipes, brooms, and kettles; jewelry and

satins; civic rank and commercial pride; scenes of avarice, lust, and fierce brawling; a flat, monotonous, unspiritual landscape, redolent with the fat of kine and herbage; foul kitchens and dirty maids; parrots and puppies, the pets of pampered wealth; houses of picturesque ugliness; manners offensively blunt, and intellects as heavy and methodical as their cash-books and ledgers; — in short, whatever a thrifty, vulgar-minded race of fighters and traders, proud of their ingots, their tables, and their freedom, delighted in, their artists presented with a fidelity, spirit, and richness of tone that no future art may expect to excel; for no subsequent people, it is to be devoutly hoped, will have the same hearty esteem for these things as did the Dutch in their early manhood. No artist has ever depicted the avarice of the Jew like Rembrandt. So his fellow-artists have, with equal success, pictured the characters of their countrymen, by emptying upon their canvas the feelings that consumed them, rising, in their highest elevation, to convivial or stately domesticity, a love of the pastures, canals, and seas so closely associated with their riches, and but rarely, as if it were an unpopular theme, giving indications of a spiritual faith or life.*

English painting rises above this level, without aspiring to high art. Fine art, technically considered, is its principal aim. Its chief characteristics are a wholesome love of nature and home life, delighting in portraiture, landscape, animals, the sea, and whatever is connected with the material grandeur or prosperity of the nation, or the social importance or actions of the individual. Like their civilization, it first plants itself firmly upon the earth, associating with whatever is significant of wealth, power, family, and station, — at heart affectionate and moral, in appearance coldly decorous, thoroughly realistic, sometimes humorous, seldom religious, and not often attempting the spiritual or imaginative.

Protestantism ignores its saints, but deifies its military and civic heroes, and showers its honors upon the tamers of men and nature, the supporters of order, and stimulators of freedom and civilization. Its chief virtue is in human development on the side of morality and worldly prosperity. Hell is indeed a place of positive tor-

* See Appendix, Note B.

ment; but heaven is a vague, undefinable happiness, with no definite period of realization for the soul. Both doctrinally vibrate between the hour of death and an unfixed day of judgment. There is no settled condition between burial and the deferred resurrection of the dead. Church government is an affair of state patronage or popular suffrage, and is either extremely aristocratic or democratic. Strictly speaking, it has no absolute, independent existence, and recognizes neither traditions, martyrs, nor a celestial court. There are no personal intermediates between God and man. Face to face he would speak to Him, or not at all. Consequently, recognizing in its most literal sense the second commandment of Sinai, the Protestant confines his art to the earthly range of humanity, leaving in the main untouched its spiritual capacities, and depicting only those scenes and feelings that are on a level with the popular material apprehension. Protestantism reasons more than it feels. It is the logic of liberty and progress. As yet it is imperfectly understood, and narrowed by political, social, and commercial interests, it shows itself selfish, monopolizing, and ambitious; nevertheless, under the impulse of the growing democratic mind, it is a mighty, self-expanding power, destined to conquer the world, and ultimately open to mankind new heavens and a new earth, before whose radiance, error, superstition, and tyranny shall pass away in the smoke of their own torment.

This we conceive to be the ultimate destiny of Protestantism. But, viewing it simply in its relation with art-motive and execution, as compared with the matured results of its antagonistic element, the Papal, or Conservative, which represents the general principle of retention of power and religious stagnation, and is frequently as selfishly and fanatically displayed under Protestant as Catholic forms, the latter is vastly its superior. To art it offers the infinite range of religious imagination, inspired by its saints and martyrs, a glorious host that no man may number; legends golden with supernatural love, faith, and charity; traditions that bring angels down among men; relics more potent in miracles than nature in law; a heavenly and an earthly hierarchy; orders and ranks of celestial beings; spiritual presences ever about living men;

a purgatory in which to expiate the unrepented sin of life; a hell if possible more vast and suggestive than enters into the conception of the Protestant mind; a heaven more attractive in individual joys and associations of heart; a goddess-mother, of virgin purity and maternal consciousness, to love and intercede for men; a human god, tempted and suffering like one of us and for us; a Father of all, the omniscient ruler of the universe, yet not wholly beyond the ambition of the human faculty to seek to personify; an easy forgiveness of sins; deeds before faith; all penance, discipline, and donation to the church to be repaid a thousand-fold in the heaven of which it holds the keys: such is the boundless field the Papal element of Christianity offers to art.

Under such inspirations, and fifteen hundred years of watchful experience, of patronage of priest and king, and devotion of subject, what matter of surprise that Papal art should excel the humble beginnings of its new-born rival? But its triumphs are of the past. Its life-blood is oozing away from self-inflicted wounds. Decadence is everywhere written on it. Architecture will not again employ itself in erecting cathedrals in the likeness of the old, nor state-temples of worship patterned after St. Peter's. The unfinished remain as the mediaeval spirit left them. It is with difficulty that many of them are kept in repair, and even these more as archaeological monuments than places of worship. Restoration, indeed, revives old forms; and many ancient churches, in Italy and France particularly, by the antiquarian zeal of communities and governments, have been made in their main points to look in the nineteenth century pretty much as they did in the twelfth and thirteenth. They have become, however, in the main, mere sanctuaries of artists and sight-seers, empty shells of an exiled faith, which only great ceremonials can fill. The places of worship of modern fashion, if worship it can be called, are those churches whose style is represented by the meretricious Madeleines and Notre Dame de Lorettes of Paris, Annunciata of Florence, and the gaud and foolery of the "Company of Jesus" everywhere, and, in its best estate, by that haughty Renaissant cathedral belonging to the Benedictine convent at Monte Casino, near San Germano, in the kingdom of Naples,

whose lavish wealth, and profuse adornment of precious stones, sculptured marbles, frescos, and wood-carving, as it stands in its solitary eyry on that bleak mountain-peak, contrast so strongly with the desolation about it, — a church that sinks St. Peter's glory into dimness in comparison with its fulness and reality of ornament; for there is no cheating the eye here, but all is solid wealth and marvellous magnificence. Each and all of these edifices, replete with attractions for the senses, are powerless to touch the heart.

Nor is fashionable Protestantism more devout of spirit. It builds miniature cathedrals and pretty churches, borrowing the architectural forms of the obsolete feeling of its rival in sheer emptiness of its own artistic heart, parodying an art which can never be its own. Nowhere are there more comfortable lounges for sermon-hearing, religious essays, or melancholic psalmody, than among the diverse sects of England and America; but they are the sanctuaries of riches and fine raiment. Poverty erects its humble altars apart. The style and thought of the palace have everywhere corrupted the temple of God, meretricious ornament being the object among Catholics, and luxury with Protestants: both exalting the material above the spiritual in art and religion. In fact, we are now almost destitute of religious art, though not without symptoms of its renewed dawn. Yet the religious sentiment was never deeper in the heart of men than now; only they cease to have hope in their spiritual and civil guides, and are slowly learning to lean more on themselves. Their prayers are now oftener uttered in houses not made with hands. Religion is beginning to find its way from church and state to the people. It will soon pass out of the chrysalis form into the winged soul. Prince and priest have long tried its keeping. Both have done much to advance humanity. The history of the church is full of glorious triumphs. Its works speak to us through a thousand channels, which we fail to appreciate in the sacrifice and energy which created them, because, like sunlight, they have now become common property. So, too, of state governments. Civil order, security, increase of wealth, fusion of races, and extinguishment of sectarian passions and national hatreds,

are slowly but surely preparing the way for the universal government based directly upon the enlightened will of the entire people.

There is vitality in Protestantism, because it permits the gradual unfolding of the higher truths which Romanism resolutely opposes. It represents the new progress in art, science, and religion. Catholicism can no more revive its mediaeval ecclesiastical power by jesuitical principles than it can its early religious art through the efforts of the German Pre-Raphaelites. Both attempts are futile, because not in harmony with the needs of the age. The hope of art now lies in the free principles of Protestantism.

XII

What Protestantism offers to Art. — Its Scope of Idea, — Identification with the People, — Fashion, — Promise. — Dutch School. — English School. — Turner. — Blake. — Pre-Raphaelitism. — The German, Belgian, and French Schools, and their Chief Artists.

WHAT is the new liberty in relation to art? Simply of unlimited self-development. Catholicism, first in its ignorance, and afterward by selfish policy, aimed at its restriction to a defined, dogmatic, religious expression. But while itself under the impetus of growth and expansion, its art partook of the same partial freedom and noble energy, and to the extent of its liberty strove to be true and spiritual. Unfortunately for its final perfection in this direction, that art, whose varied progress and lofty genius were represented by Giotto, Niccola Pisano, Orgagna, Ghiberti, and Masaccio, culminating in a Raphael, Titian, and Buonarotti, with them passed under princely patronage, and shortly, in the hands of Vasari and contemporary artists, was degraded into an instrument of state pomp and aristocratic luxury.

Although Protestantism was the offspring of freedom of thought, in its infancy it was nursed in a theological despotism more severe than even that of Rome. Emerging from error, corruption, and ecclesiastical assumption, its career has been a checkered one: now verging upon wild infidelity, and, as in the first French Revolution, disowning its Christian parentage; then fanatical and destructive from religious bigotry, as with the Scottish Covenanters and German Anabaptists: by turns philosophical, skeptical, anarchical,

and conservative, uniting the ritual extremes of Puseyite and Quaker, and the theological antagonisms of Calvin, Voltaire, Fichte, Kant, and Channing, in its comprehensiveness of idea, yet always protesting against error, and essaying to prove all things.

The question of art is so intimately interwoven with that of civil and intellectual progress, that a synopsis of the one implies a succinct view of the other. Having portrayed its various aspects and principles, tracing them from the Classical, through the Catholic, up to the semi-developed Protestant phase, as shown in the materialistic art of England and Holland, we will now glance at the various schools of the present century.

In all ages there exist true men, laboring, in humble sincerity and with apostolic forethought, to sustain and illumine art. We find such artists even now in Italy, and perhaps in Spain, countries in which its decay is the more conspicuous from contrast with former excellence, and its revival the more difficult from the general stagnation of thought under the blighting influence of but half-strangled ecclesiastical despotisms. Truth and falsehood so intermingle that it is only at a certain distance we can distinctly distinguish the lines of each. With individuals, also, art equally varies as in epochs, its condition depending upon the varying conditions of mind. So, in speaking of art-distinctions of various nations, times, or persons, we mean simply to state the prevailing feature or motive, premising that in all particular degrees of excellence are to be found, and special indications of genius, proving that no age is without its lights.

The spiritual superiority of Catholic art has been traced to its claim, from the outset, to represent the supernal element of religion, and the loftiest teachings of faith. There were, it is true, in the mediaeval democracies of Italy, exceptions to its exclusive religious or aristocratic bias; and, in proportion as it sprang from and was nurtured by the people, it prospered and grew still more lovely. But the democratic sentiment of that age was mainly one of castes, and too often a promoter of anarchy by party violence, instead of an orderly principle of civic liberty. Consequently, its influence was unsteady. With the disciples of Savonarola it was

stringently ascetic, and tended to reaction from excess in the direction of pietism. Finally, in Italy, art was debased into a mere courtier and state lackey, on the one hand, and on the other, an instrument of church pageantry and artifice. Every drop of democratic blood was drained from it. Its vices were those of princes; its absurdities, those of priests.

As soon as Protestant art freed itself from the control of rulers sensual and papal at heart, like the English Stuarts, it identified itself by degrees with the people, assuming their level of thought, and their liking for the homely and common. Mark! — *liking*, not LOVE, in England, any more than in America; for in neither country does aesthetic feeling assume the dignity of a passion. In both, Fashion is still its protecting deity. A few minds only receive it as a conviction or sentiment; perhaps none as a portion of the true bread of life. Yet it is slowly making its way to the heart of the multitude, by bringing into the homes of the people that which is intelligible, dear, and pleasurable to them, without any need of church or state to interpret or dictate. Catholicism exalted the art-motive, but Protestantism gave it liberty.

The Dutch school, as we have shown, was the base of the democratic revolution of art growing out of Protestant freedom. England also caught up the new life, founding her art upon a similar taste for *genre* subjects, — every-day humanity, fat pastures, animal life, and rural scenery; the instincts of the masses, and their loyalty and homage to aristocracy; in fine, every feature, good or bad, which makes up the stolid, insular Englishman. Hogarth is their first great master of realism, tempered by allegory and caricature. His art is that of a censor or moralist; but he painted actual life from a point of view and for an elevated purpose that makes his pictures of value to all time.

England may be said to have developed in the present century two distinct styles of painting, each serving to counteract the extremes of the other. One of them is founded upon the broad, naturalistic, imaginative treatment of nature by Turner, wherein he shows how thoroughly and deeply he has penetrated into her spirit, felt her poetry, understood her forms, and comprehended

her aesthetic laws. Turner is the father of the modern landscape art in its broadest sense. The old men, Claude, Salvator Rosa, the Poussins, the Carracci and their school, all pale before him. Titian alone resembles him in the strong sweep of his brush and lofty use of the landscape as a whole, in subordination to the higher aims of his genius. Turner could be as greatly true in details as in principals. Capricious he was, audacious, arbitrary, and eccentric, but also intensely earnest, diligent, daring, and experimentive, original ever, studying great masters to rival or subdue them, the world of nature to master its distinctive features and qualities, and then flinging himself upon a skeptical, unsympathetic public, a strong, new, prolific, omnific artist, who sees and paints in his own way, founds a new school, and bequeaths to his country a priceless legacy of landscape, redeemed from the conventional, little, superficial, and unmeaning, and endowed with a living soul. Rare Turner! He has exalted forever the landscape into the range of high idealistic art.

The technical strength of Turner is mainly shown in his masterly rendering of the phenomena or emphatic features of nature, wonderful power of suggestiveness of forms and moods and the essential differences and relations of things by color. His canvases speak, have souls; pictures form within pictures; ideas thrill us; feelings quicken; and figures come and go like ghosts. Not only nature reflects humanity, but her own mysterious selfhood is seen and felt. Color flashes, blazes, melts, interblends, riots, and slumbers, at his magic touch, with alternated magnificence, repose, or gloom. He recalls to us the everlasting variety and splendor of the elements themselves. To heighten the eloquence of color he never hesitates to sacrifice the little and literal in design, but it is always done in the intent of great thought or subtle meaning. The power to perfect is manifested; the idea passes from him to us; a moment's pause in the side-speech, and we pass on to the great fact he interprets. Receptive of the beautiful, sublime, and mysterious in nature, perceptive of her miraculous variety to a degree no other artist has equalled, his imagination was as competent to high creative art as his knowledge to naturalistic truth. In audacity of

original thought, splendid and gorgeous painting, what equals Ulysses deriding Polyphemus [1]; for terrible imaginative power, his Dragon of the Hesperides [2]; for weird, supernal invention, the Angel standing in the Sun [3]; for tender sweetness and poetic aspect of landscape, Crossing the Brook [4]; for sublime pathos, Old Téméraire [5]; and for poetic feeling, the Burial of Wilkie? [6] Once beginning to point out the versatility of Turner's genius, we know not where to pause. He has established his fame in the English school as its great master, as Titian stands in that of Venice; each reversing the prominent art-motive of the other, but with much that is characteristic in an aesthetic view in common. Titian centered the delicacy and splendor of his brush on the human figure, Turner on the landscape: the accessory of the one artist being the principal of the other.

In assigning so high a rank to Turner we are not unmindful of what Reynolds, Gainsborough, Wilson, and their contemporaries have done to dignify the English school of painting. They are idealists in color, and imbued with true sentiment. None of these, however, were great original men, creating an era. They painted well, formed individual styles of much merit and beauty, elevated the tone of English art, but based their ideas and knowledge on existing schools or previous example.

A vigorous, unideal, thoroughly British class of painters succeeded them, insular in type and tone, inferior in color, realistic in expression, naturalistic in aim, low, common, external in motive, academic in training, intelligible and popular because of the delight of the nation at large in their topics and materialistic treatment. Men of talent, certainly, and of local fame; but not of genius and universal reputation. Frith's Derby Day, embodying the lower traits of English national life, and his Railway Station, the external commonplace of that confused spectacle, are graphic results of the style and taste of English realists.[7] In opposition to similar notions of art, and as a counteracting power to their externalism, we find "mad Blake," as his contemporaries called him, but who is now more justly viewed as one of the great lights and warnings of the school.[8] He essayed to lift it out of the commonplace and

material into the sublime, spiritual, and supernal, giving, as with a clairvoyant sense, hints of the life not of the earth; a solemn, original thinker, powerful and inventive in design, in idea transcendent, "mad" only because in soaring so high he went far above the range of his brethren. Blake's inspiration is Miltonic; like the poet, he creates, but also, like Ezekiel, sees visions. He paints or draws the Almighty with the same reverent freedom as Titian the human figure. Hierarchies, thrones, angels, and satans, the powers and dominions of light and darkness, were as familiar to his imagination as were the voluptuous beauties of the court of Charles II. to the sensual eyes of Sir Peter Lely. They are real, palpable, visible. He gazes into the unseen infinite with the mingled glances of artist and seer, not hesitating to paint portraits of the olden dead. Men of quality, who once strutted and vexed awhile the earth, reveal their ghastly lineaments to his interpenetrative look. He draws for us effigies of the Builder of the great Pyramid, Richard Coeur de Leon, and others, whose mortal integuments have long ago rejoined their mother-dust. But in this visionary art he suggests more than he realizes; so that, fully to understand it, or enter into its spirit, we must draw largely on the mysticism of our own imaginations.

Nevertheless, Blake stands forth in the prosaic English school, grand and lovely in his solitude; its John the Baptist, preaching in a wilderness, without the multitudes that flocked to the prophet to hear the truth, but none the less an inspiration to those who believe in the highest destinies of art. We quote Frith and Blake, the opposite poles of English painting, to show its wide range of idea. Although Turner creates a school, like Michel Angelo, he is intrinsically of too great an artistic calibre to have successful disciples. Imitators and pupils abound, but his mantle is not to be worn on narrow shoulders. Indeed, viewing him as the standard, landscape art has not advanced since his death. It is easier to parody his exaggerations or denounce his experiments than to demonstrate equal power and intuition. Even his imperfect experimentive work, scraps and studies, assert the depth and abundance of his reserved power, and the quality of his ambition. They are like the

fragments thrown off the sculpture of Titans. Smaller minds may profit much by studying him; but to attempt to rival him in his own manner would be to waste ability and produce inchoate, wild work. The legitimate channels of study are the proper schools for them. They are to be found in that newly arisen, earnest, laborious class of English artists, which on account of the sincere spirit which animates it, rather than from any very obvious points of technical similarity, has come to be called the Pre-Raphaelite, after the predecessors of Raphael, unmindful of the fact that the system of finish of detail in accordance with the externalism of nature is as old as the early painters of Greece, and has never been peculiar to any time or people. The name, however, is used to cover up so much dry mediocrity, and barren imitation of the natural and common by a class of painters whom the Greeks in the scorn of their idealism would have called mere dirt-painters, that it ought to be redeemed from its ambiguousness to that definition, which, in justice to the really able men who adopt it, it should alone bear.

We understand its underlying principle to be that which infused vitality into classical art and made the mediaeval so true and high-toned. The inner life, or idea, is its profoundest recognition. This it seeks to incarnate with scrupulous technical skill into appropriate forms, giving to each its due. It is pure, wise, and true in aim. Instructed by nature, it seeks to combine science with feeling and wisdom. Universal in range, it is both humble and exalted in tone. Recognizing the divine in the material, uniting form and idea into a harmonious whole, truthful that it may be beautiful, simple yet erudite, natural yet dignified, inquiring yet believing, prone to prove all things, disowning conventionalism and the bondage of societies yet faithful to fact, elaborate, a hard worker and patient student, surcharged with enthusiasm for the faith that sustains it, a regenerating power in art: such is our conception of the real intent and meaning of Pre-Raphaelitism.

This precious germ in little hands degenerates, as we too often see, into trite pettiness and wearisome literalness, from a tendency to subordinate great laws to lesser, and to exalt the common and

integumental above the intellectual and spiritual. They also forget that nature, their teacher, invariably in the landscape hints at more than she discloses, leaving in the mystery of her forms in masses a delightful scope of suggestiveness to the natural eye, which is to it as is hope to the religious faculties, or as is imagination to the intellect, an angel of promise to draw one onward in pursuit of the ideal. The painter, like the moralist, should accept the spiritual law that the naked fact is not always to be given in its absolute exactness of matter; otherwise it would obscure or detract from more important facts, and arrest attention as it were on the threshold of the temple of art. Neither memory nor sight can cope with the infinite and ever-changing panorama of life. At the best, at any one time, we get only a partial view. The unseen and undetected must in any stage of progress outnumber the seen and known. Nature is not to be exhausted by the utmost diligence of exploration; nor can we hope by the finite to render her infinite. The higher law of art is interpretation; imitation is secondary. Those artists who exalt the latter above the former of necessity fail, because life or spirit is something more than color and form. These are the mediums only, as words are, of ideas and feelings, and if made paramount, represent death or inanimation rather than life. That for which they were created being withheld from them, they may exhibit labor, skill, and marvellous memory and dexterity, but afford no clue to the soul of things. So far, therefore, as Pre-Raphaelitism robs art of her poetry in order to give the literal facts of nature, it may subserve exact science by way of illustration, but it subverts noble art. And, then, nature will not disclose herself with microscopic realism to the naked eye. We do not see things as the majority of self-styled Pre-Raphaelites put them in their work. Any training that would make us so see nature would exchange half of its beauteous mystery as a whole, with its proper emphases of parts and its lovely gradation of distances, for a photographic, unidealistic rendition of the forms, hues, and appearances of things great and small on one monotonous standard of mechanical exactness. The average men of the Pre-Raphaelites also, to a great degree, lose their own in-

dividuality or consciousness in their zeal for rigid representation, and in this are the opposite of Turner, who largely endowed his works with his own life. But Pre-Raphaelitism in the keeping of genius, uniting Turnerian breadth and freedom to its legitimate spirituality of vision and scientific accuracy, offers a possibility of progress as exhaustless as the pure principles and noble aspirations which are or should be the basis of its theory of painting. We estimate it not so much by what it has accomplished, even in the hands of Millais, Hunt, or Dante Rossetti,[9] as by what it professes to be. For although emancipated from the bondage of effete ideas and paralyzing formalism, and having already won brilliant distinction, it still has much to acquire in the science and methods of painting, something yet to learn of the logic and rhetoric of art, whose rules as a complete, harmonious whole do not seem to be fully observed. But, born of the resurrection of aesthetic feeling and of the knowledge of our own time, cradled in freedom of thought and execution, nursed by faithful study, the art-child of Protestant liberty of progress, Pre-Raphaelitism indicates a solid foundation for a fresh and vigorous school of painting.

Germany affords examples of laborious study and clever manual results. Her schools in general, of the Dryasdust order, are the ballast of modern art, keeping it from premature flights, or being too much swayed by imagination and impulse. They serve, therefore, as the conservative element of art, advancing heavily through steady application, producing respectable pictures, chiefly of the furniture or decorative style, without much evidence of lofty intellectual inspiration or creative genius.

The most popular of these schools is the Dusseldorf: in its best men, of whom Achenbach [10] and Lessing [11] are favorable examples, dramatic, artistic, and graphic; in its little men, formal, pedantic, and artificial. Versed in art-trickery, spectacular, it gives everything to the eye, nothing to the mind or heart. America is inundated with its works, which are useful so far as they help educate our people in the rudiments of design and composition; but in other respects the Dusseldorf school is a millstone about our necks.

But Germany is not wholly given over to the mechanical and decorative in painting. It possesses idealism of a high order. The chief protest against its externalism comes from the school of Cornelius [12] and Overbeck.[13] This is correct in principle, lofty in purpose, and great in intellectual motive; but in execution incorrect so far as it seeks to revive or imitate mediaeval work. Although more spiritual in aim and religious in expression than English Pre-Raphaelitism, it lacks the healthful freedom and versatility of the latter. The Past clings heavily to its garments, and weighs it down. It is the fourteenth century trying to sway or push aside the nineteenth. The ascetic Umbrians are not at ease in our atmosphere.

Belgian art is too much a cross between German and French to call for a special analysis. Personally, we delight in Leys,[14] its great Pre-Raphaelite, a lineal successor of the Van Eycks, to their spirit and style adding the advantages of modern science. He paints ideas as well as forms, with an individuality of expression, though somewhat uniform in type, a vigorous, deep-toned, admirably subdued, and harmonious coloring, and a picturesqueness of composition, which distinguish him as a great modern master, deeply imbued with the sincerity and earnestness of the old men, and ambitious to rival their solid and faithful painting.

France bears the palm to-day in modern art. In painting she presents a wider range of styles and motives, a greater knowledge, and more eminent names than any other country. This she owes to her artistic and scientific liberty, intellectual culture, the national love of beauty, and widely diffused aesthetic taste, helped as they are by admirable systems of instruction, accumulations of objects of art of all eras and races free to her people, while her own traditions create a universal art-atmosphere, and make every Frenchman a lover and critic of art; and, above all, to the subordination of the ecclesiastical to civil authority. The French are the Greeks of modern life. Leavened with the Protestant spirit of civil liberty and progression, they unite in themselves the extreme of philosophical skepticism with the spiritual exaltation and material superstition of Catholicism. Amid such elements, art exhibits every

aspect, from a refined, ecstatic, symbolical, or naturalistic Pre-Raphaelitism, to a sensualism delighting in lust and horror, a vanity that is ridiculous and deteriorating, and a flimsiness and exaggeration that defy every rule of good taste.

Great lights, however, shine throughout this medley, gradually extending correct ideas, and educating the public to a purer standard of aesthetic judgment. A few names out of the many that now so rapidly rise and succeed one another in the rivalry of progress, will suffice to illustrate the varied brilliancy, excellence, and wide reach of French painting. Their sculpture is too common in inspiration, low in aspiration, and indifferent in execution, to require us to break silence in its behalf in this connection.

The best painters of France in their motives and styles include the elements of the classical, mediaeval, Renaissant, and modern schools, devoid of servile imitation and inane reproduction. They develop a large degree of individualism in invention and manner, based upon keen aesthetic susceptibility, great executive skill, and well-digested knowledge. These virtues are, however, mainly of recent growth. The academic pseudo-classicalism, disgusting materialism, and empty sentimentalism of the Empire, equally with the pharisaic religionism, wanton prettinesses, lying Arcadiaism, mean pride, and aristocratic folly of the previous Bourbon phase of art, have given place to a more wholesome taste and truer appreciation of aesthetic aims, far from perfect, but in contrast with preceding art as is the invigorating break of day to smoke of the bottomless pit.

Although Calame [15] is Swiss, he comes within the pale of the French school, and we quote him as illustrating more through design than color, which is positive and cold, those qualities of the landscape that give it a deep, poetical significance, almost pantheistic in sentiment, but truthful in forms. He recreates in forest, field, or flood, the same tone of mind which led the Greek artist to impersonify nature. In Calame it is deep, solemn, mystical, a brooding of the supernatural, begetting awe and silence, as of a terrible expectation.

Rosa Bonheur [16] and Troyon [17] are to be thanked for leading

their art out of mock pastoralism and classical puerilities into a healthful love of agriculture and animals. Lambinet,[18] Auguste Bonheur,[19] and Rousseau[20] are working in a similar spirit in behalf of the much-abused and long-suffering landscape, aiming at truth of color and generalization. Frère[21] consecrates his captivating brush to domestic life. With a subtile, tender instinct, he brings out of the common and humble the delicate, pathetic, and natural, elevating humanity in the masses, and showing how much above the atmosphere of fashion are the emotions and actions of genuine manhood, womanhood, and childhood, and what there is of real poetry in lowly life. His is the true democracy of the heart. Mèrle[22] is equally true and tender.

Millet[23] favorably represents the Pre-Raphaelitism of his country, which is superior in its scientific execution and has more breadth of idea and manner than the English, as we see in the realistic Gérome,[24] particularly in the subordination of inferior parts and lesser motives to the principal, and a more correct understanding of the philosophy of art. Haman,[25] after another style, is classical in feeling, with a delicious delicacy of sentiment and play of fancy. Meissonnier[26] is the painter of the *salons*. Fashion is his stimulus. His vigorous design, tasteful composition, exquisite finish, minuteness without littleness, manual skill, his force and spirit, despite the inferiority of his motives and want of sympathy for noble work, almost elevate him to the level of a great master. Indeed, in so far as doing what he attempts superlatively well, he is one. Couture[27] develops altogether another style of painting. He is among the foremost in skill and science, not a great creative mind, but one of striking talents and profound knowledge, to which are superadded original conception and individual force. The Romains de la Décadence is his masterpiece.

Horace Vernet's[28] mastery of pencil is chiefly directed to illustration and history. His hand is ready and quick, full of dash and spirit, most clever in those realistic qualities which captivate the multitude. He has an indifferent feeling for color, finds no sentiment in it. Scenic and sensational, he is not a great master, although passing for one. Delaroche[29] surpasses him in imagination,

feeling for color, lofty motives, and graceful conceptions. He is also a painter of history, but his naturalism is tempered with idealism. Vernet is the artist of the field and camp, Delaroche of the academy and studio; the one observes, the other studies. Delaroche appeals to ideas and sympathies, and has a lofty intellectual estimate of art. Vernet carries away the spectator by the vigor of his action and dramatic effect.

Daring, original, powerful men, Décamps[30] and M. Robert Fleury[31] display subtile thought and feeling. In their specialities they are artists of the first order. Of opposite tendencies, cold and weak in color, but pure in sentiment, poetical in conception, and spiritual in feeling, is Ary Scheffer,[32] who represents the French progress in this direction. Doré[33] in design is master of the terrific, grotesque, and diabolic. As a poet of Dantesque power of imagery, profundity, and inventive insight, he presents the shadow side of the imagination, peopling the earth and air with wondrous frightful creations, solemn and mystic in tone and of unlimited force and variety.

Delacroix closes this reference to the breadth, variety and range of French painting. He is grand, fearless, powerful, and profoundly imbued with the sentiment of color, an enthusiast in art, sombre in temperament, a master of the tragic, founding his power on those sympathies and convictions that stir the impressible spectator most deeply and lift him most mightily. His is an art that ennobles and dignifies human nature. It is not faultless, for positive criticism would find much in him to cavil at. His vigor of experiment and power of invention may appall the timid conventionalist. But above all his shortcomings — short only through the inability of hand to match the will — rises up the imagination of a great genius, overmastering him and his age, as Michel Angelo's overmastered himself and his.

XIII

An Inquiry into the Art-Conditions and Prospects of America. —
Art-Criticism. — Press, People, and Clergy. — Needs of Artists and
Public. — American Knownothingism in Art. — Eclecticism. — The
True Path.

WE have now succinctly traced the art-idea in its historical
progress and aesthetic development in the civilizations of
the Old World to the period of its advent in the New, showing,
as we proceeded, that, though the love of beauty is a fundamental
quality of the human mind, yet its manifestations in the form of
art are checked, stimulated, or modified by the influences of cli-
mate, habits, and traditions of race, relative pressure of utilitarian
or aesthetic ideas, the character of creeds and tone of religious feel-
ing, and above all by the opposite degrees of freedom of choice
and qualities of inspiration permitted to the artist by Pagan, Papal,
and Protestant governments.

American soil, but half rescued from the wild embrace of the
wilderness, is a virgin field of art. By America we mean that ag-
glomerate of European civilizations welded by Anglo-Saxon insti-
tutions into the Federal Union. The other portions of the conti-
nent are simply offshoots of their parent countries, without na-
tional life in art or literature. Consequently, our inquiries belong to
that people which, in virtue of their power and progress, have
taken to themselves the designation of Americans, sanctioned by
the tacit consent of the world, prophetically foreshadowing a

148

period in their destiny, when, by the noble conquest of ideas, the entire continent shall of right be theirs.

An inquiry of this nature, under the circumstances of newness and inexperience which everywhere present themselves, is, in many respects, embarrassing. At the same time, it is interesting, involving as it does not only the previous points of our investigations, whether by inheritance, transmission, or imitation, but new forms, rooted in novel conditions of national being; in short, the future of the art of the intermingling races of a new world, fused into a democracy which is now passing through its gravest struggle for existence, to reissue, as we believe, the most powerful because the most enlightened, the most peaceful because the most free, and the most influential people of the globe, because having sacrificed the most for justice and liberty.

But the dark cloud of civil strife still lowers over us. The timid quake; skeptics jeer. We have scarcely begun to sow the fields of art. The critic has more difficulties in his way than even the artist. A harvest is to be reaped, however, and that sooner than many think. Let us carefully sift the seed as it is sown, and not wait until the tares are big and strong before trying to uproot them. A bright vision of national growth in art does indeed come before our mental sight, but that must not tempt us to overlook the fallow Now. He who would hasten the realization of that vision is under bonds to apply to the art of to-day those strict rules by which alone it may be sped joyfully on its way. It is a duty to vindicate art, not to foster national conceit, stimulate personal vanity, or pander to individual interests. "More *Light*," says Goethe; "MORE LIGHT." Precisely our public and private want! Those readers who have kept us company thus far, know that the aesthetic taste advocated is based upon pure examples; and that the principles which underlie it are drawn from deep and lofty aspirations, so far as long and conscientious study has enabled us to detect them. Believing, therefore, that the BEST is none too good for America to aspire to, we shall speak plainly of our deficiencies, and cheeringly of whatever justifies hope or praise. And the more emphatically at this particular juncture of our national affairs, because the

experience of the world shows that great artists and a corresponding advance in art are almost always contemporaneous with the cessation of great wars and decisive crises in historical periods.

For the present, America, like England, prefers the knowledge which makes her rich and strong, to the art that implies cultivation as well as feeling rightly to enjoy it. In either country, climate, race, and religion are adverse, as compared with Southern lands, to its spontaneous and general growth. Americans calculate, interrogate, accumulate, debate. They yet find their chief success in getting, rather than enjoying; in having, rather than being: hence, material wealth is the great prize of life. Their character tends to thrift, comfort, and means, rather than final aims. It clings earthward, from faith in the substantial advantages of things of sense. We are laying up a capital for great achievements by and by. Our world is still of the flesh, with bounteous loyalty to the devil. Religion, on the side either of heaven or hell, has but little of the fervid, poetical, affectionate sentiment of the Roman creed and ritual. In divorcing it from the supersensuous and superstitious, Protestantism has gone to the other extreme, making it too much a dogma. Franklin most rules the common mind. He was eminently great and wise. But his greatness and wisdom was unspiritual, exhibiting the advantages that spring from intellectual foresight and homely virtue; in short, the practical craft of the scientist, politician, and merchant. His maxims have fallen upon understandings but too well disposed by will and temperament to go beyond his meaning, so that we need the counteracting element which is to be found in the art-sentiment.

What progress has it made in America?

To get at this there are three points of view: the individual, national, and universal. American art must be submitted to each, to get a correct idea of it as a whole. Yet it can scarcely be said to have fairly begun its existence, because, in addition to the disadvantages art is subjected to in America in common with England, it has others more distinctively its own.

The popular faith is more rigidly puritanical in tone. This not

only deprives art of the lofty stimulus of religious feeling, but subjects it to suspicion, as of doubtful morality.

Art also is choked by the stern cares and homely necessities of an incipient civilization. Men must work to live, before they can live to enjoy the beautiful.

It has no antecedent art: no abbeys in picturesque ruins; no stately cathedrals, the legacies of another faith and generation; no mediaeval architecture, rich in crimson and gold, eloquent with sculpture and color, and venerable with age; no aristocratic mansions, in which art enshrines itself in a selfish and unappreciating era, to come forth to the people in more auspicious times; no state collections to guide a growing taste; no caste of persons of whom fashion demands encouragement to art-growth; no ancestral homes, replete with a storied portraiture of the past; no legendary lore more dignified than forest or savage life; no history more poetical or fabulous than the deeds of men almost of our own generation, too like ourselves in virtues and vices to seem heroic, — men noble, good, and wise, but not yet arrived to be gods; and, the greatest loss of all, no lofty and sublime poetry.

Involuntarily, the European public is trained to love and know art. The most stolid brain cannot wholly evade or be insensible to the subtle influences of so many means constantly about it calculated to attract the senses into sympathy with the Beautiful. The eye of the laborer is trained and his understanding enlightened as he goes to and fro the streets to his daily labor; so, too, the perceptions and sentiments of the idle and fashionable throng in their pursuit of pleasure. A vast school of art equally surrounds the student and non-student. None can remain entirely unconscious of its presence, any more than of the invigorating sensations of fine weather. Hence the individual aptness of Italians, Germans, and Frenchmen to appreciate and pronounce upon art, independent of the press and academic axioms, thus creating for their artists an outside school, which perhaps is of more real benefit to them than the one within doors in which they acquired their elementary knowledge and skill. Of these incentives to art-progress America is still destitute.

To this loss of what may be termed a floating aesthetic capital must be added the almost equal destitution of institutions for instruction in the science of art, except in a crude and elementary way. Academies and schools of design are few, and but imperfectly established. Public galleries exist only in idea. Private collections are limited in range, destitute of masterpieces, inaccessible to the multitude. Studios would effect much for the development of taste and knowledge, were they freely visited, by bringing our public into more cordial relations with artists, who do not yet exercise their legitimate influence. In a nation of lyceums and lecturers, every topic except art is heard. Indeed, outside of occasional didactic teaching and a few works not much read, we are without other resources of aesthetic education on a public scale than meagre exhibitions of pictures on private speculation in some of the chief cities.

This leads us to enlarge on the special disadvantages to American art arising from false criticism. The ordinary productions of men who handle brush or chisel are spoken of in public prints as "works of consummate taste and ability," "perfect gems," proofs of "astonishing genius," and with similar puffery. These vague, swelling words would be received at their real value, did not so many of our people, just awakening to aesthetic sensations, have such a mistaken estimate of art. They view it as an undefined something above and apart from themselves and their daily lives, an Eleusinian mystery of a sacred priesthood, to be seen only through the veil of the imagination, not amenable to the laws of science or the results of experience, nor to be spoken of except in high-sounding phrases and wanton praise. Feeding artists on this diet is like cramming children with colored candies. Every true artist shrinks from it, and yearns for a remedy. This will appear as soon as the public comprehend that it is as feasible to teach the young to draw, paint, and model, presupposing average intellectual faculties, as much else they are required to learn; and that the result would equal much that now passes for fine art. We can educate clever external artists as readily as clever artisans; a certain knack of hand, and development of

taste and of the perceptive faculties being sufficient. When the public see this, they will cast aside their nonsense and mummery about art, and judge its mechanical qualities with the same intelligent freedom and decision that they do the manual arts with which they are acquainted. In fact, design and the science of color should be made an elementary branch of instruction in our system of common education, precisely as we are now training the ear to music, and the muscles to strength and suppleness. Genius is not essential to mere painting and modelling, certainly not to a knowledge of principles, and a respectable degree of skill or dexterity in their manifestation. These qualities can be acquired by study and application. Genius is the exception, talent the rule, of art and literature. It is as fatal an error to postpone the acquisition of knowledge, or the development of a faculty, from the want of genius, as to fancy that genius exists because we have a facility of doing certain things. Unless we conform our language to truth, we shall lose sight of the right distinction of words. An artisan who makes a good coat is more useful and respectable than a painter who makes bad pictures. Even a child would laugh at the absurdity of calling "dime-novels" or "Rollo story-books" works of astonishing genius, or of applying to them any of the hyperbolical expressions of admiration which are so lavishly showered by excited friendship or an indiscriminating press upon almost every effort of an American artist. Yet the larger portion of productions are no more matchless or divine than the common run of books, nor imply any more intellect to produce them. If we should begin with exhausting the capacity for praise of our tongue on penny-a-line writers, what would be left for Irving, Emerson, Hawthorne, Bryant, or Poe? And could we invent words suitable to their merits, which would be doubtful on the scale applied to art, imagination would utterly fail us in coining terms to measure the genius of the absolutely great lights of literature, the Dantes, Homers, Goethes, and Shakspeares. Common sense must stop this debasing flattery by exposing its fallacy. It will be a fortunate day, when our public and our artists meet understandingly face to face, having put out of sight the present

pernicious system of befogging and befooling. The reform lies more with the artists than the public, for they are its teachers. Eschewing clap-trap, let them recognize only that sort of criticism which justifies its faith by reason and honest likings. The daily journal of New York most devoted to art thus sums up a notice of the last Artist Fund Exhibition: "All the pictures possess more or less merits and defects. Perhaps the merits preponderate." Sagacious on-the-fence critic! At the opening of this exhibition, at which the *élite* of the artists and *literati* of the city were present, they listened complacently to the following nonsense, which we find in the "Evening Post:" "He [the speaker] referred to Cole's picture, hanging before him, as embodying the *chief requirement of art, namely, shadows.*" We will not pursue this ungracious portion of our subject farther. Enough has been said to indicate the disadvantage of American art in lacking a discriminating public, and in the present habit of senseless praise; the poorer the art, the more words used to inflate public opinion relative to it.

Before the establishment of the "Round Table" of New York, there was scarcely a newspaper or journal in America sufficiently independent to admit a free discussion of artists and art. An article calculated to provoke discussion was tabooed, for fear of wounding the sensibilities or harming the interests of some one. Few writers ventured to assert the cause of art itself, because of the artists or their friends. This false system has fostered a deceitful ambition in numbers who might usefully fill other positions; so that we are inundated with bad, mechanical work, exulted over by the press at large as proof of American genius, when in reality it is so much sad evidence of pretence and folly.

Art has another drawback, in the superficial remarks of writers who are tempted to wander into a field which they have not taken pains previously to explore. The sugary platitudes of the author of "Our Artists" * are a fair specimen of this sort of writing. Its patronizing pat-on-the-back tone is an affair of the artists themselves, so we pass it over. Some of the sentiments expressed are trite and true; but for an article intended to inform the million,

* *Harpers' New Monthly Magazine*, Jan. 1864.

it gives them little beside pretty writing and mistaken history or inference. We quote a few sentences. The writer, who tells us he is a clergyman, says to the artists, that he likes to "chat with them over the social table about pictures;" talks of "the sparkling glass soon empty in the hand, but when shall that brimming cup of beauty be exhausted in the grasp of high art?" and adds that he "who sips the dew from a maiden's lip may take away some of its freshness," etc. We submit to those who honor beauty whether this is the sort of talk to dignify it, or whether "the occasion of unusual enjoyment," in which punch and sensuous similes flow freely, is the best method of diffusing intelligent ideas of art. In every age, "the social table" has proved the bane of spiritual growth in any direction. Instances of living genius, half-ruined by its seductions, are already too common. Certainly, no true friend of art, least of all the clergy, should advocate festivals of this character as a means of good to it.

Other remarks of the same writer prove that cultivation in one profession is not necessarily a passport to intelligence in another. Speaking of introducing pictures into churches, he remarks: "We should hope to be saved the infliction of worshipping in constant presence of many of the customary ecclesiastical monstrosities that cover cathedral walls. Broiling saints, pinched and starved hermits, grim inquisitors, ghostly monks and nuns, are not to us the best impersonations of the Christian religion." The only broiling saint that we can recall, after ten years' travel and study of art in Europe, was not on a cathedral wall. It was St. Lawrence, a martyr-hero of the early Church, painted as only Titian could paint. Would not such a "monstrosity" be welcomed even by American artists, on any wall, civil or sacred, — a picture which ranks among the masterpieces of the world's greatest painter? The saints, nuns, and monks that he sneers at were in their days the "humanity which God made, redeemed, and consecrated;" and their "impersonations" are chiefly by artists like Fra Angelico, Francia, Bellini, and Raphael, men worthy to paint those who consecrated their lives to a piety which was often tested by martyrdom. It may be bad taste, but really we have the weakness to see

in them a vital energy of self-sacrifice for truth, as they saw it, which calls for, at the least, as much respect as the nineteenth-century life of the pastor of a fashionable Protestant congregation. If the writer, in exploring "cathedral walls," which nowadays are *not* covered with "broiling saints" and "grim inquisitors," saw only bad pictures, he was unfortunate in his discrimination.

While defending the pious dead from the assaults of the unsympathetic living, and trying to uphold the truth and dignity of high art, we cannot pass over a mistaken notion widely disseminated by the eloquence of the Rev. Henry Ward Beecher, at heart a true champion of liberty, but who nevertheless has been inadvertently led into publishing some singular conclusions in regard to Italian mediæval art. It is not an easy task to rectify errors that harmonize with popular prejudices, and are sanctioned by eminent sectarian authority. Mr. Beecher, in his lecture before the Sons of New England, Dec. 21, 1860, says: —

"In all the Italian schools, not a picture had ever probably been painted that carried a welcome to the common people. To be sure, there were angels endless, and Madonnas and Holy Families without number; there were monkish legends turned into color. Then there were heathen divinities enough to bring back the court of Olympia, and put Jupiter again in place of Jehovah. But in this immense fertility, — in this prodigious wealth of pictures, statues, canvas, and fresco, — I know of nothing that served the common people. In art, as in literature, government, *government*, GOVERNMENT, was all, and *people* nothing! I know not that the Romanic world of art ever produced a democratic picture."

We understand this to mean, that before the seventeenth century there was no art the common people cared for; that, up to that period, art was "silently fascinating and poisoning the soul through its most potent faculty, the imagination," and that it was wholly an instrument of pride, superstition, and oppression on the part of the rulers, lay and clerical. At the same time, he asserts his predilection for the Germanic schools, because their pictures teem "with natural objects, with birds and cattle, with husbandry, with domestic scenes and interiors." We make no issue with those

whose tastes prefer a boor's pipe or gin-flagon to a martyr's palm or saint's nimbus, a Flemish villager's carousal to an Italian tournament, a kitchen-scrub to a Madonna, the ditch and dike to the valley or mountain. Such taste is as free to enjoy after its kind as any other. But it is not free to condemn on unsound premises, and to jumble historical truth and personal liking into a medley of falsity and injustice.

It is quite true that the Italians never did have that taste in art which seems to make Mr. Beecher's highest æsthetic enjoyment. Neither did the Greeks. They preferred the more dignified, heroic, refined, and ideal aspects of humanity. As he rightly observes, "Art is a language;" and in their conversations they took more satisfaction in the poetical and imaginative than in the familiar and common. Teniers *vs.* Raphael, — the *sabot*-footed, beer-swilling boor opposed to the angels that Abraham entertained.

Besides, democratic institutions had the upper hand in Italy, especially in Tuscany, at the epoch which Mr. Beecher denounces. Art decayed as soon as its patronage fell into aristocratic keeping. To be a noble in Florence in the days of the Giotteschi was as uncomfortable as to be a Secessionist at the North now. The art of Italy, from its revival in the twelfth century to its prime in the sixteenth, was emphatically the offspring of the feeling and taste of all classes of the people. They created the demand for it, and paid for it most liberally out of their profits in trade. Giotto's Campanile, the shrine of Orsanmichele, Ghiberti's Gates of Paradise, and miles of large-hearted frescos, all came from the people. They carried Cimabue's noble picture in triumph to its final resting-place, — Duccio's, too, with songs and music and banners; they crowded to the opening of the Carmine chapel to see Masaccio's work, and took as lively and intelligent an interest in the rivalry between Leonardo's and Michel Angelo's cartoons as we now do in the question of iron-clad ships. We ask Mr. Beecher to point out a single great work of one of the great masters whom he anathematizes, which is, as he asserts of the entire art of this period, "the minion of monarchy, the servant of corrupted religion, or the mistress of lust." Protestants and Catholics who are privileged

to see the works of Fra Angelico and his school have but one opinion of their purity and spirituality. Do not the "Scriptures" of Raphael in the Vatican furnish the very designs used by Protestants to illustrate their Bibles and religious works? [1] Do we not daily recognize Masaccio, Ghirlandajo, and their contemporaries, in manifold ways, in our illustrated books? Do not the walls of the Campo Santo at Pisa tell the entire story of revealed religion, from the creation to the crucifixion? Have not Orgagna, Martini, Gozzoli, and a hundred others scattered far and wide throughout Italy, in church, chapel, council-hall, and private dwelling, on the streets and by the road-side, the Scriptural story of the fall and redemption? Are these nothing to the common people? Does the identical religious fact or dogma which is "poison" to the soul if put into a pictorial form before printing was invented, become a means of grace, in the shape of a tract or sermon, in the year 1860? Was it "nothing" that the hope of immortality, the lessons of faith, the fear of hell, and the bliss of heaven were brought vividly home to the feelings of an imaginative, demonstrative people, in a more efficacious way than by the Puritan machinery of lectures and colporteurs? Their taste demanded instruction and entertainment in this way, and it continues to do so to this day. They find refreshment and sympathy in the pictured and sculptured representations of maternal and filial love and sacrifice, in the pure sentiments and holy aspirations and self-denials set forth in those sacred pictures which Mr. Beecher condemns. They touch their hearts, and we have had occasion to know that they are quite as potent an influence for good as are the spoken appeals of Puritan preachers. Italian artists of the best periods, with but few exceptions, sprang from the people, were trained among them, were democratic in principle; but they also had elevated tastes and aims, and much devout feeling, and they embodied in their works that which the people, apart from and independent of the government, most desired. Emphatically we pronounce their art to have been the art of the common people. It is a cause of thankfulness that the Italian schools kept alive the highest instincts of art, elevating its mission above the sordid, sensual, common, or

material aspects of humanity. Not that we value the motives which inspire the better efforts of the Northern schools the less, for each is excellent and enjoyable in its way, but because we believe the higher the motive, the more it elevates the taste. Italian art was chiefly devoted to religion. Mr. Beecher says "every altar-piece was a golden lie, every carved statue beckoned the superstitious soul to some pernicious error." Surely it is not uncharitable to retort that every word which he has uttered in this connection is a "pernicious error;" for altar-piece, statue, and truth alike refute his statement. We censure that Oriental egotism which holds all but the flowery land to be only as the dust of the earth. How much better is it in one of us, with the means of information almost at our door, to pass such wholesale condemnation, unjustified by any adequate study? If there be no element or phase of humanity wholly good, so there is none wholly bad. We have had a long experience in the study of altar-pieces and sacred sculpture, and, although not a Roman Catholic, have discovered in them quite as much Scriptural truth, as pure motive, as exciting incentive of holiness, and as convincing arguments for a spiritual life, as we have found in the prolific productions of tract societies, and the average quality of Protestant discourses. Let us be just even to the "scarlet lady." There is no gain to humanity in falsifying the record of history. The Bible is as much the inspiration of Catholic religious art as it is the basis of Protestant religious literature; and whenever art borrowed its motives from the traditions of the Church, the men and women it glorified were those who have honored humanity by self-denying lives and unflinching martyrdoms, — men and women whose counterparts in good deeds Protestants find in the Howards, Frys, and Nightingales of to-day. Because the æsthetic Italian chooses to perpetuate the memories of his martyrs and saints in stained glass, stainless marble, and luminous canvas, is a preacher of the gospel common to all Christians, though he be of a different temperament and ritual, authorized to assert that "every window suborned the sun, and sent history to bear on a painted lie or a legendary superstition?"

But "legendary superstition" did not monopolize Italian art.

The Pre-Raphaelite period affords some of the purest examples of certain qualities of landscape-art which we know. Correggio and Titian, later, are as truly great in that as in other departments. In every instance it is secondary, as it should be, to higher motives, but none the less informed with its true spirit. There is also in early Italian art much spirited and affectionate treatment of animal life, always subservient, indeed, to some loftier purpose. The people indulged themselves in pictures to an extent which we Northern utilitarians would consider as luxurious extravagance. But they loved allegories, poetical fancies, historical pieces, rich and animated spectacles, — they do now, — and they largely patronized the art that gratified their taste. This was "the life of the common people." Fierce and turbulent democrats they were, most of them, though Mr. Beecher will have it that their art was the "minion of monarchy," and that the Italian citizen has "no thanks to render to the art of the past." He does, however, render homage to it, and prizes its remains as a glorious memorial of ancient liberties. When Mr. Beecher says of it, "I know of nothing that served the common people," he could not have been aware that the most remarkable historical painting of the new kingdom of Italy, Ussi's Expulsion of the Duke of Athens from Florence by the people in A. D. 1342, is but a new version of a fresco of that time by Giottino, representing the same scene, with the addition that the people are represented as acknowledging their victory as due to Divine aid, — a sentiment, we trust, as creditable to them in his eyes as was the thanksgiving of our Puritan fathers upon their victories over the Indian Philip and George III.

It is an artistic anachronism which several of our critics have fallen into, upon a superficial glance at the few and minor specimens of the old masters to be seen in this country, to consider their works as comparable only to the efforts of children in their first lessons in writing. What! the designs of a Giotto, Orgagna, Fra Angelico, or Luca Signorelli of no more beauty or value than the pot-hooks of a six-year-old girl! By parity of reasoning, the architect who designed the best of our new meeting-houses ought to have displayed astonishing genius in comparison with the de-

signers of the Loggia and Campanile at Florence. Six centuries have but served to stamp the Florentine monuments as marvels of beauty and skill, original and lofty conceptions, in harmony with their purposes, and burning with intellectual life. Certain works of man are a perpetual joy, — the same yesterday, to-day, and forever, — because they are a revelation from the unseen, and an assertion of the eternal supremacy of spirit over matter. Genius creates, talent constructs. The power of the one is instinctive, a gift from above; of the other, receptive, accumulating by example and training. Hence genius alone gives birth to great, new, or noble work; while simple talent, however clever in execution, often fails from want of intuitive discernment and original thought.

In viewing art new to him, one should not abandon himself to first impressions without investigating their soundness. If he does so too hastily, he often finds upon further experience that his wisdom was foolishness. Art may seem obscure or unintelligible, and the fault lie not in it, but in us. We can comprehend no work until we have raised ourselves to the level of the author's meaning and feeling. All partial or one-sided comprehension is a mutual loss. Yet the best beginning of any intercourse is frank expression; for the basis of misconception being exposed, an understanding is more than half accomplished. We sympathize with the visitor who said before us, of some early Italian paintings, "I should as soon think of enjoying bad health or bruises as them," because it needs a few hints only entirely to change the point of view. There is, indeed, a wide gulf between the extremes of cultivation and sympathy and stolid apathy or ignorance. Each can be sincere and genuine. The visitor who exclaimed on seeing for the first time gold-background pictures, as he passed from one room into another, "More of these d — d ridiculous Chinese paintings!" was as much a representative of one class of critics among us — such an exclamation would not have occurred in Europe out of England —as the person whom we saw seated, moved to tears, before one of the very works thus profanely condemned was a representative of another.

The rough, uncultivated class is a more hopeful one to elevate

to higher perceptions in art than that which looks upon the work of the hands that designed the Spina church at Pisa, adorned the Cathedral of Orvieto, or wrote Bible-stories in fresco at Assisi, covering the walls of its Duomo with spiritual allegory, as but the scrawls of children in comparison with the portfolio of the modern drawing-master. The latter class seeks results not sought by the old master. It overlooks the fact that the men whose works it superciliously condemns have received for centuries the unanimous suffrage of the cultivated judges of all nations. There is much technical failure in their work. But it often serves to make more conspicuous their spiritual feeling and depth of earnestness. Chaucer and Shakspeare do not spell as we do; but do these differences of form between the literature of our ancestors and our own prove theirs to be the scrawls and ideas of children? Why should it be held different with art? Giotto was worthy in all respects to be the friend of Dante, and Martini of Petrarch; so the poets themselves tell us. Painting and poetry are but different phases of speech. It becomes us to throw off all conceit of actual superiority in intellect over our predecessors, and, before judging them, to inquire in what circumstances they differed from us, and whether what we do is as well done, and from as exalted inspiration, as what they did. Any other course puts us farther apart, and leads to wrong conclusions. "I do not believe in them," is the doctrine of conceited judgment, effectually darkening the mind to light. Some critics misjudge the early Italian art from choosing a wrong point of view. We have seen a professor of drawing go hastily up to one of Lorenzetto's angels, and turn as hastily away, with the curt remark, "That man did not know what bones were." Perhaps not. The teacher had been doing nothing else except trying to draw anatomically well. Lorenzetto's imagination had striven to rise to the vision of ethereal beings, and to the symbolizing of spiritual ideas. To us his success seemed wonderful, which might not have been the case had he practised more on "bones." The scientific knowledge of design of the old eclectic school exceeded that of our own. Yet, as Blackwood justly states, "learned" as it was "in all the tricks of composition, and declamatory in startling

effect, it has in great measure given place to those earlier works where thought and deep emotion are content to be simple and truthful." We are to enjoy both the material and spiritual aspects of art, but each at its relative value. It is an error to suppose there can be no attractiveness in painting without perfect design. Supernal beings can only be suggested by art, just as they are to our imagination. That artist is most successful in this who best impresses the spectator with the *idea* of a spiritual being, avoiding all intrusion of technical artifice, or display of anatomical dexterity. Fra Angelico is excelled by many a school-boy now in the science of design, yet no artist of any age equals him in the spirituality of his angels and Madonnas, or gives more elevated types of heavenly beings. But were a committee of drawing-masters to report upon his scientific knowledge, we fear their list of defects would be as long as would be the list of misspelt words taken by some modern pedagogue from the "Faerie Queene," or the letters of Abélard. Give, however, to either an angel to conceive, or a poem to compose, and the result would plainly show the absolute difference between inherent genius and acquired knowledge. What should we think of one who could find no loveliness in a sunset because unable to analyze its colors, and get the exact proportions of the orange, violet, gold, or emerald hues which form its glory? Yet of such a disposition are those who approach art solely through science. Art is an occult power. If the eye is trained to see only a bush, it sees nothing more; but if the inner vision is opened, as with Moses, the angel of the Lord is beheld "in a flame of fire out of the midst of a bush."

There is another obstacle beside the want of imagination to prevent enjoyment of art. None find joy in natural scenery whose minds are captious or irritable. Both art and nature demand a receptive mood. Heart and mind should overflow towards them, with the desire of Christ's little children to know about the kingdom of heaven. The conceit of pseudo-amateurship spoils much pleasure from its want of faith. A fear of being deceived and the vanity of affected knowledge are stumbling-blocks to progress in any direction. In art they often look ludicrous or stupid. The word "origi-

nal" is a strange mystery to many. They attach to it vague ideas of superexcellence. We have heard a critic of this sort pronounce the very pictures in a gallery about which there might be discussion, perfectly genuine, and those of which, from their very character and material, there could not be the slightest doubt, fabrications. Although wholly ignorant of that form of art, he thought it incumbent upon him to pronounce judgment upon it. Let every one, however, be honest in his taste, seeing with his own eyes and not another's, before a common point of view is formed. It is absurd for a realist to try to force his liking into that of an idealist. Until his senses are awakened by the natural growth of mind in that direction, let him enjoy beauty *after his own kind,* frankly and earnestly. In being loyal to truth, truth will more readily come to him.

To return from particular to general aspects of the question. Our haste to be rich extends itself in the direction of premature effort and ambition. There is too eager desire of immediate realization. We declare ourselves to be men before attaining the full experience and knowledge of childhood. Premature greatness and newspaper-fed reputations thus become the national foible. It is not manual labor that is shirked, but intellectual self-discipline, — the patient reflection and slow mental growth, modestly inquiring of the past and studying deeply and earnestly the signs of the present, in order to build up a secure future, as have done all great masters, not in the littleness of Dutch broom-painting, but with the devout and steady inspiration which led an Angelo and a Turner to take no heed of time in their struggle for lasting success.

We think we have not leisure to allow the feeling for art its legitimate rights, and so crowd it aside, or talk business to it. It is an affair of idle moments, a phase of fashion, or the curiosity of a traveller, who brings the trick of bargaining into his new-born love of beauty, and fails to appreciate an object of art except as it is cheap or dear, — a pretty something to complete the furniture of a house, on a par with upholstery as ornament, to be shut up, like dress-coats and best chambers, for occasional use, — an article to be ashamed of for its cost, yet to be proud of, in being able to

own, — a necessity of gentility, — a presumptive evidence of cultivation or refinement, — a competitive display of art-riches, — in fact, anything but *itself*, — such is the loose, fluctuating, mercenary, and vain sentiment too many dignify as the love of art, but which, in sober truth, is a selfish vanity of possession.

These are some of the general disadvantages art has intrinsically to contend with in America. On the other hand, what it lacks of inspiration from the past is compensated for in the bright horizon of the future.

First, it has freedom of development, and a growing national knowledge, refinement, and taste, to stimulate it, and strengthen the common instinct of beauty, which never wholly deserts human nature even in the most untoward conditions. It has also a few earnest hearts to cherish its feeling, and promote its spread, with the enthusiasm of sincerity, and conviction of its importance to moral welfare and complete education.

Secondly, it is not overborne by the weight of a glorious past, disheartening the weak of the present, and rendering many, even of the strong, servile and mind-ridden. True, it has not the compensating virtue of lofty example and noble standard; but the creative faculty is freer, and more ready to shape itself to the spirit of its age. Especially is our country free from those weighty intellectual authorities and conventional conditions which powerfully tend to hedge in the student to prescribed paths, undermine his originality, and warp his native individualism.

Thirdly, art is in no sense a monopoly of government, religion, or social caste. It is not even under permanent bondage to fashion. It rather leads or misleads it than is led by it. For its sustenance it appeals directly to the people. Borne along on the vast ocean of democracy, art being a vital principle of life, it will eventually spread everywhere, and promote the happiness of all.

Fourthly, it possesses a fresh, vigorous, broad continent for its field: in the natural world, grand, wild, and inspiriting; in man, enterprising, energetic, and ambitious, hesitating at no difficulties, outspoken, hardy of limb, and quick of action; thought that acknowledges no limits; mind that dares to solve all questions affecting

humanity to their remotest consequences, daring, doubting, believing, and hoping, giving birth to new ideas, which are ever passing on to new forms.

But the favorable conditions named are more negative than positive in character. Indeed, in this respect the art of America is on the same footing as the remaining branches of her civilization. Their specific advantages of growth over the Old World are simply greater latitude of choice, and few obstacles to overcome in the way of time-worn ideas and effete institutions. In one word, art is free here; as free to surpass all previous art as it is free to remain, if it so inclines, low and common. But if America elects to develop her art wholly out of herself, without reference to the accumulated experience of older civilizations, she will make a mistake, and protract her improvement. There is a set of men among us who talk loftily of the independent, indigenous growth of American art; of its freedom of obligation to the rest of the world; of its inborn capacity to originate, invent, create, and make anew; of the spoiling of those minds whose instincts prompt them to study art where it is best understood and most worthily followed. Perhaps so! Nevertheless it would be a great waste of time to adopt such a system, and possibly it might fail. This sort of art-knownothingism is as impracticable, and as contrary to our national life, as its foolish political brother, which perished still-born. We have not time to invent and study everything anew. The fast-flying nineteenth century would laugh us to scorn should we attempt it. No one dreams of it in science, ethics, or physics. Why then propose it in art? We are a composite people. Our knowledge is eclectic. The progress we make is due rather to our free choice and action than to any innate superiority of mind over other nations. We buy, borrow, adopt, and adapt. With a seven-league boot on each leg, our pace is too rapid for profound study and creative thought. For some time to come, Europe must do for us all that we are in too much of a hurry to do for ourselves. It remains, then, for us to be as eclectic in our art as in the rest of our civilization. To get artistic riches by virtue of assimilated examples, knowledge, and ideas, drawn from all sources, and made national

and homogeneous by a solidarity of our own, is our right pathway to consummate art.

No invidious nationalism should enter into art competition or criticism. The true and beautiful cannot be permanently monopolized by race, class, or sect. God has left them as free and universal as the air we breathe. We should therefore copy his liberality, and invite art to our shores, generously providing for it, without other motive than its merits. From whatever source it may come, Greek, Italian, French, English, or German, nay, Chinese, Hindoo, and African, welcome it, and make it our own. Let every public work, as are our institutions, be free to the genius of all men. Let us even compete with other nations, in inviting to our shores the best art of the world. As soon as it reaches our territory, it becomes part of our flesh and blood. Whither the greatest attraction tends, thither will genius go and make its home. Titian was not a Venetian by birth, but his name now stands for the highest excellence of that school, as Raphael does for that of Rome, and Leonardo for the Milanese. In adopting genius, a country profits not the artist so much as itself. Both are thereby honored. Foreign governments set a wise example in throwing open the designs for their public edifices to the artistic competition of the world. Least of all should America be behind in this sound policy, for no country stands in sorer need of artistic aid.

XIV

Painting and the Early Painters of America. — Benjamin West; Copley; Leslie; Trumbull; Sully; Peale; Stuart; Mount; Vanderlyn; Cole; Washington Allston.

AMERICANS first won distinction in painting. We have, however, to look back but a few years to witness the immature efforts of those painters who first showed our people that the art-faculty existed in them. To Benjamin West[1] is due the credit of the discovery. And, as if nature meant to show that not even a rigidly hostile creed, added to the hard necessities of an incipient civilization, was capable of stifling her æsthetic instincts, the first bright example she gave of them was under the garb of a Quaker. West by intuition was as much an artist as Raphael. Nothing could have diverted him from the career nature formed him for. Americans owe him a statue, not so much as an artist, as for asserting to the world the æsthetic capacity of a newly fledged race. That one West should be an artist was by itself a fact of no interest to mankind. But as the first-born artist, fresh from the wilderness of the New World, he was a surprise to Europe and a wonder to his countrymen. He quickened our blood into æsthetic life, and took away the reproach of non-artistic vitality. To what an extent West could have developed his talents had he remained at home, is matter of conjecture. That he would have been more original in invention and national in the motives of his painting it is easy to perceive. But transplanted in early youth, first to Italy, and

later to England, the academies took possession of him, and he became eventually more distinguished for knowledge and taste than for inventive thought and original power. He had large ideas and high aims, and formed his manner upon the best school-examples of illustrative, historical, and religious art.

After West comes Copley,[2] whom, with Leslie,[3] we can claim as American only by birth. In every other respect they were thoroughly English, doing nothing whatever for their own country except to leave it. Copley painted some hard, realistic portraits here, cold in color and aristocratic in type, as was his feeling. He speedily became eminent abroad, because of his cleverness in the mechanism of painting, aiming rather to give historic facts, or scenic effects, than ideas. He is dramatic, mannered, with slight æsthetic feeling, but considerable manual skill, individualistic in style, and English in tone, with precisely the qualities of coloring and design to please Londoners of rank and fashion, calling for no more exercise of the intellectual faculties than would be necessary for the enjoyment of panoramic painting. There is nothing in his art to make him a loss to America. Indeed, had he been partial to his native land, neither he nor any other artist, unless of eminent genius, could have lived long under the weighty pressure of British character without losing much of their own individuality. Copley was entirely absorbed into English life. So was Leslie, a painter of sufficient talent to make Americans desire to claim him, but who gives no patriotic response in his works. Positive, cold, and inharmonious in color, expressing no sentiment by it, he is, nevertheless, quite a master of intellectual expression and vigorous design. He, too, was artist of the aristocracy, refined and cultivated, but with no more sympathy for the highest walks of his profession than he had for the democratic proclivities of his countrymen. His friend Wilkie[4] with broader instincts opened up his art to the feelings and sentiments of the people. Leslie narrowed his to the artificial atmosphere of *salons*. There we leave him.

Trumbull,[5] Sully,[6] and Peale[7] are Americans in feeling and expression, although their education, of necessity, was more or less foreign. Trumbull resembles Copley in his general style, but he

was a man of finer taste, warmer color, and wider ideas. He was our first historical painter, much the best we have had in composition, truthful and natural in portraiture, avoiding exaggeration, faithful to his principles of art, and too honest to rely on technical artifices for effect. Above all, we see the gentleman and patriot of the old school in his paintings. There is a high-toned sense of character and individuality in his portraits. Our forefathers are better represented in the portraiture of their day than the distinguished men of ours in theirs. His historical compositions are graphic, well-balanced, well-composed. Fond of spirited action, he equally understands the value of æsthetic repose and the subordination of minor to principal parts. The American school of historical painting and portraiture has a respectable parentage in Trumbull. This parentage was creditably supported by Sully and Peale, particularly the former, whose historical painting of Washington crossing the Delaware,[8] both in sentiment and composition, is of a high order of merit, and deserves to be removed from its present exposed position in a theatre, to a national gallery. In view of much of what has been done since in this line, it may justly be termed a masterpiece.

Stuart's [9] manner betrays English influence, but of the better character, refined into a delightful style of his own. Diaphanous, rather suggesting than defining outlines, with subtle interblending and gradation of tints, he evokes the soul of the sitter and brings it to the surface of his canvas. In his best portraits, without weakening the materialistic force of costume or external feature, he subdues them to their proper secondary positions. Add to this dexterity of brush his grace and purity, and we perceive that the estimation in which Stuart is held by cultivated people is not above his deserts, although his qualities are not such as now most command the popular applause.

Mount [10] deserves mention in his special department of "*genre*," for the cold purity of his style and thoroughly English tone. His figures are well-designed and expressive. He was the first artist of repute of our school in this direction.

Vanderlyn's [11] reputation, owing to the scarcity of his works

accessible to our public, is not as high as it deserves to be. Unlike the painters before named, his taste and predilections were formed by the French classical school. This is seen in his Ariadne in the gallery of the Historical Society, New York. Time has dealt harshly with its once clear shadows and aërial perspective, and the delicate flesh-tints have become dry and hot. The landscape is after Domenichino's artificial manner. Ariadne's face and figure are not of the most elevated type, but the treatment is pure and delicate, the handling broad and easy, the modelling carefully studied from nature, and the entire conception free from affectation. So far, our school, in the nude, has done nothing to rival it.

Cole [12] was the father of landscape art in America. In æsthetic feeling and intellectuality he takes rank with the best of those we have named. The classic school of Italy was his chief inspiration. That he greatly admired Claude we have abundant evidence in the treatment of his own landscapes. But as his was a broad and unconventional mind, he soon emancipated himself from anything like servility of manner, and formed a distinct style. The character of his compositions is ideal and intellectual. Inclining to allegory, he unites to poetical feeling a picturesqueness of conception which at times almost attains to the lofty and great. The landscape charms him, not as it does his successors, because of its naked externalism, but as a groundwork of his art, which he is to quicken with human associations, or dignify and spiritualize by the subtle power of the imagination. Cole is greater in idea than action. Yet in the latter he had skill enough to make the reputation of a lesser man; though, like most artists who live in the ideal, he was unequal in his work. We have seen pictures of his, particularly a view on the Mediterranean, glowing with color, warm, translucent, and harmonious, simple and pure in composition, and imbued with the solemn repose of nature in one of her serener, sensuous moments, which showed what he was capable of in these respects. There are others, like his series of the Course of Empire, which, besides being exaggerated in parts in composition, surcharged with action, and scenic in effect, are cold and inharmonious, inclining to extremes of paleness and thinness in color. But in all his work we find the artist

actuated rather by a lofty conception of the value of art as a teacher than by an ambition to excel in mere imitation. With him American landscape art began its career with high motives. Progress in this direction requires no ordinary degree of thought and imagination. It is, perhaps, on this account that he is not popularly estimated at his right value, and has left no followers to carry forward the beautiful significance and lofty suggestion with which he aimed to endow landscape art.

We close our notice of early American painters with Washington Allston,[13] whose training was also European. The old masters of Italy were his teachers. Although he lived some time in England, its art exercised no influence over him. Resisting the inducements of patronage and the appreciation of noble friends, he returned to his native land, and there devoted himself to his art. In view of the uncongenial atmosphere to which he exiled himself, this was a Spartan resolution. His home of predilection was among the works of Raphael, Titian, Correggio, and Michel Angelo, whom he aspired to emulate, and with whose feeling he was deeply imbued. This self-sacrifice was, however, of real advantage to that section of the country where he opened his studio. It implanted and kept alive an æsthetic sentiment of a high character, inspired, doubtless, more by an admiration of the genial, high-toned virtues of the man than a full recognition of his ideas and aims as an artist. In that respect his life was necessarily much that of a recluse. Boston was proud of him, but gave him no cheer of great work. A few warm friends, fewer orders: these were his lot. But the artistic fire was too deep within him to be put out even by the æsthetic chill of New England. What a man of the exquisite impressibility of Allston must have felt in this atmosphere can only be conjectured. He, however, nobly stood to his post; and as West proved that an artist could arise even out of the unpropitious blood of the followers of Fox, so Allston showed that the most rigid Puritan land could not always resist the art-faculty. Under the circumstances, we wonder not so much at what he failed in, as at the largeness of his style and the quality of his ambition. His rare merits tend to disarm criticism.

This is the tendency of all noble effort. But in estimating what has actually been done in American art, its defects must likewise be told. In Allston's case they were inequality of execution, imperfect modelling at times, not infrequent bad taste in details, and a forcible realism of feature and *pose* in some of his greatest figures, amounting almost to awkwardness and ugliness. Beside this, like most colorists by temperament he experimented to a degree that has proved injurious to the permanent transparency and brilliancy of most of his pictures. Their subtlest qualities are now gone forever. But, though falling short of that perfect consummation of idea and execution which makes the great master, he never fails to hint one.

It is somewhat strange that Allston, who gave up wealth and distinction abroad to love of country, should have been in his art so completely foreign in feeling and motives. There is not a trace of American influence in either. His subjects, including his landscapes, were almost exclusively taken from Europe and the literature of the past, or else composed under the overshadowing influences, generally mixed, of the great masters he had copied and studied. Yet he had fine native powers of composition and much original conception. Perhaps, if he had lived always in Italy, where the varied degrees and qualities of excellence tend in the end to neutralize one another in the student's mind, Allston would have the sooner emancipated himself from extraneous influences, and formed an independent style of high character, such as his works evidently aim at. But the early studies and remembrance of those great men were too much for him in his isolation from all intercourse and examples of an inspiriting nature.

With landscape Allston had less sympathy than with the human figure. The range of his mind, nevertheless, was genial, wide, and lofty. It was, however, chiefly directed towards historical, illustrative, and religious compositions of a high intellectual order. He seems to have aimed at combining the force of Michel Angelo with the grace of Raphael and the color of Titian. Perfect success would have implied the perfect artist, such as the world waits to see. That he suggests these masters is of itself a noble distinction. We have referred to the strong realism of some of his human types. In others

there is a bewitching idealism, which betokens a keen sense of the beautiful. For examples of the former, look at the Magi and principal figures of Belshazzar's Feast,[14] the greatest, best composed, and most difficult painting yet attempted by an American artist, though so greatly misapprehended by the public, owing to its unfinished condition and incompleted changes of figures, which leave several in the guise of human monsters. Then turn to that lovely woman with the turban, gazing so earnestly at Daniel. Her sweet, pure wonderment is a vision of grace, that, once seen, haunts the imagination. The prophet is good, but it is a repetition of Raphael's St. Paul preaching at Athens. The finished accessories of this picture are painted with great precision and skill. Its action is intense, varied, and expressive. The color is rich, subdued, and solemn; the perspective well planned; while every part manifests matured thought and power. Completed as indicated in details, it would have been a masterpiece, marking an important era in American art.

Allston's figures do what he means them to do. In the Valentine,[15] the lady *reads*; she is wholly at her ease, absorbed in her occupation, and not self-conscious, or desirous of attracting the spectator's eye, as a common artist would have represented her. In other respects the picture is much deteriorated, and is not a fair example of his capacity as a colorist. His Beatrice is weak and pale, a sentimental nothing. Lorenzo and Jessica[16] is Giorgionesque in conception and feeling, but its colors have irrevocably sunk. The Sisters[17] is a lovely composition, slightly strained to recall Titian's Daughter, but spirited, graceful, and suggestive. Its silvery flesh-tints and cool, life-like grays are a combination of Titian and Correggio. Miriam is a grand picture, failing unhappily in its vehicles of color, but in idea and action a literal song of triumph. Jeremiah and the Scribe Baruch[18] is still in fine condition. The drapery is far from faultless, the figure is heavy, the features have no supernatural elevation, and the composition suggests labored thought, though as a whole it is impressive, and displays a master-hand in the dignified breadth of treatment and facile sweep of brush.

With these allusions to the varied qualities of a painter who may

be said to represent the promise rather than the fulfilment of a great school of painting, we shall turn in the next chapter to the more copious topic of contemporary art, first asking the reader to keep in mind the high qualities of the artists we now take leave of. Note well their gentlemanly repose, quiet dignity, idealization, appreciation of thought and study, and absence in general of the sensational, exaggerated, vulgar, and superficial. They had qualities which ought to have endeared their style to us and made it take root and grow. But there were powerful causes of a political nature at work to strangle its life in its youth. It is gratifying to know that the American school of painting began its career with refined feeling and taste and an elevated ambition, basing its claims to success upon high aims in portraiture and historical and imaginative art. It evinced not much love for *genre* or common subjects, and indulged in landscape only in an ideal sense. This was indeed a lofty inauguration of the art-element, and, considering the limited number of artists and inauspicious condition of the country, one fruitful in fine art. Under similar circumstances no other people can show a better record, certainly not a brighter beginning. Why it failed of making a permanent impression will appear as we go on.

XV

IT is comparatively easy to decide upon a completed career, for the evidence is all gathered in. But in treating the works of living men, the material is partial and incomplete. Our best artists have scarcely formed their styles, still less shown the full measure of their talents. New names come forward so rapidly, exhibiting much that is meritorious, that it is perplexing to do adequate justice to all. We must confine our remarks to those examples our notes afford.

The painters described in the preceding chapter belonged to an "old school," just as we speak of the "gentlemen of the old school." The semi-courtly manners of our more polished ancestors have been swept away in the flood of democratic habits of the later generation. Their art partook of the aristocratic colonial element, born of European social ideas. But to the masses it was an exotic. They admired it as they did fine manners and polite learning.

America was then as much under bondage to Europe in these respects as she had been before in political matters. Herein lies the cause of the failure of its early art in a national sense. It had no root in the people. They cared for none, especially one antipathic to their instincts and reason. No art can long live which does not represent the actual vitality of a nation.

Ours has attained a hopeful position, though not a perfectly defined one. Immediately after the old men there arose a generation of commonplace painters, peculiarly American in their feelings and aims. These were Doughty,[1] Fisher,[2] and their contemporaries, — names fast fading from memory, though of repute in their time. They were sincere and earnest artists, materialistic in expression, and deserving of kindly remembrance as the pioneers of what has since been developed into a distinct school of American landscape.

The Dusseldorf gallery, a speculation of an enterprising German, a score or more years ago, had a marked influence on our artists. Its historical, *genre*, and religious pictures were new and striking, while their positive coloring, dramatic force, and intelligible motives were very pleasurable to spectators in general. To our young artists they afforded useful lessons in the rudiments of painting and composition. They were, indeed, of no higher order than furniture paintings, being mechanical and imitative in feature, seldom rising above illustrative art. The masterpiece, Lessing's immense Martyrdom of Huss, is only a fine specimen of scientific scene-painting. With these pictures there came a popular class of artists, trained in their school, and ably represented by Edwin White [3] and Leutze.[4] White has good taste, pure sentiment, industry, and a correct intellectual appreciation of his historical subjects. There is, however, nothing great or original in his art, though, as a whole, it is truer and more effective than much of that of his German teachers, owing perhaps to his studies in Italy. As a colorist he decidedly excels them.

Leutze is the representative painter of the American branch of this school, and stands the highest in popular esteem. He manifests some originality of thought, much vigor, overmuch dramatic force,

and has abundance of executive skill, but is spasmodic and unequal. *Tours de force* delight him. He has the vicious coloring of the Dusseldorf school in its fullest extent. The Rotunda painting in the Capitol of the Star of Empire is his most ambitious work. This, the well-known Washington crossing the Delaware, the Storming of the Teocalli at Mexico, and the portrait of General Burnside, are striking examples of his epic style. Bad taste in composition overpowers much that is meritorious in design and execution. Leutze is the Forrest of our painters. Both men are popular from their bias to the exaggerated and sensational, cultivating the forcible, common, and striking, at the expense of the higher qualities of art.

The English school has ceased to exercise any influence over ours, unless a crude interpretation of its Pre-Raphaelitism by a few young men may be considered as such. Some, like Mr. Richards [5] and his followers, show decided talent in imitative design, and are earnest in their narrow, external treatment of nature. We do not believe, however, that their principles and manner will become firmly rooted here, in face of the broader styles and more comprehensive ideas of another set of our young artists, to be referred to in their proper place.

There is as little affinity between the art of England and that of America as between their politics. Our artists rarely go to London to study. If they do, they speedily become English, or else make haste to leave England for the more congenial atmospheres of France and Italy. Aside from the waning popularity of the Dusseldorf school, these two countries alone exercise any distinctive influence over American art. But the Italian schools are too much of the past, too exclusively an expression of classicalism and mediævalism, to give a positive direction to ours. Their lofty principles, noble elements, and consummate technical skill, must make them always of inestimable value to appreciative minds. But their most seductive influence over modern art springs from the solemn splendor and deep significance of their varied systems of coloring. Even in this respect their power is but lightly felt here. To comprehend the full meaning of color, and assimilate its joyous dignity or sensuous delight, it requires a temperament and training akin to those

of the old masters themselves. Few Americans develop in this direction. The two painters who have most studied the color-toning of the Venetians, aiming at similar results, are Tilten [6] and Page.[7]

Tilten has too little science or original thought to produce anything strikingly new, or to comprehend the great principles of art which underlie the works of those he seeks to rival. Of an impressible and ardent temperament, with an undisciplined intellect, he reflects similar qualities in his landscapes. When not borrowed directly in idea from Turner, Claude, or others, they are studies after nature of considerable merit in aërial perspective, cloud-forms, gradations, and tones, but of late so thinly painted, infused and false in hue, and undefined in design, as to seem more like the ghosts of pictures than tangible art. If he hits upon success in some special quality of painting, it is chance skill, not scientific law. A weak sentimentalist in color, having no solid foundation of knowledge or inventive force, Tilten goes backward rather than forward, thus disappointing the hopes of many who were attracted to him in the early part of his career by the delicate sensuousness of his style and apparent promise of truthful work.

Page is a man of larger calibre, but of a similar system of painting. While Tilten dreams, Page theorizes. He intellectually tries to grasp the old masters, and to absorb them into styles and ideas of his own. His latest manner is thin and bituminous, and almost destitute of other design than mere suggestions of forms, bones, and articulations. Both Page and Tilten seek effects by artifices, novelties, and experiments of the brush, and ambushes of studio. Their art, seen away from certain given conditions, is as unsatisfactory as dissolving visions. Wanting in creative thought, Page plagiarizes whole compositions from the old men.[8] We do not know an original composition of his of any moment. Even his Venus bears a close resemblance to that of the Frenchman Péron.[9] It is sensuous and graceful in idea, but bilious in color. In avoiding the meretricious daintiness of his prototype, he has fallen into a repellent realism, which not even his intense dinginess of hue can sufficiently veil. It is an apotheosis of the animal woman, suggestive of sportive wantonness and conscious seductiveness. Seldom, indeed, do mod-

ern painters of the naked woman lift her out of the mire of the sensual. To paint a good portrait requires a master's hand; much more the entire woman, as the highest type of divine creation, morally, intellectually, and physically. The religion of the pagans demanded this of art, and theirs was equal to the call. But the religion and taste of the moderns both condemn it. Hence these pictures are exceptional, and are apt to excite exceptionable curiosity. Being experiments to test the powers of the artist, they should be essayed by no one not a consummate artist, and holding to the highest idealization of woman in every quality. The recent attempts of Wight [10] in the Sleeping Beauty and Eve at the Fountain, though creditable to his ambition, are injurious to him as an artist, on account of their sensualism and excess of surface-charms. Tyros in the human figure should not flush their virgin brushes with such difficult subjects. Only the maturity of power of a Titian, Bazzi, or Raphael, can elevate them into the region of pure art.

But to return to Page. There is much in him to command respect. He experiments boldly in pursuit of the combined splendor and purity of Titian, thinks profoundly, reasons plausibly, speculates acutely, and always essays high art. Ever ready to confound or convince, he surprises, delights, confuses, and disappoints all at once. Some of his portraits exhibit nice discrimination of character; while his ideal art, notwithstanding faults of grammar and much want of good taste, when he departs from direct copying, has something grand in suggestion, showing familiarity with great work. A great artist is hidden somewhere, but he eludes actual discovery. And so far as Page has sought to translate the magnificent Venetian into American art, he has failed.

No one of our artists has brought back with him from Italy a more thorough knowledge and appreciation of the old masters, technically, historically, and æsthetically, than C. G. Thompson.[11] He conscientiously endeavors to infuse their lofty feeling and motives into his own refined manner. But it is the French school that mainly determines the character of our growing art. In some respects New York is only an outgrowth of Paris. Every year witnesses a marked increase of the influence of the metropolis of

France in matters of art, taste, and fashion, on the metropolitan city of America. So powerful, indeed, is its influence in Europe, that the hope of the English school now lies in the example and teaching of its rival. Exhibitions and sales of fine specimens of the French school have already vastly benefited us. Owing to the concentration of our most promising artists at New York, it has grown to be the representative city of America in art, and indeed for the present so overshadows all others that we should be justified in speaking of American painting, in its present stage, as the New York school, in the same light that the school of Paris represents the art of France. This predominance is more likely to increase than decrease, owing to growing professional facilities and the encouragement derived from a lavish patronage. It is particularly fortunate for the American school that it must compete at its own door with the French. The qualities of French art are those most needed here, in a technical point of view, while its motives and character generally are congenial to our tastes and ideas. The Dusseldorf was an accidental importation. That of Paris is drawn naturally to us by the growth of our own. Were the French school what it was under the Bourbons, or the Empire even, conventional, pseudo-classical, sensual, and sentimental, deeply impregnated with the vices of a debauched aristocracy and revolutionary fanaticism, we should have been less inclined towards it than to any other. But it crosses the Atlantic refined, regenerated, and expanded by the force of modern democratic and social ideas. The art of France is no longer one of the church or aristocracy. It is fast rooting itself in the hearts and heads of the people, with nature as its teacher. The primary tendency of what may be called the democratic art-instinct, as distinguished from that founded on the ideas of an aristocracy of blood, is to materialistic expression. This, in turn, gravitates toward the animal, sensational, and common, from a disposition to please the masses. In no democratic community, as yet, have they been elevated in æsthetic refinement and taste to the standard of the aristocratic sentiment. That they may and will be, we devoutly believe. To this end, we cannot watch too closely the training of our youthful school. In art as well as literature the most

enduring things and endearing are those which best intimate an existence above the level of the worldly and vulgar. Next in value is that which eliminates from man's nature the coarse, sensual, and superficial, substituting the beautiful, good, and permanent in their stead. Any art which bases itself upon the purer instincts of humanity at large, such as a healthful enjoyment of nature, domestic love, and the sentiments and passions that dignify the human race, holding fast the great principle of elevating the entire people to the full stature of manhood, — such an art is, in virtue of its birthright, essentially democratic. The progress of French art being in this direction, it is the natural friend and instructor of American art; and, while it remains true to its present renovating principle, we cannot have too much of it. If our art relied solely on its own intuitive popular instincts for its development, its inclination would be too much toward the low and common, or purely external, as we see in those artists who are averse to studying foreign examples. Their proclivities naturally return towards their source, in the vast underlying materialism of the present stage of our civilization. France holds a check over democratic vulgarity which we lack. This exists in the standards of refinement, elegance, and finish, the perfection of styles and details as fine art, which an aristocracy accumulates as evidence of its intrinsic superiority of position and education. We have the reflected influence of this in the works and pupils of the French school. Without this living, refining element, destitute as we are of museums and galleries of classical and mediæval art, our progress would not merely be less rapid, but would be mainly in a direction not the most desirable.

The chief evidence of the growing value of the French school to ours is shown in the development of a taste for something beside landscape. As yet we borrow motives and styles somewhat lavishly, and put them into American types, with a moiety only of French skill and feeling. In time, imitation will weary alike the painter and buyer, and a more laudable ambition possess them. Thanks to French incitement, the dawn of a respectable school of *genre* and home painting is nigh at hand. We say "home," because there is no other word which includes so entirely, to the Anglo-Saxon

ear, all those feelings, sentiments, and ideas which have their origin and growth under the family roof and in social training. Its motives are healthful, aims excellent, spirit patriotic; but as yet the flesh is weak to execute. Eastman Johnson [12] and Thom [13] worthily represent this branch. Johnson would be a greater man, if he could be taken from New York, and placed where he could be stimulated by the competition and example of equal or greater abilities.

Animal life is almost unrepresented. Hinckley,[14] with the worst technical faults of the native American school thick upon his brush, has but few competitors in his line. Some of his early pictures were clever, but he has done nothing since except to repeat himself in thin skins of cattle, with no more vitality in them than in the canvas to which they stick. We have in Beard,[15] however, fresh from the Western wilderness, an artist of the genuine American stamp, of decided originality and versatility. He paints animals from the human point of action, passion, and sentiment. With him humor is fine wit. He has an exquisite sense of the ludicrous and sensuous. His brutes are four-legged humanity. In his own vein he has no equal. He paints not merely jokes, but ideas vital with merry thought and healthful absurdity, so that his pictures mean something beside painting. They interest, at first glance, from their freshness and novelty, and draw us again and again to them by their subtle meanings and cheery moods. The most elaborate and best painted of his quaint compositions that we have seen is a March of Silenus, in which tipsy bears do the Bacchanalian dance. The Exchange of Compliments between the braying donkey and the cackling geese almost makes one hold on to his ears; while the Jealous Rabbit embodies in the form of the timid puss more of amorous anger and ludicrous surpise than it has been our fortune as yet to see put into human form in our painting.

The instinct of our best colorists lies in the blood, though the development and training is much due to foreign sources. Dana, Thorndike,[16] Cole, Hunt, La Farge, and Babcock may be mentioned in this connection. In all there is a warmth, delicacy, or refinement of execution and sentiment seldom excelled anywhere. Thorndike is so thoroughly French in style and motives that his

pictures need naturalization before being popularly welcomed at home. Dana [17] is full of talent, colors attractively, though not always harmoniously, as is shown by his most ambitious picture, Heart's-Ease, which neither in taste nor treatment is equal to some of his less pretending works. The motives of his compositions are among the most charming of *genre* painting. Children become real on his canvas, in their merry games or pensive moods. He has a tender sympathy for them, for animals, and for whatever is refined and beautiful. But he has the fault common to most American painters. *Chiaroscuro* is neglected, and color overpowers design. There is more show than substance of modelling. The touch is either too thin or too heavy and clumsy, lacks self-confidence, decision, and precision. The emphases of art, those pencil-strokes which betray the master-hand, being of exactly the right quantity, quality, degree, and fineness, in exactly the right place, to a hair's-breadth, are yet to be acquired by many of our best young painters.

William Hunt [18] is one of those who are over-inclined to disregard force of design for subtilties of expression and color; but it is so deliciously done, and with so tender or fascinating sentiment, that one scarce notes the deficiency of special artistic virtue in the attractiveness of the whole picture. We perceive that he is feeling for great qualities, and so overlook any transitory failure of lesser. His style is vaporous, diaphanous, and unpronounced in outline, in fact, too unsubstantial, but singularly clear, broad, and effective; nothing little or forced, though sometimes slight and incomplete in details of modelling. The sentiment of his common motives is sweetly musical in feeling, because of delicate harmonies of color. He has introduced grace, freedom of action, and original thought into his portraits, establishing for himself an individuality of expression and treatment as distinctive as that of Vandyke or Veronese. There are draperies of his treated after a manner which either of them might call his own. At present he bestows too much labor on the accessories of his portraits, which often are so beautifully executed as to distract attention from the principal features. French influences are apparent in his painting.

The Drummer-Boy is a Parisian *gamin*, no Yankee blood in him. His Bugle-Call is a very spirited phantom, suggesting characteristic fire and action. Hunt is evidently on the road to eminence, working out an original manner exceedingly seductive in its general character, but has not yet given the full measure of his power, or displayed great range of composition.

J. F. Cole [19] gives to landscape its long-needed poetical, sympathetical elements, expressed chiefly in delicate gradations of color, and quiet, slumberous distances, indicative of the mysterious tenderness and repose of nature. His pictures are sweet melodies and pensive poems, as welcome as the soft, low strains of dreamy music, or the quiet tones of a much-loved friend, but pitched too much on one key, and with a tendency to sameness, and want of local emphasis and general vigor, which he would do well to heed in the beginning of a promising career.

The prophecy of a great colorist and a profound artist of deep religious feeling, of a tone inclining to spiritual melancholy, and of a rare and peculiar sensibility, intensified, perhaps, by influences outside of art, strictly speaking, is rapidly unfolding in La Farge.[20] Of a wealthy New York family, La Farge goes to art with earnest devotion and an ambition for its highest walks, bringing to the American school depth of feeling, subtility of perception, and a magnificent tone of coloring, united to a fervid imagination which bestows upon the humblest object a portion of his inmost life. These qualities are rare and remarkable anywhere, but particularly so in America. He evokes the essences of things, draws out their soul-life, endowing them with an almost superhuman consciousness. The solemn splendor and interpenetrative power of his free, unconventional manner, with its spiritual suggestiveness of hues, seize upon the imagination and bind it firmly to his art, through sentiments that act more directly upon the heart than the head. His forms are massed and hinted in an effective manner, instead of being sharply outlined and elaborated as is the art of the realists. But La Farge's, although devoid of much that the Pre-Raphaelites insist on as the exact, rigid truth of nature, as seen with microscopic eye, is truer to the consciousness of his topics in the whole.

His landscapes are gems of imaginative suggestion and delicate, vital treatment, not pantheistic in sentiment, although the soul of nature breathes in them. They interpret nature to us as sentient, sensible, not sensuous, but spiritually beautiful, — the Christian idea of one God manifest in the universe, contrasted with the Pagan invention of gods many. He takes up the spirit of the landscape where Turner left off, and infuses it with a wonderful vital quality, making it a living thing akin to man, or uniting it and the spectator into one common sentiment of childhood to the Father, bestowing upon it human moods of inspirational fervor and intenseness, such as we have seen in no other American artist. This treatment is as remote from the Greek idea on the one hand, as it is from the ascetic, spiritual conception of the mediævalists on the other. It is a fresh truth given to landscape art, and, if perfected, destined to win for it a holy distinction, and endearment in human hearts.

A flower of his has no botanic talk or display of dry learning, but is burning with love, beauty, and sympathy, an earnest gift of the Creator, fragrant and flexible, bowed in tender sweetness and uplifted in stately pride, a flower whose seed comes from Eden, and which has not yet learned worldly ways and deformities. Out of the depth and completeness of his art-thought, by a few daring, luminous sweeps of his brush he creates the universal flower, the type of its highest possibilities of beauty and meaning, using color not as fact, but as moods of feeling and imagination, having the force of passion without its taint. Such are his Wreath of Violets, the Rose-mallow, Lilies, and other evidences of his genius in unpretending motives, all of them suggesting capacity for greater themes.

Though of Puritan stock, not one element of it is perceptible in William Babcock's art.[21] Paris has taken him to herself. Nevertheless, his individuality is of marked character. His sense of color is derived from no extraneous source, but is an infusion direct from original life. It is a madness, a wild passion, a splendid frenzy; Babcock is color-drunk. It would be hasty to say that he cannot draw or model, but he will not heed design while the fury of color is upon him. For him there are no cold tints in nature; on clear, hard

skies, sharply defined outlines, high lights, dull browns, chalky whites, chilling grays, or leaden hues; none of the atmospherical gloom and other common characteristics of the American eye in painting. Neither is there a metallic glare or staring opacity to his pictures, nor positive, prismatic, spotty discord, or straining after the eye-offending crudities of pseudo-colorists. But he revels in his own magnificent sensuousness, as indifferent to the opinions of common mortals as Jupiter at an Olympian banquet. Rich-toned ultramarines, purples, oranges, crimsons, and violets blaze in his skies, deepen his vegetation, and glow upon his figures with the consuming fervor of an Oriental's dream of voluptuous languor, or his vision of a flesh-entranced paradise. This fanaticism of color is no superficial charm. At will, it is transparent, harmonious, majestic, tender, and sensuous. By his magic wealth of brush he transmutes the common air and world into a new earth and heavens. The first glimpse of the spectacle is so captivating to the sensitive eye that it throws a glamour over the senses and stirs the heart to wild beats, like strains of Beethoven. But this is all. His delight in childhood is tender, sensuous, and pagan; in womanhood, voluptuous, though not vulgar. He aims to give the charm of warm, pearly, elastic flesh, ripe surface-beauty. The feeling of his inspiration is essentially pantheistic. His little ones are *amorini* or loves, sometimes naked, sometimes clad in artistic costumes of his own fashioning. He seems to scorn men, because not offering those corporeal qualities he pants for. We seldom find them in his pictures. The types of his figures, so far as the drawing goes, is often common, if not worse. Evidently, his idealism is exhausted on pigments, and he is gifted with no grace of design, though showing no little taste and spirit in composition. One views his works with mingled regret and admiration. Unless the chaotic feeling and force he displays be reduced to artistic order, nothing absolutely great and good will arise out of them, but, as with Poe, we shall have to mourn over the quenched fire of a real poet.

Having shown the various foreign elements that influence American painting, we now turn to its more indigenous phases. The conventional or academic branch has nothing very distinctively local

in tone, original in conception, or distinguished in feature. Like its fellows everywhere, it is eclectic by principle, deriving its instruction from older schools, and assimilating, as well as possible, the scientific learning of art. It has developed clever men, but they have too much the character of artists made to order. An academy, as commonly conducted, is too literally a pedantic *school*. It trains many minds of average abilities into certain styles, with an amiable indifference as to what they paint, so that they please patrons and grow famous. In undergoing this sort of discipline, individualism must be sturdy not to sink into conventionalism, and accredit the grammar of art as of more value than its spirit. Artists educated after this manner never wholly free themselves from the bondage of an imposed style and outside dictation. The picture is the chief aim. It comes to be with them as with a certain class of literary men: elegance of expression takes precedence of originality of idea. Each phrase is composed by rhetorical rule, and marshalled into place by bugle-call. The painting of France flourishes, because it is the free growth of studios and nature. Individual genius has liberty of choice and nutriment. Democracy favors the system of free competition. Aristocracies found academies, and seek to bind art down to rule, or guide it by favoritism and patronage. America is too democratic to yield up hers solely to such guidance. The academic influence is already undermined. In future, it will have little weight either with the intelligent public or young artists; for it has small cohesive force, and no strong outside pressure, as in England, to give it strength of resistance. So far as it affords facilities of elementary instruction, keeps alive the traditions of art, collects, preserves, and disseminates knowledge, and promotes a more intimate union between artists and the public, it is useful. But the inherent tendency of an academy, under present forms of organization, is to exclusivism, dictation, and narrowness. A few are petted; the many pine. In the end, New York will boast one more handsome building in its Academy of Design, controlled by a *dilettante* clique, — of qualified benefit, but having no life-giving control over the young democratic art of the land.

Durand,[22] Gray,[23] Wier,[24] and Huntington [25] are representative

artists of academic training. The refinement and high-bred tone of the last-named painter are very winning. In general, the academicians proper exhibit considerable skill of manipulation and detail, facility of composition, and those composite qualities which make up an accomplished rather than an original man. No great men are to be looked for in this quarter; for greatness would be at war at once with its system of routine and conventionalism, and consequently would not be tolerated.

The common portraiture of the day is far from being a lineal descendant of our early art. It is less refined, heavier and darker in color, more materialistic in technical treatment and realistic in expression. Elliot [26] is the chief exponent of the new style. He has a Salvatoresque touch of brush, and brings forth the coarser elements of his sitters. Healey [27] has done good things in historical composition, and forcible things in portraiture. He has much talent, but is deficient in the language of color. Ames [28] is the reverse, when he takes time to finish. He has a delicate fancy for color, composes in it, and has produced many good portraits. By nature he is an idealist, with considerable poetical ability, but does not give that attention to design and solid painting which complete art demands. And here let us remark, as a qualifying statement due to the reputation of many, that the exigencies of life and sitters force them frequently to hasty and superficial work, which their knowledge condemns. This is a mistake. Whatever is worth doing is worthy of best work, and would ultimately command a suitable return; whereas the opposite course encourages weakness and superficiality, or tempts to sensational experiments.

The thoroughly American branch of painting, based upon the facts and tastes of the country and people, is the landscape. It surpasses all others in popular favor, and may be said to have reached the dignity of a distinct school. Almost everybody whose ambition leads him to the brush essays landscape. To such an extent is literalness carried, that the majority of works are quite divested of human association. "No admittance" for the spirit of man is written all over them. Like the Ancient Mariner's "painted ship upon a painted ocean," they both pall and appall the senses. Their barrenness of

thought and feeling become inexpressibly wearisome after the first shock of rude or bewildering surprise at overstrained atmospherical effects, monotonous in motive, however dramatically varied in execution. The highest aim of the greater number of the landscapists seemingly is intense gradations of skies and violent contrasts of positive color. The result is destructive of any suggestion of the variety and mystery of nature. We get coarse paintings, pitched on a wrong key of light or color, hastily got up for a market, and sold by scores, often all by one hand, at cheap auction-sales. The more common features of nature are so easily given on canvas as they appear to the undiscerning eye that the public is deluged with a sort of trash-literature of the brush, which ought to be consigned to oblivion so far as it attempts to pass itself off for true art.

Furthermore, we are undergoing a virulent epidemic of sunsets. Despite that one of our transcendental painters says there can be no great work without the three fundamental qualities of "rest, repose, and tranquillity," our bias is rather in the direction of exaggerated action and effects. In accordance with his scale of definition, he might have added three others much in vogue, namely, "bigness, greatness, largeness," culminating in what an artist wittily calls full-length landscapes. To be added to these foibles are slipshod work, repetition, impatient execution, and an undue self-estimate, arising from want of competitive comparison with better-instructed men. Numbers of pictures seem painted for no other purpose than to display the painter's autograph. We have noticed this even in portraits, the artist's name being more conspicuous than the sitter's features. Thus much for the weaknesses of our landscape art. Now for its strong points.

Church [29] leads or misleads the way, according as the taste prefers the idealistic or realistic plane of art. Certain is it that Church has achieved a great popular success in his tropical scenery, icebergs, and Niagaras, — success which brings him orders for pictures as fast as he can produce them, at prices heretofore fabulous in his branch of art. Dr. Johnson says he who writes otherwise than for money is a fool. For "writes" read "paints," and we get

a primary motive-power for any school of artists. Not that true artistic ambition does not here exist, but a sudden success, measured by pecuniary gain and sensational effect, is not the most wholesome stimulant for youthful art.

No one, hereafter, may be expected to excel Church in the brilliant qualities of his style. Who can rival his wonderful memory of details, vivid perception of color, quick, sparkling, though monotonous touch, and iridescent effects, dexterous manipulation, magical jugglery of tint and composition, picturesque arrangements of material facts, and general cleverness? With him color is an Arabian Nights' Entertainment, a pyrotechnic display, brilliantly enchanting on first view, but leaving no permanent satisfaction to the mind, as all things fail to do which delight more in astonishing than instructing. Church's pictures have no reserved power of suggestion, but expend their force in *coup-de-main* effects. Hence it is that spectators are so loud in their exclamations of delight. Felicitous and novel in composition, lively in details, experimentive, reflecting in his pictures many of the qualities of the American mind, notwithstanding a certain falseness of character, Church will long continue the favorite with a large class.

But a competitor for the popular favor in the same direction has appeared in Bierstadt.[30] He has selected the Rocky Mountains and Western prairies for his artistic field. Both these men are as laborious as they are ambitious, regarding neither personal exposure nor expense in their distant fields of study. Each composes his pictures from actual sketches, with the desire to render the general truths and spirit of the localities of their landscapes, though often departing from the literal features of the view. With singular inconsistency of mind they idealize in composition and materialize in execution, so that, though the details of the scenery are substantially correct, the scene as a whole often is false. Neither manifests any grand conception of nature, nor appreciation of its poetry. Graphic beauty of composition and illustration are their chief points. Bierstadt uses the landscape also to illustrate Indian life. His figures are picturesquely grouped, prosaically true to actual life, giving additional interest to most observers, though

rendering his great work, the Rocky Mountains, confused, and detracting from its principal features, beside making it liable to the artistic objection of two pictures in one, from different points of view. We form our estimate of him from this picture. It is to be welcomed, because it recalls one from the delusive enchantments of the Church style to a more strictly scientific expression of nature. Titian and Correggio in their backgrounds give us the highest qualities of the landscape, by a broad and noble suggestion of its forms, in tone and meaning subordinated to their chief motive. But this grandly simply treatment finds few friends in America. Its practical life demands absolute truth of representation. In many respects Bierstadt has been very successful. If he has no liking for the broad, imaginative treatment of Titian, neither has he any more for the conventional lifelessness of the mechanical Dusseldorf school. He seeks to depict the absolute qualities and forms of things. The botanist and geologist can find work in his rocks and vegetation. He seizes upon natural phenomena with naturalistic eyes. In the quality of American light, clear, transparent, and sharp in outlines, he is unsurpassed. Cloud-shadows flit and play over sunlit hills and distant snow-peaks, rising clear and cold against the lofty horizon, with truthful effect. But his light is pitched on too high a key, which leaves his color cold and glaring, and produces overmuch transparency of atmosphere, whereby distances are in some degree confused and deceptive. As a colorist, Bierstadt appears to better advantage in his Sunshine and Shadow, a reminiscence of the Rhine. On the whole, however, he has well depicted the silvery clearness and translucency of the mountain-air of the West, and managed to avoid the prominent defects of the school in general. At the same time, we must confess that our taste has but transient sympathy with its hard-featured rationalism, no matter to what degree it compels admiration of its executive qualities.

Kensett [31] is more refined in sentiment, and has an exquisite delicacy of pencil. He is the Bryant of our painters, — a little sad and monotonous, but sweet, artistic, and unaffected. In his later pictures there is a phantom-like lightness and coldness of touch

and tint, which give them a somewhat unreal aspect. But they take all the more hold on the fancy for their lyrical qualities.

Gifford [32] has an opulent sense of color, but its tone is artificial and strained, often of a lively or deep brimstone tint, as if he saw the landscape through stained glass. His touch is vigorous, his design more forcible than accurate, and his style, as a whole, conventional and untrue, but manifesting qualities attractive to those who, having outgrown the merely mechanical and literal, have not yet familiarized their minds with the highest aims and efforts of art.

Cropsey,[33] Sontag,[34] Ginoux,[35] Heade,[36] and G. L. Brown,[37] are names also in good standing as American landscapists, of something more than local reputation. All are realistic to a disagreeable degree, Heade only by color affording any sensuous gratification or relief from the dreary, mechanical intellectuality of the others. His speciality is meadows and coast-views, in wearisome horizontal lines and perspective, with a profuse supply of hay-ricks to vary the monotony of flatness, but flooded with rich sun-glow and sense of summer warmth. Sontag and Ginoux are dexterous in the forms and composition of American scenery, delighting in the wildly picturesque, catching its spirit in that respect, but painfully disappointing from their insensibility to low tones and harmonies of coloring. The extreme delicacy and poetical feeling of Kensett's style almost make one forget his weakness of tint; but in the artists now under review their deficiency of imagination and profuse employment of cold pigments are absolutely disagreeable, while their scale of light, false to art, in its futile attempt to rival nature by the lavish use of white-lead, renders their coloring dry, spotty, and glaring, disclosing details in design akin to the rude emphases and conventionalisms of Salvator Rosa's brush. But barren of ideas and vicious in manner as is their style, it is fine art as compared with the average productions of G. L. Brown. His is pictorial slopwork; crude tints, hot, staring, and discordant, loaded on the canvas with the profligate palette-knife dash of a Rembrandt, without the genius that transformed his seeming

193

recklessness into consummate art. Brown having been educated under the influences of the best schools, his knowledge of drawing and composition is of no inferior order. Yet the American taint of hasty, sensational work is so strong upon him that he degrades his talents into a vulgar style, crowded with trickeries, and no more resembling high art than a speech of Parson Brownlow is like an oration of Wendell Phillips.

We are almost tempted to withdraw Ginoux from this connection as showing the extravagant and false tendency of one section of our landscape art, on the strength of his Niagara by Moonlight. Although painted after his usual manner, it gives a fair realistic suggestion of the flow and force of the cataract, under the mysterious conditions of a clouded moonlight, which greatly heightens the effect of the whole scene, and baptizes it with the spirit of the imaginative unreal, making it the opposite of Church's Niagara by Sunlight, whose sole suggestion is of mathematical quantity, space, depth, rapidity, and fall, with accurately imitated tint.

Bradford [38] has made a decided advance in the forms and motions of waves. He has put movement into the ocean, and swept its surface with gales. Some of his colored and India-ink sketches of shore-scenery are fine bits of realistic study; but in painting he gets metallic and hard, and keeps repeating himself.

The prominent characteristics of the American landscape school are its realism, vigor, enterprise, and freshness. Partaking of the spirit of our people, it is dexterous, quick to seize upon new points, intellectual, and mechanical, viewing nature rarely in other than external and picturesque aspects, and little given to poetry or ideas. Aspiring to the natural only in motive, it looks as earnestly to the practical in result. If it be deceptive, it is so only as trade is, from ambition of success and fervor of competition. Partaking of the enterprise of commerce, it sends its sons to Brazil, to the Amazon, to the Andes, beyond the Rocky Mountains; it orders them in pursuit of icebergs off frozen Labrador; it pauses at no difficulties, distance, expense, or hardship in its

search of the new and striking. The speculating blood infuses itself into art. Within proper limits, the zest of gain is healthful; but if pushed to excess, it will reduce art to the level of trade.

But landscape does not wholly go in this direction. Inness [39] is a representative man of an altogether different aspect. He influences art strongly in its imaginative qualities and feeling; impersonating in his compositions his own mental conditions, at times with a poetical fervor and depth of thought that rises to the height of genius, and at others with a chaotic wildness and disregard of law or fact, though never without a disclosure of original power, that causes one to pause before deciding upon his final position. Wildly unequal and eccentric as he is, recklessly experimentive, indulging in sameness of ideas, often destroying good work by bad, lawless in manner, using pigments sometimes as though they were mortar and he a plasterer, still there is ever perceptible in his works imagination, feeling, and technical instinct of a high order, which need only the balancing power of experience and a steady will to raise their possessor to the rank of a master. The French school has tempered his style, but he is by no means a mechanical follower of it. He can be as sensitive as he is powerful in his rendering of nature's phenomena. The aërial distances and perspective of his best moods are subtile and delicate, like nature herself. We can breathe in his atmosphere, and travel far and wide in his landscape. At times his skies are tough, woolly, and opaque, from carelessness of brush in details, while infusing the whole with vital life and action. His trees sway; his leaves play in the breeze; his clouds lower and are rainladen; water sparkles and ripples in limpid, rhythmic joy; vegetation has the qualities of tender growth; the earth has a sense of maternity; mountains, hills, and meadows, sunlight and shadow, all gleam with conscious existence, so that, unlike the generality of our landscape art, his does not hint a picture so much as a living realization of the affluence of nature. Inness gives with equal facility the drowsy heat, hot shimmer, and languid quiet of a summer's noon, or the storm-weighed atmosphere, its dark masses of vapor, and the wild gathering of thunderclouds, with their solemn hush before the tempest breaks. He uses

sunlight sparingly, but it glows on his canvas, and turns darkness into hope and joy. His is, however, a stormy nature, pantheistic in feeling with a naturalistic expression, brooding over the changeful scenes of earth, rejoicing in the gorgeous mysteries or wild mournfulness of glowering sunsets, or clouds radiant with rainbow-promise of final peace. There is nothing of terror or the grotesque in his imagination. It speaks rather of the mourner who faints and hopes. This overflow of sadness is almost epic in expression, and is heightened by his intense idealism of color, which is as much of his blood as Babcock's. The spirit of his landscapes alone is American. Their tone is not Venetian, nor wholly French, but partakes of that fervid warmth with which we love to invest the heart's creations. Gold and purple, intense greens, crimsons, hues that melt and harmonize into liquid warmth, vigor, daring, intensity, poetry, a passionate delectation in nature, as if he were born of her untutored, irrepressible emotions: such are his characteristics, varied with startling inequalities and wantonness of brush, making Inness the Byron of our landscapists.

Darley [40] is a prolific artist in design of the homely, pathetic, and humorous, strongly individualistic in the American sense, but with a heavy, monotonous stroke of pencil and commonness of human type which give to his compositions an almost uniform sameness of style and character. Nevertheless, he has great facility and vigor, a knowledge of drawing, intenseness of executive skill, and capacity of realistic illustration, which stamp him as a remarkable man.

Hammatt Billings [41] has capacity of higher order. His taste is refined, talent versatile, fancy subtile, and imagination inventive. In the limited scope of architecture allowed here, he has given evidence of a latent genius which in any other country would have been stimulated and developed to its fullest power. Thus far, he is more commonly known by his beautiful illustrations of Keats, Tennyson, and the most intellectually spiritual of the poets. In the lyrical grace, variety, and delicate beauty of his compositions, and sympathetic rendering of the text, he has no superior in this country. His brain is a rich mine of æsthetic

wealth. He does not so much translate poetry into pictorial art as recast it in exquisite shapes of his own invention. The mere overflow of his mind would make a reputation for the common run of architects and artists. Indeed, we fancy, more is already due him in Boston than appears on the surface, for his own generous virtues and modest self-appreciation stand in the way of his worldly prosperity.

The lofty character and vast issues of our civil war have thus far had but slight influence on our art. Rarely have our artists sought to give even the realistic scenes of strife. This may be in part owing to their inaptitude in treating the human figure, or the delineation of strong passions and heroic action.

Judging from wood-cuts in "Harpers' Weekly" of compositions relating to the various stages of the war, Nast [42] is an artist of uncommon abilities. He has composed designs, or rather given hints of his ability to do so, of allegorical, symbolical, or illustrative character, far more worthy to be transferred in paint to the wall-spaces of our public buildings than anything that has yet been placed on them. Although hastily got up for a temporary purpose, they evince originality of conception, freedom of manner, lofty appreciation of national ideas and action, and a large artistic instinct.

We close this brief analysis of the elements of the American school of painting with a notice of a young artist whose incipient career gives promise of great distinction. Prediction is ever uncertain, but there are elements of æsthetic genius of so unmistakable a character, that, when perceived, we are warranted in believing in their final expansion into consummate art, if their possessor be but true to them. Such, we trust, will prove to be the case with Elihu Vedder, [43] of New York. We have watched his career in Europe and at home with interest. He has had no adventitious circumstances of fortune of friends to aid him, but has bravely struggled through many adversities. Vigor and independence in him are allied to great ambition and genuine æsthetic instinct. He has, moreover, perceptive and imaginative faculties of no common order. While in Italy, he manifested a keen appreciation of the

best elements of its old art. A close, indefatigable student, he never became a mere copyist, but, making notes of ideas and technical details, assimilated to himself much of the lofty feeling and strong manner of the world's masters in painting. Without falling into servility of style, Vedder gradually acquired the strong, fine, solid manner of painting which distinguishes him. If we compare his figures with those of another artist of decided talent, William Hunt, for instance, we see a marked contrast in an essential quality of art. The men, women, and animals, and lately the landscape, of the latter, are mere shadows in comparison. They are effigies or phantoms, beautiful in sentiment, but falling short of consummate art. Vedder's are solid projections, having the strong relief of nature, standing out of the canvas, indicating absolute substance and weight. His big men are ponderous; all his forms are substantial. Hunt's are more potential; the one aiming rather to secure certain effects, the other realities of art.

The development of Vedder's talents has been systematic and orderly, at times troubled by the contrast in his own mind between his ideal and his execution, but ever onward, with the assurance of laying a firm foundation each step of his way. The great masters cheered and sustained him, because he lived their lives over in himself, believing their possibilities were as much his as was their slow and checkered progress. Weak men are apt to be discouraged on looking at the result of a great life, but strong men see in it each successive failure and discouragement bravely put aside, until perfect work grew at the master's touch. They analyze and deduce. Difficulties and obstacles stimulate as much as fruition cheers. In these points Vedder has shown himself to be an artist of rare mental calibre. The greatest trial has ever been to satisfy himself. To this day, but few of his pictures have been given to the public, although often in extreme straits of purse. He aspires to nothing hasty, premature, superficial, or sensational, but great work, in a broad, true manner. The smallest detail is equally cared for with the profoundest fact, in its relation to artistic unity. He understands emphasis and punctuation in painting, and has already seized upon that rarest of qualities, the indefinable touch of a master.

Fortunately, his instinct and knowledge of color are well balanced, so that he does not disport himself, as many do, in fantasies and passions. We do not mean to assert, what Mr. Vedder would thoroughly disclaim, that he is a complete master, but that he is on the right path to become one, and has already shown an original ability and formed an individual style remarkable for so young a man, comparatively unaided, and quite unexampled in comprehensiveness in our school of painting. Experience and study will do much for him in the future, if he persevere as he has begun. It is only by striving to attain consummate art in a large manner that he can lay a broad and deep foundation for final success.

Vedder is a painter of ideas. His style is naturalistic as relates to truth of illustration, but ideal and intellectual in motive. He has shown no more fancy for the barren externalism and dry-bones literalism of the extreme Pre-Raphaelites than for the flimsiness and carelessness of their labor-shirking opponents. The character of his art is Turneresque in largeness and variety of conception, while he seeks to avoid the inequalities of technical execution of the great English master. Vedder's inventive and perceptive faculties have a wide range, united with intense power of expression, thus far confined almost wholly to intellectuality of motive. Neither human passion, nor spirituality, in the sense of a deep apprehension of the ideas and sentiments that draw man's attention to his future being, exalt and intensify faith, in short, promote and invigorate his religious consciousness, has he shown a bias for, any more than other of our artists. The absence of the passionate and ecstatic leaves a great chasm in our art. Nevertheless, Vedder is as versatile as he is forcible. He can be alternately sentimental, humorous, tender, grotesque, terrible, and suggestive, giving nature truthfully after its external features, or endowing it with pantheistic vitality and variety of ideas. We should be glad to see the pure element of spirituality in his works, as we understand Christ's interpretation of it, and which La Farge alone of our artists hints at. But the spiritual growth of man is either the fruit of spontaneity of soul or of maturity of knowledge, and must manifest itself in our art either from intuitive consciousness or by the

slow, cumulative process of development of wisdom. We shall not, therefore, blame young men for the lack of powers out of the compass of will to command. Vedder has enough beside to enchain attention and command recognition. Especially is his imagination active and acute in its pantheistic sympathy with the mysterious, grand, terrible, or desolate in nature. It broods over solitudes that recall primeval desolations, where no living thing could be, unless it was some monster more fearful even than the awful silence of a nature dumb with the terror of its own creation. The best things of Vedder exist mainly in sketches or unfinished work. Hence, the public must look upon him rather as a suggestion of possible greatness than as the fulfilment. He can treat children as charmingly as Frère, and with a finer poetical meaning. Witness the picture of the tiny peasant Baby tottling down steep stone-steps to reach the flowers held out to her by her little sister in a wild area below into which she has strayed, as charming in color as delicious in sentiment, — a picture which epitomizes young life's giddy pursuit of pleasure, or the angelic trust of babyhood in its puny grasp after happiness.

Vedder's sense of humor and power of illustrative art are admirably shown in the graphic series of compositions of the well-known fable of the Old Man, Son, and Donkey, and his pictur-esqueness of thought and vivid conception of Orientalism in his beautiful paintings taken from the "Arabian Nights' Entertainments." These glow with tropical fervor, and sparkle like precious gems. His Sphinx is true to the idea conveyed, though lacking as a picture of the mysterious desert. In the faint morning twilight, a naked Arab puts his inquiring lips to the mouth of the inscrutable statue, and asks to know the Great Secret of life, but receives no answer except the devouring silence, solitude, and death that encompass him. The Star of Bethlehem displays the volcanic sterility of the region of the Dead Sea, through which journey the Wise Men of the East, with their gifts, guided by the miraculous star, which illumines the far heavens, and discloses troops of celestial beings hurrying down to earth with the glad tidings to men.

Another of Vedder's thoughts is Christ on the Cross at Midnight, the prophets and patriarchs, having risen from their graves, looking up in solemn wonder at the divine sacrifice, to know what it portends to them.

Themes like this show an incipient desire to treat the supernal, and to reach forth after the sublime. Into everything he undertakes he infuses new life, filling the spectator with fresh currents of thought and imagination, or quickening his sympathies into intenser action.

Vedder needs a cultivated audience. His capacity is both lyric and epic, but he excels in the latter. If he were not so drawn to painting by delight in color, he could be eminent as a sculptor. That he would be the most original and inventive of our school, the dramatic force of expression and power of modelling shown in his recent bas-reliefs of the Arab Slave and Endymion sufficiently attest. Then, too, his conception of the classical grotesque, as exhibited in his pantheistic idea of the Tree Imps, is exquisitely beautiful, ludicrous, and poetical. We know of nothing more characteristic in Grecian art, or better conceived, a spice of modern humor being superadded to the grotesqueness of the antique idea. The little brown imps, miniature fat men, with the active organization of boys, are crawling out of holes in the trunks of trees as the morning breaks, yawning, and looking so naïvely mischievous and frolicsome, while a solemn owl blinks at them, that we believe in their existence, natural history to the contrary.

Great refinement of thought is seldom united to great power. But we have it in Vedder. There is no vulgarity of style or motive; no commonplaces or inanities; no pilferings or disguisings from others. Everything is fresh, original, and tasteful. His talents crowd and confuse one another. He needs to acquire firmness of choice and concentration of thought. His proper place is Paris. Yet he can live in America and grow great, if opportunity of work be given, without other aid from European examples than he has already received. The underlying motives of his art are rather universal than local or national. They spring from intuitive per-

ceptions of general humanity and nature at large. In some respects Vedder is not unlike the greatest living poet, Doré, with the advantage of consummate coloring, while Doré's greatness is limited to design. If he lack the Frenchman's terrible concentration of the horrible, that fearful power of turning all natural objects into avenging demons, and transforming air, earth, and water into a living hell, an imagination so enveloped in shadow that heaven seems only a dream, there is either an intense repose or pervading naturalness of conception in the terrible of our artist that makes it more real and effective. The Lair of the Sea-Serpent fascinates by its oppressive probability of fact. Doré appalls the imagination; Vedder alarms the reason, lest these things be so. He has a way of rendering certain moods, perhaps we should say temperaments, of the landscape, suggestive of its early stages, that cause one to shrink from it as the foe of man. A similar intensity of meaning he puts into human topics. One of his latest paintings is the Alchemist, who, having discovered the illusive secret of his science, dies from excess of emotion, with no witnesses of his joy or his pangs except the mysterious agents of his success in the bottles of his laboratory.

We have now given our reasons for believing that in Vedder the American school has the promise of an artist of wider scope, greater vigor, more varied, intense, and original conceptions and thorough executive skill, than has hitherto appeared. It is indicative of a radical difference of æsthetic feeling between New York and Boston, that the pictures of Vedder and La Farge, our most profound artists, which remained almost unnoticed in New York, were bought in Boston as soon as seen, while those of artists held in the highest fashion in the former place are rarely purchased by Boston amateurs.

Looking back, we find the American school of painting in its first phase foreign and aristocratic in sentiment. The paintings of the early masters soon passed into the quiet repose of old families, whence the best specimens should be culled for public galleries.

Their lineal successors are our academicians, whom fashion rules instead of the loftier feeling which animated the art of Stuart, Trumbull, and Allston. Academic art is deceptive, shallow, and

showy by nature. Ours has no fixed prestige of rank and cultivation to guide and sustain it, but fluctuates with the fickleness of its presiding divinity. It strives for the appearance of things, rather than their fundamental qualities, and is content with making pretty pictures and babbling light sentiment. Primary instruction or elegant illustration is its highest effort. The first impression is ever the best, like that of fine manners united to an empty head. Deception and disappointment are ambushed in it; for, concentrating whatever ability it has on the surface, it risks all to catch the eye and make the false seem true.

All men are either spiritualists or materialists, in philosophy, temperament, and faith, so that art must partake of one proclivity or the other. Realism, as they term it, best satisfies those who confide in what they consider as the substantial and tangible in nature, holding to epidermal representation as the end and aim of art; while idealism alone will content those who believe that its legitimate purpose is the expression of inner life or the soul of things. The art which most happily combines the two is the most successful with mankind at large. Whether they comprehend its principles or not, their instincts recognize them. But mere materialists find so many snares in the exercise of the spiritual, creative, or interpenetrative faculty, that they seek to confine themselves to the direct facts of nature, avoiding other idealism than that of the naked eye in its recognition of integumentary beauty. Naturalism readily degenerates into matter-of-fact realism, or delights in inferior truths and subordinate aims. It is, then, objective in character, and confines itself mainly to illustration. We cannot, however, classify either art or artists with unerring fidelity. One may represent ideas in a naturalistic manner, as does Vedder, or he may give nature in idealistic form, as does La Farge, with infinite variety of expression and mental interchange. In general, however, an artist, governed by his temperament, adheres to one style.

Idealism tends to subjective treatment. It awakens that inner consciousness of things which responds with telegraphic alacrity to the spiritual faculties. Realists love facts; idealists clutch at the soul of the fact. The English school is strongly realistic, and de-

ficient in the sense of color, which is more particularly the language of idealism. We have eminent examples of each kind.

Beginning with our academicians, we have only to recall the works of Louis Lang [44] for illustrations of lackadaisical sentimentalism of the most hollow kind, mere soap-bubbles of art; the Taking the Veil, by Wier, for scenic, cold, formal externalism and false key of color and light; Huntington's Angel of Mercy, for meretricious weakness; his Sibyl, for more successful rendering of the theme, but with the value all on the outside; the pictures of Gray, for average cleverness of conventionalism and prettiness; of Edwin White, for better taste and motives and more picturesque composition than is usual; in fine, the general mediocrity of execution, lack of original inspiration, and absence of nature's utterance, for proving the inability for great art of academic realism.

Academic teaching in some sort does recognize the ideal, but fails in its mehod of attaining it. Compare Hall's [45] fruit-pieces with La Farge's flower-compositions. Aside from exact imitation, Hall's work is the most barren of art. As Hinckley paints animals with the *animal* left out, so painters of horticulture like Hall exhaust their art on the outside of things, with the fidelity of workers in wax. The more natural, the greater the lie, because they try not for a type or suggestion, but for actual deception. An untrained eye may be deceived, but such success is positive condemnation. Art has fallen into the low condition of artifice. Sooner or later the mind detects the subterfuge, outgrows its juvenile liking, and the sham becomes to it stale and wearisome. Who thinks of the science of the horticulturist, or pauses to taste, weigh, or price flowers and fruit painted as La Farge paints them? His violets and lilies are as tender and true suggestions of flowers — not copies — as nature ever grew, and affect our senses in the same delightful way. Their language is of the heart, and they talk to us of human love and God's goodness. Hall's fruit is round, solid, juicy — huckster's fruit; only it proclaims paint and painter too loudly to tantalize the stomach. The violets of La Farge, and, indeed, his landscape entire, quiver with poetical fire. We bear away from

the sight of them, in our inmost souls, new and joyful utterances of nature.*

Continuing the comparison, as regards fundamental qualities, between the realists and idealists, let us contrast the warm magnificence of tone and poetical significance of a landscape by Inness with the spotty, staring, obtrusive coarseness and materialistic objectiveness of one by Brown, or turn to his semi-ideal composition of Rome, and put it beside Church's Heart of the Andes or Bierstadt's Rocky Mountains, all three composed on the principle of rendering the general truths of landscape in the most picturesque and characteristic manner, without regard to absolute fidelity of local detail, so that a true impression of the spirit and appearance as a whole is given. The radical difference between the antagonistic styles of these masters will be felt at once. However much our admiration is captivated for a season by the dramatic spectacular touch of Church and his gem-like, flaming brilliancy of color, or the broader, less artificial, colder tinting of Bierstadt, the rich harmony of Inness and attendant depth of feeling, with his perfect rendering of the local idea of the City of the Cæsars, seize fast hold of the imagination, and put the spectator on his feet in the very heart of the scene. He becomes an integral part of the landscape. In the other paintings he is a mere looker-on, who, after the surprise of novelty is gone, coolly or impatiently criticises the view. The countryman that mistook the Rocky Mountains for a panorama, and after waiting awhile asked when *the thing was going to move*, was a more sagacious critic than he knew himself to be. All this quality of painting is more or less panoramic, from being so material in its artistic features as always to keep the spectator at a distance. He never can forget his point of view, and that he is looking at a painting. Nor is the painter himself ever out of mind. The evidences of scenic dexterity and signs of his labor-trail are too obvious for that; indeed, with too many the value attached to his work is in the ratio of their display. But the effect of high art is to sink the artist and spectator alike into the scene. It becomes the real, and, in that sense, true realistic

* See Appendix, Note C.

art, because it realizes to the mind the essential truths of what it pictorially discloses to the eye. The spectator is no longer a looker-on, as in the other style, but an inhabitant of the landscape. His highest faculties are stimulated to action, using the external senses as servants, not masters. He enjoys it with the right of ownership by the divine seisin of kindred thought and desire, not as a stranger who for a fee is permitted to look at what he is by its very nature debarred from entering upon and possessing. We dwell strongly upon the underlying characteristics of these two styles, because true progress and enjoyment are so dependent upon a correct estimate of their relative values in art. The artist who first suggests himself, no matter with what degree of talent, has only achieved a subordinate success. Noble art is ideal at root, and the idea should be so treated, in accordance with the requirements of beauty, as to absorb the spectator primarily in the subject. First, the thought; then, the thinker: such is the correct progress of artistic perception. But to return to our illustrations.

We may contrast the tender, aërial gradations, the transparent, eye-reposing and spirit-soothing atmosphere, and delicious, dream-like aspects of vegetation, gently gliding water, or silvery moonlight of Cole, with the pretentious *"tours-de-force"* details, crude, positive, impenetrable pigments, falsities of light and expression, and prevailing unrest of Sontag or Ginoux, so forcibly opposed to the low-toned effects of the idealistic painter; the fulness of soul-expression which Page, by sleight of color, brings to the surface of his portraits, with the almost savage realism and acerbity of Elliot, or the hard intellectualism of Healey; the sweetness, variety, delicacy, and fertility, the fine taste, imagination, fancy, and pure feeling displayed in Billings's designs of the Sleeping Palace, St. Agnes's Eve, Marguerite, and the Sister of Charity, with the dramatic vigor and obtrusive individualism of Darley's drawings, which are the strongest and best productions of realism, in their special direction, that our school has to show. Both Billings and Darley draw in a masterly manner, but on what different keys of design! Grace guides one pencil, force the other. Darley in design and John Rogers [46] in sculpture are akin in power

of expression. For a final comparison we would suggest that our readers should look at the thin, positive-colored, tableau-like compositions of the academic-trained and impatient Leutze, and then turn to the miniature illustrative paintings of Vedder, like the Roc's Egg and Jinnee, and note well their brilliant but harmonious coloring, finished detail, breadth of treatment, dignity and yet vigor of action, well-ordered masses, sense of repose, and solid beauty, and, above all, their mental suggestiveness, every stroke of the brush betraying definite intent, and all tending to unity of idea and execution.

If we look at our painting as a whole, we find, that, though indebted in many respects to the French school, it has some characteristics more promising than those of its master. The French manner is too intellectual, too realistic, too little spiritual and idealistic, wanting also in passion and the language of color. Delacroix is exceptional, and not to be cited against this view. He was unrecognized in his time, and even now has no positive influence, though a giant of original force and vehemence. Indeed, his nature was too deep and intense to mix with the natures about him. A fresh revelation he is and will ever remain. So we cannot cite him, nor can we the Englishman Turner, as evidence of general qualities. Such men serve rather to show the lack of generic virtues than the presence of them. The French school is not one of powerful color, like that of Venice, or the Spanish. Its chief defect, aside from spirituality, is in this direction. Its color is more the result of scientific calculation than of feeling or instinct. Now, American art, though in intellectual knowledge and technical ability so greatly behind it, has actually given hints of ideas, in Story's Sibyl and Ward's Freedman, that belong to and express thoughts of the living nineteenth century. Imperialism in France will not permit art to become the language of social and political hopes and aspirations. But there is no reason why the art of democratic America shall not. What lessons might not be taught out of the demoniac passions that give birth to New York riots, if their true origin, spirit, and intent were exhibited realistically or symbolically.[47] What, also, of the wider view of the duties of

humanity which is coming to the surface of men's consciences in the present struggle of the powers of light against the powers of darkness! But, setting aside lofty motives, we have better promise of a genuine, original school of color than any other nation. On looking at Allston, Babcock, Hunt, La Farge, Inness, and Vedder, it really seems as if the mantle of Venice had fallen upon America, and the far-off New World was about to revive the departed glories of the Old. Possessing the burning language of poets and prophets, we await their full prophetic utterance.

No nation can turn to a more heroic or grander record of sacrifice, suffering, and triumph. We are now passing through the transition period of unformed youth, with its raw impulses, weak compromises, and hasty decisions, into the fuller wisdom of ripe manhood, tried by an ordeal of the greatest civil war the earth has ever seen, and for the greatest ideas and largest liberty to the human race. Ours is the victory for all humanity. Out of this war for equality, exaltation, and unity of peoples, must spring up a school of art of corresponding nobleness. The people's Future is its field. A great work is before it. Little is done, — nothing, compared to what there is to do. But slight as is the showing of our art in a national sense, it still precedes the popular taste. Art awaits a valid public opinion to inspire it, and to be amenable to. The common taste rests upon the level of materialistic landscape. It is just expanding into a liking for dead game and ordinary *genre* subjects. To it, the sublime, impassioned, or spiritual, is an unknown tongue. It has not even learned the true definition of art, much less comprehended its entire spirit and purpose. There is a crude liking of prettiness, mistaken for beauty, but no deep conviction of our æsthetic poverty, still less any such fixed faith in art as we have in science. Art itself has not grown into a faith. It aspires overmuch to dollars and praise. Although leading public taste, it stoops to it. Knowing the right, it hints at better things, but hesitates to do them. It wants backbone; has no lofty conception and belief in its own future. But, full of young blood, the dawn of its morning twilight tinges the horizon with far-off golden light.

XVI

*The American School of Sculpture. — Its Origin. — Greenough. —
Modern Motives. — Sculpture as a Trade. — Clark Mills; Powers;
Crawford; Dexter; King. — Chantrey's Washington. — Our Portrait-
Statues. — Those of the Ancients. — Randolf Rogers. — The Gates of
Paradise, — of the Capitol. — Ball; Brown; Harriet Hosmer; Miss Steb-
bins; John Rogers; Dr. Rimmer; Paul Akers; Palmer; William Story;
Ward. — Conclusion.*

I N the progress of civilization sculpture usually anticipates paint-
ing. But in America it has been otherwise. We had eminent paint-
ers before a sculptor appeared. Such sculpture as we possess is
the work of the present generation. All remember with what naïve
surprise and fastidious delicacy, scarcely a score of years ago, the
Chanting Cherubs of Greenough were greeted.[1] A marble figure
by an American was in itself strange and curious. At that time we
had so vague a notion of æsthetic enjoyment that even the cold
purity of marble could not protect these little children from the
reproach of immodesty, or secure to them any higher interest than
would have been given to a Japanese mermaid. They were simply
interesting as the work of a countryman in a profession of doubt-
ful utility; if favored at all, to show that Americans could do
some things as well as Europeans. Yet these venturous pioneers
of a noble art, happy in motive though crude in execution, did
signal service, by proving that there existed in the American mind
capacity for plastic art. They are the germ of our present school.

Rightly to estimate the progress made, we must examine what has been done since the Cherubs awakened the idea of native sculpture.

We were as fortunate in having Horatio Greenough for a pioneer in this direction as Allston in the sister-art.[2] Both were true artists, in advance of their times, inspired by the best examples of the old schools, though in execution unequal to their conceptions. Like Allston, also, Greenough's ambition prompted him to a high range of art. His æsthetic feeling was eminently lofty and pure. We cannot point out any masterpiece, as showing an entirely satisfactory fulfilment of his own desires, but his whole career was an example in the right direction. There exist unfinished work of his in plaster bas-relief, such as the Genius of Italy, Castor Gemelli, and Bacchante and Young Faun, replete with the best classical feeling. They are severely composed, and vital with inward life and graceful action.[3] His horses are beautiful creations, full of fire and spirit; steeds of eternity, like those of Phidias. These compositions are the seed-thoughts of a great master of the highest style of art. In his Washington he rises above mere portraiture, and seeks to symbolize, in a colossal statue of a godlike form, the nation's cherished "father." [4] As we rise to the level of his sympathies and knowledge, so shall we better understand him and appreciate his efforts.

Our sculptors are mostly men of unfulfilled careers. In justice to them, as with the painters, the public must not forget that the examples before them are not only the works of a school still in its infancy, but also, in general, the efforts of young men. The modern standard of sculpture, also, as compared with that of classical Greece or mediæval Europe, is low. It seldom rises above decoration as an accessory to architecture, pretty fancies, realistic portraiture, or imitations of obsolete myths and Pagan forms. Christian sculpture, once so fertile, varied, and eloquent, has degenerated into lifeless symbolism, lying obituaries in stone, and prosaic materialism. Yet there are indications of ambition for better things. A purer idealism and loftier spirituality begin to interpenetrate the prevalent styles and motives. Nevertheless, our sculpture

as a whole, disregarding the example of Greenough, who left no scholars, was speedily seduced into the facile path of realism by the national bias to the material and practical. This has been the more complete because of our isolation from Europe. Her modern schools can teach us much of the science of art, while the old masters of Greece and Italy will always remain great examples of past styles, and incentives to excellence in ways and ideas of our own. Possessing standards of excellence and models of taste in every department, Europe has the inestimable advantage of enlightened tribunals of criticism: America has only her instincts to guide her. We may profit by foreign work and ideas without imitating their phases of art, past or present. Our own phase must be born out of our own life, as the art of Europe has sprung from its varied civilizations. If we would exalt our sculpture, we must dignify our lives with great ideas and heroic deeds. We believe that American sculpture is destined, like its painting, to partake of the new, strong life that is fast coming upon us, — a life equally of ideas and action.

It is unnecessary to allude by name to the crowd of common sculptors, of whom America already has an ample supply. These men degrade art to a trade. They manufacture statuary on the same principle that they would make patent blacking, founding their standard of success on the amount of their sales. And yet their work is not to be altogether contemned, mechanical and lifeless as it may be, because it helps to familiarize the public with the idea of art, and gradually creates a desire for something better. Forbearance ought not, however, to go beyond private work and individual choice. If the ignorance of legislative bodies or the zeal of interested parties, at a heavy outlay of public funds foists upon the people works whose sole effect on the cultivated mind is disgust or ridicule, and on the common simply wonder at mechanical dexterity, bigness, or theatrical display, as in the instance of Clark Mills's equestrian statues at Washington, no protest is too strong;[5] for such abortive work tends to bring all art into disrepute, even with the multitude. The desire for greatness is in itself a noble instinct, but in matters of art must not be confused

with bigness or mechanical skill. Too many unfledged sculptors, among them women, unmindful of the obligations to science of genius even, and the slow, hard labor by which it learns to master material and shape it to its ideas, seem ambitious to begin their careers where Phidias and Michel Angelo left off. Misled by inchoate imagination or crude fancy, they attempt the colossal, heroic, or sublime, before mastering the rudiments of art-knowledge. It is as if Columbus, with the idea of a new Orient fermenting in his brain, had embarked on the Atlantic in a skiff to find it. Badly articulated joints, displaced muscles, in fine, anatomy reduced to chaos, bulk being its chief quality, with perhaps a good motive lost in the wreck of execution, are the frequent net results of premature attempts. It is to be expected that those qualities which ripen soonest in our national life should be correspondingly manifested in our art, because to the common mind they are the most attractive and intelligible. Even though the motive be idealistic, as in much of the statuary of Powers and Palmer, the greatest stress of the artist is shown in surface-work, the appreciation of the spectators being directed to the skin rather than to the idea. Neither Allston nor Greenough was able to enlighten the popular notions of art. The strong current of realism rising in the headwaters of American civilization has swept them and their works into transient oblivion, while it has brought to the surface of popular esteem clever men of the opposite tendency, in no wise their equals, but noteworthy in many respects.

Among them, Powers and Crawford have until recently stood foremost. Hiram Powers [6] fitly represents the mechanical proclivities of the nation. His female statues are simply tolerably well-modelled figures, borrowed in conception from the second-rate antique, somewhat arbitrarily named, as if he doubted the authenticity of his work, all of one monotonous type, but exquisitely wrought out under his supervision by Italian artisans. By nature Powers is a mechanic, and his studies are chiefly in that direction. He has paid more attention to improving the tools with which he works than to developing his æsthetic faculty. The popular esteem for his statuary lies in its finish, which is like ivory-turning. No

other American has so suddenly won for himself a reputation; but being founded simply on a talent for the manufacture of pretty forms from a given model, without sufficient intellectual power to exalt or vary his subjects, to be original in choice, or to compose a group, not even a student of art, but content with transitory triumphs, his fame has no solid basis, although his manual skill and taste still preserve for him an honorable rank.

Crawford [7] is superior to Powers in versatility of invention, largeness of expression, and quality of aspiration. An earnest, impatient worker, his most ambitious attempt is the Washington monument at Richmond, Virginia. Single statues, particularly Jefferson's, have merit as portraits. But as a composition, the monument lacks unity of action, harmony, and repose. Parts do not sustain one another. Judged by Grecian æsthetic taste, it is very faulty. Washington is exhibited in his popular military costume, on a badly modelled horse, and not being properly placed in reference to the remaining figures, fails in attracting the spectator as the central point of interest, as he also fails in his highest qualities as a man. The eye is distracted by the variety and inharmonious action of the different statues, each one claiming for itself the entire interest, instead of being subordinated to the principal. The eagles are fierce birds, whose threatening aspect warns off visitors, typical indeed of "spread-eagleism," but in no wise giving an exalted opinion of our national symbol.

The designs for the pediment of the Capitol at Washington are a still greater failure. Effort of this character suggests, as a standard of comparison, the groups of the Parthenon. Tried by them, they are incongruous, mean, and feeble, betraying impatience and self-exaggeration. Art destined to symbolize to coming ages the ambition of a great nation ought to have been the fruit of mature study. Such a commission would have thrilled a master with glorious conceptions, and, while filling his mind with a proud consciousness of strength, suffused it likewise with fear, lest he might be wanting in the fulfilment of so exalted a trust. In the faith and doubt of a great intellect lies its strength. Nothing short of its entire best, inspired by golden opportunity, would have

satisfied the judgment. But we find no trace either of humility or strength in these designs.

On the contrary, they are crude and puerile. Indeed, in reference to their object and position it is impossible to regard them otherwise than with indignation. We have bales of merchandise marked with the sculptor's initials, — the whole work seems gotten up in rival haste for a market, — a flat mass of marble called an Indian grave, an Indian warrior meditating upon a rock, a squaw reclining with a pappoose at her breast, a backwoodsman in shirt-sleeves, school-boys in jackets, with a pedagogue initiating the youngest into the mysteries of a primer, a mechanic reclining on a cogwheel, sheaves of grain, and a colossal symbolical figure in the centre; the whole a jumble of modern commonplace, savage life, and allegory, whose good points are confined to isolated action and modelling.

A composition of this character confuses and conflicts with noble art. It tells to children a story after the manner of nursery-maids, truth and fiction blended to amuse and amaze. Seen from below, as they must always be, the figures will look like monstrous stone toys, placed, with a sort of random regard for size, the biggest in the middle, upon a triangular shelf, the meaning of all of which it will be useless to seek to solve by the unaided eye. Does such a group adequately symbolize the American Republic?

In undertaking it Crawford overstepped his ability. Powers, more wary, has never been misled by his ambition into attempting great work. That Crawford was capable of excellence in a subordinate branch is evinced by his single statues, particularly that of Beethoven. This is simple, dignified, elevated in sentiment, and with skilfully treated drapery, bestowing classical grace and freedom upon modern costume. The first design was bombastic and theatrical, — an indifferent effigy, with uplifted hand and stick, beating time, — a mere orchestra-leader. A judicious critic suggested that that was not Beethoven, and Crawford, with happier thought, wrought out the noble figure of the Boston Music Hall, which combines with idealistic treatment some excellent characteristics of realistic portraiture.[8]

Our school of sculpture may be said, in general, to excel in busts. We have men of decided native ability, like Dexter [9] and King,[10] who give strong realistic portrait-busts, with something of the character of Elliot's likenesses in painting. These are men of executive force and unfathomed powers, needing only more favorable conditions for a broader development of their talents. King's bust of Ames,[11] the artist, is throughly Roman in type and feeling, with the old Etruscan fidelity of portraiture. It would have been better for the permanent fame of Powers if he had confined himself to bust-making. His facility in giving the likeness, refined by his sense of beauty, and popular, wax-like finish, make him the favorite sculptor of wealth and fashion. Like Sir Thomas Lawrence and Sir Thomas Lely, in painted portraits, he is sure to gratify his sitters by satisfying the superficial notions of good taste and the beautiful. We have used the term beautiful somewhat loosely in reference to Powers, though in the light in which most persons view art, it might pass unquestioned. But it is necessary to be more explicit. The sculpture of Powers does not render the real beautiful. He is rather the sculptor of sentimental prettiness, a dainty workman in marble, as incapable of realizing high ideal motives by his conventional treatment as he is of rendering genuine naturalism. California, Eve, America, the Greek Slave, are the same woman, and each might be called something else with equal felicity of baptism.[12] The California is essentially vulgar in *pose* and commonplace in allegory. As the Greek Slave is universally known, we shall take that to illustrate our meaning. Power's idea was to make an effigy of a terror-stricken girl, whose purest instincts and holiest affections are about to be trampled into the dust by a mercenary wretch. Under no conditions could maidenly modesty and innocence appear more pathetically to the sympathies of spectators before whose compassionate look pure girlhood must instinctively shrink. What have we? A feebly conceived, languid, romantic miss, under no delusion as to the quality and value of her fresh charms viewed by the carnal eye, and evidently comforted by them, naked and exposed though she is to the lustful gaze of men! We need have no pitying pang; the bought and

the buyer will soon be on speaking terms, for a coquette at heart always has her price. This failure to attain high art out of an exalted motive is caused by mistaking the outside pretty for the interior beautiful. To thoroughly understand the difference between the two, turn from the Slave to the Venus of Milo. This statue has less to touch the heart, but more to elevate the mind. It is one of the highest efforts of classical art; the incarnation of the Greek ideal of womanhood; "the goddess-woman;" a mother of nations, and the perfect companion of the perfect man. Nothing frivolous, weakly sentimental, or immodest in her, and yet no charms that sexually attract are wanting, but they are subdued to the greater expression of the virtue and intelligence that assert the true woman's prerogative to the homage of man. The most sensual eye can detect no consciousness of nakedness in the faultless grace, dignity, tenderness, and majesty of that figure, whose conception and execution are alike lofty and harmonious.

The spectator should be on his guard lest he attach too much importance to surface-work. Its seductive qualities are the first to arrest the eye. But great sculptors never exhaust themselves in details, though giving them their due value. The best statue of Washington was done by the Englishman Chantrey.[13] While giving a beautiful finish to his surfaces, devoid of waxen hardness, he attains to a life-like treatment of flesh, with correct indications of bones and muscles, and a natural dignity of *pose*. His treatment of costume and details is likewise excellent, and at the same time he infuses his marble with the lofty character of his subject. In these respects his taste and knowledge might benefit all our artists who attempt portrait-statues. Much of the workmanship so attractive to the untrained eye is the handicraft of artisans. Powers gets the best he can at annual wages of a few hundred dollars each, some of whom have the feeling and knowledge of real artists. Chantrey paid a thousand pounds sterling to his two best cutters, and they made work which passed for and was paid as his, in one instance as high as five hundred pounds sterling for a repetition of a bust of George IV. for the Duke of Devonshire, to the satisfaction of all parties. We mention these facts, that those who attach

so much importance to the mere workmanship of the American school may learn that even in that quality it is not beyond indebtedness to foreign sources.

We cannot award the restricted praise of the prettiness and finnish of the busts of Powers to his portrait-statues. These are soulless figures, made up of laboriously modelled details of costume and the shell of the outer man; as if all that was necessary to create a heroic statue were the clothes and a mask of the original. Indeed, American portrait-statues, with but partial and particular exceptions, are pitiful failures. Straining after the sublime, they too often attain only the ridiculous. In general, they have no backbone or internal anatomy. They are too much like the stuffed scarecrows of cornfields, the drapery, heavy or commonplace, being but a coarse artifice to conceal the inability of the sculptor to master anatomy and bestow dignified action or graceful repose upon his work. The worst specimens of this old-clothes statuary are Powers's Webster,[14] ridiculous from the peculiarity of its action as seen in certain directions, and Hart's Henry Clay, the meagrest effigy of all.[15] The Otis, Adams, and Winthrop of Mount Auburn Chapel are somewhat better examples. If the chief aim of sculpture be shirt-ruffles, voluminous cloaks, big boots, and the dress-coats and trousers of the tasteless modern apparel, to the intent to exhibit the fashions of the hour, why then we have several masterpieces. But if we ever reach that æsthetic standard which caused the Greeks to appoint officers to remove statues that were an offence to good taste and the canons of art, not a few of our public characters who have been victimized in bronze or marble will be taken down from their high places.

How do our portrait-statues compare with those of the ancients which are the standards of classic excellence? The noblest examples now extant are the Sophocles of the Lateran and the Aristides or Æschines of Naples. The poverty of thought, feebleness of modelling, homeliness of draperies, and awkwardness of postures, of modern work, in contrast with these classical prototypes, are but too apparent. What else could we expect before the mute eloquence which awes even the Apollos and Venuses of their own

times? Those statues were the supersensuous idealizations of classical art, appealing to man for recognition as gods, and failing in the full measure of the idea, because in form and action too human. But the noble art-treatment of humanity as seen in Sophocles and Aristides raises our feelings and thoughts to the godlike, and commands our admiration for work which fulfils the highest conceptions of its particular aim in art.

Which of the two is the superior is a nice question; but in view of our subject it is profitable to refer to their good points. Sophocles is more broadly executed, and the drapery is more simple and graceful. Aristides excels in refinement of features and in moral qualities of head. The lines of his raised elbow are remarkably fine, and in harmony with his whole figure. The intellectual aspect of each is admirably sustained by the secondary means of attitude, drapery, truth and grace of proportions, and modelling of details. It is the harmonious combination of the highest laws of art in thorough naturalness of form which makes these statues the finest examples of plastic portraiture.

Notwithstanding the wide gulf which at present exists between the best Grecian sculpture and ours, much credit is due Crawford and Rogers of Rome for their energy and versatility. Their principal weakness is in the too hasty undertaking of great compositions. One remedy for the abortive work which is so rapidly disgracing our public edifices is to adopt the European system of anonymous, competitive concurrence of artists for the designs needed; the prize to be awarded by competent judges, after the designs shall have been submitted to the criticisms of the people, whose *right* it is to be heard in these matters, because they are to pay for what in the one case may be an ever-during joy, in the other a horror forever. The great work of Europe has been the result of competitive designs or the contribution of many minds. Although Ghiberti was the youngest of the aspirants for the bronze doors of the Baptistery at Florence, and had for opponents Donatello, Brunelleschi, and the most profound artists of that great age, yet even by their generous verdict the commission was awarded him, and he was nearly a lifetime in executing that which,

when done, became the gates of Paradise in the eyes of the greatest sculptor the world has seen since Phidias. Randolf Rogers,[16] of Rome, was commissioned by a far greater people to create doors for their Capitol. In the light of symbolical portals to a Temple of Freedom, the idea partakes of the sublime. But the American sculptor is too impatient for original inspiration, and has no adequate conception of his opportunity for noble work. Borrowing his general idea from Ghiberti, he hurriedly elaborates a prosaic, historical composition of the discovery of America and life of Columbus, clever and interesting as illustration, but far beneath the requirements of creative art or the dignity of the occasion, and stamps the whole with his name.

Plagiarism is rife among some of our artists, because of their indifference to the requirements of high art and unwillingness to acknowledge their obligations to others. The Nydia of Randolf Rogers evidently is an exaggeration of a well-known mutilated statue of the Vatican, probably one of the Niobe group; the Proserpine of Powers recalls the celebrated Psyche of Naples; and Miss Hosmer's Beatrice Cenci [17] savors too much of a design of Scheffer. We have Pandoras, Ganymedes, Cupids, and similar feeble reproductions of classical sculpture in scores. But the American mind, eclectic as it assuredly is, neither lacks vigor nor independence. It will not always remain a plagiarist, or be in contented bondage to unyielding realism, though the present bias is towards the literal exactness of Etruscan art, rather than the lofty idealism of the Greek. Our most clever sculptors give faithful portraits, concealing nothing, exalting nothing, yet vigorous, natural, and effective. The Franklin of Richard Greenough is of this character.[18] Ball's Webster is so superior to that of Powers it is a marvel the citizens of Boston should have consented to placing the latter where it is, when they had at their command the natural and forcible model made by their own modest and painstaking townsman. The spirited equestrian Washington, of colossal proportions, destined for the city of Boston, on which Ball is now engaged, is creditable to him from the realistic point of view, but fails to represent the Father of his Country.[19] He has made him a captain

of dragoons. The action of the drawn sword is spasmodic and inappropriate. Looking at it in a naturalistic point of view, Washington would be very apt to injure himself or his horse with it. When shall we have an artist for Washington? Brown's equestrian statue at New York is of a higher intellectual character, but not one that completely fulfils the national want.[20]

Harriet Hosmer is an example of a self-made sculptor, by force of indomitable industry and will. She alone of the women of America who have essayed sculpture has achieved a reputation.[21] Puck displays nice humor, and is a spirited conception; but Zenobia is open to the charge of mere materialistic treatment. The accessories of queenly costume overpower the real woman. Indeed, Miss Hosmer's strength and taste lie chiefly in that direction. She has not creative power, but has acquired no small degree of executive skill and force. Both Miss Hosmer and Miss Stebbins are now engaged on portrait-statues, of Thomas Benton and Horace Mann, which, if successful, will establish for their sex an enviable position in sculpture. But Miss Stebbins, although possessing refined taste and some imagination, as evinced by her idea of a design for a fountain in Central Park, New York, — the Angel of the Lord stirring the Waters, [22] — has shown no power of execution, and but scanty anatomical knowledge.

We now come to a man of a high order of ability, indeed, we may call it genius in its peculiar province, as original as he is varied and graphic, pure in sentiment, clever in execution, and thoroughly American, in the best sense of the word, in everything. If we were to compare the spirit of his compositions with foreign work, we should say that they included the finest qualities of Wilkie and Teniers. But this would not do him full justice. Beside dramatic power, picturesqueness of composition, naturalness and fidelity of detail, harmony and unity of proportions and grouping, he has a mine of humor, delicate sentiment, and elevated meaning, alike satisfying to head and heart. We know no sculptor like John Rogers, of New York, in the Old World, and he stands alone in his chosen field, heretofore in all ages appropriated by painting, a genuine production of our soil, enlivening the fancy, enkindling

patriotism, and warming the affections, by his lively, well-balanced groups in plaster and bronze. Although diminutive, they possess real elements of greatness. In their execution there is no littleness, artifice, or affectation. The handling is masterly, betraying a knowledge of design and anatomy not common, and a thoroughness of work refreshing to note. His is not high art, but it is genuine art of a high naturalistic order, based on true feeling and a right appreciation of humanity. It is healthful work, and endears itself by its mute speech to all classes. The Village Post-Office, Returned Volunteer, Union Refugees, Camp-Fire, Village Schoolmaster, and Checker-Players aptly illustrate our praise. His pathos, *naïveté*, and simplicity of motive increase with his subjects, and give even to the commonplace almost the dignity of the heroic. The chief feature of his art is his power over human expression, bestowing upon plastic material a capacity and variety of soul-action which, according to the canons of some critics, it was useless for sculpture to attempt. But he has been successful in this respect, and inaugurated a new triumph in his department. As an experiment, we should like to see the effect of one of his groups painted to life, to test the ability of color under such conditions as an auxiliary to form. At all events, John Rogers is a master of those motives which help unite mankind into one common feeling of brotherhood.

Dr. Rimmer, of Boston, an accomplished teacher of design, of much original mental force, destined to do good service to American art, has given a striking example of his capacity for realistic sculpture in a model of an athlete reeling under the force of a death-blow.[23] The knowledge of anatomical science displayed is wonderful, although the choice of time and action partake more of mechanical than æsthetic art. Its chief merit is its difficulty of execution and truth of detail. In a head of St. Stephen, carved by himself from granite, Dr. Rimmer has shown a fine capacity for lofty expression.

America is not without a few representatives of idealistic motives in sculpture. Paul Akers died too soon to give the full measure of his powers.[24] He was impressed with the Greek feeling of beauty, and his Pearl-Diver and St. Elizabeth of Hungary, immature works,

display pure sentiment and refined treatment. But in Palmer,[25] of Albany, we have a prolific sculptor of this class, whose education and inspirations have been confined to our own shores. He owes, therefore, nothing to foreign training. Powers has even said that he had nothing to learn from Europe. Undoubtedly, Palmer has a poetical, versatile mind. His fancy is varied and rhythmical, and he shows some imagination. The Longfellow of marble, he is unequal to the poet in artistic skill. His favorite mode of expression is allegory or symbolism. Aiming at original invention, he has attained a style peculiar to himself. There is an incongruity between his motives and his treatment, the one being ideal, the other materialistic, in some instances to coarseness. Brain and hand are at war. Perhaps his finest composition is the Indian Maiden finding the Cross in the Wilderness, simple and suggestive, the figure of the maiden being far more refined than his white women. The Ambush Chief is forcible and natural, a truer savage than Crawford's. The Peri, Spirit's Flight, Peace in Bondage, Morning, Evening, Resignation, Faith, Memory, mostly medallions, although somewhat capriciously baptized, manifest the varied idealism of his thought. They are more to be commended for their intention than execution. As with Powers, prettiness is a prominent characteristic, though, unlike Powers, the result with Palmer is sometimes almost ugliness, from his want of taste in the selection of an æsthetic type of features and form. But in art, as in morality, to him who loves much, much is to be forgiven. Palmer typifies in himself American art in bondage. The will and feeling to be original and inventive are there, but they are in the bonds of materialism and inexperience. If the study of classical art profited Michel Angelo, and inspired Niccola Pisano to found the wonderful mediæval school of sculpture of Italy, we may well believe that the indigenous greatness of the American mind will never be of a quality beyond benefiting by the example and experience of other nations. The best artists of Florence on first going to Rome, at the sight of the masterpieces there collected, were tempted to throw down their brushes in despair. Such must be the emotion of any true artist. The isolation of America may be of advantage in the development

of native ideas, but it is a disadvantage to any school not to have within its reach fountain-heads of knowledge, and the highest standards of comparison. Particularly in men like Palmer we feel this necessity. The beauty of high art does not interpenetrate his work. He has made the White Captive, his most popular statue, a petulant, pouty girl, vulgar in face and form, apparently the copy of a very indifferent model, with so materialistic a treatment of the surface of the marble as to suggest *meat* and immodesty.[26] Indeed, this low style of model runs through his adult female figures. It has been said to us that his aim was an indigenous American type of womanhood. If so, he has indeed secured an original, but Venus forbid that it should ever be taken for the ideal standard of form of the women of America. His undraped women are guiltless of Mrs. Browning's "white silence." The uniform type of his female heads is as low as is his treatment of flesh. It has no savor of intellect. He suggests hair rather than gives it. His drapery is weak, but some of his children's faces are very tender and sweet. No sculptor can satisfactorily render the human form without sufficient knowledge to compose his figures from the best points he can obtain from many models, joined to enough ideality to harmonize the whole, as did Raphael, into the completely beautiful. Palmer has much to learn from classical art before developing a perfect American type or style.

William Story [27] is little known or appreciated in his native land from two causes. First, his range of art is ideal, and his treatment derived from the best examples of Greece and Italy. Secondly, we are without any work of his to show his entire ability, although his statue of his father, Judge Story, at Mount Auburn, seemingly borrowed in thought from the Menander of the Vatican, is the best ideal marble portraiture our school has produced. We doubt his ability to give a realistic portrait. The bust of Theodore Parker is Socrates in modern guise, resting on a pile of books; a device worthy only of an artist of the Bernini order of taste. But the simplicity, repose, correct management of drapery, and vital glow of character of his father's statue cause it to contrast favorably with the badly conceived and mechanically executed statues of the

same chapel. Unhappily, England has secured the two conceptions, Cleopatra and the Libyan Sibyl, which have placed him, in European estimation, at the head of American sculptors. Their greatness consists in the originality of thought. They are the growth of new art-blood. We may ethnographically object that Cleopatra, sprung from Hellenic blood, could not be African in type. Still it is a generous idea, growing out of the spirit of the age, — the uplifting of downtrodden races to an equality of chances in life with the most favored, — to bestow upon one of Africa's daughters the possibility of the intellectual powers and physical attractions of the Grecian siren. In harmony with the spirit of this statue is the loftier idea of the Sibyl, a suggestion, we are told, of Mrs. Harriet Beecher Stowe, founded upon her knowledge of the runaway slave, Sojourner Truth. The Sibyl is Africa's prophetic annunciation of her Future among nations. Sculpture of this character displays a creative imagination and daring of no common order. Born of, and yet in some degree forestalling, the great political ideas of the age, it is high art teaching noble truth. Wherever greatness of idea exists, minor defects in execution are more readily overlooked, because further study and experience may correct them. The defects of these statues are to be seen in their want of perfect harmony of anatomical structure, that lack of the science of art which must always exist whenever the intent is not sufficiently sustained by executive knowledge. But in these attempts American sculpture has emerged from the bondage of the past into a promising future. Profiting by the knowledge of the old masters, and forming his taste upon the best styles, Story has had the independence to seek out an unused field. In this he confers honor on our school, and gives to it an impetus as new as it is refreshing. But it requires something more than fine single conceptions to constitute a great master. Much in the right direction is to be looked for in Story, now in the maturity of his powers. He has to guard against the emasculating flatteries of success, impatience of study, and mean greed of fame and gain, which so often prove the bane of artists. Further, let him beware of that fatal snare to greatness, leaning too much on the ideas of others. In his more recent work

there is evidence of this, which might pass unremarked had he not shown so much virgin thought in other figures. Judith is spirited, but recalls Donatello. Saul, which the sculptor esteems his best work, is a paraphrase of the Moses of Michel Angelo. Drawing inspiration from such deep springs of art, with the best Christian and Pagan work about him, Story could not fail of bestowing upon his borrowed motives somewhat of the heroic grandeur of the original ideas. Excepting a certain feebleness, which almost all other work must show in comparison with the supernatural force of Michel Angelo's statues, Saul, as seen in the photograph, is Michel Angelesque in feeling, has grandeur of conception, broad treatment, strength of anatomical detail, well-managed drapery, and expression characteristic of the soul-harrowed king of Israel. We object to the too evident taking of the treatment as a whole from the Florentine sculptor, and especially to the exact imitation of the right hand, anatomically and in its abstracted play with the beard, one of the finest points of the Moses.

There is, however, another production of our school, completely original in itself, a genuine inspiration of American history, noble in thought and lofty in sentiment. It is a simple statuette, to us the work of an unknown name, and the sole one we have had the good fortune to see. We refer to the African Freedman, of the New York Academy Exhibition, 1863, by Ward.[28] A naked slave has burst his shackles, and, with uplifted face, thanks God for freedom. It symbolizes the African race of America, — the birthday of a new people into the ranks of Christian civilization. We have seen nothing in our sculpture more soul-lifting, or more comprehensively eloquent. It tells in one word the whole sad tale of slavery and the bright story of emancipation. In spiritual significance and heroic design it partakes of the character of Blake's unique drawing of Death's Door, in his illustration of the Grave. The negro is true to his type, of naturalistic fidelity of limbs, in form and strength suggesting the colossal, and yet of an ideal beauty, made divine by the divinity of art. The expression of the features is as one of the "redeemed." It is the hint of a great work, which, put into heroic size, should become the companion of the Washington of

our nation's Capitol, to commemorate the crowning virtue of democratic institutions in the final liberty of the slave.

In conclusion, there are two distinct points from which to view American sculpture. If we regard only the zero from which it started a quarter of a century ago, we have abundant reason for self-congratulation. No nation, in so brief a period, has produced better work, or developed a wider range of motives. From nothing, sculpture has risen to be a popular want. Out-doors and in-doors statues are multiplying; monuments are designed; and plastic art begins to assert a place in architecture, but not yet the one rightly belonging to it. True, there is a surfeit of mechanical and inane work, and our national taste is not yet sufficiently cultivated to discriminate between the relative merits of realistic and idealistic art, or to exact that scientific truth of treatment and breadth of style which characterize the best men of Europe. It prefers the superficial attractions of imitative to the profounder thought and purer handicraft of creative art. Yet a people whose school of sculpture, commencing in a Greenough, in less than one generation gives birth to artists of the varied calibre of Ward, John Rogers, and Story, has no occasion to envy the progress of other nations in the same space of time. But if we would become truly great in this branch of art, we must look keenly at our deficiencies, and keep steadily in view, as a possible attainment, the standard of those masters whose genius elevates them far above the narrow limits of nationalities. Tried by that test we have no great sculpture; perhaps we should say compositions, for, as we have shown, we are not deficient in single ideas or suggestions of absolute merit.

XVII

Review of American Architecture, Past and Present. — The Prospect before it. — Summary of Fundamental Principles.

OUR synopsis of the Art-Idea would be incomplete without referring to the condition of architecture in America. Strictly speaking, we have no architecture. If, as has happened to the Egyptians, Ninevites, Etruscans, Pelasgians, Aztecs, and Central American races, our buildings alone should be left, by some cataclysm of nations, to tell of our existence, what would they directly express of us? Absolutely nothing! Each civilized race, ancient or modern, has incarnated its own æsthetic life and character in definite forms of architecture, which show with great clearness their indigenous ideas and general conditions. A similar result will doubtless in time occur here. Meanwhile we must look at facts as they now exist. And the one intense, barren fact which stares us fixedly in the face is, that, were we annihilated to-morrow, nothing could be learned of us, as a distinctive race, from our architecture. It is simply substantial building, with ornamentation, orders, styles, or forms, borrowed or stolen from European races, an incongruous medley as a whole, developing no system or harmonious principle of adaptation, but chaotic, incomplete, and arbitrary, declaring plagiarism and superficiality, and proving beyond all question the absolute poverty of our imaginative faculties, and general absence of right feeling and correct taste. Whether we like it or not, this is the undeniable fact of 1864. And not merely this: an explorer

of our ruins would often be at a loss to guess the uses or purposes of many of our public edifices. He could detect bastard Grecian temples in scores, but would never dream they were built for banks, colleges, or custom-houses. How could he account for ignoble and impoverished Gothic chapels, converted into libraries, of which there is so bad an example at Cambridge, Massachusetts,[1] or indeed for any of the architectural anomalies which disfigure our soil and impeach our common sense, intensified as they frequently are by a total disregard of that fundamental law of art which demands the harmonious relation of things, condemning the use of stern granite or adamantine rock in styles where only beautiful marbles can be employed with æsthetic propriety, or of cold stones in lieu of brick, or the warmer and yet more plastic materials belonging of right to the variety and freedom of Gothic forms? If the mechanical features of our civilization were left to tell the national story, our ocean-clippers, river-steamers, and industrial machines would show a different aspect. They bespeak an enterprise, invention, and development of the practical arts that proclaim the Americans to be a remarkable people. If, therefore, success attend them in whatever they give their hearts and hands to, it is but reasonable to infer that cultivation need but be stimulated in the direction of architecture to produce results commensurate with the advance in mechanical and industrial arts. If one doubt this, let him investigate the progress in shipbuilding from the point of view of beauty alone, and he will discover a success as complete in its way as was that of the builders of Gothic cathedrals and Grecian temples. And why? Simply, that American merchants took pride in naval architecture. Their hearts were in their work; their purses opened without stint; and they built the fastest and handsomest ships.

To excel in architecture we must warm up the blood to the work. The owner, officer, and sailor of a gallant ship love her with sympathy as of a human affinity. A ship is not *it*, but *she* and *her*, one of the family; the marvel of strength and beauty; a thing of life, to be tenderly and lovingly cared for and proudly spoken of. All the romance of the trader's heart — in the West, the steam-

boat holds a corresponding position in the taste and affections of the public — goes out bountifully towards the symmetrical, stately, graceful object of his adventurous skill and toil. Ocean-clippers and river-steamers are fast making way for locomotive and propeller, about which human affections scarce can cluster, and which art has yet to learn how to dignify and adorn. But the vital principle, *love of the work*, still lives, that gave to the sailing-vessel new grace and beauty, combining them with the highest qualities of utility and strength into a happy unity of form. As soon as an equal love is turned towards architecture, we may expect as rapid a development of beauty of material form on land as on the ocean.

Our forefathers built simply for protection and adaptation. Their style of dwelling-houses was suited to the climate, materials at hand, and social exigencies. Hence it was true and natural. They could not deal in artifice or plagiarism, because they had no tricks of beauty to display and nothing to copy. Over their simple truth of expression time has thrown the veil of rustic enchantment, so that the farm-houses still standing of the period of the Indian wars are a much more pleasurable feature of the landscape than their pretentious villa-successors of the nineteenth century.

The public buildings of our colonial period are interesting solely from association. Anything of architectural pretence, more destitute of beauty, it would be difficult to originate; and yet, as meagre a legacy as they are of the native styles of ancestral England and Holland at that date, they avoid the worst faults of ornamentation and plagiarism of later work. Any of them might have been sent over the seas to order, like a dress-coat, and placed wherever needed, without other thought than to get a substantial building for as little money as possible. Yet there is about them, as well as the aristocratic mansions of colonial times, a certain quiet dignity of constructural expression which bespeaks conscious rank and gentlemanly breeding. It is true, they have misplaced pilasters, pillars, and other incongruous thefts of classical architecture, in mathematical rank-and-file order upon wall-surfaces, with which they have nothing in common in feature or spirit, but, notwithstanding the pettinesses of the pettiest of the imitators of Wren or Jones, they

are not overborne and crushed by them, but wear them with as self-possessed an air as their owners did foreign orders and titles, rejoicing in possessing conventional distinctions of rank not had by their neighbors.

Fergusson says, "There was not a building erected in the United States before A. D. 1814, worthy of being mentioned as an example of architectural art." This sweeping assertion may disturb the serenity of those who look upon the City Hall of New York, the State House at Boston, and buildings of their time and class as very wonderful. We agree entirely with the judgment of Fergusson from his stand-point of criticism. But there are details and features in many of the earlier buildings that are pleasurable and in good taste, while the edifices, as a whole, are not displeasing. The Boston State House is a symmetrical, well-proportioned building, simple and quiet in its application of classical details, with an overgrown lantern on a diminutive dome, but, as an entirety, effective and imposing. Its good taste is more in its negative than positive qualities, and happy adaptation of foreign styles to our wants, which at this early period almost savors of a germ of new thought. The New York City Hall is a meagre, Renaissant building, with nothing new in expression or adaptation, and would find itself at home almost anywhere in Europe, without attracting notice of any kind.

Fergusson, who is an excellent guide in the forms of universal architecture, further states as a reason for our deficiency of original thought, that "an American has a great deal too much to do, and is always in too great a hurry to do it, ever to submit to the long, patient study and discipline requisite to master any style of architecture perfectly. Still less is he likely to submit to that amount of self-negation which is indispensable if a man would attempt to be original." This is too true for any one to gainsay it; neither would it lessen its force, to retort on the weak points of his countrymen. But perhaps he overstrains criticism in stating that "the perfection of art in an American's eyes would be the invention of a self-acting machine which should produce plans of cities, and designs for Gothic churches and classic monumental buildings, at so much per foot super, and so save all further thought or

trouble." * Resentment at this caricature is checked when we remember that our countrymen have actually patented machines for producing sculpture, whether from life or copy; and that almost every new town *founded* — once they were allowed to grow — is on a rectangular, gridiron plan, utterly devoid of picturesque beauty or æsthetic design, as monotonous and unrefreshing as a table of logarithms. Such towns have no organic structure. They are all extremities, as if the human being was made up only of arms and legs, and his sole function to get about at right angles. The saving feature of Boston is that it has a heart, head, and lungs, as well as extremities. We refer to our towns in this connection, because the absence of taste and inventive thought in laying them out is at the root of corresponding weaknesses in architecture. "It is in vain to urge," says the same author, "the prosaic ugliness of such a system of laying out towns, or the vices of the way our architects *edit* buildings, after the free manner of using the scissors in making up a newspaper, when there is no feeling to perceive the deformity of the one, or knowledge to comprehend the absurdities of the other." It will be a healthful symptom of progress when we are willing to confess our deficiencies and seek remedies, instead of endeavoring to disguise them by lauding to the skies buildings styled architectural by those who erect them, but which do not possess the first principles of correct taste or beautiful design. Could the public criticise these edifices with the same warm feeling and appreciative knowledge that is applied to naval architecture, we should soon see a different state of things, the sooner, because, having no examples of high art in architecture on our soil, we could more rapidly develop a style of our own.

When our people were seized with a mania of fine buildings, one generation ago, their taste turned to classical models. Although the men of Athens to whom Paul spoke might not have viewed the buildings we call Grecian with the same admiration which was bestowed on them here, put as they are to uses foreign to their spirit, and debased by utilitarian details and changes which destroy their true character, yet our builders did succeed in erecting tol-

* *Modern Architecture*, Book IX, p. 436.

erable copies of the Parthenon, and temples of the Doric, Ionic, and Corinthian orders, converted into nineteenth-century banks, custom-houses, colleges, and churches. The influence of these examples spread like wildfire over the country. Cottages were hid behind wooden porticos, while lean or bisected columns, lank pilasters, triangular masses of framework dubbed pediments, rioted everywhere, upheld by a fervor of admiration because of their origin, which now to look back upon borders on the absurd. It was indeed an invasion of Hellenic forms, but distorted into positive ugliness by ignorance of their meaning and want of taste in their application. We do not believe that Grecian architecture, born of a widely different race, country, and religion, can be adapted to America. A literal copying of it only makes it appear still more misplaced; especially, torn as it is from high places to be crowded into narrow streets, overtopped by lofty houses, and confronted with buildings of a wholly opposite character. Indeed, the attempt to reconcile it to our purposes was so manifestly preposterous that it was speedily given up.

Then we had a Gothic flurry, which ended still more absurdly, owing to entire ignorance of the forms and character of Gothic architecture. The Girard College and old United States Bank, at Philadelphia, and the United States Sub-Treasury, Wall Street, New York, could indeed instruct the public eye as to the external anatomy of Grecian temple-architecture, but the buildings that were erected as Gothic outheroded Herod in their defiance of its instinctive spirit.[2] Anything pointed, having a parapet or towers with obelisk-like blocks perched about them, was palmed off as Gothic. The churches of Boston built a score or more years ago, and the Masonic Temple, are absurd caricatures and wretched parodies of their father-style. Peaks and points even invaded our domestic architecture with a wanton enthusiasm, like that which just before multiplied columns and pilasters everywhere. It is only necessary to state the fact, for individuals to select examples of either architectural folly by thousands in every State. We no sooner acquired a dim idea that ornament was needed, than builders turned to their books, and made an indiscriminate raid on whatever

was given as Gothic or Grecian, perverted temple and church to false uses, wrenched old forms from their true purposes and positions, and stuck our houses all over with a jumble of ill-applied details, degraded to one low standard of masons' or carpenters' work. We do not disparage the mechanical arts. They are as honorable as they are useful. Whenever our mechanics confine themselves to those utilitarian arts the knowledge of which is their professional study, they make their work as perfect of its kind as that of any other people. But when they seek to superadd beauty, a new principle comes into play, which requires for its correct expression not only a knowledge of æsthetic laws, but a profound conviction of their value. A boat-builder may make a respectable boat, but he is not the man our merchants would intrust to model a Sovereign of the Seas. So a master-mechanic may plan a building every way adapted to common uses, but be incompetent to erect temples and cathedrals, or even a bank or railway-station.

Architecture naturally grows out of the wants and ideas of a people, and its ornamentation should be in harmony with them. Our Grecian and Gothic manias were nothing of this kind. Their forms were simply old fashions, of foreign origin, made ridiculous by ignorant application, just as a savage with new-found trousers is as likely to put his arms through the legs as to wear them properly. We laugh at the mistake of the savage, but tens of thousands of buildings in America betray an ignorance of the elementary principles of architecture quite as great as that of the wild Indian of the uses of a white man's garment. In this relation stands the placing steeples astride of porticos, or thrusting spires and domes apparently through roofs, and sticking pinnacles and pillars anywhere and everywhere, without regard to their true meaning and uses; the breaking up and confusing Grecian horizontal lines with Gothic angular and pointed, in an attempt to unite two antagonistic styles which can no more mingle than oil and water; and, the climax of solecism, trying to put the new wine of American life into the old bottles of departed civilization. Copying does not necessarily imply falsity. Imitators occasionally gave us clever examples of their originals, like the Doric portico of the Tremont

233

House, Boston,³ and the circular colonnade of the Exchange, of Philadelphia; ⁴ but, in general, the whole system of imitation is simply a subterfuge to avoid thought and study. Although it may be carried out at times with good taste, it is essentially extraneous art, like a foreign literature, the delight of a learned few, but having no root in the ideas and affections of the people. The classical and Gothic phases of building of the past generation had no germinating force, because they were not the vernacular speech, but only dead tongues and obsolete characters galvanized into a spasmodic life by transitory fashion. Since then, though there have been no more repetitions of Grecian architecture on a large scale, we have had some better imitations of mediæval Gothic, especially for ecclesiastical purposes, and with a truer expression of its intention. New York city furnishes conspicuous examples of copies of several of its styles, as well as of early Italian, a mode which has been followed elsewhere, both for civic and commercial purposes, not to enumerate the attempts to adapt it to domestic architecture.

The question of its adaptability to every need of modern life is not one easily decided. But the underlying spirit of the Gothic, namely, the right of free growth as of nature herself borrowing from her the models or forms into which it incarnates its fundamental ideas, the same as vegetation, although of one great family in relation to the planet, yet adapts itself, by an infinitude of beautiful shapes, to every variety of soil, — this spirit, we think, coexisting with nature herself, is capable of responding to every architectural desire. If this be a correct view of the Gothic idea, the mediævalists, so far from having exhausted its scope and variety of application, have left us only on the threshold of its power. Grecian architecture was a perfect, organic, disciplined whole, limited in intent, and condensed into a defined æsthetic code, outside of which it could not range without detriment to its rule of being. Gothic, on the contrary, has no settled, absolute boundaries. Its essence is freedom of choice, to the intent to attain diversity of feature. Hence it is both flexible and infinite in character, affording working-room for every intellectual and spiritual faculty. The sole limit of its being is the capacity of invention and adaptation of the

workman. We perceive that he was never conventional. He might be rude, grotesque, wild, or wonderful, but the free play given individual fancy saved the Gothic from sameness and repetition. Genuine Gothic buildings of every class possess as marked individuality of expression as the human countenance, because in each the human soul, animated to excel, and vary what had been already done, is permitted free expansion of character. Its novel and beautiful doings are a perpetual surprise and delight, overflowing with exhaustless poetry and spiritual joy. In fine, believing Gothic architecture to represent and be founded upon the fundamental ideas of natural and spiritual freedom which are born of Christianity, we can limit its adaptation to human wants only by the power of the gospel to make men free and wise, and its variety and quality of expression only by the variety and quality of Christian life. Therefore, in whatever nation the promise of these is the highest, there may we look for the highest types of this architecture.

But the present question is confined to our varied, mongrel, generally mean, and rarely good imitations or copies of its past features. The fact that we are sufficiently advanced in our appreciation to borrow them for church edifices augurs well for its future career among an inventive people, and it does noble service to the principle of worship, by rescuing it from styles which are permeated by sensual, sensuous, or sordid influences. The interiors of too many fashionable churches are planned to suit the luxurious requirements of modern disciples of Jesus, with every facility for corporeal ease and none for spiritual watchfulness; while not a few are no better than a hybrid union of Mammon and Sectarianism, preaching and singing above, below, magazines of merchandise or a "depot" of ice-cream, of which we have had a notable instance in one of the most conspicuous meeting-houses in Boston. A plagiary which redeems sacred buildings from such incongruous uses is a cause of thankfulness, for it shows that we have got a step beyond the notion, that, because a building or a portion of it is beautiful, it is desirable to repeat it without regarding the original intent, thus degrading architecture from a creative to an imitative process, and

putting its forms upon a level with the copies of old masters which are imported by thousands as furniture-decoration for our walls. The buildings we fix in our streets are like so many Old-World cousins come over on a visit, not having had time as yet to get other naturalization than Yankee sharpness and awkwardness of outline. We are glad to see them, though they bluntly tell us that we have many master-builders but no Giottos. It is encouraging, however, to begin to have a taste for what Giotto loved, though unable to create art in his spirit. In his day men *created* art. That is to say, they invented, designed, and composed with reference to home thoughts and needs. True architecture is not what so many fancy, simply ornamental building, but, as Fergusson emphatically observes, the accumulated creative and constructive powers of several minds harmoniously working out a great central idea. Everything is designed from a penetrative insight into its latent meaning, with reference to a certain position and use. The best men of each craft that enters into its constructive expression, painters, sculptors, carvers, moulders, stainers of glass, mosaicists, masons, carpenters, the very hodmen, all labor in unity of feeling for the one great object, which becomes to them the incarnated ambition of their lives, and into which enters a variety of language, fact, and feeling, having a word to all men, and commensurate with the harmonious variety of human capacity when stimulated to its fullest power. Not before we appreciate the possibilities of architecture in a grand combination of the intellectual and spiritual faculties, aroused to action by the deepest emotions, can we expect to create work to rival that of olden time. That was the product of many brains. A mediæval cathedral was a miniature commonwealth. Embracing in its erection and purposes an entire community, the very names of the designers finally become lost in the edifice. They did not think of a monument to themselves, but of a monument worthy of their faith and lineage. Gradually the system changed. Architecture dwindled to the business of a class. What had been the care and joy of a people was delegated to a professional one. A great structure no longer *grew*, but was made by contract. The old men thought only how they should construct the best possible building

for the intended purpose. The new man, now architect by distinction, designed the whole, and he alone, not the buildings, grew famous. The public copyrighted his work for him. Instead of the ever-increasing variety of Gothic forms, there was a monotony of one man's talents. In England, Inigo Jones and Wren for centuries held almost supreme sway. In Italy, Alberti, Brunelleschi, Michel Angelo, Palladio, Sansovino, and their scholars dominated the public taste. Indeed, Italy, after the Gothic freedom of hand and thought died out, in the persons of her architects virtually made a conquest of Europe, not absolute, but enough to show the force of mere fame, and the injury to originality by the supremacy of a system which concentrated into the hands of a single man what had been sufficient for ages before to employ the entire energies of many. The fatal effect upon architecture was not immediately perceived, for the men of genius, having lofty conceptions and noble aims, invented new combinations suited to the new era of European life. But their followers either were incapable of this, or else they were seduced to display their learned adroitness or tempted by sordid views. Their work speedily degenerated into mechanical conventionalism, based upon the ideas and inventions of their predecessors. It could not be otherwise; for to no one person is given the power of revolution, any more in art than in government. External change must be predicated on the growth of fundamental ideas and the coöperative magnetism of multitudes. Architecture delegated to a professional priesthood had lost its power of growth. It had but one step lower to fall. Having ceased to be practised to develop beauty, it passed into the keeping of tasteless, superficial professors, who, having enslaved art to vulgar sentiments, in turn easily became the slaves of ignorant patrons, in whose minds utilitarian or egotistical considerations reigned paramount. The old men would have scorned such bondage. If they had not, their public, appreciating the dignity of architecture, although ignorant of so much that the nineteenth century considers school-education, would have scorned them.

The largest and most expensive of our public buildings are at Washington. If the nation possess no architecture of its own at its

capital, it is not owing to any stint of pecuniary stimulus, but to the causes already mentioned. The Smithsonian Institute is an example of a solitary effort, on an extended scale, to introduce into the chief city of the Union a species of modernized Norman style suited to scientific uses. It represents an abbey church of the eleventh century in plan, but gives nothing new or beautiful by way of modern adaptation, and so must be classed among the blundering imitations of mediævalistic architecture which have so numerously overspread the land with corruptions, very often in wood, of the several styles of Gothic known as Tudor, Elizabethan, Flamboyant, Perpendicular, Castellated, and are now, for variety's sake, invading the Lombard, Tuscan, Romanesque, Pisan, and German. Of the other public buildings it is not necessary to speak, because they are even more unfortunate debasements of Old-World prototypes. The classical feeling rules at Washington. It is better suited to its chess-board outlines than the Gothic. Indeed, a true Palatial style, such as its eminent Italian originators composed out of the Roman and Grecian architecture, would suit well with the purposes of the national capital. Leon Battista Alberti, Palladio, or Sir Christopher Wren, would have rejoiced in the opportunity which Washington affords for a display of the finest qualities of the Renaissance. Either one could have created a city to be proud of. But the only building, thus far, which answers in a respectable degree to the lofty and elegant spirit of that composite style, is the Capitol. Before its recent enlargement it was in many features beautiful; but its simplicity of external detail and general symmetry have been marred by the disproportionate height of the florid cast-iron dome, and the crushing effect it has, placed upon the roof of an edifice complete and beautiful without it, and whose slender, detached columns, whether of the portico or peristyle, seem illy calculated to sustain the immense weight that towers above. A tall dome is of itself a delightful feature, full of majesty and dignity, and has been used by men of the calibre of Brunelleschi, Michel Angelo, Wren, and Mansard, with powerful effect, as may be seen in the Duomo of Florence, St. Peter's at Rome, St. Paul's at London, and the Hôtel des Invalides at Paris. But even

with these examples, and borrowing their architecture entirely from Europe, the projectors of the Capitol have failed in harmoniously uniting the two great parts of the edifice.

The Washington Monument, apart from the extraordinary portico of pillars contemplated in the original design, is a lofty idea, borrowed in motive from the Greek *phallus*, and identified with Egypt's history under the form of her obelisks.[5] As old as the earliest dawn of civilization, the symbolism of this form of a monument is not inappropriately applied to the Father of his Country; and as his moral grandeur overtops that of every other soldier and statesman, it is fitting that his monument should pierce the skies. Equally significant of uncompromising Puritanism is the stern nakedness of the Bunker-Hill shaft. But in neither of them is there anything of a monumental character born of American invention.

Another style of foreign origin is making progress in America, known as the French Renaissant, of which the new City Hall, Boston, is an example.[6] Destitute of the ornate richness of its prototype, it gives no adequate conception of it except in making conspicuous its specific defects, and is stilted and forced compared with the best Italian Renaissant style. Cut up and overladen with alternate courses of tall and stunted pilasters having nothing to do, its ornamentation a meagre theft of classical orders, or a meaningless exhibition of horizontal or perpendicular lines and the simplest geometrical forms, robbing the building of simplicity without giving it dignity, there is not a single element of original thought in it. Architects who design buildings of this character are mere parasites of art, obstructing natural and tasteful growth, and impeding the right men from being felt and heard. A city given over to their hands, so far as indigenous development of art is concerned, becomes a mean sham. If we do not speedily outgrow the present system of erecting public edifices, they will be so many monuments of our moral and intellectual dulness, instead of, as they might be, the incarnation of vivifying thoughts and new shapes of beauty. It is to be conceded that the City Hall is imposing from its height, and attractive from the bright solidity of its ma-

terial, though the use of granite for the fine and free carving required in the Corinthian order is a waste of money and hard labor not to be commended. But the building cannot be too strongly condemned on account of the entire want of keeping of the conspicuous rear portion with its front and sides. The least that the architect ought to have done was to make that conform to the remainder of the edifice. Instead, it would appear as if, tired of his work by the time he arrived at the farther angles, he gave it to his youngest office-boy to finish, who, at a loss for what to put in, by a happy thought turned to one of his early copy-books in writing for aid. Opening to the page which precedes the pot-hook period, he espies a multitude of upright lines. *"Eureka!"* He marks an equal number, divided by window-spaces, all over the great wall-surface, and at last we have an original American style of architecture. Such work is an insult alike to those who pay for it and those who have to look at it.

But meagre imitation does not wholly bear sway. There is, beside, a restless, inquiring, experimentive spirit, approaching the inventive, in our building. At present it is chaotic and capricious, with an imperfect comprehension of beauty. Still, it is an active instinct seeking something new. Evidently the architects are called upon to vary their old hole-in-the-wall styles, a house being a brick box pierced with oblong apertures, or else their patrons are taking the matter in hand, and with a crude, experimentive zeal are striking out new shapes and combinations. Individuality, or the expression of personal taste in architecture, is a spirit to be encouraged; for it is rooted in the freedom of choice which first begat rude Gothic forms, and subsequently developed them into ripe beauty and infinite variety. We could name many buildings for private purposes which manifest this spirit of new life, in some cases almost arriving at the grotesque, and frequently at that climax of bad taste known in Europe as *rococo*, but which are refreshing to view because of their departure from old conventionalisms and servile copying. The Boston Organ in its architectural features is a striking example of *rococo*.[7] The organ, being essentially a Christian instrument of music, requires a case in harmony with its spirit

and purpose, or, if put into any other, the details should be kept strictly in unity with its animating spirit. Instead of this, we have an incongruous, grotesque whole, made up of details partly taken from the Christian art-idea and partly from the Pagan, gigantic caryatides and classical masks intermixed with puny Cupid-angels, a feeble St. Cecilia, and inane and commonplace ornamentations; fine workmanship throughout substituted for fine art; and the entire mass made the more emphatic in its offensiveness by its want of adaptation to the size and æsthetic character of the Hall[8] over which it domineers so unpleasantly.

Though individual taste has not yet accomplished anything worthy of perpetuation or to be an example to other peoples, still recent enterprise is eminently suggestive and hopeful. This new movement springs from a rising passion for something novel and beautiful in the dwellings and places of business of our merchants. They clamor for carving and color, for something that expresses their taste or want of it. Decoration is not wholly left to the architects. People's hearts being with their treasures, it is as natural that they should strive to embody them in appropriate forms as that the mediævalist, stimulated by his hopes of heaven and fears of hell, should put his treasure into cathedrals and monasteries. The estimation in which our merchants hold their stores and houses, as compared with their churches and civic edifices, is fairly shown in the relative sums expended on them. Many private buildings cost far more than public. In no respect is the contrast between the spirit of the mediævalist and the modernist more striking than in their respective expenditures on their sacred and civic architecture. The one gloried in whatever adorned his city or exalted his religion in the eyes of the world; the other reserves his extravagance for private luxury and the exaltation of the individual in the estimation of the community. Not a few dwelling-houses are built on so extravagant a scale, compared with the needs of the proprietor, as to come to be called, in popular talk, such a one's "folly." No public building has ever been made obnoxious to a similar term on account of lavishly exceeding its uses and appropriate ornamentation, though millions of dollars have been profitlessly

buried in them by the machinations or peculations of unclean hands.

Without investigating the causes of the differences in the above respects between the merchant of the fourteenth century and his brother of the nineteenth, or enlarging upon their social consequences, we feel justified in stating that our citizens have entered upon a phase of feeling which prompts them to love display in their marts of business and their homes; to feel after beauty, as the untutored mind feels after God, if haply it might find him. We hail this as a fruitful promise of final development of fresh architectural forms, which shall make our century, before its completion, a fit companion in æsthetic progress to any one that has preceded it. True, the motive now is strictly personal, and, therefore, not the highest. But give man liberty, and the good in him is ever striving to assert itself. Already we find solid and handsome blocks of stores, in more or less good taste, appropriate to their purpose, effective as street-architecture, and novel in many of their features. This improvement is greatly owing to the infusion of his own individuality, and the greater latitude the merchant gives his architect in designing an edifice which is to distinguish his business than committees do in plans of a public character. So, too, with dwelling-houses. Doubtless we have as bad, perhaps the worst specimens of expensive domestic architecture of any country. Certainly, nothing more mixed, vulgar, overdone with inappropriate ornament, mechanical, presumptuous, and mannered, can be found elsewhere. At the same time, no other country affords more hopeful indications of varied styles for domestic purposes, combining the modern constructive and utilitarian requirements with the privacy, refinement, and luxury that appertain to the Anglo-Saxon ideas of home. Boston, which is so poor in public buildings, is the most advanced in private architecture, both for domestic and commercial uses. If more regard were paid to specific fitness and beauty in details and a better disposition and harmony of masses, Boston might become an elegant as well as picturesque city; all the sooner, too, if her citizens would admit into public edifices, with a view to their own honor and dignity, lavish adornment, and freedom of inven-

tive design similar to that they bestow upon private buildings. In Hammatt Billings they possess an architect capable of fine work. The Methodist Church, on Tremont Avenue, a Gothic group,[9] the Bedford Street Church, and the adjoining building for the Mechanics' Association, the finest public architecture Boston has, are but meagre examples of what his taste could do if scope were given. One turns instinctively to the Roman Catholics for ecclesiastical architecture commensurate to the æsthetic nature of their ritual. But the Church of the Immaculate Conception is an agglomeration of the worst faults of the most debased types of architecture.[10] Externally, it presents a sort of jumble of the fashions in which we build factories and jails, with much vicious and misplaced ornamentation, or what is meant as such, but, as applied, resulting in absolute ugliness. Internally, it has the air of a bank and *café* in its staring, hard, common look; no religious repose, abundance of sham decoration, and not one gleam of real spiritual significance. It is inconceivable how a sect with so much feeling in general for religious art, and so liberal in their contributions, should have erected a building for a sacred purpose, which violates so preposterously the æsthetic spirit and aim of their faith. Stranger still is it that a Puritan sect, "Orthodox up to the hub," as we were told by one of its members, should have built the Shawmut Church, on Tremont Avenue.[11] The style is early Lombard, somewhat meagrely carried out, with slight modifications for special purposes. But its distinctive features are essentially anti-Puritan and of Roman Catholic origin. These are the detached, massive, lofty clock-tower, or *campanile*, which makes so conspicuous an object in the air-line of the city; the superabundance of stained glass, causing the interior to sparkle with brilliant colors, and rendering it fervid with spiritual symbolism; its low-toned frescoed walls and grandly treated roof, its harmonious adaptation of æsthetic taste and design to the requirements of Protestant worship, and chiefly the numerous carved crosses on the outer walls, and *credat Judæus*, surmounting the very church, astounding innovations, but surpassed by that climax of religious horror to Calvinists, placed over and above the pulpit, the crucified Saviour in

stained glass, answering to the crucifix of the Romanists. The persecuting Saul of art among the prophets! Puritanism arraying itself after the fashion of the scarlet lady of the seven-hilled Babylon! Is not this a change of sentiment worthy of historical note? The gentleman who assured us that the church was Orthodox up to the hub also added that at first he did not like these innovations on their old system of whitewash and absence of all beauty, but had come to like them. He will find, later, that what he now likes will become indispensable, for it is the unlocking of a divine faculty which has been long closed in his sect through misapprehension of its true nature. And the example of the Shawmut Church is a striking and unlooked-for illustration of the rapid growth, in this instance revolutionary in its abrupt force, of æsthetic taste in America, confirming in a welcome manner our theory of its eventual destiny.

We do not purpose, however, to criticise in detail, but to point out the general grounds of our faith in the æsthetic future of our architecture. Its foundation is the variety of taste and freedom of inventive experiment shown by private enterprise. If a knowledge of the fundamental principles of architecture equalling the zeal displayed in building could be spread among all classes, a better order of things would soon appear. To this end, we condense from the best authorities a number of axioms or truths, which, once comprehended by the public, will go a great way to counteract bad work.

Pugin tells us, *"The two great rules for design are: First, that there should be no features about a building which are not necessary for convenience, construction, and propriety; Secondly, that all ornament should consist of enrichment of the essential construction of the building;"* [12] and adds that the neglect of these two rules is the cause of all the bad architecture of the present time.

Another English authority who treats architecture comprehensively, J. B. Atkinson,* sums up its living principles somewhat as follows: —

* *Fine Arts Quarterly Review,* London, No. 2.

Construction (or use) is the ground or root out of which decoration (delight) should germinate. It is the bone, marrow, muscle, and nerve of architecture as a decorative art. Architecture is capable of any variety and expression, based on the above principle.

Construction must be decorated; not decoration *constructed*.

Decoration must accord with conditions of situation, fitness, and use.

Each genuine style of architecture demands a corresponding type of ornamentation. Specific types grow out of cognate forms in the outer world, so that decorative art becomes intimately or remotely the offspring of nature.

Decoration is not only the reproduction of external form, but also the representative of inward ideas, the symbol of thought and fancy, and the earnest expression of faith. Consequently, decoration has a distinctive character and is subject to classification, as naturalistic, idealistic, symbolistic, geometric, and descriptive or illustrative.

Naturalistic decoration should accord with natural forms and conform to the principles of organic growth. The flower or leaf should represent its natural qualities or organic structure; so, too, of birds, animals, etc.; of which the public can see some fine examples of carving by workmen after nature in Central Park, New York, a beginning in the right direction, and there to be contrasted with conventional or the architects' work, from similar subjects.

Idealistic ornament is usually natural forms subjected to the control of some governing *idea*. It may be conventional or creative; the one extreme tending to mannerism, the other to extravagance.

Allied in certain points to idealistic is symbolic ornament, or the outward manifestation by form of an inward thought or abstract truth.

Geometric ornament consists only of the symmetric distribution of space and a balanced composition of lines, pointing to a central unity and radiating into erratic variety. The Saracens, whose religion forbade images, were the masters of this style.

Architecture admits also of descriptive, historical, and pictorial painting on wall-spaces; also of color, to enhance the effect of

light and shade, produce relief, and add emphasis to articulate form, and for purpose of æsthetic delight generally.

The final purpose of decoration being beauty to promote pleasurable delight, it is of paramount importance that every design or detail should conform to æsthetic laws.

Every style must be judged from its peculiar stand-point of principle and aim.

In fine, architecture is, we emphatically repeat, the materialistic expression of the life, manners, needs, and ideas of a people. It reflects them; expands and develops as they themselves do. Endowed with life of its own, it is GROWTH; man's objective creation as distinguished from nature's.

XVIII

THE chief expressions in America of the Art-Idea, under the forms of Painting, Sculpture, and Architecture, having been succinctly traced to their present conditions, we perceive a steady, and of late a rapid advance of each in quality and variety, showing that the unfolding of the art-idea bears fruit in objects of taste and beauty, suited to all degrees of knowledge and feeling. True, an article may be as useful for common purposes without ornamentation as with it; but in that condition it is a cheap and common thing, of value only for menial service. Elevate, however, the quality of any technic art, whether it be glass-making, iron-work, tailoring, or even cookery, and the infusion of the æsthetic element refines it into a fine art in degree, and, by putting it upon the level of the intellectual sympathies, converts it into a friend. Art, like nature, adds so much to enjoyment, and in such manifold ways, that we do not recognize the full extent of our obligations to her. But what she has done is as nothing compared with her power in reserve. Every good picture, statue, or bit of architecture is one more joy for the human race. By it some

247

heart is touched, some imagination stirred, or some spiritual faculty excited to activity. The end and aim of the merely useful thing is earthly and transitory; of the beautiful thing, spiritual and eternal. Keeping in view the fundamental distinction between things useful and things beautiful, we perceive, that, as a people or as individuals, it is a duty incumbent on all, in the interests of civilization, to make life as lovely as possible in manners, dress, and buildings; to adorn our homes, streets, and public places; in short, to infuse beauty by the aid of art into all objects, and to make unceasing war upon whatever deforms and debases, or tends to ugliness and coarseness. He who is not prepared to serve art with unselfish fervor has no adequate conception of the compass and requirements of the art-idea.

We cannot make the world more beautiful without making it better, morally and socially. The art-idea is the Beautifier, an angel-messenger of glad tidings to every receptive mind. Upwards of four million visitors enjoyed Central Park, New York, the last year. We cite the Park as an example of the carrying out of the art-idea, because, beside a barren site, it owes nothing to nature. Art here has done everything, even to nursing and training nature herself. An institution like this, combining art, science, and nature in harmonious unity, is a great free school for the people, of broader value than mere grammar schools; for, besides affording pleasing ideas and useful facts, it elevates and refines the popular mind by bringing it in intimate contact with the true and beautiful, under circumstances conducive to happiness and physical well-being. What matter if it should cost a score of millions of money? Is it not so much saved from prisons, priests, police, and physicians? By it bodies are temporarily rescued from dirt and misery, and opportunities given the eye to look up to the clear vault of heaven, and take into the mind the healing significance of nature and art. In many it awakens the first consciousness of their spiritual birthright. To all it operates as a magnetic charm of decent behavior, giving salutary lessons in order, discipline, and comeliness, culminating in mutual good-will and a better understanding of humanity at large, from its democratic intermingling of all

classes, under quickening, many-sided, various refinements and delights. It is, too, a far cheaper amusement for the million than theatres, not to speak of the exchange of foul air for pure, noxious gas-light for health-giving sunlight, dubious morality and nerve-exhausting incitements for glorious music, invigorating games, boating, and exercise, the humanizing sight of merry childhood, the zoölogical and horticultural gardens, and, lastly, the galleries of art, science, and history soon to be there, enshrined in beautiful temples, open to all without cost. Why not add one more temple for the spiritual wants, fashioned in the choicest forms of kindred architecture, dedicated to the universal FATHER, and consecrated by the noblest efforts of painting, sculpture, music, stained glass, mosaic, and every device of art that helps lift the spirit towards its Maker? A cathedral into which the poor and humble could freely enter to disburden their overladen hearts in silent prayer; one where the sad and weary could find a moment's repose, shut out from worldly turmoil and trial, and the glad could utter anthems for the bounty vouchsafed to them: a cathedral where all classes, with souls attuned in harmonious devotion and grati-tude, could mingle in democratic equality of right-mindedness and humanity before their God; where the great vital truths of Christianity, that tend to elevate manhood, exorcise the demon out of theology, repress priestcraft, and develop the charitable, beautiful, tolerant, and practical in religion, could be preached by men of all shades of opinion, without hire and without provok-ing sectarian strife, emulous only of doing their "Father's busi-ness." The present tendency of sects is to a unity of religious purpose, so far as the instincts and conclusions of the people have free play. The marks and boundaries that keep them apart are more of the clergy than of them. But caste is destined to go down before advancing humanity, and the garnish of the temple to be held cheaper than human souls or bodies. An edifice dedicated to universal piety, symbolizing the true brotherhood of Christianity, might be made the grand architectural feature of the Park, indeed, of the city itself. It would be the noblest building yet designed by man, consecrated to the loftiest purpose. Beside it St. Peter's would

be mean and unworthy. Freed from the tyranny of sect and caste, it would be a holy example of that perfect toleration which democratic liberty means, and a living proof that in religion, as in our politics, the lion and lamb can lie down in peace together. Above all, it would dignify the purpose of Central Park, by making it something better than a mere place of amusement. Combined with other features, it would elevate it into the position of a University of the People, leaving no human aspiration for the good, true, and beautiful without its teacher. In this way its usefulness would be far above that of the ordinary colleges of our country, stultified as they are by pedantry and substitution of the husks of knowledge for germinating ideas. We might as well compare the ethereal vault of heaven to the tasteless roofs of the brick pens of Harvard College, as attempt to estimate the relative benefit to mankind of these two institutions: the one so broad and beautiful, the other so restricted in purpose and so hopelessly ugly in external features. None but the All-Seeing can tell the good done to the people at large by the joyous, life-imparting elements of instruction of the Park, and the actual hindrance to the progress of sound education occasioned by the sluggish conservatism and torpid routine of the college.*

The sore need of our people is not more institutions to protect and preserve the larvæ of learning on the time-honored system of substituting the anatomy of words for their essence, but those which will most widely disseminate ideas and promote the happiness of the masses. The rich provide for themselves. If what they wish is not at one place, they go to another. Not so with the vast multitude, who are the bone, muscle, acting and thinking brain of the nation, deciding our destinies for good or evil. Give them ideas, and, as we have seen in our leviathan war, they put them into shape and press them home to their uttermost conclusions. The national brain has been heated to white-heat in the strife, purifying, expanding, and lifting up from their foul soil the great democratic truths, heretofore misused, which underlie our nationality, and which under happier auspices, if we remain true to them,

* See Appendix, Note D.

will bear us on to a degree of prosperity which shall be an example and a wonder to the rest of the earth. Having no Past, we needs must put faith in our Future. Believe in great things, and we shall achieve them. This cannot be unless each individual does his best, according to the opportunity given him, in little things or great, not covetous of fame or profit, but serving the people as he is called upon to serve God, with his whole heart, mind, and strength. Every person has a part in a nation's growth. As the war draws to a close, the more intense need of preserving and perpetuating the public spirit and unity of feeling it has called forth, for the healing of its wounds, the wise deciding of the questions which it has given birth to, and proving to the world that God has not intrusted in vain to the American people the keeping of his law of freedom.

In one direction we have already gone far enough. Anglo-Saxons, in their one-sided idea of home, are becoming selfish and unpatriotic. A home is a nursery and safeguard of domestic virtue, a protection of individuality, lest it be merged entirely into the mass. But man's selfhood being asserted and trained, he owes allegiance to the community. Home is indeed the primary school of life and the sanctuary of its affections. As such it should be jealously guarded. We would make it as sacred in spirit as the holy of holies of the Temple itself. But any virtue pushed to excess becomes a vice. An American home has become something more than its original intent. It distracts the individual too much from mankind at large; tempts him to centre therein wealth, luxury, and every conceivable stimulus of personal ease, pride, and display. The tendency is to narrow his humanity, by putting it under bonds to vanity and selfishness. The family is made an excuse for neglecting the responsibilities of citizenship. As with trade, short-sighted, he forgets that the welfare of the neighbor in the code of Christian ethics is put upon the par with one's own, and that as he neglects it, the State drifts towards anarchy and turmoil. New Yorkers make too much money to care whether their city is given over or not to scoundrelism. They pay a blackmail to villany, in order to shirk their duties as citizens and patri-

ots, to make money as traders, or luxuriate as heads of fashionable families. Easy enough to see where this will end. July riots are the legitimate results. Put a bounty upon Catilines, pay a premium for murderers, thieves, drunkards, and lecherites, give to crime the honors and confidence due to virtue only, and any community must reap a harvest of debasement. Home or business, viewed from the point of view of selfishness, becomes a curse instead of a blessing.

The family is the first step of civilization; the community or nation is one higher. A man may make himself very satisfactory to his kin by concentrating on them his time, money, and energies, to increase the luxury of their living, or to acquire a conventional social position; in short, to promote whatever in their narrowness of understanding and selfishness of purpose makes them most conspicuous or fashionable. But such indulgence tends to undermine civic virtue, and to foster in the child the notion that self-acquisition is the great object of society. By example always before him he is led to feel that the individual must prosper, whatever befalls the community. We are drifting in our great cities in the direction of internecine convulsions. The chief ambition is to outdo one's neighbor in riches or position. Listen to the current of common talk, and note how it sets. Look at acts; see how willingly wealth — nay, with what rival eagerness, it disgorges its coin to accumulate within exclusive walls treasures of art, or whatever administers to pride of possession or isolated gratification, and how little, in comparison, does it expend for the common good. There are many exceptions to this narrowness, else the community would fall to pieces from sheer rottenness of heart. The honor in which they are held is the best evidence of the appreciation of the people at large for high-minded conduct, while the slight regard they have for the pretence of public spirit equally proves the detective magnetism of their moral instincts. Without enlarging further on this topic, we wish to press upon thoughtful minds the consideration whether there is not in general among us an exaggeration of the home feeling amounting to a corresponding negation of public liberality, which it would be well to tem-

per with somewhat of the *"chez-moi"* spirit of the French race; that is to say, their man lives more in his *nation* than we do, but is at home when domestic duties or pleasure bid him to be. By cultivating this enlarged idea of civilization he enlarges his own mind, and identifies himself accordingly with whatever promotes the welfare, beauty, or glory of the body politic, and prides himself therein, and consequently is enabled to take larger views of great questions affecting the human race. In this respect, see how French intelligence is ahead of English public opinion, how much quicker it is moved, and the rapidity of its perceptions, even in the limited action tyranny allows. If we could expand the low-toned rivalry of individuals for wealth and power into a generous competition of cities and states in the growth of public institutions and the founding of parks, galleries of science and art, libraries, fine taste in architecture, schools of ideas, and whatever dignifies and advances human nature morally, intellectually, and æsthetically, individuals competing with one another to be associated in noble enterprises with the same zeal and lavish expenditure they now devote to excel in costly houses, equipages, dress, and the gratification of appetites, we should shortly see the true golden age dawn. We are no illusionist. We do not look for this tomorrow, or the day after. But there are young minds to be formed on nobler ideas than have yet largely obtained. A little seed dropped here and there may spring up into vigorous life. We are earnest in our advocacy of a larger measure of public spirit; of a collective local pride, and rivalry in good works; of the diminution of the selfishness of the home feeling by the substitution of a more generous sentiment, expanding love of the individual into a love of the people.

The specific axiom of our topic is to make the world as *beautiful* as possible. Coming down from the general idea to a particular locality, by way of partial illustration, we select Boston, because, as our birthplace, we are personally interested to see it grow in beauty; because it has already an enviable historic reputation as a town of ideas and action; because its population, and that of New England generally, is, in the aggregate, intelligent and liberal-

minded; and, lastly, because, in addition to its advantages of loca-
tion, general wealth, and culture, it has great need to entertain
and discuss suggestions of an æsthetic character. Still, whatever
is applicable to one city in idea, is equally so to all.

We wish briefly to point out the applicability of the art-idea to
embellishment of the city and the refinement of the people, show-
ing how it enters into all things, and how much beauty may be
obtained from exercise of good taste and at little cost. That beauty
is demanded, the crude efforts to obtain it, and the devotion shown
it when obtained, sufficiently demonstrate. It would not be diffi-
cult, either, to prove that exactly in the degree a thing is beautiful
is it respected and admired by the masses; and that, in a population
like that of Boston, it would be sufficient to place beautiful ob-
jects under their safeguard to have them as much respected as
shrines in Catholic countries. Respect for the beautiful is one of
the deepest instincts of humanity. When not shown, it is because
it has been covered up by the inhumanities of life and false train-
ing. Even in the present condition of public sentiment we believe
the iron fences around our public grounds and lots in cemeteries
to be as useless as they are ugly and opposed to the spirit of their
localities. What need to protect public property from the public,
or the sanctity of the grave by the employment of materials
which suggest social insecurity and exclusiveness, disfigure the
grounds, and add vastly to the expense, diverting money to dubious
uses which could be so much better employed in adorning the
spots in harmony with their true purposes? Mount Auburn, lovely
and spiritual in some respects, speaks too loudly of property, ex-
clusion, and building, things of the earth, instead of the symbolism
of heaven. The artistic tone of the cemetery is mechanical, heavy,
and cold. There is little or no original invention or evidence of
right feeling in its monuments, very little that proclaims Christian
faith. A philosopher of no creed might wander long about it un-
able to decide whether the pagan, pantheistic spirit, the mere mer-
cantile, practical, or skeptical modern feeling, the sectarian senti-
ment, or the family desire to honor the dead, predominated. He
would see a great display of names, not unfrequently conjoined

after the manner of mercantile firms, and an immense expenditure in iron and stone guiltless of æsthetic taste and religious significance except in rare instances; much bastard pagan and classical design, a general vagueness and incongruity between purpose and execution, and a sameness and poverty of epitaph that would puzzle him exceedingly to decide upon the faith or character of those there buried. The wish which prompts making our cemeteries lovely for the living is the right one. As yet, however, whenever they are pretentious and expensive, like Mount Auburn and Greenwood, they fail in spiritual essentials and proprieties. The more simple and rural ones, of which Forest Hills, at West Roxbury, is a pleasant example, accord better with their fundamental motives.

Returning from the tombs to the living, we trace in the moving panorama of the streets of Boston evidence of a rapidly increasing feeling for beauty. Not long since few thought it expedient in their dwellings or business to give any heed to the cry for the beautiful. Indeed, so entirely dormant was the æsthetic faculty that the general conclusion in regard to it was that none existed in the descendants of Puritans. But the signs now are that it is as deep-seated in the human race in New England as ever it was in Greece or Italy. We mean the latent, innate love of the beautiful. The mere fact of its non-development and absence of culture does not disprove its existence. Without it man would be shorn of half his being, and God could take no delight in his creature. So let us cast out, once and forever, the mean idea that the nature of the New Englander, or the American at large, is not possessed of all the elemental faculties that make the complete man. He has them. All he requires is opportunity, stimulus, and culture, to become as proficient in the æsthetic as he is in the practical arts. The bias of his nature is even now turning that way. Rich men begin to believe that the buildings which represent them should exhibit other features than prosaic utilitarianism and utter barrenness of thought and fancy. Compare the stores of 1850 — homely wall-surfaces broken up by graceless apertures, as destitute of ornamentation as a mud-scow — with those of 1860,

with their plethora of carving, classical orders, *rococo* fancies, striking bits of originality, and here and there ingenious adaptation, in fine, the universal struggle for beauty in some shape or other. The same is true of dwelling-houses. A tall, swell-front, naked brick wall, with ugly, gaping windows and awkward steps, was a few years ago the height of ambition in building of millionaires. Now they are content with nothing less than palatial architecture subdued to their requirements, and begin to value color for its own sake for outward decoration. The finest materials are eagerly sought for their dwellings. They wish them to appear handsome in the public eye, and in degree, not the highest, recognize its claim to be gratified in whatever is made a permanent object of view. Look, also, at the colors and costume of the hour as contrasted with the uniform, dull, or homely fashions of the immediate past. If this go on, we shall arrive at something like the picturesque brilliancy and variety of mediævalism, devoid of its coarseness, exaggeration, and grotesqueness. Being more refined morally and socially, with greater knowledge and superior science, a better taste will ultimately direct our delight in what gratifies the eye. The opportunity our streets offer for studies of this character is not half appreciated. The horse-cars, with their gay colors, lively movements, flashing prismatic lights at night, glide by, like so many Brobdignagian firebugs, with eyes of emerald, ruby, and sapphire, or, in fog and darkness, resolve themselves into spectral processions melting into nothingness, as the tinkle of their tiny bells dies out in the distance. Beside their inestimable utility to all classes, they have added greatly to the poetry of our streets.

Shop-windows are another æsthetic element of almost untried capacity of effect. Much of the minor attractiveness of Paris is owing to the good taste of shopmen. They arrange their merchandise, not merely neatly and orderly, but with regard to color, variety, harmony, and always decently, so that it displays its best qualities at first glance. A few of our tradesmen are beginning to understand this. There is a shop in Harrison Avenue which is a notable instance of how attractive objects unattractive in themselves may be made by good taste in arrangement. It is a sausage

or *comestible* shop, and affords an excellent lesson to apothecaries and others, in more conspicuous places, who, with the best materials for beautiful arrangement, present only a chaos that jars a sensitive eye as unpleasantly as false notes in music a fine ear. There are also in Boston a class of shopkeepers who thrust before the public in the most offensive manner the innermost apparel of both sexes, artifices of female toilet, and unpleasant devices for supplying corporeal deficiencies. This undressing in the street is a violation of æsthetic morality. Every woman should protest against it by avoiding these places, on the score of disrespect to her sex. Neither men nor women wish to have vulgar and common necessities constantly thrust upon view and memory. This may seem a foreign matter as regards the art-idea, but it lies at the root of a great principle. Each person is morally bound to contribute his mountain or mite towards the general happiness, welfare, and orderly being of society. Displays that border on indecency and bad taste demoralize the æsthetic faculty, and familiarize the people with images of "dirt." The same rule of the beautiful in all things applies to manners. Were it better observed, we should see no vulgar exposure of persons, heels higher than heads, at hotel-windows on the most prominent streets, nor tobacco-filth scattered everywhere, to the injury and annoyance of others; but, instead, a prevailing refinement of habits and gracefulness of manner, which would make the Americans, in time, the most polite, as they really are at heart the best-disposed and most obliging, people of the globe. Is not this worth trying for?

If other evidence is needed of the extending taste for the beautiful of our population, go to the crowds, including young children, often of the poorest classes, that daily frequent windows or shops in which are to be seen objects of art. These are great educators, for every hour there are borne away from them ideas, fancies, hints, and impressions destined to affect the individuals who receive them during their entire existence. Often they are the first suggestions the recipient has of a positive æsthetic faculty, the primary lessons in art for scores of thousands of mothers and fathers, who go home and implant in the youthful minds intrusted to

them the seeds of their love of the beautiful. Everywhere, these shop-schools are potent auxiliaries of the great art-galleries, and which, in America, they must supply the place of, until we can found them. The art-feeling and average culture of Boston we believe to be already in advance of New York, owing, in great measure, to the number and accessibility of print and picture stores, and frequent exhibitions of objects of art. Those of New York are not visited by the multitude, but chiefly by the idle and fashionable. Pictures having ideas are quicker appreciated in Boston. The taste is truer and deeper, less easily satisfied with the material and shallow. In intellectual matters in general the same contrast holds good. Boston and its neighborhood is one vast reading and lecture-going society. Its numerous public and private libraries attest the universal demand for books, as much among the poorest as the richest classes. There is nothing corresponding to this in New York. That city is almost destitute of private circulating libraries. The common confession is that there is no time to read. There is not, nor ever will be, not even time to think, as New York lives. She is given over to prodigalities of pleasure, fashion, politics, and material gain. Nothing miserly or small, but grand and vehement in her loves and passions, she only awaits resurrection into a nobler phase of life to take the lead in every good work. Meantime, Boston leads not only intellectually other cities of the Union, allowing for differences of population, which, in the case of New York, is as five to one, but morally the world, for it is the only large city in which refined womanhood has won the right to go about as freely and safely by night as by day. This is due, in the main, to the almost universal demand of both sexes for the intellectual food of concerts, lectures, and the better class of theatres. The social victory of Boston women, though in the light of natural right a small thing of itself, will ultimately make itself felt to the very core of our civilization.

We perceive that the art-idea is expansive enough to take in little things as well as great; that it enters, in some shape or other, into every phase of our daily lives; that it besets us at street-corners, shop-windows, and public and private resorts. We can no more

escape it than our conscience. Too much care, therefore, cannot be bestowed on its training. The sources of our happiness are in the ratio of the public comprehension and obedience to its laws. We should never throw away an opportunity of enjoying its gifts.

Nature has been very kind to Boston. Few cities anywhere possess a more picturesque and varied water and air outline. The spade has labored to destroy both, by overmuch levelling of hill and lessening the reservoirs of tide-water. Compass and chain have also lent their aid to cut up the new-made lands into monotonous squares and parallelograms. But nature has her limit of patience. By her fiat spade and rule can do no more harm. The old Romans made a statue of their traditionary wolf-mother. Bostonians equally owe one to the mythic cow that laid out their ancient streets. Perhaps she overdid her work; but it is an error that gives to Boston a variety of urban expression that no other city of this continent excels. The new portion, with its noble avenues, fortunately not all running in one direction, fits well to the old. Both, thus happily united in æsthetic wedlock, have a rare capacity of beauty. Take the view from Beacon Hill as one of many. The outlook ranges for miles over the wave-like hills of the varied suburbs, until it breaks against the Blue range on the one hand, or sinks into the island-dotted ocean on the other. Look when the sun, sinking in the west, pours its golden shimmer and roseate hues through the foliage of the stately elms of the Common, lighting up their forest-aisles and graceful vaults with spiritual life, merging all forms into poetical mystery, then glances and glistens, like the sparkle of countless gems, from window, dome, and spire, irradiating every street with celestial halos or glowing fires. Italy herself could find enjoyment in this scene.

Viewed from the country, Boston has an almost equally picturesque charm on account of its high air-line, the long reaches of bridges crossing its silvery setting of many waters, and the darting, snowy steam-trails on every side that mark the course of the iron sinews that bind it to the mainland. New York and Philadelphia, like all flat-footed cities, are doomed to look in upon them-

selves, always gnawing their own vitals. The Gothamite and Penn-
ite, by force of locality, can get no idea of the general aspect
of their towns. A sample of one part, multiplied indefinitely, pro-
duces the whole. They live and move by blocks and squares, are
rectangular by compulsion, have lost the sense of the picturesque,
or see beauty only in geometrical plots bounded by tall iron fences,
flower-bed bastilles, from which dogs and the people are remorse-
lessly warned off, always excepting Central Park, the idea of
which is so grand and universal that it seems like a protest for the
beautiful wrung out of the soul of famishing millions.

Bostonians at will can get free air, open sky, clear horizon; see
sunsets, sunrises; breathe water-kissed summer breezes; have range,
liberty, variety. The Back Bay, for the present, is a rude park,
whose diversified attractions are not as much known as they de-
serve to be. From a dense throng of unattractive humanity in its
busy mood, the craver of a free breath and elbow-room, in a
ten minutes' walk, can put himself into a picturesque solitude, yet
within ear-shot of human hum. The best parts of New York are
given over to the vilest uses and lowest populations, or the in-
cessant, torturing clang of machinery and the necessities of ship-
ping, with their material discomfort, filth, and bustle.

But Bostonians have thrown away a golden opportunity of
adorning their city at small outlay with an architectural feature
which Venice would be proud to call her own. They have con-
tinued Beacon Street straight out over the Mill-Dam, making an
avenue finer than anything New York has to show, but poverty
itself compared with what was in their power to do. If, instead
of fronting the houses on the present line, they had faced them
the other way, looking on a magnificent esplanade of ample width,
a feature of unique value and loveliness for America would have
been given to their city. That beautiful sheet of water, forming
a tiny lake, fed by Charles River and the ocean, used for regattas,
not coveted by commerce, might have been bordered for miles
with palatial houses and public edifices, forming a splendid drive
or promenade, attractive at all seasons, and in summer obviating
any necessity of going elsewhere to escape heat, or obtain more

beauty. Sunrise and sunset would have painted on its cool, delicious waters an endless variety of pictures in purple, orange, crimson, and gold, intensified by the dark shadows of the overhanging houses, or flaming back from their crystal windows sheets of glory, lighting up earth and sky with dazzling effulgence, such as no Claude or Church can rival, and only Turner suggest. Quick-pulling wherries, with their gayly uniformed crews and dancing banners, the snowy sails of the tiny yacht, and the rhythmical strokes of the row-boat, would have made of each fine day a joyous carnival, and turned the heaviness of Puritan life into a thankfulness and delight. How the French or Italians would have rejoiced in such an opportunity! Our grandchildren will expend millions to redeem the want of taste of the present generation, and to assert for Boston all her rights of gracefulness. It would, also, have proved a far more profitable speculation than the present system, as any one may estimate by comparing the prices of building-lots that have beautiful outlooks with those that have not.

It is unnecessary to pursue this portion of the topic farther. What we have said is simply by way of suggestion, the value of which the reader can test in manifold ways.

XIX

Art-Institutions and Art-Education in Europe and America.

THE inquiry now arises by what means, in America, may the knowledge and appreciation of art be best promoted?

One means is the establishment of professorships of art, similar to those for science and literature, in our advanced seminaries and colleges. Design and coloring need not be technically taught so much as the laws and principles which underlie them. But the chief value of this branch of education would be in teaching the relation of art to civilization, and particularly its connection, in all times, with the religious and emotional sentiments, and its close affinity with the imaginative and creative faculties. A course of instruction of this character, with appropriate illustrations, would not only enable the student to classify art according to its origin, genealogy, and the quality of intellect it represents, but would gradually create an intelligent public opinion, calculated to arouse the artistic mind to its fullest capacity, by not only demanding noble motive and superior execution, but by resolutely exposing imbecility and artifice.

The first duty of art, as we have already intimated, is to make our public buildings and places as instructive and enjoyable as possible. They should be pleasurable, full of attractive beauty and eloquent teachings. Picturesque groupings of natural objects, architectural surprises, sermons from the sculptor's chisel and painter's palette, the ravishment of the soul by its superior senses,

the refinement of mind and body by the sympathetic power of beauty, — these are a portion of the means which a due estimation of art as an element of civilization inspires the ruling will to provide freely for all. If art be kept a rare and tabooed thing, a specialty for the rich and powerful, it excites in the vulgar mind envy and hate. But proffer it freely to the public, and the public soon learns to delight in and protect it as its rightful inheritance. It also tends to develop a brotherhood of thought and feeling. During the civil strifes of Italy art flourished and was respected. Indeed, to some extent it operated as a sort of peace-society, and was held sacred when nothing else was. Even rude soldiers, amid the perils and necessities of sieges, turned aside destruction from the walls that sheltered it. The history of art is full of records of its power to soften and elevate the human heart. As soon would man, were it possible, mar one of God's sunsets, as cease to respect what genius has confided to his care, when once his mind has been awakened to its meaning. First, therefore, educate the people in the principles of art, and then scatter among them, with lavish hand, free as water, its richest treasures.

The desire for art being awakened, museums to illustrate its technical and historical progress, and galleries to exhibit its masterworks, become indispensable. In the light of education, appropriations for such purposes are as much a duty of the government as for any other purpose connected with the true welfare of the people, for its responsibilities extend over the entire social system.

The most common means of popularizing art and cultivating a general taste is by galleries or museums. But even in Europe these have been only quite recently established. Before 1780 there were only three, those of Dresden, Florence, and Amsterdam. As early as the fourteenth century associations of painters had been formed, like that of Florence, A. D. 1350, which was the origin of the present Academy of Fine Arts of that city. But this institution did not possess a museum until 1784. Indeed, public galleries were not in vogue until long after art itself had degenerated into that impotency and insipidity which preceded its revival in the present century. True, there were noble and royal collections like the

Pitti, Borghese, and Modena. To these, however, the public had only partial access. But as the churches and public buildings of that period still retained altar-pieces and other important paintings in those positions for which they were originally designed, the people did not miss as much as they otherwise would have done the less important easel-pictures of the same masters, in the private collections of their rulers. Later, however, on the suppression of many convents and churches, places of deposit had to be provided for the works of art taken from them. Many of these fell into the hands of individuals, or became the prey of speculators. To prevent their total loss, the several governments promptly instituted galleries, into which were gradually gathered all works of art belonging to them, or which had been declared the property of the state. In this way masterpieces which for centuries had been lost to the public eye, or half forgotten in rarely explored apartments of princely residences, were brought out from their obscurity, and restored to their legitimate functions of popular enjoyment and instruction. Yet even in the best of these institutions there was no special order or system, and they had little to recommend them beside the indifferent opportunity they gave to those disposed to study art.

The present Museum of the Louvre is composed of numerous galleries of objects of art and antiquity, embracing the entire range of civilization, founded and conserved on a scale of imperial liberality and magnificence. As the visitor wanders through its long ranges of halls, overflowing with precious works, he is surprised to learn that this chief attraction of the most attractive city of the world is scarcely seventy years old. On the 18th of October, 1792, the first year of the French Republic, M. Roland wrote to David, the painter, that the National Convention had decreed the establishment of a museum in the palace of the Louvre, of which he was to be the director. Be it borne in mind that the greatest museum of Europe was founded by republicans. It was not until the people had won political power that the rulers threw open to them the treasures which had hitherto been enjoyed in selfish privacy, or displayed only as reflections of aristo-

cratic taste and magnificence. When absolutism began to give way to democratic ideas, one of the first results was the restoration to the people of their art of previous ages. Republican France, although engaged in a death-struggle with coalesced Europe, bleeding and poverty-stricken, convulsed with civil strife, and tortured by the hate of castes and sects, with her very existence at stake, thought and labored for art. The numerous portable works which the nation owned were gathered into a museum, free to all; whilst 100,000 livres annually were decreed for the purchase of pictures and statues in private hands, which the Republic considered it would not be for its honor to permit to be sold out of the country. From this beginning, and under these circumstances, within the memory of those now living, the glorious Louvre has risen.

What was oligarchical England doing meanwhile? Not founding galleries; for, with the example of the Louvre before them, the British Parliament refused as a gift what now constitutes the admirable Dulwich Gallery. The British government cared not at that date to instruct the people, or provide for their enjoyment. Fortunately, before long it became fashionable to have a taste for pictures. This potent influence, added to the enlightenment of a few leading minds, who perceived that it was necessary for England to do something for the education of her artisans for the benefit of the manufacturing interests, jeoparded by the superior taste and skill of continental artistic training, led to the purchase of the overrated Angerstein collection of pictures for £57,000, as the foundation of a national gallery. While other countries had abundant store of works of art as public property with which to begin their great museums, England was almost destitute, the only royal collection of value it had ever possessed, that of Charles I., having been long before dispersed. But no sooner did the people of England have an opportunity of studying art, than the National Gallery began to assume an importance proportionate to the greatness of the nation. The people have proved more liberal than the government; for while that has added to it by purchase since 1823 less than three hundred pictures, gifts and bequests have increased it by

upwards of eight hundred. Meantime, the South Kensington Museum, more directly devoted to artistic education, has been established. In connection with it there are already fourscore schools of design, instructing 70,000 pupils, costing annually, in round numbers, $500,000, both galleries, the National and Kensington, yearly receiving more than a million of visitors.

The most careless observer cannot have failed to notice, of late, the rapid improvement in graceful design and harmonious coloring of those British manufactures into which art enters as an elemental feature. As yet there is not much originality or variety of invention, though considerable skill and taste are displayed in adaptation from classical and mediæval examples, betokening a general spread of knowledge of art-forms, and a riper appreciation of their refining and æsthetic influences, even when associated with objects of common use. This is greatly due to the institutions above named, and that eloquent literature of art which has grown up with them, of which Ruskin is the most conspicuous example. England preserves her preëminence by schooling her artisans in matters of refined taste and perfect workmanship. Under similar advantages, there is no reason why our people, with more cosmopolitan brains, acuter sensibilities, readier impressibility, and quicker inventive faculties, should not excel her in these respects, as we do already in some of the industrial arts. We have a continent of fast-multiplying millions to supply with all the fabrics into which æsthetic enjoyment may enter, as well as with absolute works of art. And what utensil is there with which we may not, as did the Greeks, connect beauty of form and color, and which we may not make suggestive of hidden meaning, pointing a moral or narrating a tale?

To stimulate the art-feeling, it is requisite that our public should have free access to museums, or galleries, in which shall be exhibited, in chronological series, specimens of the art of all nations and schools, including our own, arranged according to their motives and the special influences that attended their development. After this manner a mental and artistic history of the world may be spread out like a chart before the student, while the artist, with

equal facility, can trace up to their origin the varied methods, styles, and excellences of each prominent epoch. A museum of art is a perpetual feast of the most intense and refined enjoyment to every one capable of entering into its phases of thought and execution, and of analyzing its external and internal being and tracing the mysterious transformations of spirit into form. But galleries, as they in general exist, formed upon no consecutive plan, are like the *disjointed* pages of a book, one being at Berlin, another at Paris, Rome, Florence, Madrid, London, Munich, Vienna, or St. Petersburg; no one of these singly affording a complete view of the history and progress of art.

It has been well said that a complete gallery, on a broad foundation, in which all tastes, styles, and methods harmoniously mingle, is a court of final appeal of one phase of civilization against another, from an examination of which we can sum up their respective qualities and merits, drawing therefrom, for our own edification, as from a perpetual well-spring of inspiration and knowledge. But if we sit in judgment upon the great departed, they likewise sit in judgment upon us. And it is precisely where such means of testing artistic growth best exist that modern art is at once most humble and most aspiring; conscious of its own power, and, in many respects, superior technical advantages, both it and the public are still content to go to the Past for instruction, each seeking to rise above the transitory bias of fashion or local ideas, to a standard of taste that will abide world-wide comparison and criticism.

An edifice for a gallery, or museum of art, should be fire-proof, sufficiently isolated for light and effective ornamentation, and constructed so as to admit of indefinite extension. Its main feature should be the suitable accommodation and exhibition of its contents. We particularize this, for even in Europe there are few galleries that have been constructed with rigid regard to this purpose. Provision could be made for its becoming, eventually, in architectural effect, consistent with its object. The skeleton of such a building need not be costly. Its chief expense would be in its ultimate adornment with bronzes, marble facings, richly colored stones, or moulded brick, sculpture or frescos. This gradual com-

pletion, as happened to the mediæval monuments of Europe, could be extended through many successive generations, which would thus be linked with one another in a common object of artistic and patriotic pride, gradually growing up in their midst as a national monument, with its foundations deeply laid in those desirable associations of love and veneration which, in older civilizations, so delightfully harmonize the past with the present. Each epoch of artists would be instructed by the skill of its predecessor, and stimulated to connect its name permanently with so glorious a shrine. Wealth, as in the days of democratic Greece and Italy, would be lavished upon the completion of a temple of art destined to endure, as long as material can defy time, as a monument of the people's taste and munificence. Then would be born among them the spirit of those Athenians who said to Phidias, when he asked if he should use ivory or marble for the statue of their protecting goddess, "use that material *which is most worthy of our city.*"

Until recently, no attention has been paid, even in Europe, to historical sequence and special motives in the arrangement of art-objects. As in the Pitti Gallery, pictures were generally hung without regard even to light, so as to conform to the symmetry of the rooms; various styles, schools, and epochs being intermixed. As the progress of ideas is of more importance to note than variations of styles or degrees of technical merit, attention should be given to exhibiting lucidly and consecutively the varied growth and phases of artistic thought among diverse races and widely separated eras and inspirations. By this arrangement, taste is stimulated in an onward direction from lower to higher elements, rising from master to master, until it pauses upon those masterpieces which form the climax of reputation of any one period. Prominent motives and systems of color or design, as they advance or recede in their particular aims, can thus be harmonized into effective æsthetic wholes, avoiding all jarring contrasts and inharmonious relations. The mechanism of art is so intimately interwoven with the idea, that, by giving precedence to the latter, we most readily arrive at the best arrangement of the former. Each

cycle of civilization should have its special department, Paganism and Christianity being kept apart, and not, as in the Florentine gallery, intermixed, presenting a jumble of classical statuary and modern paintings, in anachronistic disorder, to the loss of the finest properties of each to the eye, and the destruction of that unity of association so essential to the proper exhibition of art. It is essential that every variety of art should be associated with those objects or conditions most in keeping with its inspiration. In this way we quickest come to an understanding of its originating idea, and sympathize with its feeling, tracing its progress from infancy to maturity and decay, and comparing it, as a whole, with corresponding or rival varieties of artistic development. This systematized variety of one great unity is of the highest importance in affording the spectator sound stand-points of comparison and criticism. In the Louvre, feeling and thought are readily transported from one epoch of civilization to another, grasping the motives and execution of each with pleasurable accuracy. We perceive that no conventional standard of criticism, founded upon the opinions or fashions of one age, is applicable to all. To rightly comprehend each, we must broadly survey the entire ground of art, and make ourselves, for the time, members, as it were, of the political and social conditions of life that gave origin to the objects of our investigations. This philosophical mode of viewing art does not exclude an æsthetic point of view, but rather heightens that, and makes it more intelligible. Paganism could be subdivided into the various national forms that illustrated its rise and fall; Egypt, Persia, India, China, Assyria, Greece, Etruria, and Rome, each by itself, as a component part of a great whole. So with Christianity, in such shapes as have already taken foothold on history; the Latin, Byzantine, Lombard, Mediæval, Renaissant, and Protestant art, all subdivided in accordance with their schools or leading ideas, graphically arranged, so as to demonstrate, amid the infinite varieties of humanity, a divine unity or origin and design, linking together mankind into one common family.

Beside statuary and paintings, an institution of this nature might contain specimens of every kind of industry in which art is the

primary inspiration, to illustrate the qualities and degrees of social refinement of nations and eras. This would include all varieties of ornamental, transitory, or portable art, in which invention and skill are conspicuous, as well as those works more directly inspired by higher motives. Architecture, and objects not transportable, could be represented by casts or photographs. Models, gems, medals, sketches, studies, drawings, and engravings come within its scope. There should be, also, a suitable library of reference.

Connected with it there might be schools of design for studying the nude figure, antique casts, and modern works. Also, for improvement in ornamental manufacture, the development of architecture, and whatever aids to refine and give beauty to social life, including a simple academic system for the elementary branches of drawing and coloring, upon a scientific basis of accumulated knowledge and experience, providing models and other advantages not readily accessible to private resources, but leaving individual genius free to follow its own promptings, upon a well-laid technical foundation. As soon as the young artist has acquired the grammar of his profession, he should be sent forth to study direct from nature, and mature his inventive faculties unfettered by academic conventionalism.

Were we to wait long enough, fashion and interest here, as in England, would provide galleries and means of instruction in art for the people. But the spirit which animates such efforts is in the main egotistical. Better is it by far that the people act for themselves, supplying their own demands for æsthetic enjoyment, after a manner which, while it offers to the taste a perpetual gratification, stimulates the mind to enlarge its scope and deepen that sympathetic feeling and comprehension of genuine art without which its appeals are as fruitless of life as water poured upon sand. To wait until some Crœsus shall bequeath the means to erect a monument to his memory, in the shape of a gallery of art, would be as unwise a thing as for the thirsty traveller to deny himself the water he could dip up in his gourd, because he had not a crystal goblet for that purpose. Leave egotism to do after its kind,

but as far as possible free art from any motive in its support other than that which springs from perfect love and appreciation. Surely, the means already exist among us for beginning institutions which could in time grow to be the people's pride.

For immediate wants it would be sufficient to provide a suitable locality where such wealth of art as we possess could be got together in orderly shape. As the people grow into an appreciation of the value of art-institutions, they will as freely provide for their permanent support and growth, either by private liberality or State aid, as they now do for more common education. That America possesses the population calculated to sustain and enjoy such institutions, we have evidence in the progressively increasing interest awakened by every fresh appeal to its intellect and taste.

America has already advanced from indifference to fashion in matters of art. It has become the mode to have a taste. Private galleries in New York are becoming almost as common as private stables. Thousands of dollars are now as freely given for pictures as hundreds a short time ago. The result is, that not only large sales of indifferent foreign ones are frequent, at prices that will be likely to flood us with the cheap paintings or falsifications of Europe, but our own artists, to meet the demand, are tempted to sell even the sketches from their walls at valuations which but recently they did not venture to affix to their finished works. Compared with past neglect, this is beneficial, but it is not the sort of stimulus art craves for its highest efforts. That cannot be given by mere competition of rich men, but must come from an educated public appreciation of the real meaning and purpose of art. There is a growing zeal to establish institutions for the promotion of art and the preservation of its works. Under the auspices of the Historical Society, a large sum is collecting to improve their noble grant of land in Central Park by elegant buildings to receive their various collections, on the plan of the British and South Kensington Museums, free to the public. New York, possessing sufficient land in the very centre of the city, in the midst of its beautiful Park, for indefinite expansion for centuries to come, has a decided advantage over European capitals for founding a

national art-institution. Baltimore has a similar institution, begun on the Peabody gift of half a million of dollars, with the promise of as much more. Neither is Boston behindhand. Its Institute of Technology, carefully studied from the experience of Europe, is the most scientifically complete and comprehensive in its organization of any as yet begun in America. In connection with it, but independent in organization, there is forming an Institute of Fine Arts, to include galleries of all epochs and schools. Numerous smaller organizations are springing up in cities like Buffalo, Rochester, and Chicago, showing that the war, so far from stifling the growth of educational institutions at the North, has had the effect to stimulate them, by convincing Americans that the only permanent security for a republic is the enlarged culture of its citizens. Without rating too highly what has as yet been accomplished, we feel warranted in stating that the present time has proved the most auspicious for art and artists that America has seen, and leads us to believe, that, under the influence of that activity which characterizes the American mind whenever awakened to topics of universal interest and utility, she will shortly possess schools and galleries of art that shall be commensurate with her mental growth in other directions.

We append a few statistics of some of the principal galleries of Europe, showing the sums of money periodically devoted to their increase, and the number of paintings each contains.

In the National Gallery, London, the average cost of recent acquisitions is about $6000 each. The largest sum expended for one painting was $70,000, for the Pisani Veronese. The gallery now numbers about 800 paintings.

The Louvre boasts nearly 2000. Since the first Empire 217 have been added, at an expense of $260,000, of which the Sebastiani Murillo alone cost $125,000. Versailles has upwards of 3000 paintings illustrating French history. The Gallery of Turin has 369 pictures, largely repainted by one hand, and, in consequence, of comparatively little value. In the Uffizi, at Florence, there are 1200; in the Pitti, nearly 500; and in the Belle Arti, about 300. At Rome, the Vatican contains only 37 pictures, and the Capitol 225. In the

Academies of Venice and Bologna there are about 280 each; in that of the Brera, at Milan, 503; and at Naples, exclusive of those of ancient Greece and Rome, 700. The Pinacothek at Munich, of recent origin, already numbers 1270, and the Berlin Gallery, still younger, has acquired 1350 paintings. Vienna (the Belvedere) has upwards of 1300, Madrid about 1900. The Dresden Gallery outnumbers all the others, exceeding 2000. At Amsterdam there are 386; at the Hague, 304; Antwerp has 387, and Brussels, 400. Some of the private galleries of Europe in number and value excel the public. The Borghese has 526 pictures; the Sciarra has few, but choice; the Bridgewater Gallery counts 318; the Duke of Sutherland's, 323; the Grosvenor Gallery, 157; and that of the Marquis of Exeter, upwards of 600. Lord Dudley's (formerly Ward) is one of the most choice and valuable in London.

This list could be indefinitely extended, for there is scarcely a city of repute in Europe which has not public or private galleries of established reputation, examples for us to follow, not only for our æsthetic satisfaction, but as investments materially contributing to the prosperity of their respective cities, by the numberless travellers they attract. The city of America which first possesses a fine gallery of art will become the Florence of this continent in that respect, reaping a reward in reputation and money sufficient to convince the closest calculator of the dollar that no better investment could have been made.*

* The substance of this chapter has been in print before, mostly in the *Christian Examiner*, Boston, and the *Fine Arts Quarterly Review*, London.

XX

Review of the Art-Phase of Civilization, as derived from Greece and Judea. — The Future of Art based upon Protestant Freedom. — Quality of the Artistic Mind. — Of the Scientific Need of Art. — Radical Difference between Science and Art. — The Intellectual Repose of the Scientific Mind, — the Passional Unrest of the Artistic. — Analysis of Causes and Results. — What Science can do. — Legitimate Sources. — Highest Art. — What Cultivation requires.

W E have sought to trace the action of the art-idea in its relation to civilization, more in generals than particulars, with especial reference to the needs of America, using names only so far as required to illustrate its various motives and stages of progress. Let us look back for a moment, and take a summary view of its historical course in its best forms, as guided or controlled by those great currents of religious thought which have borne mankind, from time to time, out of one kind of existence into another. We will confine our retrospection to those sources of ideas which more directly underlie the intellectual and religious structure of our own civilization, namely, Greece and Judea.

The expression of thought as art has taken, we find, three strongly pronounced and clearly defined aspects. First, the classical Pagan, or sensuous-mythological. Second, the Roman Catholic, or ascetic-theological, with its reactionary offshoot of Renaissance, or the sensual-worldly, based on aristocratic culture, and the interests and tastes of lords temporal as opposed to lords ecclesiastical. Third, the Protestant, or democratic-progressive, founded

upon the elevation of the people into a power of state. Art now loses in intensity of sacred symbolism and princely grandeur, but becomes more largely human in motive and humane in character. Escaping alike from priestcraft and state-craft, its growing tendency is to express the religion of humanity: praise to God alone and good-will to all men, as distinguished from the two previous phases of misguided religious thought and misinterpreted Christianity.

From the very nature of Greek mythology sculpture was admirably adapted to embody its spirit. All that classical paganism can strictly be said to have required of its art was an idealization of man's faculties and forms, and an imaginative personification of the hidden forces of the natural world, both required, by an imperative public taste, to aspire to the highest degrees of ideal beauty and intellectual meaning the particular conception was capable of. We qualify Greek beauty by the term intellectuality, because it is necessary to keep this characteristic constantly in mind in judging between it and the more spiritual or ascetic types of Christian art. In the superior fitness of classical inspiration for material expression and adaptation to the laws of natural science, perfected as it was by scrupulous study and refined sensuous feeling, we detect the secret of the success of Greek artists. Their art and religion contemporaneously rose and fell, the one growing naturally out of the other. Therefore, in calling Greek art successful, we do not mean that it is the highest expression of man's æsthetic capacity, but that it was the highest and most complete it was capable of attaining under a given religious condition of mind.

Christianity now intervened, with its more spiritual faith and wider expanse of soul. Is it equally successful in its development of an appropriate art?

If this question were confined to Gothic ecclesiastical architecture in comparison with the Greek temple, we should say Yes. But, having more particularly in view painting and sculpture, as representative of the aspirations of the Christian heart on the basis of the teaching of Jesus, we think not. In this respect Christian art still fails in degree. It has nowhere attained to an equal ideal

standard of expression of the divine, when compared with its quality of spiritual motive, as the art of Greece in comparison with its intellectual inspiration.

We have observed that the painted Almighties of mediævalism, and the sculptured Christs of Thorwaldsen, Tenerani, and others, are heavy and vulgar by the side of the Jupiters and Apollos of the best masters of antiquity. Do we ever see in Greek mythological art a posture, costume, or expression, that excites the feeling of the ridiculous or absurd? Yet, as has been seen, this is common in Christian art, if we contrast the idea with the execution, not to recall our frequent disgust at overwrought physical agony, or the filth and misery of corporeal asceticism. Whenever this occurred it is evident that the artist had no proper conception of the spiritual beauty of soul, and its intimate connection with a high moral beauty of action, harmonized into a corresponding quality of form, and, if ever divorced, only by the force of some transitory law, of which the temporal character should be so plainly suggested as to have the effect of shadow in bringing light into greater brightness. A few faith-illumined imaginations did, indeed, aspire to realize this in art. We see in the virgins, prophets, sibyls, and apostles of Leonardo, Titian, Raphael, Michel Angelo, and Blake, and their most distinguished scholars, evidence of correct impersonifications of their respective attributes. But, as a general thing, whenever Christian art has sought to reduce the highest notions of divinity to sensuous perception, it has fallen short of the intent.

Moses only repeated an Oriental law when he prohibited art from attempting to embody the Divine essence, and Protestants have strictly obeyed his injunction. But in the cherubim and seraphim of the holy of holies even the Jew ventured to prefigure God's love and wisdom. The Greek, by constantly aspiring to personify his intellectual ideal, finally succeeded. May not the Christian, by resolutely pursuing the path indicated by his Pagan brother, finally redeem his art from the reproach of unspirituality — or of not adequately representing in tangible form his conceptions of future life, and its intimate relation with the present — that it now lies under?

CHAPTER XX

We have seen that Christianity, by enlarging the field of art and elevating its motive, gave to painting, as a means of expression, a predominance over sculpture. It is on that, therefore, that we must chiefly rely for ultimate success. The bastard union of Classical forms with Christian thought, having no power of procreation, cannot long perpetuate its existence. As it dies out, the Protestant direction of art begins to predominate, springing from the people, humble and common in its origin and taste, and not unseldom, as has been shown, vulgar and vicious, still thoroughly human, and claiming full liberty of utterance according to individual needs. Born of progressive humanity, protesting at all of the past that deadens the spirit of the present, it impels man onward in a constantly enlarging circle of needs and ideas, based upon the expansive power of science to overcome matter, to reduce its laws to human service, and to expose the underlying spirit of all things. In this respect science not only beckons to art to move on, but demands that it shall. But art prefers to look back; to represent the past, or, at the most, to give only what is acceptable of the present. It reflects too much the popular feeling, right or wrong, and demands welcome, not so much because it teaches, as that it sympathizes. Seldom, like science, does it reveal new and startling truths. Hence, it has no persecuted Galileo, no martyred Socrates, dying for conscience' sake. It is too little a law, and too much an emotion. Since it emerged from the ruins of Greek civilization, it has been a fluctuating sentiment, rarely indulging in anticipation, but too full of contrarieties, jealousies, and rivalries; a divided host of individuals or societies, with single or rival ends in view, each one contributing his or its best to the great tide, but constantly going round and round again in the same circle, no artist being the wiser, except as his own perceptions lead him to the discovery of the means and laws of preceding art. Turner, Titian, and their equals, in dying, have left no sign behind of their peculiar methods, except general results. Great artists have devoted their lives to ascertaining the secret of Venetian color; and learned treatises have been written upon what, in one sense, from perishing with the individual, is a lost art. Every artist has been more or less compelled

to reproduce by himself all previous excellence of his kind, as his primary basis of progress. Much time was necessarily lost, and genius stultified, in this endless routine of experiments on material. Yet the world will not forgive any inferiority of kind. This is right in principle, but often wrong, considering what it requires of the artist.

Must art in its material aspect be thus a perpetual system of fluctuating reproduction? Why may not its technical laws be steadily evolved, like those of science, by the harmonious unison of minds engaged in the common pursuit of its practical truths? Art should, indeed, give no direct evidence of rule. Like nature, it is the product of law; but it should seem an inspiration, and its greatest power rest upon its apparent spontaneity. Indeed, all the great ideas which from age to age have revolutionized mankind have partaken in their outset of the character of revelation. Whence they came, and whither they were to go, no man could tell. They are the fruit of that mysterious intuitive faculty of the human soul which baffles all logical analysis or mental explanation. But, once received into the mind, they gradually resolve themselves into law. From first feeling a truth, or an intuitive consciousness of its existence, delighting his heart, man aspires to a knowledge of its principles of being, for the satisfaction of his reason, and to acquire that control over nature vested by God in him through the enlightenment of his understanding. He knows that all revelation and all enjoyment must have a law, and that law be in harmony with its divine authorship and the ultimate purpose of life. Beauty, indeed, cannot be reduced to manufacture, for its essence is that freedom which defies analysis and outlaws compass and receipt. But, while instinct, as we see so often in semi-barbarous nations, leads the workman to anticipate science in that subtle employment of color which most satisfies our demand for its specific enjoyment, yet from analogy we may be assured that there is for this a positive law, as mathematically exact in its operations as gravitation or crystallization. Art cannot rival nature, because of their essential difference in means, the former wielding few, and subject to the limitations of matter at second-hand, the latter having at

command the entire laboratory of God, inspired by his will. At the same time, the science of nature is not the limit of art. She has something given her to do apart from the uses and objects of nature, and therefore must not be circumscribed by scientific law. When art in spirit departs from the position of imitator or copyist, it may be that either she is asserting her own independence of creative will, in the fulfilment of a new prophecy and revelation, or that she is misled by error and ignorance. Between art and nature, the spectator is the judge. Of one thing he may be sure: until the artist ascertains the true relation between cause and effect in the management of his materials, he must, at the best, work at random, or under the guidance of that feeling for the true and beautiful which, when successful in its highest degree, we call genius, but which in general is but a groping of the mind from darkness for light, and keeping right only in degree of its knowledge.

The difference between art and science is the form under which the spirit of either is rendered, the one seeking to incarnate it as beauty, a thing of love and joy, and the other as abstract law or material fact, an instrument of power or a canon of wisdom. Each is requisite for the complete existence of the other. Indeed, throughout nature they are twins in being, but not in degree; for, although beauty and its offspring, art, are the result of absolute law, yet nature as well as man exercises a choice as to whether the useful and scientific or the beautiful and artistic shall most predominate in the external expression given to objects.

We now arrive at an important inquiry as to their relative moral effects. Why is it that moral science or wisdom in its loftiest flights leads to philosophical repose? How is it that it exalts the mind above sense, basing it solidly upon divine law, so that past, present, and future are to it but the peaceful, progressive to-day; leading it to a secure reliance upon that Providence it so beautifully reveals; making it charitable, unselfish, trustful, and obedient; a little child, through faith inspired by knowledge; all being true, good, and lovely that it has learned, all that there is to learn must be still more so; the heart growing serene, simple, and peaceful, as its spirit-sight penetrates the vast unknown, through the portals of

the known? Why is it that this science of the future thus blesses its possessor, though it may bring upon him the reproach, misunderstanding, or persecution of the world, while, though he may be the idol of the day, art so often disturbs the harmony of the artist with himself, society, and God, that its genius has become too proverbial for eccentricity or wretchedness? Why is it that the intellectual or spiritual repose of a Socrates, Plato, Newton, Swedenborg, Fichte, Boehme, Kant, Channing, or Humboldt, is opposed by the passional unrest of a Sappho, Jeremiah, Dante, Petrarch, Tasso, Burns, Byron, Keats, and Shelley: high philosophy and high art ever in severe contrast in the relative happiness they confer upon their greatest disciples?

Judging of poetry simply by the erratic impulses of the poetical faculty in individuals, one is tempted to call it the weak side of God. Genius in song is even more eccentric and unbalanced than when it descends into the hand, and is represented by plastic art. But both poets and artists, from their being born on the love and beauty side of life, are more subject to the caprices and antagonisms of feeling than sages, whose ideal of good, through reflection, aspires more directly to wisdom. In proportion as this element is received into the artist-mind, by establishing a mental equilibrium, it produces more harmonious and universal men, appreciable in degree to all temperaments, truly greater from being wiser, though not always reaching to the particular spiritual insight of those more sensitive beings whose hearts are self-devoured from the failure of the actual to correspond with visions which too often blast their souls "with excess of light." With such, art is more the disclosure of their own than of the universal soul, which we find in men who, like Shakspeare, Milton, Goethe, and Wordsworth, unite the poetical and prose elements in more justly balanced degrees. By prose we mean the science that comprehends life, morally, intellectually, and physically, but whose instincts repose more in law than beauty, though fully recognizing the need and power of the latter to make the former loved.

All men demand beauty, first, as a primary instinct, and, secondly, in degree and quality in accordance with their mental growth.

Art is its material form. Poetry is abstract art. Its pictures are addressed to the inner sight. With the exception of a certain cadence in words, of value only as it corresponds to the idea, it is wholly ideal, and commends itself to man's sense of spiritual beauty and truth. But no beauty that is not approved of reason and conscience secures to itself a permanent repose in his heart. Greek poets understood this principle as well as their artists. Although their understanding was less spiritual than the Christian, yet their genius still retains its sway, from its harmoniously combining beauty with rule; form, action, and song being a revelation of nature's truths, under their most poetical aspects. Beauty thus cherished ceases to be a fatal gift either to possessor or receiver.

Christianity, in elevating and enlarging the life-motive, requires of beauty the loftiest and purest unity with truth. As it recognizes but one God, of equal and immutable love and wisdom, so it knows but one perfect source of inspiration. The ideal of art or science must centre in His beauty and law. There can be complete and harmonious manifestation of either only as each reflects the other. Beauty, to be perfect, must correspond with science; science, to be complete, must be beautiful. This is a necessary corollary of divine perfection, which consists of an equilibrium in attributes and powers. All life short of the divine must, of necessity, vary from perfection in the degree of distance from Him. Education, in its correct appreciation, is the training which best establishes that equipoise of power and feeling in man which most accords with divinity. Our happiness depends upon our nearness to Him. The Greek, equally with the Christian, was cognizant of this truth; but the difference between the character of the two sprang from their varied obligations of duty, founded upon their respective conceptions of God. This is as true of individuals as races; therefore the quality of artistic inspiration must depend upon the feelings and perceptions of the age or artist, though all true art can have but a common aim, namely, through beauty to educate man to a better understanding and more perfect love of the Creator.

We have said, that, as feeling precedes reason in the process of education, it follows that the unrestrained inclination of man is

primarily towards sensation and beauty. Wisdom is born of the later-aroused reflective faculties. Poet-artists are the prophets and messengers of truth in the garb of beauty, as are sages its teachers in the abstract shape. Owing to the natural inequilibrium of human power, arising from defective wills and understandings and a multitude of esoteric agencies of nature the results of which we become conscious of before comprehending the law of their action, poets and artists too often yield to the force of impulse, and pursue careers of despondency, illumined by fitful flashes of glorious light, revealing both their disappointment and their deathless hope. They may wring out their lives, drop by drop, in anguish, protesting against man's neglect of divine beauty; but a belief in something high and noble remains ever within them. Skepticism is not born of poetry. The life-principles of this divine gift are sympathy and faith. Poets' souls burn in sight of the future revealed through their imaginations. If they sing of the past, it is in harmonious strains, that appeal alike to the consciousness of all ages; if of the actual present, they make to themselves a common joy. But when they speak of their inward future, their words to the multitude seem like a vain sound, or the delirium of a dream. In proportion as the poetical and philosophical temperaments are equally and largely intermingled in one man, he becomes a great teacher. Of this class of well-balanced, highly illumined minds are Plato, Shakspeare, and Swedenborg. In art its type is best characterized in Leonardo da Vinci. In him genius descends into actual life. Whether treating the humblest plant or the most repulsive reptile, landscape or figure, the strife of brutal men or the loving tenderness and sad reproach of the Saviour, the indignant surprise of Peter, the affection of John, or the avarice and treachery of Judas, angelic expression or the astonishing creations of his own imagination, unlike aught of earth, yet terrific and sublime in their seeming naturalness, we find in everything he did that thorough application of science to feeling which leads to perfect art.

Artists like Blake are misunderstood, because going beyond the external consciousness of their age, and treating of life in its divorce from matter: the substantiality of existence beyond the tomb, so

unreal to the ordinary mind. He awaits his audience. Others, like Haydon,[1] shipwreck existence, and reflect their intolerance and exaggeration amid much that is clever and noble, from the egotism common to those whose feelings, by over-balancing reason, keep their moral faculties in perpetual disorder, and lead them to refer all men and subjects to the standard of an excessive I. Ruskin, to a certain extent, is another instance of the infirmity of the artistic mind to be so seduced by single truths or isolated feelings as to lose sight of the higher and more universal, and thus largely to disqualify its judgment and defeat its intent. In an opposite and still more faulty one-sidedness are artists like the American sculptor, Hart, who invents a machine to reduce sculpture to an external accuracy of lines and dots. This, indeed, may give the crust of mind; but feeling and thought depend upon the artist himself. No machine can compensate for their absence.

The need of art is, therefore, mental equipoise and more patient and combined investigation. Its inherent weaknesses are one-sidedness, extravagance, suspicion, intolerance, haste, jealousy, want of completeness intellectually, and of harmony morally. To counteract the excessive impulses of feeling, and the tendency of artistic thought to narrowness of intellectual vision and an exuberance of individualism, it requires a greater cultivation of the scientific and reflective faculties. The discipline of philosophy is ever beneficial to the imagination, as may be seen in those few great minds which have so admirably combined the two that the world is in doubt whether to esteem them most as poets, artists, or sages.

Genius should not, however, be enslaved by law, nor misled by feeling. True genius is an apparently unconscious, spontaneous action of law, noble and natural in all that it does, whether little or great. Its greatness consists in its truthfulness to nature. But genius is in itself rather an innate force of mind, tempered by material circumstance, though partaking in a high degree of spiritual clairvoyance, and thus making it in generals anticipatory of the coming truths of the age, than a definite, positive revelation of particular truths, without self-effort or will. Its native manifestations are irregular in manner and varied in quality. Therefore, though it may

be accounted in its possessors as a divine gift, over and above the measure of ordinary humanity, yet it is subjected, for its perfect expression, to the study and labor common to all men who would win to themselves the power and repose of wisdom. If it bestow more upon the individual, it also requires more of him. His penalties of misapplication are in ratio to his joys of appreciation. Therein God shows his unerring justice. He gives to all as they are qualified to receive, and holds each to a strict responsibility in use. So fearful is this responsibility, and so liable to abuse, that the earthly destiny of genius is a proverbial warning to the common mind not to covet an excess of the divine light. Apollo alone safely guides the chariot of the sun.

Notwithstanding its dangers, genius is indispensable to high art. It is its elementary force. In science we find no routine of individual reproduction, as in art, but a systematic unfolding of progressive truths; so that the startling or discredited discovery of one age becomes the familiar knowledge of the next. Thus a mighty whole is gradually built up. Nature gives freely, as she is pertinaciously asked. Scientific men proclaim and combine their results. Throughout the world they are a living brotherhood, connected by the common pursuit of knowledge for practical ends. Is a system, which is so favorable to science, applicable to art? Or, as we before put the question, how far is it possible to avoid the reproduction in art which so delays its progress as compared with science?

Just as far as knowledge is transferable, and no farther. A material fact or philosophical thought, once established, becomes common property. Every discovery in the laws of matter which affects the elementary substances in art-use, simply or combined, should be carefully scrutinized, to detect its practicability to enlarge or improve the means of art. Perspective, of which so little was formerly known, is now reduced by science to so simple a study that a school-girl in this respect can surpass the efforts of ancient masters.

If art paid more attention to the theory of light, making public the results of individual experiments or the secrets of peculiar effects, why might not an equal certainty and skill be obtained in use of colors as of lines? The system of painting continues to

be one of accident, or of arbitrary method. Successful results of lucky mixtures are still concealed as if they were golden secrets; the curiosity of the public is excited, but not enlightened, by private experiment. Our artists begin, in this respect, at the beginning of the science of coloring, reaping small benefit from the experience of their predecessors. Science advances by the accumulation of knowledge. Apply this rule to the perfection of colors, and the means of art generally, each artist conscientiously contributing his discoveries to the common stock, and there would soon cease to be a perpetually recurring infancy, or disappointment in its material expression. We know that every color is the fact of an absolute law, and undoubtedly can be made a sure servant of art, mastery of hand being equal. When science has bestowed upon art the entire secrets of pigments, and a more correct and facile management of material, certain coveted effects will be secured, with unmistakable accuracy, upon the canvas in the outset of an artist's career, and his time gained for the development of that which, being born wholly of the individual, is as untransferable as existence itself.

Science, by enlarging the area of thought and observation, demands more than it once did. It measures the capacity of art by its own depth and breadth. Not only does it exact excellence in the use of material, but harmony with spirit, because it sees into the law of unity. What art has done are to it but indications, and not the finality of power. As with science each step widens the horizon, discovering new divinity in the law, order, and sequence that it discloses, so it sees, in its intellectual illumination, a field as new and limitless for art as for its own interpenetration. New truths develop new forms. The back view, though it ranges over decades of centuries of civilization, looks narrow and confined, compared with the illimitable expanse above and beyond. Until art has exhausted God, it may not complain of wanting a future. But so long as it clings convulsively to the past, or labors only in the material present, presenting the common and little, it will be without fulness of life and promise.

There are two legitimate sources for high art. First, the deduc-

tive, or that which is based on nature as the teacher, suggesting spirit by form, to be judged not as imitation, but as the divine working in the natural, in obedience to the laws of science.

Secondly, the inductive in principle, having its foundation in the innate creative faculty, seizing ideas in their inmost significance, and creating for them corresponding forms, which out of their spirit-depths overpower our senses, and recommend themselves to our imagination as comporting with its view of, and faith in, things and joys unseen. They may not necessarily have similitude to known objects, and yet have the force of the inevitable. Whether of good or evil import, they are to be classed as supernatural and strange to the external view, being with or without kin in kind on earth, yet true and real to the interior sight. In Shakspeare, in the "Tempest," this was a second sight; but in Dante, Swedenborg, Milton, and Blake, it was their primary vision. Their imaginations dwelt more on the unseen than the seen; and yet in actual life they preserved sane and noble minds, aspiring and believing because they saw into the future.

Lastly, we cannot repeat this law too often: art, like God's works, should seem self-existing. Without labor and study it cannot be perfect; but it ought to disguise its means in its naturalness, as if the artist said, "Let my idea live," and it lives. The highest art ends here. Seemingly spontaneous, yet obedient to human will, it reconciles itself to nature, and makes its author partake of the attributes of the great Author of all.

This much men must require of art for perfect satisfaction. If it have the capacity, which it would be impious to doubt, in its ultimate unfoldings, of representing to us as sentient beings all that we are capable of feeling and knowing, then we are right in demanding of art, in whatever form it speaks, unmistakable expression of its highest qualities. Artist and spectator, though differently gifted in power and form of soul-expression, have still a common past and future. It is the duty, therefore, of the artist, if he would maintain his rightful position as teacher and interpreter of Beauty, so to cultivate his own soul as to keep not merely intellectual pace with his constituents, but far enough in advance to continually

stimulate their faculties to their fullest limits of thought and feeling by the successive glimpses he gives them of the unutterable things that lie beyond both, far-reaching into eternal joy. Nay, more. The artist who would fulfil his entire mission must manifest the completeness of his divine credentials by displaying *creative* power. For this rare faculty, in its perfection sublime, most closely affirms the tie of genius with its Creator. Beyond it he may not aspire. The kingdom given him is alike over mind and matter. Its possession is to be won, not with the pride and self-sufficiency, nor with the artifice, indolence, and superficiality, of the carnal heart, delighting in the incense of easily-won applause, as temporary as are its triumphs trivial and hollow, but with prayer, faith, and sincerity, humble in view of the exalted work given him to do, and yet, sustained by its beauty and dignity, firm against the assaults of vanity, falsehood, avarice, and mean fame, strong and true by virtue of his sight into things unseen, and self-poised by culture of heavenly wisdom. Thus should, yea, *will* the rightly inspired artist labor. Eye has not yet seen nor ear heard the entire compass of even what exists in the kingdom of nature, around our external senses: much less has the mind wholly penetrated its prolific and harmonious correspondence with the final destiny of the human soul. Mighty wonders surround our daily steps, prophecies in matter of that glorious futurity Christianity seeks to impress upon our hearts, in accents of peace and hope. Hence, there is a cogent stimulus to the teacher and the taught, each reacting upon the other, giving and receiving, in mutual appreciation, the artist fulfilling the law of progress, and the spectator the law of sympathy. Herein lies also the scope and direction of art, GODWARD; spirit talking through matter, face to face with man, as the Almighty spoke to Moses. But, to arrive at this degree of comprehension of art, we must first walk patiently and humbly, receptive to those pure influences which are constantly knocking at the door of our hearts, with untiring love, leading wisdom by the hand, desirous to enter and find a home therein. When we began our art-education, like an infant that pleases itself in picking out the letters of the alphabet, we rejoiced to find out names from styles; now, something more than

external form is required. We must have great principles in art, truths that make this world joyous and instructive, and the next bright with hope and faith. If our thoughts and experience, fellow-pilgrim on earth, have helped you on your way, they have performed a double duty, bringing good to you and to us. May God guide us both.

APPENDIX

NOTE A

WE are aware that the authenticity of the bust of Æsop is doubted, and probably with reason; for the era of bust and statue portraiture began about the time of Alexander the Great. The Greeks created effigies of their public men, as we know to have been the case with Home, the Seven Sages, and others. But it is highly probable that there existed, in all these instances, traditional likenesses or descriptions bearing a general resemblance to the originals, which the Greek artists used as the foundation of their partially imaginary portraits, adding thereto, through the power of their subtile and marvellous idealization, a heroic and generic type, indicative of the highest qualities of the personages they sought to represent. In this manner it is true that accurate external individuality must be more or less varied from; but in its place we possess a nobler portraiture; and, if we class the idealism of the inner man under forms most characteristic of prominent mental traits and of the loftiest feelings and aspirations as superior to the merely superficially correct exterior figure in preserving to the public the deeper truths of individuality, we have a realism of character in these portraits more absolute and refined than could possibly be given by the most careful and elaborate Denner-like art. We see the heroes of antiquity as the most appreciative minds of kindred generations saw them. Their spiritualized presences are before us. It is not necessary, as we find in the case of Æsop, that the idealism should be one of mere beauty, but it must be of that type which shall best represent the highest and most noted points of character in the individual in question. In short, it is high creative art; for, esteeming as secondary, or not requiring the physical exterior to copy from, genius builds up as it were from its inmost consciousness and appreciativeness of mental attributes a form to correspond with their best expression. Thus, by revealing to the spectator the inward qualities of the man, in preference to the external and commonplace, he is actually brought more spiritu-

2 8 9

ally in sympathy with him than he could possibly be by any other principle. Of this character are the touchingly beautiful traditionary heads of Christ and St. John, actual likenesses, though the artist never saw either in the flesh, of their sorrowful yet loving relationships to each other and an erring world.

The essence of Greek genius lies in its capacity for noble idealism, whether the subject exist only in the imagination or as an actual sitter.

Roman portrait-art was the reverse of this. It was hard, practical, exact, disguising no unpleasant physical facts, but reproducing the outward man with the pitiless fidelity of the daguerreotype. It was characteristic of the seven-hilled civilization, which delighted in exhibitions of strength, power, national triumphs, and all that bespoke the haughty, conquering, implacable, hard-headed Roman. His intellectual force being based chiefly upon the lower faculties, the divine spirituality of the Greek was foreign to him; therefore his inspiration led him to matter-of-fact art, and to conceal no evil of his rulers. The comparatively brutal type of Roman busts in general contrasts unfavorably with the intellectual idealism and beauty-worship of Greek art. Both are valuable, as letting us into the secret causes of the respective parts which each nation has filled in human history.

NOTE B

THE following verses by Thornbury graphically depict Dutch Protestant art:—

> Never thoughtful, wise, or sainted, —
> This is how the Dutchman painted, —
> Glossy satin, all a-shine;
> Amber silk, as bright as wine.
>
> Red-nosed rascal, cap awry,
> Holding flagon to his eye,
> Every word a curse or lie.
>
> Utrecht feasts and Zealand dances,
> Drunken skips and reeling prances,
> Troopers with red drums and lances.
>
> Gallants robed in purple cloak,
> Orange-scarfed, who drink and smoke,
> Careless what boor's head is broke.

APPENDIX

Ladies trim in scarlet bodice,
Swansdown-edged, each one a goddess,
But laughing at an ape, — which odd is.

Knaves in steeple-hats, who lean
Over door-hatch; vine-leaved green
Gadding round the window-screen.

Brutal boors, who strum a lute, —
Screw their faces to a flute, —
Gray and scarlet each man's suit.

Pipers maddening a fair;
Mountebanks who make fools stare;
Drunken fights, with lugging hair.

Cavaliers in silver gray,
Looking, in a sodden way,
At the skittle-players' fray.

Tranquil groups of dappled kine,
Yellow-red, or dark as wine;
Willows standing in a line.

Long canals 'mid sunny grass,
Where the barges drag and pass,
Stared at by the milking-lass.

Cuyp's rich mellow gold I see, —
Teniers' silver purity, —
Potter's broad serenity, —

Jewel-color, clear of dye, —
Crystal, tender to the eye,
Subtle in each harmony.

Glossy satin's rolling shine;
Amber silk, as bright as wine;
Never thoughtful, wise, or sainted, —
This is how the Dutchman painted.

NOTE C

We have in view, to illustrate a felicitous union of naturalism of
form with a certain idealism of character, a recent picture by H. D.
Morse,[1] an amateur artist. It is a study of a Startled Doe, with ears

thrown different ways, detective of danger. There is in it no littleness of treatment and hair-counting mechanism, but broad naturalistic truth and vigorous conception. Being a sketch only, it is thin in color. The strong point is the animal's self-consciousness. Its nature and habits are clearly revealed. We see at once not only what it will do, but what only it can do, the quality of its instincts and movements. So much struck were we with its superiority in this respect that we ventured to inquire the cause. The reply was such a clue to the attainment of noble truth in art that the artist will, we trust, forgive us for making it public. He had had a very poor model, which had given him great trouble; otherwise, he fancied, he should have done better. "Pardon us," we replied; "but your cause for not doing better seems to us the real cause of your success. Your model was sufficient for general form and detail. Forced to rely on your own knowledge of the habits and instincts of the animal, you have created him partly out of your own consciousness or idealization. Had you had a more perfect model to your eye, you would, perhaps, have been seduced into mere imitation. As it was, you have evolved a picture vital with the real instincts and movement of the doe."

NOTE D

HARVARD COLLEGE is no worse than other olden institutions for drilling young men's memories in dead languages, holding the knowledge of Greek accents or roots to be of more account than the thought the Grecian tongue contains, and for recitations by rote on hard benches after the custom of infant-schools. It has certain defined purposes, but does it realize them? The general result is a few brilliant scholars, much cultivated dulness, a great mass of diluted ideas at third-hand, and indifference to knowledge at large. Many of the undergraduates regard the college as a place to train, not scholars, for they are held to be "digs" and avoided, but "gentlemen." If it did really do this, in the sense of the highest type of a man, the country would rejoice. But the "gentleman" there current has a very small conception of the large instincts and great ambitions of humanity, none at all of its real duties, but a vast estimate of his individual value. Electing himself a member of the would-be-called aristocracy, an annual crop of which comes and goes with the ebb and flow of property, he is a fortunate man if he do not subside into a shallow snob of the exquisite pattern, filled with "a divine idea of cloth," as Carlyle has it, one of the fast-increasing and inutile *jeunesse doré* of America.

APPENDIX

We deplore, for the sake of grand old Massachusetts, the increase of this kind of population, especially, if it be owing to the mistakes of its pet college. That there is something wrong in its atmosphere is evident from the fact that a diligent student is unhonored by the mass of his classmates, while recently a proposition was made to call in the city-police to aid the Faculty to put down "hazing" by the Sophomores, thus virtually confessing their inability to maintain discipline. What can be done by Harvard, with its vast resources, to train up American citizens and Christian gentlemen, is a question that the State sooner or later must inquire into. Virtually, the college regards Boston as its *villein*. There is, however, another Boston which occasionally speaks for itself, and will be heard more and more as it feels its power. It is unrecognized only at its own doorsteps. The men and women of Boston who implant and mature ideas are its real solid people. Their names are not those most often heard in the laudatory accents of the press; yet their influence is felt all over the continent. The *sobriquet* "hub of the universe," given in ridicule, has a spice of truth at bottom. Boston is a city of extremes. It grows the intensest snobs, the meanest cowardice, and thickest-skinned hypocrites, by the side of saintly virtues, intellectual vigor, general intelligence, and a devotion to the highest interest of humanity, unsurpassed by any city in the world. Its fashionable manners seem imported from Nova Zembla. Nowhere else does one friend give another only two fingers to shake, without intending an insult. But the same man is prompt with his bank-check for the public welfare. If a stranger judge Boston only by its snobs, Pharisees, and frozen-zone atmosphere of personal scrutiny and reception, he will coincide in the worst opinions of her enemies. But it takes a rich soil to grow strong weeds. Far outweighing its shortcomings, he will find, on looking farther, self-sacrificing hearts quick to respond to noble instincts, souls ripe in devotion to generous ideas, a practical clear-headedness, a not-to-be-bribed-or-turned-aside love of justice, an earnest willingness of labor, and, above all, a freedom which admits of intellectual growth in all directions, despite time-honored prejudices, the seductions of fashion and luxury, or the gibberish of cant. With such rich salt of humanity vivifying her history, Boston need envy no other city its opportunity for greatness.

THE END

NOTES

Preliminary Talk

1. This "Preliminary Talk With the Reader" appears only in the 1864 edition of *The Art-Idea*. It is included in the present reprinting because of its interest for the history of Jarves' collection of paintings.

Chapter IV

1. This is the famous *Sacré* of Napoleon, painted in 1804 by Jacques Louis David.

Chapter V

1. The idea that Christian art is superior to Greek art, simply because it is Christian, is likewise asserted by other writers, including Ruskin.

Chapter VI

1. This relief of Leucothea, Bacchus, and Nymphs (Villa Albani) is a neo-Attic work much admired for its sentimental grace. *See* Marcelli, Fea, Visconti, *Description de la Villa Albani* (Rome, 1869), No. 9801.

2. Although Jarves locates this Egyptian Apollo in the Vatican, nothing answering this description exists in the Vatican collections. He probably intends to refer to the statue of Antinoüs as Osiris in the Villa Albani. *See* S. Reinach, *Répertoire de la statuaire grecque et romaine* (Paris, 1897), II, 569, No. 5.

3. The ideas expressed in this paragraph are as near as Jarves comes to revealing a knowledge of the theory of evolution set forth by Darwin in *The Origin of Species*. This is the foundation of his own theory that a similar evolution of growth, maturity, and decay can be applied to the arts.

4. Horatio Greenough also remarks on the phallic symbolism of the obelisk in his discussion of the Washington Monument. *See* Horatio Greenough, *Form and Function*, ed. H. A. Small (Berkeley and Los Angeles, Calif., 1947), p. 23.

5. John Gibson (1790–1866) was practically a self-taught sculptor. In 1817 he was finally able to go to Rome, where he was assisted by Canova and Thorwaldsen. He conceived a theory on the Greek use of color in sculpture, and devised a method for tinting his own statues. The most famous of these was a Venus, copies of which he supplied to the Marquess of Sligo and other noble patrons.

6. This Apollo (Museo Nazionale, Naples) is the well-known colossal

statue in porphyry. Jarves was apparently unaware of the fact that the head and hands, originally in bronze, were restored in white marble in the eighteenth century. *See Real Museo Borbonico, Napoli*, Vol. III (Naples, 1824), Pl. VIII.

7. A. Reusch, *Guida illustrata del Museo Nazionale di Napoli* (Naples, n. d.), 675 (6262); Reinach, *Répertoire de la statuaire*, I, 243, Pl. 480, No. 921b.

8. For more about Lysippus' Apoxyomenos (Vatican), *see* Walther Amelung, *Die Sculpturen des Vaticanischen Museums* (Berlin, 1903), Pl. XI, 86.

9. Silence (Capitoline Museum) is the Harpocrates in the Salone, a thoroughly lifeless work of the Hadrianic period. *See* Settimo Bocconi, *The Capitoline Collections* (Rome, 1930), p. 149.

10. Bocconi, *Musei Capitolini* (Rome, 1925), p. 31.

11. Aesop (Villa Albani) is a grotesque realistic work of the Hellenistic period. *See* Morcelli, Fea, Visconti, No. 964.

12. Bocconi, *Collezioni Capitoline* (Rome, 1950), p. 20.

13. This Bacchus (Museo Nazionale, Naples) is a well-known neo-Attic relief of Ikarios and Dionysus. *See* B. Maiuri, *Museo Nazionale di Napoli* (Novara, 1957), p. 32.

Chapter VII

1. This conventional interpretation of the Laocoön seems to indicate that Jarves was familiar with Lessing's analysis of the famous group as an illustration of Winckelmann's noble simplicity and quiet grandeur. Jarves makes the mistake of seeing in it an expression of the Greek ideal simply because the figure of Laocoön does not bellow with open mouth. The tension and torment of this late Greek work have nothing to do with the Hellenic ideal, and appealed to Jarves and to Lessing because the sensational representation of pathos reminded them of the taste everywhere exhibited in the familiar Baroque images of saints.

2. The Dying Gladiator (Capitoline Museum) was the old title of the famous Pergamene statue known as the Dying Gaul. *See* Johannes Overbeck, *Geschichte der Griechische Plastik* (Leipzig, 1857), fig. 79.

3. Orgagna is Jarves' version of Andrea Orcagna, or Nardo di Cione.

4. The Apollo Belvedere.

5. Flora is a copy of a colossal statue of the Hellenistic period. *See Real Museo Borbonico*, Vol. II (1824), Pl. XXVI.

6. V. Mariani and J. von Matt, *L'arte in Roma* (Rome, n.d.), p. 48.

7. L. Goldscheider, *The Sculpture of Michelangelo* (New York, 1940), figs. 23–28.

8. *Ibid.*, figs. 85–87.

9. Pietro Tenerani (1798–1869) was a pupil of Bartolini and Canova and for a time the assistant of Thorwaldsen. The group for the Torlonia Chapel, of which Jarves speaks, was carved in 1838.

10. For François DuQuesnoy's Santa Susannah, *see* A. E. Brinckmann,

Barockskulptur, Handbücher der Kunstwissenschaft, II (Berlin, 1919), 260, fig. 265.

11. Modesty (Vatican Museum) is one of the many versions of a draped female statue known as Pudicitia, attributed to Philikos of Rhodes, 2nd century B.C. *See* M. Bieber, *The Sculpture of the Hellenistic Age* (New York, 1955), fig. 524.

12. The relief is in the Villa Albani, Rome. *See* Reinach, *Répertoire des reliefs grecs et romains* (Paris, 1912), III, 146, No. 3.

13. The St. Jerome is now in the museum at Capodimonte. *See* Bruno Molajoli, *Notizie su Capodimonte* (Naples, 1957), No. 999.

14. This is the Certosa del Galluzzo, or di Val d'Ema, on the Strada Senese.

Chapter VIII

1. Laurati is the Latin form of name of the Sienese painters, Ambrogio and Pietro Lorenzetti (d. 1348).

Chapter XI

1. For these bronze sculptures (Museo Nazionale, Naples), *see* Raphael Gargiulo, *Collection of the Most Remarkable Monuments of the National Museum* (Naples, 1863): Dancing Faun, Pl. XXVI; Bacchus, Pl. XVII; Mercury, Pl. II.

2. Boy with Mask (Villa Albani) is a genre piece of the Graeco-Roman period. *See* Marcelli, Fea, Visconti, No. 678.

3. Reinach, *Répertoire de la statuaire*, I, 355, Pl. 646, No. 1468.

Chapter XII

1. The numbers in parentheses in notes 1–6 refer to A. J. Finberg, *The Life of J. M. W. Turner, R. A.* (Oxford, 1939). For illustrations of these Turners, *see National Gallery, Trafalgar Square, Illustrations to the Catalogue*, III (London, 1926). Ulysses Deriding Polyphemus (323), painted in 1834, National Gallery, No. 508.

2. The Garden of Hesperides (126), painted in 1806, National Gallery, No. 477.

3. The Angel Standing in the Sun (577), painted in 1846–1848, National Gallery, No. 550.

4. Crossing the Brook (188), painted in 1815, National Gallery, No. 487.

5. The Fighting Téméraire Tugged to her Last Berth (482), painted in 1839, National Gallery, No. 524.

6. The Burial of Wilkie (548), painted in 1842, National Gallery, No. 528.

7. William Powell Frith (1819–1909) was a British academician and genre painter famed for his illustrations of English authors and for his large and populous figure pieces "from the life," such as Derby Day (Tate Gallery) and The Railway Station (Holloway College, Windsor). His pictures show a hard drawing and metallic coloring.

8. Jarves refers to William Blake (1757–1827), the famous poet, painter, and mystic.

9. Sir John Everett Millais (1829–1896), William Holman Hunt (1827–1910), and Dante Gabriel Rossetti (1828–1882) were all leading lights in the "Pre-Raphaelite Brotherhood."

10. Andreas Achenbach (1815–1905), trained in the Academy at Düsseldorf, was a painter of landscapes and marines.

11. Charles Frederick Lessing (1808–1880), who studied in the Academy at Berlin, was famous for his scenes from Bohemian history and the career of Jan Huss.

12. Peter von Cornelius (1787–1866), a member of the Nazarene artistic brotherhood in Rome, was known for his mythological and religious subjects in a Michelangelesque manner.

13. Friedrich Overbeck (1789–1869), active in Rome after 1810, believed that art existed only for religion, and based his style on the work of the early Italian masters.

14. Baron Jean Auguste Henri Leys (1815–1869) was a Belgian academic painter of historical genre pictures.

15. Alexandre Calame (1810–1864) was a landscape painter whose Alpine scenes were somewhat suggestive of Corot.

16. Rosaline Bonheur (1822–1899) is famous as an animalier. Her most noted canvas, The Horse Fair, painted in 1853, is in the Metropolitan Museum of Art in New York.

17. Constant Troyon (1810–1865), French landscape painter specializing in French scenery and landscapes with cattle, associated with the artistic community at Fontainebleau and the Barbizon group.

18. Emile Lambinet (1810–1878) was a landscape painter.

19. François-Auguste Bonheur (1824–1884), brother of Rosa Bonheur, was a landscapist and animalier.

20. Pierre Étienne Théodore Rousseau (1812–1867) was one of the first open-air painters defying the conventional classical conception of landscape-painting. He worked mainly at Barbizon and was associated with the famous group centered around Millet.

21. Pierre Edouard Frère (1819–1886), a pupil of Delaroche, was a painter of sentimental domestic genre scenes.

22. Hugues Merles (1823–1881) was a French genre painter.

23. Jean François Millet (1814–1875), a pupil of Delaroche, was a famous genre painter of French peasants, working mainly at Barbizon, where he retired in 1849.

24. Jean Léon Gérôme (1824–1904), pupil of Delaroche and Gleyre, was an academician and late neo-classic painter of exotic but banal historical genre pictures.

25. Jean Louis Haman (1821–1874), genre and figure painter, was another pupil of Delaroche and Gleyre.

26. Jean Louis Ernest Meissonier (1813–1891), genre and historical painter famed for his exactitude of detail, specialized in military subjects of the

Napoleonic era, revealing the most elaborate compositions without imagination or poetry.

27. Thomas Couture (1815–1879), history and genre painter, was a pupil of Baron Gros and Delaroche. He is esteemed more today for his realistic and sensitive portraits than for the pretentious historical pieces that won him contemporary fame.

28. Emile-Jean-Horace Vernet (1789–1863) was a famous painter of battle pieces, landscapes, and genre. He was a pupil of André Vincent and companion of Géricault.

29. Hippolyte "Paul" Delaroche (1797–1856) painted gigantic historical canvasses. He was a pupil of Baron Gros.

30. Alexandre Gabriel Décamps (1803–1886) was a Parisian painter of landscapes, animal and genre subjects.

31. François Antoine Léon Fleury (1804–1858) was a landscape painter of French and Italian scenes. Jarves errs in referring to him as "Robert."

32. Ary Scheffer (1795–1858), pupil of Guérin, was famed for his religious subjects and romantic paintings of subjects from Dante, Goethe, and Byron.

33. Gustave Doré (1833–1883) was a French historical painter and illustrator of books. Although gifted with a tremendously fertile imagination, he suffered from grave defects in drawing and composition.

Chapter XIII

1. By Raphael's Scriptures in the Vatican, Jarves presumably means the Old Testament subjects in the Loggie, most of which were executed by Giulio Romano, a pupil of Raphael.

Chapter XIV

1. Benjamin West (1738–1820), American historical painter, trained in Rome under Anton Raphael Mengs, worked in England from 1763 until his death, and was for many years president of the Royal Academy.

2. John Singleton Copley (1737–1815), the last of the Colonial portrait painters, was largely self-taught. He sailed for England in 1774, never to return to the United States. It is generally acknowledged that his best works are the portraits done during his years in Boston.

3. Charles Robert Leslie (1794–1859), American painter of portraits and genre subjects, was trained under Allston and West, and became a member of the Royal Academy.

4. Sir David Wilkie (1785–1841) was a famous British painter of genre scenes and historical subjects.

5. John Trumbull (1756–1843) studied under Benjamin West and became famous for his series of historical paintings from the Revolution and the period of the new Republic. His best-known canvasses of the Revolution are in the Rotunda of the Capitol at Washington.

6. Thomas Sully (1783–1872) was an American portrait painter who worked in the manner of Stuart.

7. Charles Willson Peale (1741–1826) was trained under West in London, and was known chiefly as a portrait painter. He founded a museum in Philadelphia and was also famous for his many mechanical inventions.

8. Sully's painting of Washington crossing the Delaware is now in the Museum of Fine Arts, Boston.

9. Gilbert Stuart (1756–1828) studied under West in London, and became the most famous American portrait painter of his day. He was particularly well known for his many portraits of George Washington.

10. William Sidney Mount (1807–1868), noted painter of rustic genre subjects, lived and worked entirely in New York and Long Island.

11. John Vanderlyn (1776–1852) studied under André Vincent, and his few paintings reflect the neo-classic style of David. The painting of Ariadne is now in the Pennsylvania Academy of Fine Arts, Philadelphia.

12. Thomas Cole (1801–1848), sometimes called the father of American landscape painting, was famous for his views of Italian as well as American scenery, and for several series of allegorical and religious paintings. His Course of Empire is now in the New York Historical Society.

13. Washington Allston (1779–1843) was the most renowned American romantic painter. Trained in Paris, Rome, and London, he was the first American artist to devote himself to imaginary subjects rather than to portraits.

14. Belshazzar's Feast is now in the Detroit Institute of Arts. *See* E. P. Richardson, *Washington Allston* (Chicago, 1948), No. 100.

15. The Valentine is owned by the Estate of Miss Rose L. Dexter, Boston, Massachusetts. *See* Richardson, No. 138.

16. Lorenzo and Jessica is in the collection of John M. Cabot, Washington, D.C. *See* Richardson, No. 138.

17. The Sisters is in the collection of the Fogg Art Museum, Cambridge, Massachusetts. *See* Richardson, No. 109.

18. Jeremiah and the Scribe Baruch is in the collection of the Yale University Art Gallery. *See* Richardson, No. 122.

Chapter XV

1. This prophecy by Jarves has hardly been sustained. Doughty is generally regarded as one of the founders of American landscape painting.

2. Alvan Fisher (1825–1863), a painter of landscapes, portraits, and genre, studied in Paris.

3. Edwin White (1817–1877), an American historical painter, studied in Rome, Florence, Paris, and Düsseldorf.

4. Emanuel Leutze (1816–1868), German historical painter, studied in Düsseldorf under Lessing. He first came to the United States in 1851. His most famous work is Washington Crossing the Delaware (Metropolitan Museum of Art).

5. T. Addison Richards (1820–1900), a painter of landscape in the White Mountains, became secretary of the National Academy of Design, and had his studio in New York.

6. John Rollin Tilton (1833–1888) was a self-taught American landscape painter who studied in Italy, and was particularly famed for his romantic Mediterranean views. "Tilten" is Jarves' misspelling.

7. William Page (1811–1885) studied with Samuel Morse at the National Academy. He was for many years the leading American painter in Rome. His experiments with Venetian color earned him the soubriquet of the "American Titian."

8. This allusion to Page's plagiarism very likely refers to that artist's habit of borrowing the poses of both single figures and groups from antique and Renaissance sculpture.

9. Louis Alexandre Péron (1776–1856), historical painter, was a pupil of David and Vincent.

10. Moses Wight (1827–1895) studied under Herbert and Bonnard. He was widely known for his portraits and figure pieces.

11. Cephas G. Thompson (1809–1888) was a landscape painter active in Massachusetts, Rhode Island, and New York, who also worked in Italy from 1852 to 1862. He is chiefly famous for his portraits of American authors (New York Historical Society).

12. Eastman Johnson (1824–1906) studied in Düsseldorf, Paris, Rome, and The Hague. He was a portrait painter but was especially well known for his New England genre subjects.

13. James Crawford Thom (1842–1898), a pupil of Edouard Frère in Paris, was a genre painter.

14. Thomas Hewes Hinckley (1813–1896), an animalier who studied under Sir Edwin Landseer, painted occasional landscapes in England and America.

15. William Holbrook Beard (1825–1900), a portrait painter and animalier, studied in Düsseldorf and elsewhere in Europe. He was noted for his humorous paintings of animals in human situations.

16. George Quincy Thorndike (1825–1886) studied in Paris and became a painter of landscapes and marine views.

17. William P. W. Dana (1833–1927) studied at the Ecole des Beaux-Arts and under Le Poitevin in Paris. He was noted for his landscape and figure paintings.

18. William Morris Hunt (1824–1902) studied in Rome, Düsseldorf, and in Paris with Couture and Barye. Influential as a teacher and patron, he led the trend away from Düsseldorf to the French school.

19. J. Foxcroft Cole (1837–1892), a landscapist, pupil of Charles Jacque in Paris, exhibited in the Salon in the eighteen sixties and seventies.

20. John La Farge (1835–1910) studied in Munich and Dresden, in Paris with Couture, and with Hunt at Newport, Rhode Island. He worked in stained glass, mosaic, and sculpture, and also did landscapes and figure pieces in the Pacific islands.

21. William P. Babcock (1826–1899), a pupil of Couture, was a painter of figure subjects and genre.

22. Asher Brown Durand (1796–1886) was an American landscape painter

who was trained as an engraver. A founder of the National Academy (1826), he was a leader in the Hudson River School.

23. Henry Peters Gray (1819–1877) studied under Daniel Huntington and later in Europe. He modelled his style on the Old Masters, particularly Titian and Correggio.

24. Robert W. Weir (1803–1889) studied in Florence and Rome. Painter of portraits and historical subjects, he was professor of drawing at West Point for forty years, beginning in 1832.

25. Daniel Huntington (1816–1906) was a pupil of Samuel F. B. Morse and also studied under Inman. He was well known for his historical allegorical compositions and for his portraits of notable figures of the time.

26. Charles Loring Elliott (1812–1868) worked in the studio of John Quidor, and is reputed to have painted more than seven hundred portraits of prominent personages of his time. He began painting in the manner of Gilbert Stuart and later adopted the more romantic vein of Inman.

27. George P. A. Healey (1813–1894) was a portrait painter who studied in Paris in 1836 and spent many years in Rome.

28. Joseph Alexander Ames (1816–1872) was a portraitist who studied in Boston, New York, and Rome.

29. Frederick Edwin Church (1826–1900), pupil of Thomas Cole, was an extremely successful landscape painter, famous for his spectacular panoramic views of South American and Mediterranean scenery.

30. Albert Bierstadt (1830–1902) studied in Düsseldorf. He joined an expedition to the Rockies in 1858. He is distinguished for his huge canvasses of Western scenery.

31. John Frederick Kensett (1818–1872) trained first as an engraver, went to Europe with Durand in 1840, and studied for seven years in England, Germany, Switzerland, and Italy. He had a successful career as a landscape painter in the Hudson River tradition.

32. Sanford Robinson Gifford (1823–1880), who painted landscapes of American and Mediterranean scenes, was influenced by Thomas Cole.

33. Jaspar F. Cropsey (1823–1900) was an architect and a landscape painter who studied both in Italy and Great Britain. He was active in London from 1857 to 1864, and his pictures on occasion showed the influence of John Constable.

34. William L. Sontag (1822–1900) was a self-taught landscape painter and academician.

35. Régis François Gignoux (1816–1886), pupil of Delaroche and Horace Vernet, was a painter of American landscapes and a teacher of George Inness.

36. Martin Johnson Heade (active 1847–1884) was an American landscape painter who is especially noteworthy for his luminous marines. He also did sketches of hummingbirds and flowers during an expedition to Brazil.

37. George Loring Brown (1814–1889) studied in Rome and Florence.

He was a popular painter of landscapes in a rather lurid Claudian style. Hawthorne, as a matter of fact, preferred his work to Claude's.

38. William Bradford (1830–1892), a self-taught Quaker artist, painted marine subjects in New England, Labrador, and Nova Scotia.

39. George Inness (1825–1894) studied briefly under Gignoux, but was practically self-taught. He made several trips to Europe, mainly Rome and Paris, beginning in 1847, and was influenced by the Barbizon School.

40. Felix O. C. Darley (1822–1888), an accomplished illustrator in pen and ink, was renowned for his drawings for Irving and Cooper.

41. Hammatt Billings (1818–1874) was both architect and the illustrator of works by Keats and Tennyson.

42. Thomas Nast (1840–1903), caricaturist and black-and-white artist, was famous for his illustrations and political cartoons in *Harper's Weekly*.

43. Elihu Vedder (1836–1923) studied in Paris and Italy, and lived in Rome and Capri from 1867 until his death. He painted figure subjects, landscapes, and murals for the Library of Congress, and did illustrations for *The Rubaiyat of Omar Khayyam*.

44. Louis Lang (1814–1893) was a German-born painter of portraits and historical scenes.

45. George Henry Hall (1825–1913) studied in Düsseldorf and Paris. He was famed for his still-lives of fruit and flowers and genre scenes from Shakespeare. He also did canvasses from Spanish, Italian, and Oriental history.

46. John Rogers (1829–1904) was one of the first to break the spell of neo-classicism. He is famous for his genre subjects, the so-called Rogers Groups.

47. Jarves is referring to the draft riots of July 1863.

Chapter XVI

1. For the story of Greenough's Chanting Cherubs, *see* Albert Ten Eyck Gardner's *Yankee Stonecutters* (New York, 1945), pp. 14, 39–40.

2. Horatio Greenough (1805–1852), American neo-classic sculptor, studied under Thorwaldsen and Bartolini in Rome.

3. A version of the Castor and Pollux is in the Museum of Fine Arts, Boston.

4. *See* Lorado Taft, *History of American Sculpture* (New York, 1925), p. 37, Pl. II.

5. Clark Mills (1810–1883) did the equestrian statue of Jackson at Washington, dedicated in 1853. This is illustrated in Taft, p. 125, fig. 15.

6. Hiram Powers (1805–1873), the most widely known of the American expatriate sculptors, settled in Florence in 1837 and made a fortune turning out mythological and allegorical marbles in the approved neo-classic style.

7. Thomas Crawford (1813–1857) studied in Rome. His most famous statue is the Freedom that surmounts the dome of the Capitol in Washington, D.C.

8. Crawford's statue of Beethoven is now in the New England Conservatory of Music, Boston.

9. Henry Dexter (1806–1876) was an American sculptor, who was aided by the painter, Francis Alexander. He was noted for his many portraits and sentimental memorials like that of the Binney child in Mt. Auburn Cemetery, Cambridge, Massachusetts.

10. John Crookshanks King (1806–1882) was chiefly renowned for the innumerable portraits that he executed in Boston from 1840 on.

11. Samuel Fisher Ames (1817–1901), who studied in Boston and Rome, was famous for his bust of Lincoln.

12. For California, *see* C. R. Post, *History of European and American Sculpture* (Cambridge, Mass., 1921), Vol. II, fig. 156. The Greek Slave is illustrated in Taft, Pl. III.

13. Jarves refers to Sir Francis Chantry (1781–1841). For his statue of Washington, now in the Boston State House, *see* Post, Vol. II, fig. 154.

14. For contemporary opinions on this statue — both pros and cons — *see* Taft, p. 69.

15. Joel Tanner Hart (1810–1877) was a Kentucky stonecutter who worked in Florence for a time. He was famous for his invention of a pointing machine as well as for his statues of Henry Clay.

16. Randolph Rogers (1825–1892) was a pupil of Bartolini. His statue of Nydia is illustrated in Taft, fig. 22.

17. Harriet Hosmer (1830–1908) studied with Gibson in Rome in 1852. For the Beatrice Cenci, *see* Taft, fig. 28.

18. Richard Saltonstall Greenough (1819–1904), the brother of Horatio Greenough, studied in Florence and Rome. His statue of Franklin is in City Hall Square, Boston.

19. Thomas Ball (1819–1911) studied in Florence in the fifties. His statue of Washington (Public Garden, Boston) is illustrated in Taft, fig. 18.

20. Henry Kirke Brown (1814–1886), American sculptor, produced three equestrian statues. For his Washington (Union Square, New York), *see* Taft, Pl. V.

21. Harriet Hosmer's statue of Zenobia (Metropolitan Museum, New York) is illustrated in Taft, fig. 29. Her statue of Thomas Benton is in Lafayette Park, St. Louis, Missouri.

22. Emma Stebbins (1815–1882) studied with Paul Ackers in Rome. This fountain is her best-known work.

23. William Rimmer (1816–1879), entirely self-taught, was the one progressive American sculptor of the nineteenth century. His Falling Gladiator and other works are illustrated in Gardner, Pls. IX–XI. He was famous for his lectures on anatomy, and his book, *Art Anatomy*, was published in 1877.

24. Benjamin Paul Ackers (1825–1861) studied briefly with Powers in Italy in 1851. Kenyon in Hawthorne's *The Marble Faun* is based on Ackers and his work.

25. Erastus Dow Palmer (1817–1904), an entirely self-trained sculptor, spent most of his life in Albany, New York.

26. For an illustration of The White Captive, *see* Gardner, Pl. V, fig. 2.

27. William Wetmore Story (1819–1895) abandoned the law in 1856 to settle in Rome, where he spent the rest of his life. In 1862 his reputation was made by the Cleopatra (*see* Gardner, Pl. VIII, fig. 1). His career has been recorded by Henry James in *William Wetmore Story and His Friends*.

28. J. Q. A. Ward (1830–1910) was a pupil of Brown and completely anti-classic in his work. His most famous works are the Beecher monument in Brooklyn, of which the African Freedman is a part, and The Indian Hunter (Central Park, New York).

Chapter XVII

1. This is a reference to Gore Hall, the Harvard College Library, which stood on the site of the present Widener Library. *See Architectural Record*, 26 (October 1909), p. 248.

2. *See* Talbot Hamlin, *Greek Revival Architecture in America* (New York, 1947), Pl. XX, XXI.

3. The Tremont House was a famous hostelry located at the corner of Tremont and Beacon Streets, opposite Tremont Temple. It was opened in 1829. Charles Dickens, Henry Clay, and Edward VII as Prince of Wales were among the many famous personages who enjoyed its hospitality. *See* the view of this building in the painting of Tremont Street by Philip Harry (The Karolik Collection, Museum of Fine Arts, Boston) in *M. and M. Karolik Collection of American Paintings* (Cambridge, 1949), p. 291.

4. *See* Hamlin, Pl. XIX.

5. *See* Horatio Greenough, *Form and Function*, p. 23.

6. The City Hall on School Street, designed by G. J. F. Bryant and Arthur Gilman, was erected in 1862. Its style is described in a somewhat later handbook as "Italian Renaissance modified and elaborated by the taste of French architects of the last thirty years."

7. For the Boston Organ, *see* Moses King, *Handbook of Boston* (Cambridge, 1878), p. 228.

8. The Boston Music Hall, built in 1852, had its entrance on Tremont St. opposite the Park St. Church.

9. The Tremont St. Methodist Church, located at the corner of Tremont and Concord Streets, was completed from designs by Hammatt Billings in 1862. It was built of quarry stone with two Gothic spires in a style reminiscent of the Chapel of the Episcopal Theological School in Cambridge, Massachusetts.

10. The Church of the Immaculate Conception was built in 1861 at the corner of Harrison Ave. and Concord St. This solid granite structure was designed by Arthur Gilman.

11. The Shawmut Congregational Church was dedicated in 1864 at the corner of Tremont and Brookline Streets. It had a tower derived from the Campanile in Venice and a Lombard Romanesque façade suggestive of Richardson's later use of the style.

12. A. W. Pugin, *The True Principles of Pointed or Christian Architecture* (London, 1841), p. 1.

Chapter XX

1. Benjamin Robert Haydon (1786–1846) was an English historical painter. Dreaming of founding an elevated school of art, he was constantly at war with the Royal Academy and the critics.

Appendix

1. Henry D. Morse (b. 1826) was an amateur painter in Boston who specialized in animal subjects.

INDEX

Achenbach, Andreas, 143
Adams (statue in Mt. Auburn chapel), 217
Aesop, 61
Akers, B. P., 221. WORKS: Pearl-Diver, 221; St. Elizabeth of Hungary, 221
Alatri, citadel of, 102
Alberti, Leon Battista, 237, 238
Albertinelli, Mariotto, 22
Allston, Washington, xix–xx, 172f, 202, 209, 210, 212. WORKS: Beatrice, xx, 174; Belshazzar's Feast, xix, 174; Jeremiah and the Scribe Baruch, xx, 174; Lorenzo and Jessica, 174; Miriam, 174; The Sisters, 174; The Valentine, 174
Ames, J. A., 189
Amiens, Cathedral of, 119
Amsterdam, collection, 273
Angelico, Fra, xvi, 22, 24, 27, 79, 84, 155, 158, 160, 163
Angerstein collection, 265
Annunciata, Church of the, see Florence
Antwerp collection, 273
Apelles, 50
Apollo Belvedere, 72, 79
Apollo, of dark green basalt, 60
Apollo, of marble and black porphyry (Naples), 60
Aretino, Spinello, 22
Aristides, or Aeschines of Naples, 217f
Arpino, citadel of, 102
Art-Hints, Architecture, Sculpture and Painting, xiv, xvii, 8
Art-Studies, 11
Art-Thoughts, the Experiences and Observations of an American Amateur in Europe, xiv, xxi, xxvii
Atkinson, J. B., 244

Babcock, W. P., xx, 183, 186f, 196, 208
Bacchus, 61
Ball, Thomas: Washington, 219; Webster, 219

Bartolini, Lorenzo: Charity, 79
Bazzi, Giovanni Antonio de', 12, 22, 180
Beard, W. H., 183. WORKS: The Exchange of Compliments, 183; The Jealous Rabbit, 183; March of Silenus, 183
Beccafumi, Domenico, 22
Bedford Street Church, see Boston
Beecher, Henry Ward, 156f
Belle Arti collection, 272
Bellini, Giovanni, 22, 84, 155
Belvedere: collection (Vienna), 273; Torso, 72
Berlin Gallery, 273
Bernini, Giovanni, 223; St. Babiana, 79
Bierstadt, Albert, 191–192. WORKS: Rocky Mountains, 205; Sunshine and Shadow, 192
Billings, Hammatt, 196–197, 243. WORKS: Bedford Street Church, 243; Marguerite, 206; Mechanics' Association building, 243; St. Agnes's Eve, 206; Sister of Charity, 206; Sleeping Palace, 206; Tremont St. Methodist Church, 243
Blake, William, 79, 139f, 225, 276, 282; Death's Door, 225
Blind Man, the, 61
Bologna, collection of the Academy of, 273
Bonheur, François-Auguste, 146
Bonheur, Rosa, xxi, 145
Bordone, Paris, 22
Borghese collection, 264, 273
Boston, 253f: Bedford Street Church, 243; Boston City Hall, 239; Boston Institute of Technology, 272; Boston Music Hall, 241; Boston Organ, 240; Boston State House, 230; Bunker Hill Monument, 239; Forest Hills cemetery, 255; Greenwood cemetery, 255; Immaculate Conception, Church of the, 243; Masonic Temple, 232; Mechanics' Association building, 243;

INDEX

INDEX

INDEX

THE JOHN HARVARD LIBRARY

*The intent of
Waldron Phoenix Belknap, Jr.,
as expressed in an early will, was for
Harvard College to use the income from a
permanent trust fund he set up, for "editing and
publishing rare, inaccessible, or hitherto unpublished
source material of interest in connection with the
history, literature, art (including minor and useful
art), commerce, customs, and manners or way of
life of the Colonial and Federal Periods of the United
States . . . In all cases the emphasis shall be on the
presentation of the basic material." A later testament
broadened this statement, but Mr. Belknap's inter-
ests remained constant until his death.*

*In linking the name of the first benefactor of
Harvard College with the purpose of this later,
generous-minded believer in American culture the
John Harvard Library seeks to emphasize the impor-
tance of Mr. Belknap's purpose. The John Harvard
Library of the Belknap Press of Harvard University
Press exists to make books and documents
about the American past more readily
available to scholars and the
general reader.*